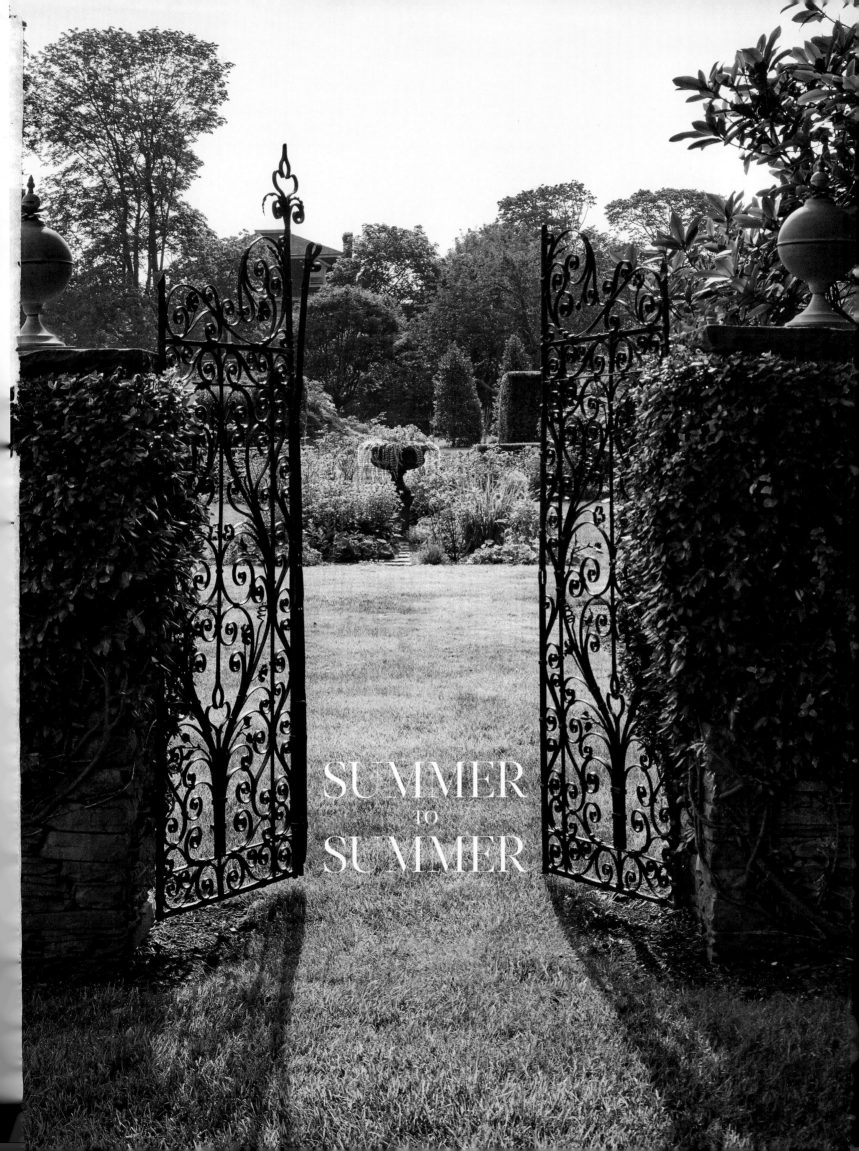

SUMMER
TO
SUMMER

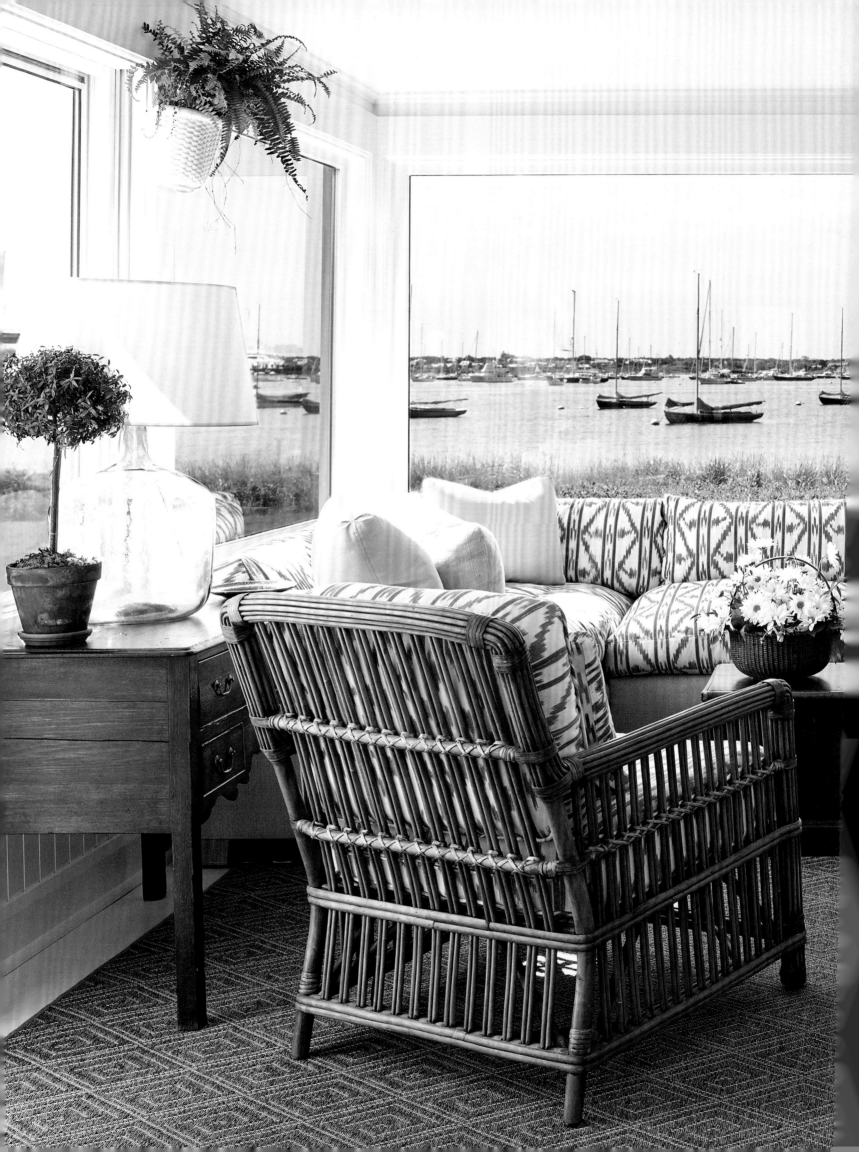

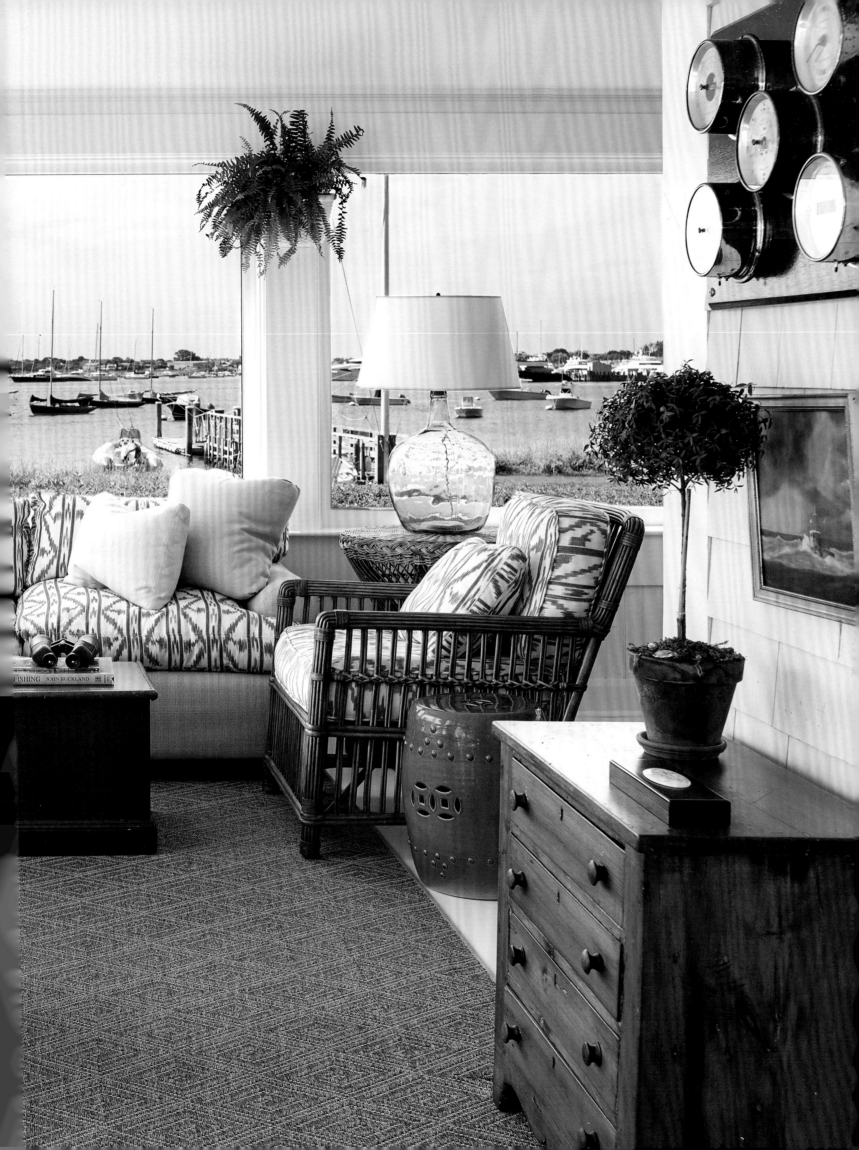

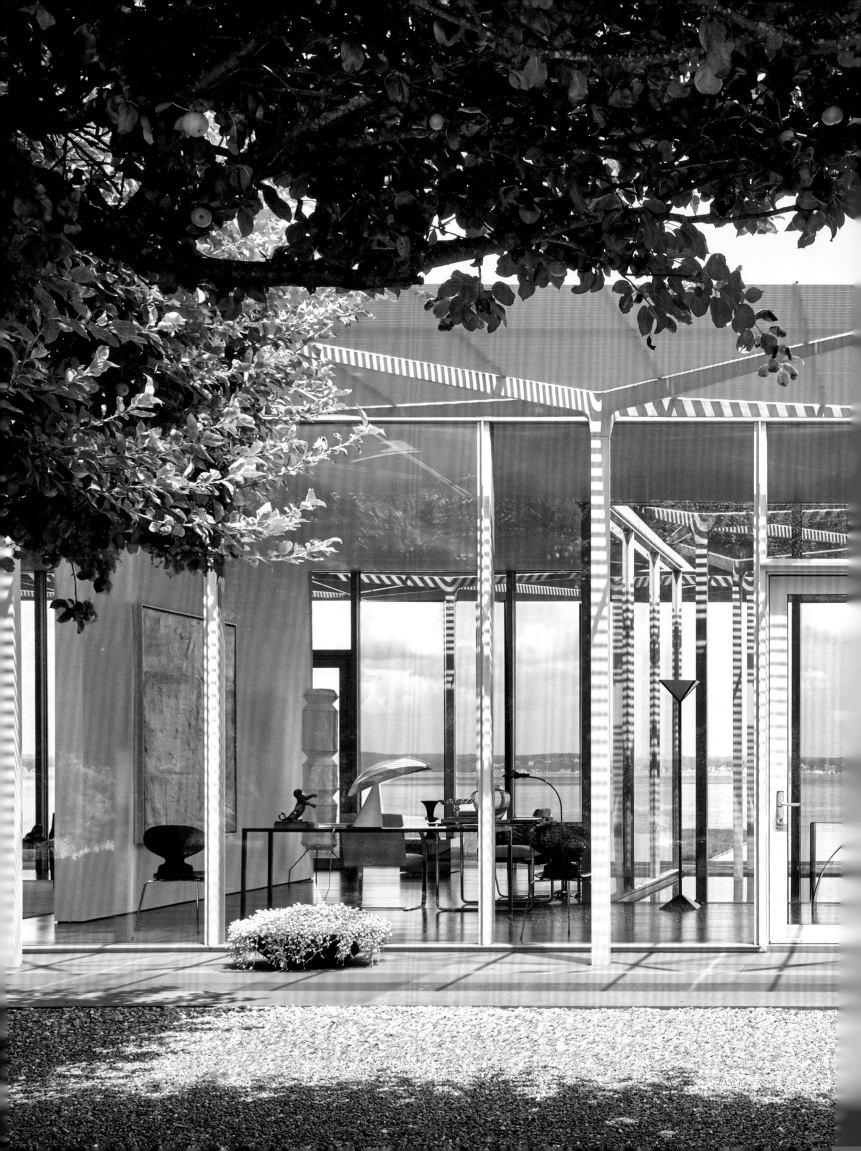

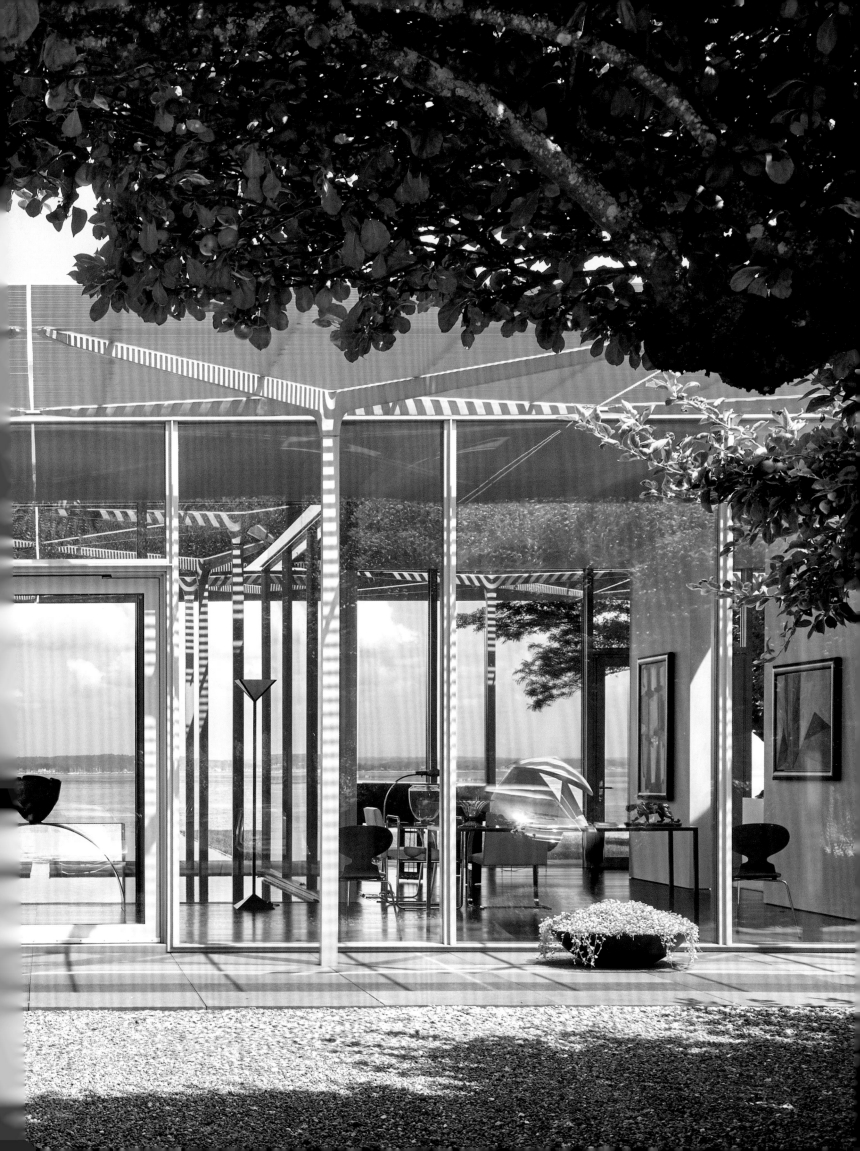

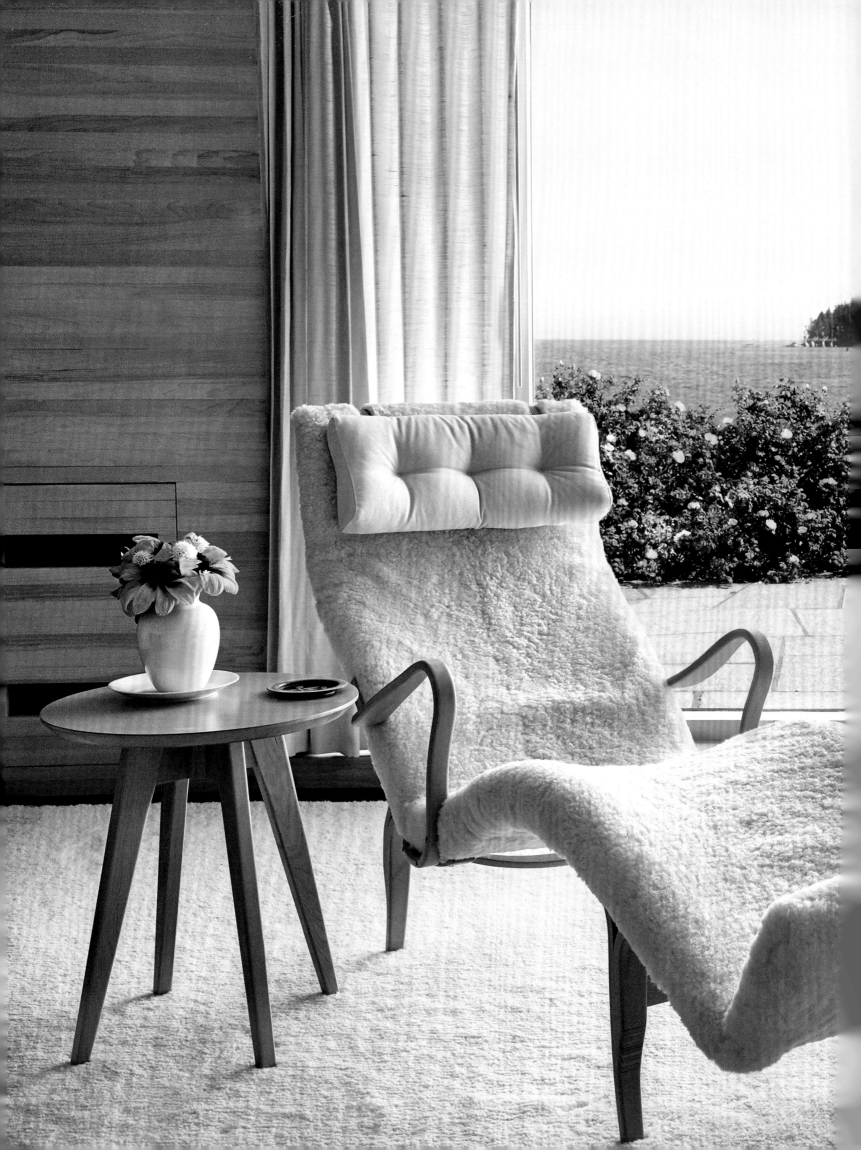

SUMMER TO SUMMER

HOUSES BY THE SEA

JENNIFER ASH RUDICK
PHOTOGRAPHY BY TRIA GIOVAN

VENDOME

NEW YORK • LONDON

CONTENTS

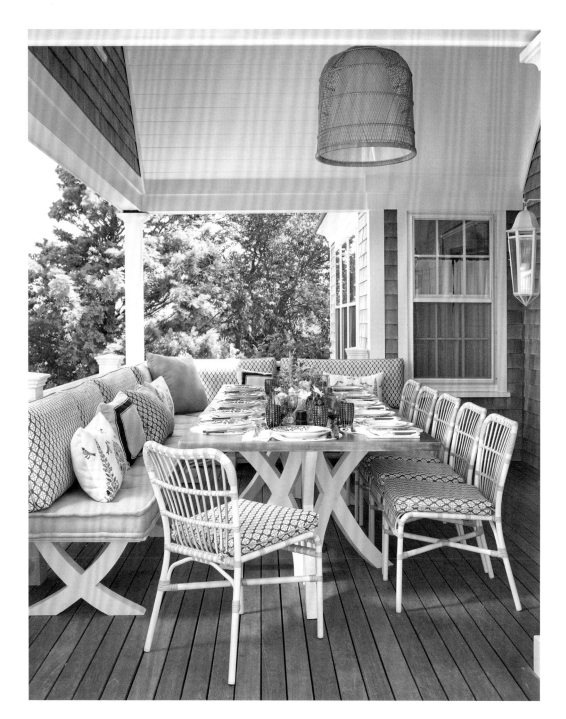

*In memory of my maternal
great-grandfather, Thomas
Lyman Arnold, a summer house
visionary. In the early 1900s he
created the summer colony Arnolda
in coastal Rhode Island. I spent
every summer of my youth there,
and it exists to this day.*

—TRIA GIOVAN

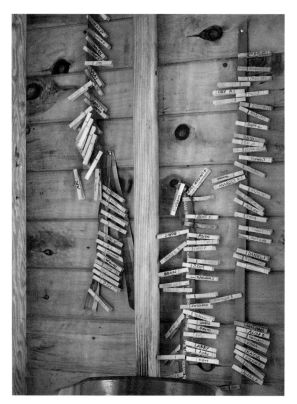

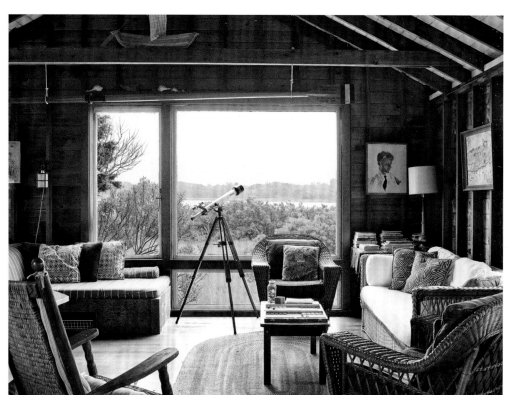

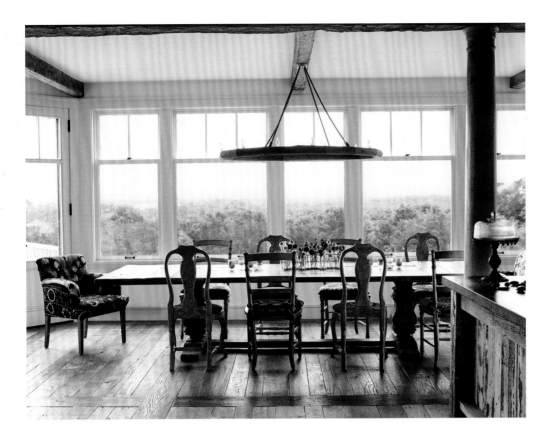

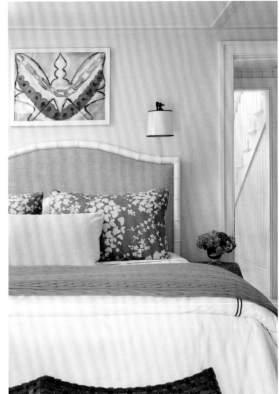

*To my husband,
Joe Rudick, whose advice
and optimism always carry
the day. He is the first to read the
text, the last to complain about
an unpredictable schedule, and
the champion behind
every project.*

—JENNIFER ASH RUDICK

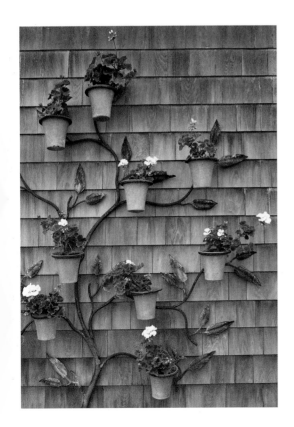

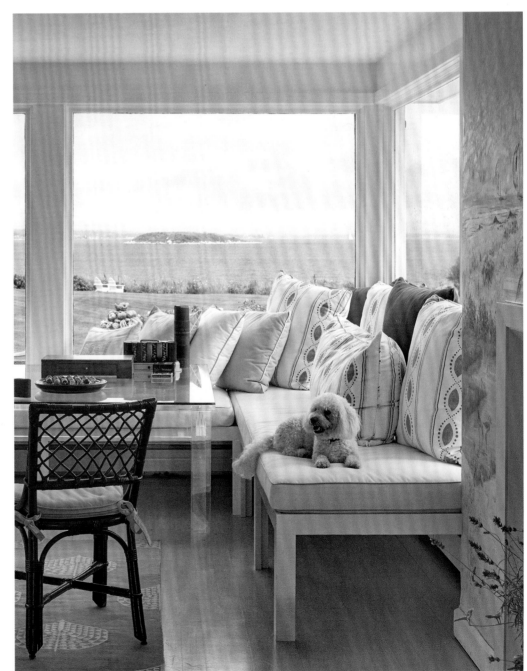

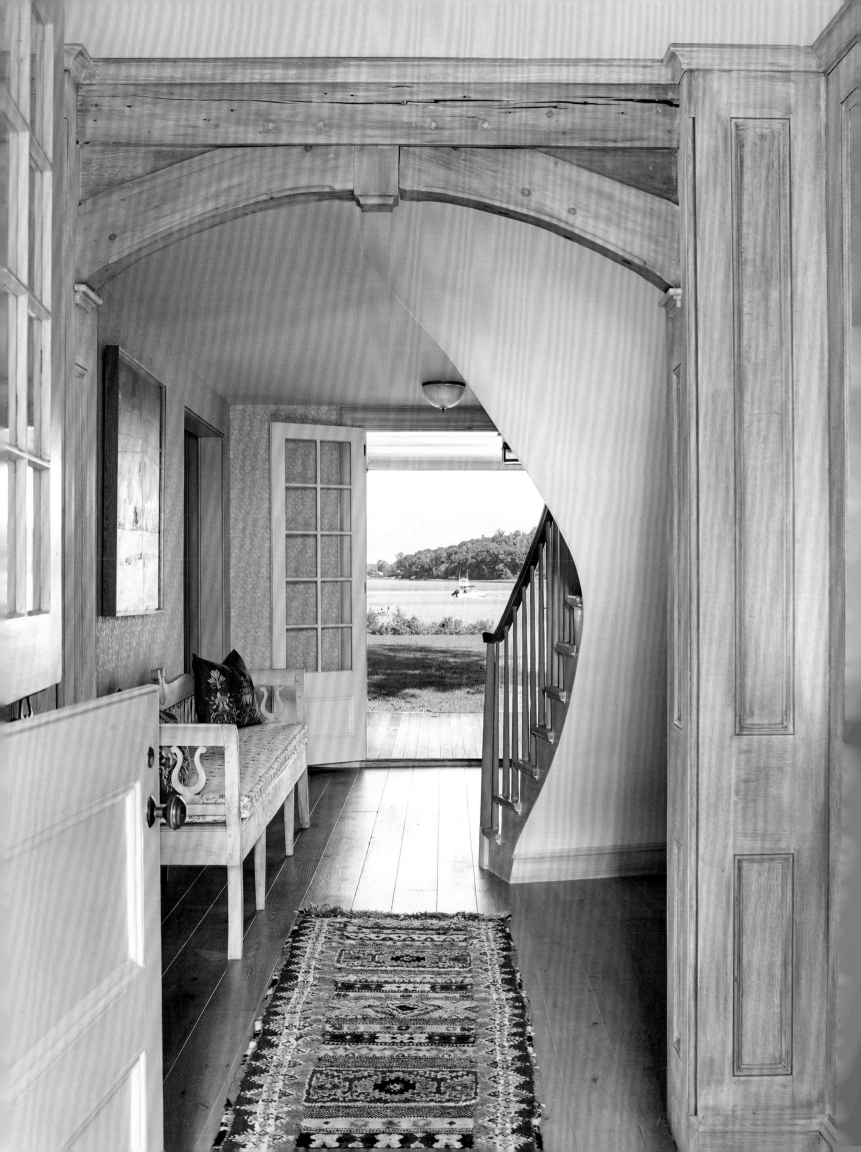

INTRODUCTION

Summer vacation is a cherished part of the American dream. We long for a place to retreat to with our family where we can escape from our normal routine and, if we're lucky enough to return to the same place from summer to summer, create traditions.

When I was a teenager, a friend's invitation to Hyannis Port, on Cape Cod, provided an early glimpse of a New England summer community (and an introduction to the use of "summer" as a verb). To say I was visiting an active family would be a wild understatement. I arrived in the late afternoon, having traveled most of the day—Palm Beach to Atlanta, Atlanta to Boston, Boston to Hyannis—yet we managed to play tennis, bike along the coast, and bodysurf before dinner. Having not eaten since the night before and too happily engaged to notice, I fainted in front of the club buffet; apparently, I missed taking down an ice sculpture depicting a giant lobster claw by mere inches.

The trip's inauspicious start did nothing to dim its positive impression and served as a primer in summer house style. On the Cape, everyone's doors were flung open and every house boasted an exuberant and offhanded mix of armchairs covered in faded chintz, blue-and-white ticking, and loads of wicker. Walls painted in pale blues and greens evoked the sea, while dark-paneled rooms resembled staterooms on nearby yachts. Antiques from different countries and various periods gave the impression of a sea captain's loot. Accoutrements of summer activities—books, board games, puzzles, and silver sport trophies—lined bookshelves and topped mantels.

I would eventually see variations on this breezy style up and down the Northeast coast. Apple Bartlett perhaps summed it up best, "With summer

houses especially, nothing should be too organized or fussy. Everything should be relaxed with very few rules. You should be able to return from the beach and hang a towel on the railing. You know the song, 'Summertime, and the livin' is easy.'" The interior of Bartlett's sprawling Maine cottage, which has been in the family since 1945, boasts painted furniture, handmade quilts and hook rugs, and baskets commissioned from local artisans, as well as curtains and upholstery in flowery chintzes and mattress ticking, a style popularized by her late mother, Dorothy "Sister" Parish, who reigned over three generations of American design as head of the legendary New York firm Parish-Hadley Associates. The house is a testament to the fact that when décor is personal and practical, it will most likely be beautiful, and its charm will endure.

This book is the culmination of a lifetime of observing and of two summers traveling around the Northeast coast with extraordinary photographer and partner in crime Tria Giovan. An inveterate traveler and keen observer with an encyclopedic knowledge of design, Tria's insights and discerning eye were invaluable.

Ferry schedules are quixotic and puddle jumpers rarely fly on schedule, but the effort it takes to get to a place is directly proportionate to its exceptionality. A case in point was our last shoot, artist Randy Polumbo's lighthouse on Plum Gut Island off the turbulent shores of Orient Point. To access the lighthouse, we were told to engage Captain Bob, who, as we headed for the island in his center-console boat, instructed us to "jump far and fast" onto what looked like a pool ladder jury-rigged on the jagged rocks. We climbed two more ladders, balancing heavy equipment on our backs, before reaching the extremely narrow walkway around the lighthouse's first floor, with only a chain-link railing protecting us from plunging onto the rocks below. Inside, Polumbo has transformed one floor into a shimmering, otherworldly "grotto," every bit as captivating as its blue cousins on Capri. Experiencing it was worth whatever it took to get there. As the sun went down, we were setting up our last shot when a magical light skated across the wall, casting a radiant glow and taking our breath away. I was instantly reminded why we look to artists to open new ways of seeing the world.

A prime example is Sea Change, as much a piece of sculpture as a house. Conceived in 1940 by artist Isamu Noguchi, architect Wallace Harrison, and art patron William A. M. Burden, it was designed to embrace nature; its serpentine lines mimic the Mount Desert Island shore on which it stands, while its diminutive size defers to the nearby towering spruces and pines.

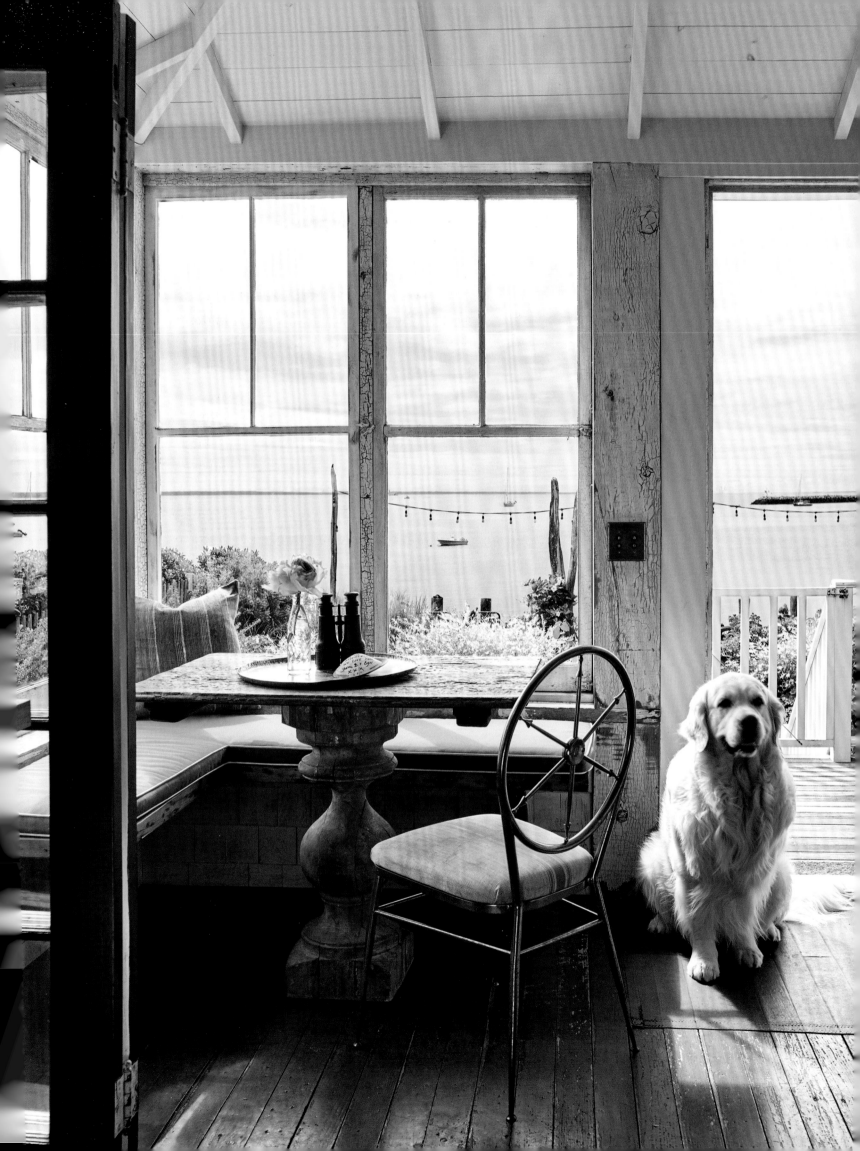

People often ask how I select the houses that I include in my books. For all their stylistic variation, I look for places that are authentic reflections of their settings and owners. The evidence of lives lived is what makes interiors so compelling. Old masters art dealer Mark Brady's Maine retreat was designed with the same unstinting discipline demanded of his profession. Its form—a series of shingled pavilions surrounding a large great room—allows its waterfront setting to take center stage. John Knott and John Fondas's nearby island house, built in 1905 as a hotel for "rusticators," brims with an exuberant collection of fabrics and furnishings, the kind of China Trade exotica that a New England sea captain might have amassed, a fitting tribute to the history of the house and to the couple, who own Quadrille Fabrics. Norman and Elena Foster's striking pool house on Martha's Vineyard is not only a glassy reflection of Lord Foster's futuristic vision, which graces skylines around the world, but also takes technical and aesthetic cues from the main house, a historic farmhouse. Down the road, singer/songwriter Carly Simon's life story is told through a magical rambler—rooms were added, not always to perfection, as the creative muse struck. There are guitar mosaics, her mother Andrea's needlepoint tableau of titles from Simon & Schuster, the publishing company co-founded by her father. At night, the family gathers around a sprawling fire pit called Stoned Henge, designed by Simon's son, Ben Taylor. Bobby and Barbara Liberman's Long Island residence began life as a boathouse, providing the perfect berth for the couple's gozzo boat, ordered while on vacation in Capri. Block Island is home to a quirky Victorian owned by three friends who pooled their assets and vision to great appeal. On the other side of Block Island, Susan and Peter MacGill's two-bedroom 1950s Cape sits atop a bluff with a protected 180-degree ocean view, thanks to Keith Lewis, who had donated almost a hundred priceless acres to the Block Island Conservancy. Recognizing that the house was all about the setting, the couple—she a photographer and he an art dealer—did nothing more than repair windows, fix roofs, and update the mechanicals.

When a home is a distillation of its owner's distinctive taste, the story it tells is the equivalent of a personal portrait. The houses in this volume comprise a whole gallery of portraits celebrating the comfort and delight of summer living by the sea.

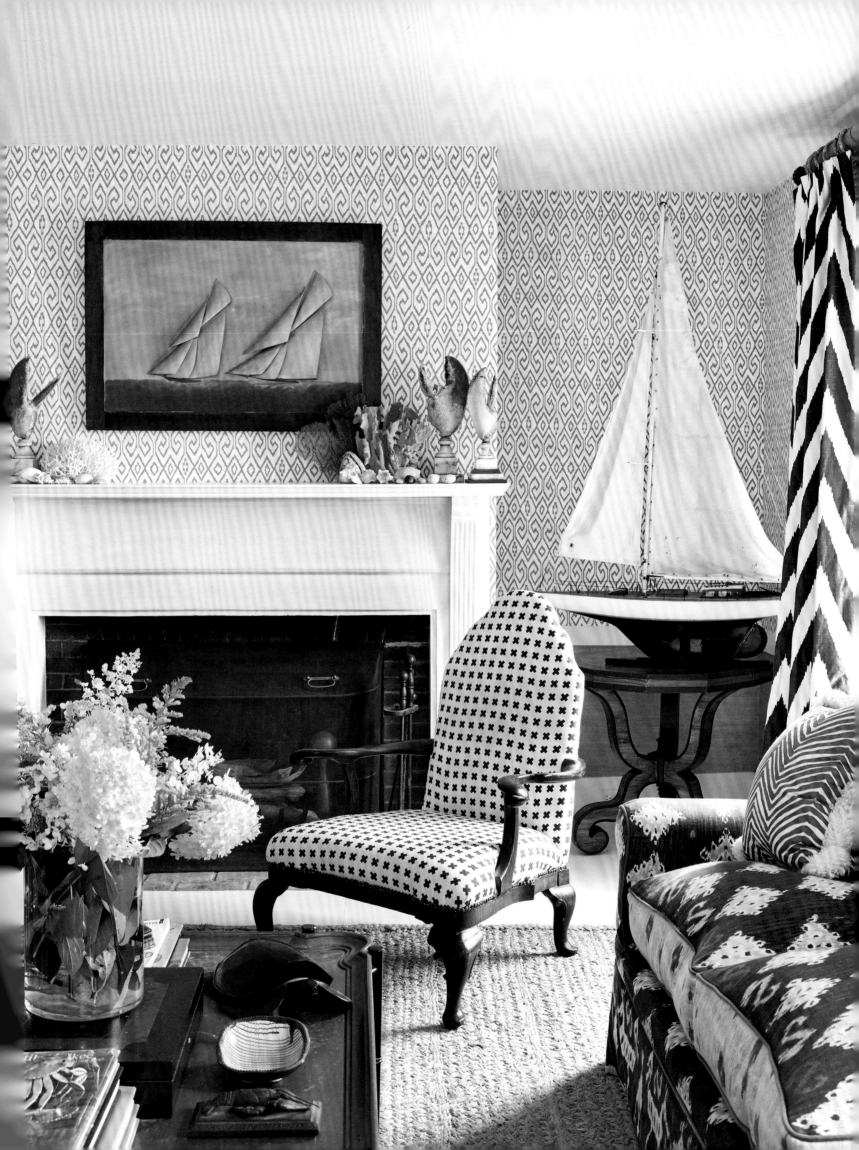

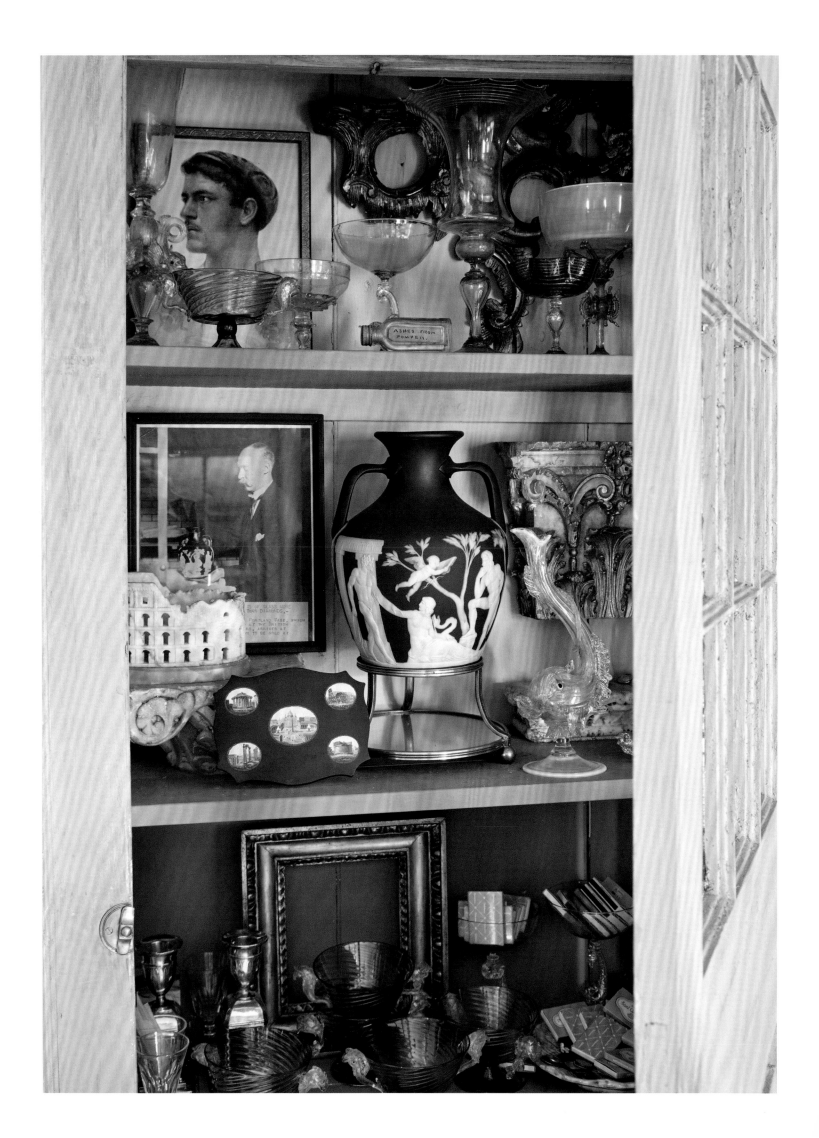

PAGE 1: A decorative wrought-iron gate leads to the extraordinary garden of Alice and James Ross's Berkeley House, a summer cottage in Newport, designed in the Queen Anne style by McKim, Mead & White in 1885. Over the course of ten years, Alice Ross created a parterre garden featuring hydrangeas, lady's mantle, daisies, David Austin roses, dahlias, peonies, and various herbs, all centered on a dramatic urn from Campania International.

PAGES 2-3: Nine miles long and one mile wide, Fishers Island is located eleven miles east of Orient Point and two miles south of both Rhode Island and Connecticut. With few shops and no restaurants or hotels, it is truly an insular world.

PAGES 4-5: A classic Nantucket Shingle Style family house, expertly refreshed with wicker furniture, sisal rugs, and painted floors by interior designer Tom Scheerer, overlooks the island's harbor.

PAGES 6-7: Bunty and the late Tom Armstrong, former director of the Whitney Museum and president of the Garden Conservancy, commissioned architect Thomas Phifer to design a glass pavilion that blurs the lines between interiors and the outdoors and creates a constant interplay between a prized art collection and their beloved gardens.

PAGES 8-9: The living room of a sleekly modernist house on Mount Desert Island, Maine, designed in 1940 by artist Isamu Noguchi and architect Wallace Harrison and faithfully restored by architect Heinrich Hermann in the late 1990s after it burned down, features sinuously curving furniture and a floor-to-ceiling picture window overlooking Great Harbor and Bear Island.

PAGES 10-11: The walls in a hallway of John Fondas and John Knott's sprawling summer house in Maine are papered in Quadrille's Vanderpoel Stripe. The shelves of an armoire are filled with shells collected over thirty years—some found, some purchased, and many from the couple's former house on Harbour Island.

PAGE 12, CLOCKWISE FROM TOP LEFT: A lunch table is set in blue and white on the porch of a picturesque house on Monomoy Island, Massachusetts. Monogrammed pillows from Leta Austin Foster's Palm Beach boutique add an ancestral touch to her summer house in Northeast Harbor. Designed by descendants of architect Stanford White, a Nantucket house overlooks Polpis Harbor, where the family sails. Clothespins are used as napkin rings and for holding place cards.

PAGE 13, CLOCKWISE FROM TOP LEFT: Interior designer and Martha's Vineyard resident Tamara Weiss transformed Linda Lipsett and Jules Bernstein's summer house on Martha's Vineyard into an airy retreat, including an open-plan kitchen and dining room. The table is from Restoration Hardware and the chairs, covered in vintage suzanis from Uzbekistan, are from

Midnight Farm, Weiss's former shop, which for years was a Martha's Vineyard institution. An inviting blue-and-orange guest room in Nantucket is in colorful contrast to the lime-green entrance hall. New York–based interior designer and Fishers Island resident Suzy Bancroft created colorful banquette seating in a family room to take full advantage of the view and to accommodate a large family. A vintage wall planter adorns the shingled exterior of a house on Fishers Island.

PAGE 14: To transform the historic mid-seventeenth-century Daniel Youngs Homestead into an airy summer house, interior designer Sallie Giordano of Leta Austin Foster & Associates bleached floors white and whitewashed furniture. The entrance hall gives way to a panoramic view of Oyster Bay Cove.

PAGE 17: Duncan, an English Cream Golden Retriever, presides over Baxter's Landing, Ken Fulk and Kurt Wootton's Provincetown summer house.

PAGE 19: The living room of John Fondas and John Knott's Little Cranberry Island summer house features a buoyant mixture of blues and a lively assortment of exotic and marine objects that a New England sea captain might have collected.

OPPOSITE: A cabinet of curiosities is found in the 1820s Greek Revival–style summer home of artist John Dowd, often referred to as the "poet painter of Provincetown."

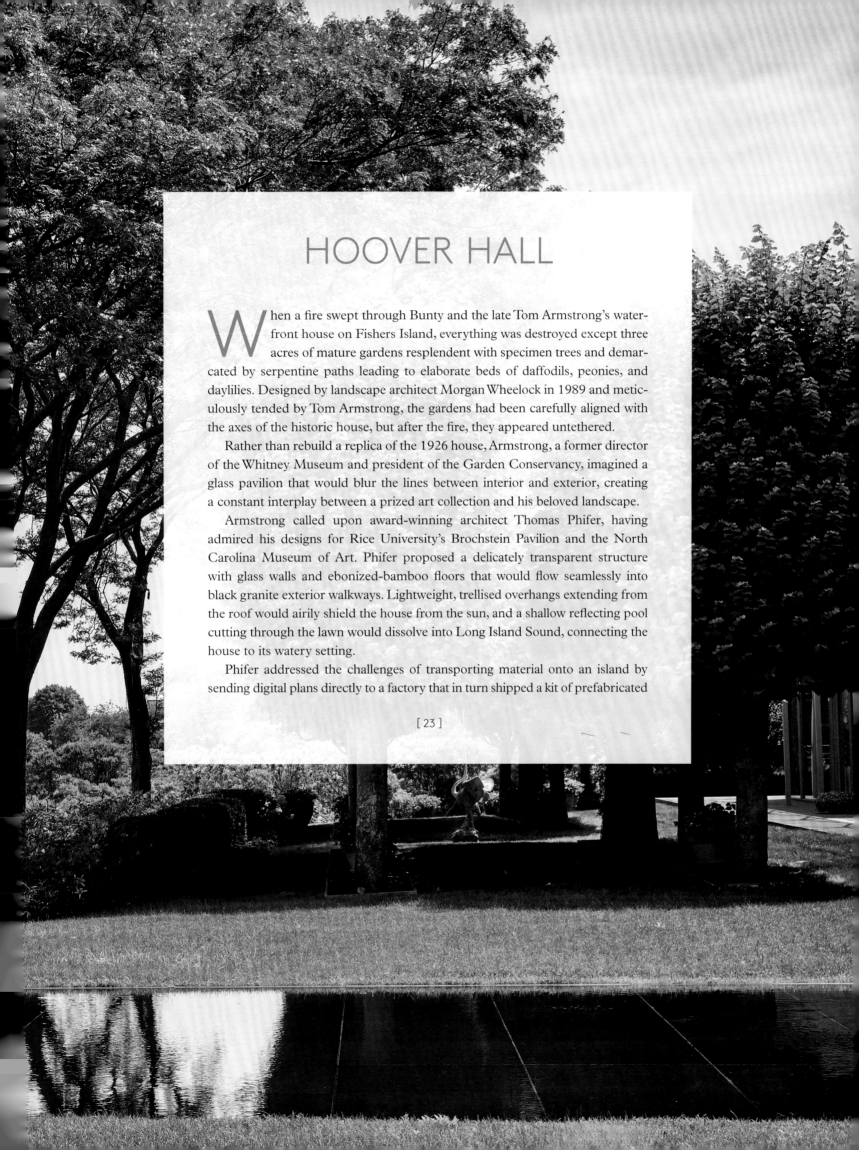

HOOVER HALL

When a fire swept through Bunty and the late Tom Armstrong's waterfront house on Fishers Island, everything was destroyed except three acres of mature gardens resplendent with specimen trees and demarcated by serpentine paths leading to elaborate beds of daffodils, peonies, and daylilies. Designed by landscape architect Morgan Wheelock in 1989 and meticulously tended by Tom Armstrong, the gardens had been carefully aligned with the axes of the historic house, but after the fire, they appeared untethered.

Rather than rebuild a replica of the 1926 house, Armstrong, a former director of the Whitney Museum and president of the Garden Conservancy, imagined a glass pavilion that would blur the lines between interior and exterior, creating a constant interplay between a prized art collection and his beloved landscape.

Armstrong called upon award-winning architect Thomas Phifer, having admired his designs for Rice University's Brochstein Pavilion and the North Carolina Museum of Art. Phifer proposed a delicately transparent structure with glass walls and ebonized-bamboo floors that would flow seamlessly into black granite exterior walkways. Lightweight, trellised overhangs extending from the roof would airily shield the house from the sun, and a shallow reflecting pool cutting through the lawn would dissolve into Long Island Sound, connecting the house to its watery setting.

Phifer addressed the challenges of transporting material onto an island by sending digital plans directly to a factory that in turn shipped a kit of prefabricated

[23]

parts directly to the building site. During construction, Tom Armstrong employed his finely tuned curatorial skills to plan interiors that would highlight his collection of twentieth-century paintings, sculptures, and glassware, including pieces by Pat Lipsky, Ilya Bolotowsky, Leon Polk Smith, Richard Stankiewicz, Myron Stout, and Arlene Shechet. Modern furniture and accessories from Eero Saarinen and Holly Hunt resonate with the art and emphasize the clean lines of the pavilion-like house.

Seating arrangements were designed for small gatherings but could also accommodate large functions, both of which Armstrong relished. His brilliance at bringing together coalitions of people to support the arts extended to his private life. "He really livened things up around here," says his wife, Bunty, perhaps an understatement about a man who was adored on the island for his madcap brand of fun. The house is named Hoover Hall after the superhero persona Armstrong adopted, often sporting a cape, tights, and a vacuum-emblazoned T-shirt for island golf tournaments. "He was obsessed with Hoover. He even ordered custom Lenox china with the Hoover name and a vacuum," says Bunty.

Today the Armstrong children maintain the gardens, no small task on a property that sprouts hundreds of annuals yearly. On an early June day, the house has the serenity of a sanctum from which to observe the surroundings—a perfect tribute to a man who adored nature and art in equal measure.

PAGES 22–23: A shallow reflecting pool cuts into the lawn in front of the house. The straight entrance drive is bordered by mature trees and plantings of annuals.

OPPOSITE: When Bunty and Tom Armstrong lost their beloved summer house on Fishers Island to fire, they opted for a transparent pavilion in its place. Architect Thomas Phifer designed a structure of glass, steel, anodized aluminum, and black granite. Seen from the entrance hall, the reflecting pool seems to dissolve into Long Island Sound. Trellised overhangs shield the house from the sun like parasols.

PAGES 26–27: In the living room, a welded-steel sculpture by Richard Stankiewicz overlooks the garden. Myron Stout's *Apollo* floats above a minimalist fireplace. On the

low Barcelona table in front of the sofa is a 2007 ceramic by Arlene Shechet. The floor lamps are from Holly Hunt.

PAGES 28–29: The late Tom Armstrong designed the interiors to double as museum-like galleries for modern art. In the dining room, an Andrew Lord bronze is displayed on one of the dining tables, and above it hangs a painting by Leon Polk Smith (left). Over an Eero Saarinen table is a canvas by Pat Lipsky (right).

PAGES 30–31: Phifer designed a glass box with two corridors running the length of the 4,600-square-foot house. Museum-white walls subdivide it into a living room, dining room, kitchen, library, and master bedroom. In the center hangs a work by Ilya Bolotowsky.

PAGES 32–33: At midday, the master bedroom is dappled with light patterns created by the trellised overhangs. At night, the floor-to-ceiling white Isamu Noguchi light sculpture—one of eight in the house—provides soft illumination.

PAGES 34–35: In this organically shaped garden "room," Armstrong designed the plantings himself, based on principles of mid-century abstract art. He left natural boulders in place, as they reminded him of the smooth forms in Ellsworth Kelly paintings.

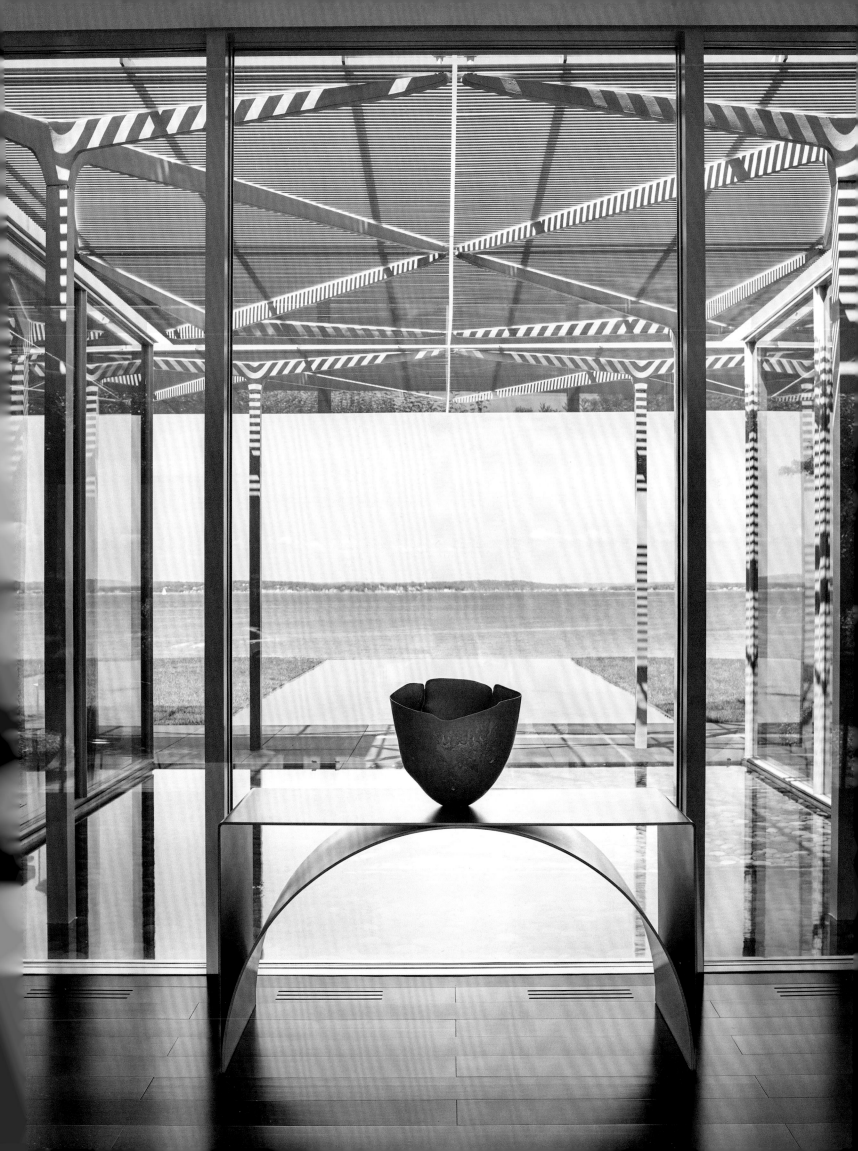

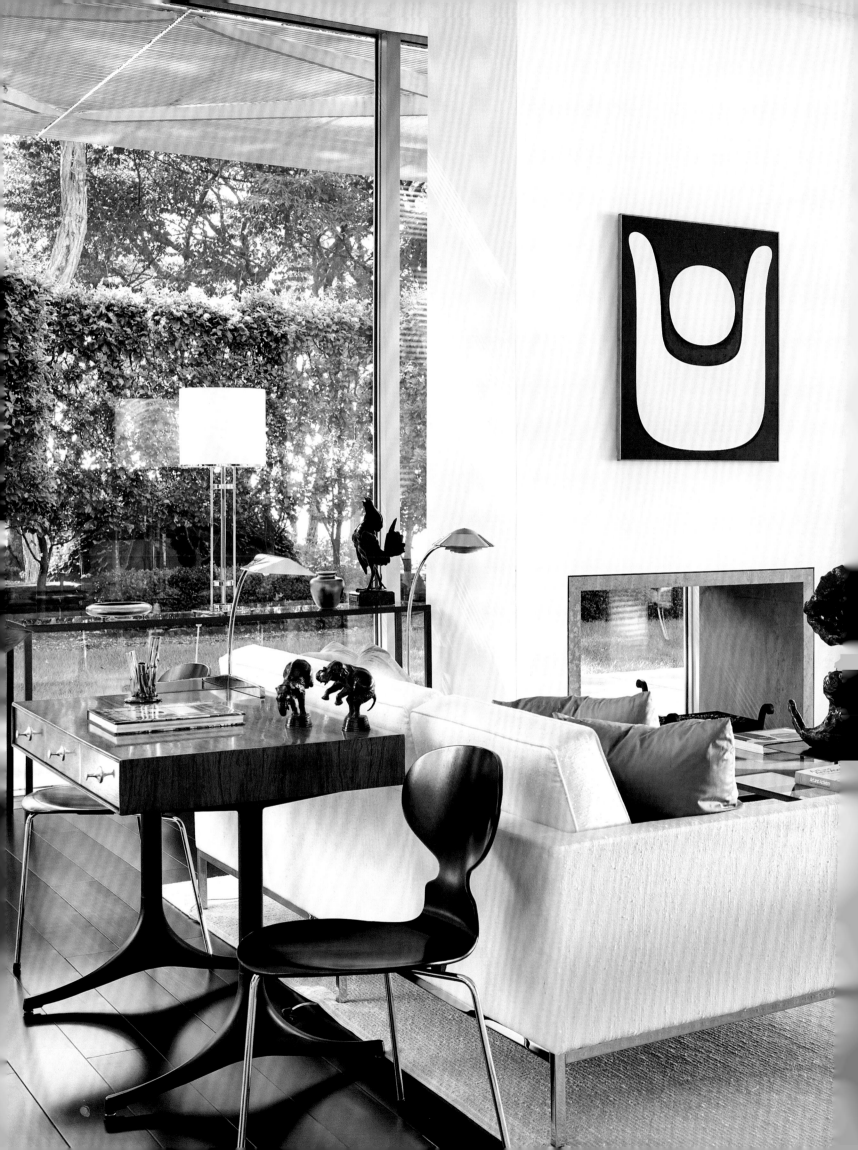

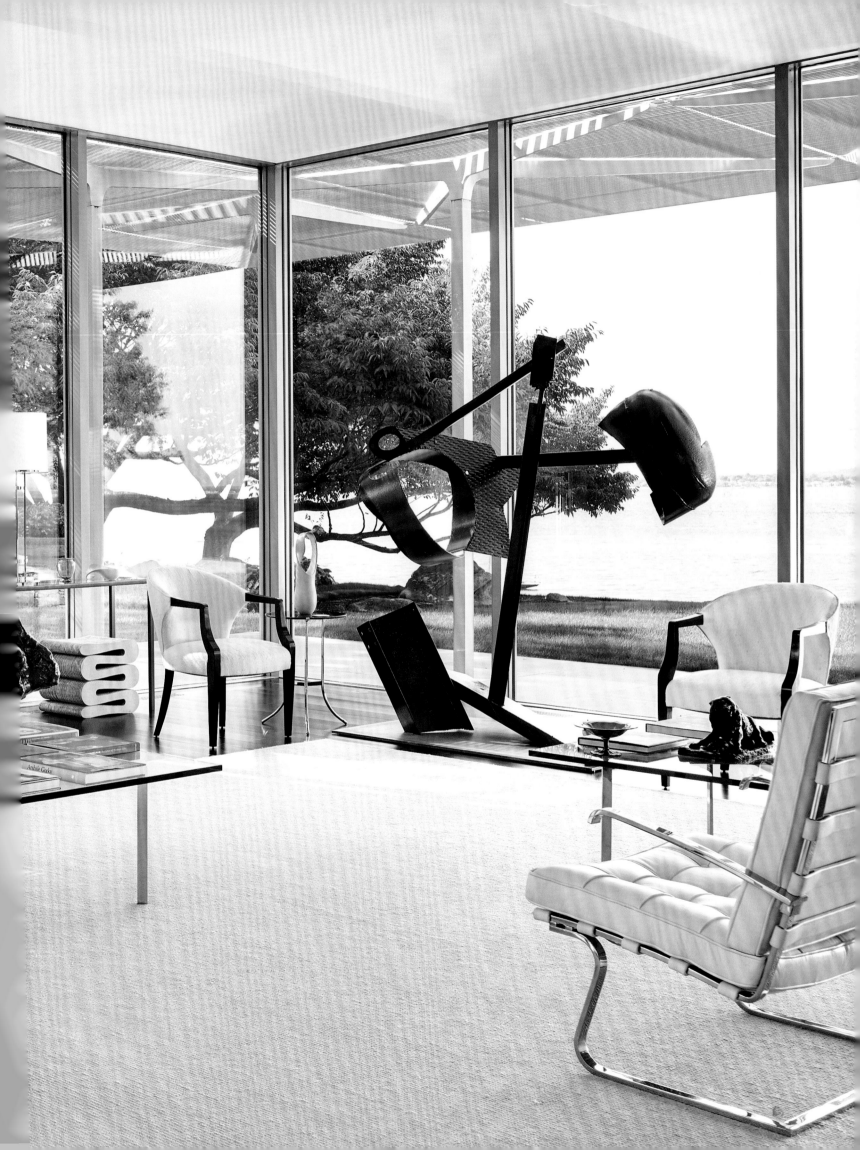

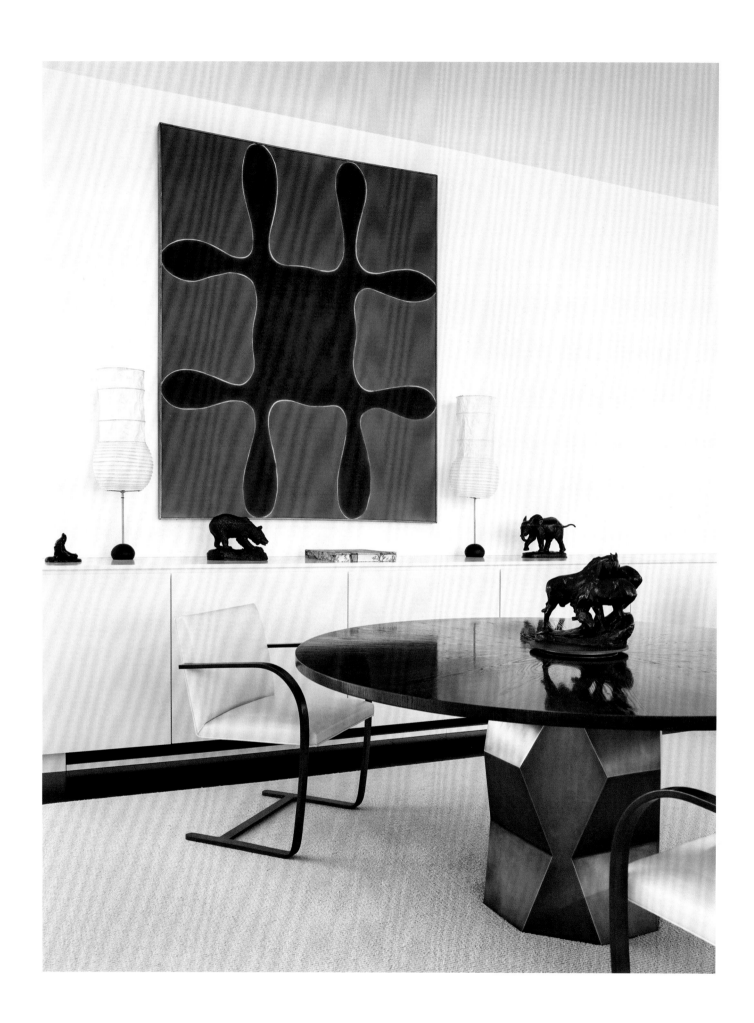

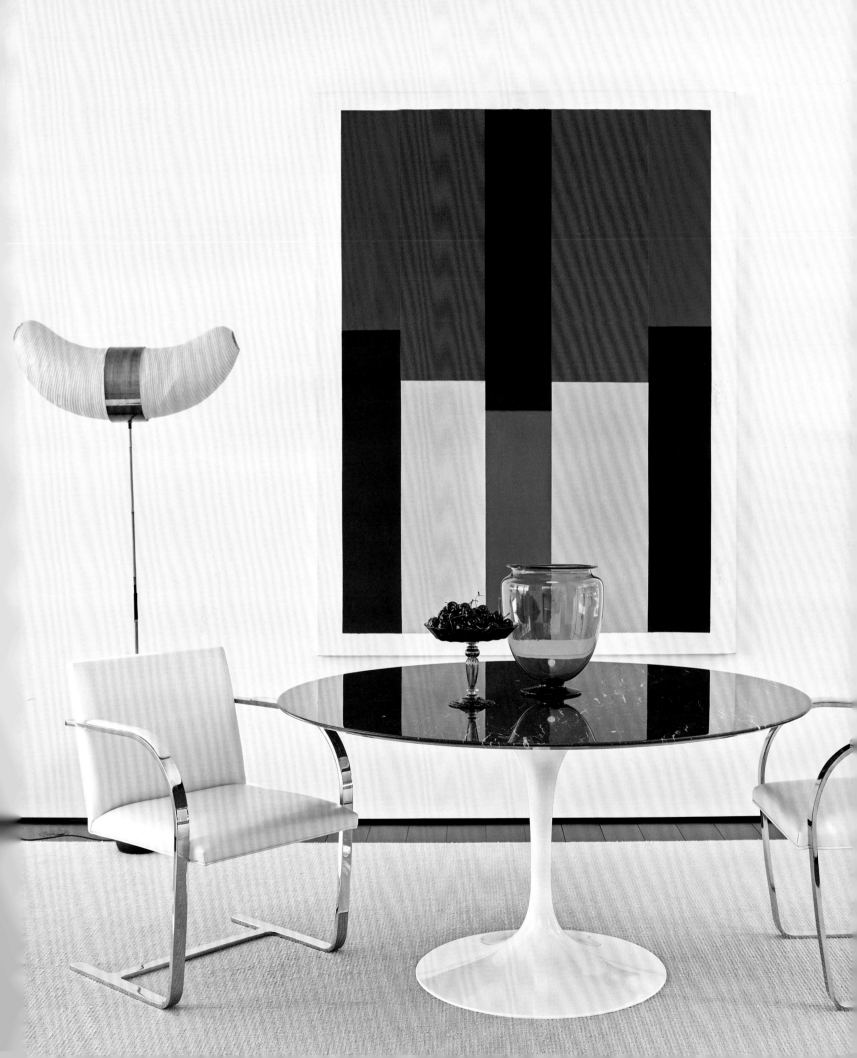

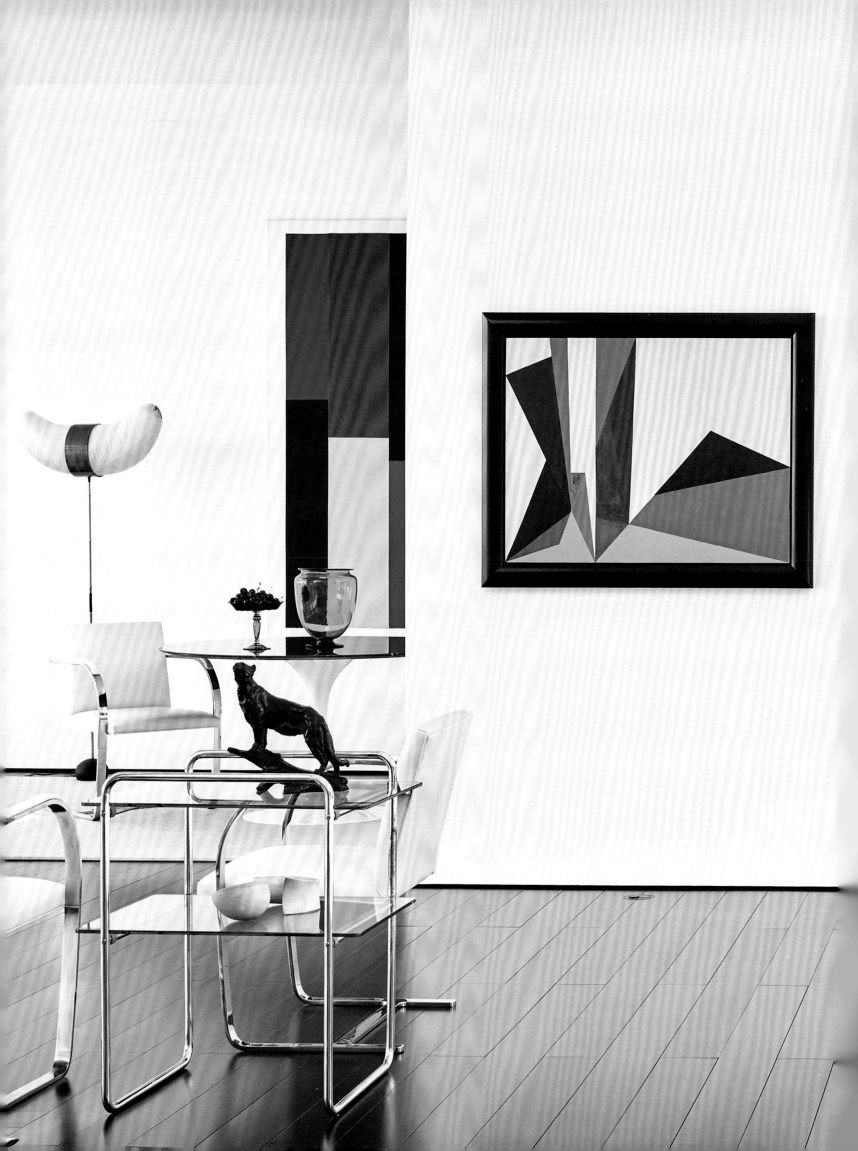

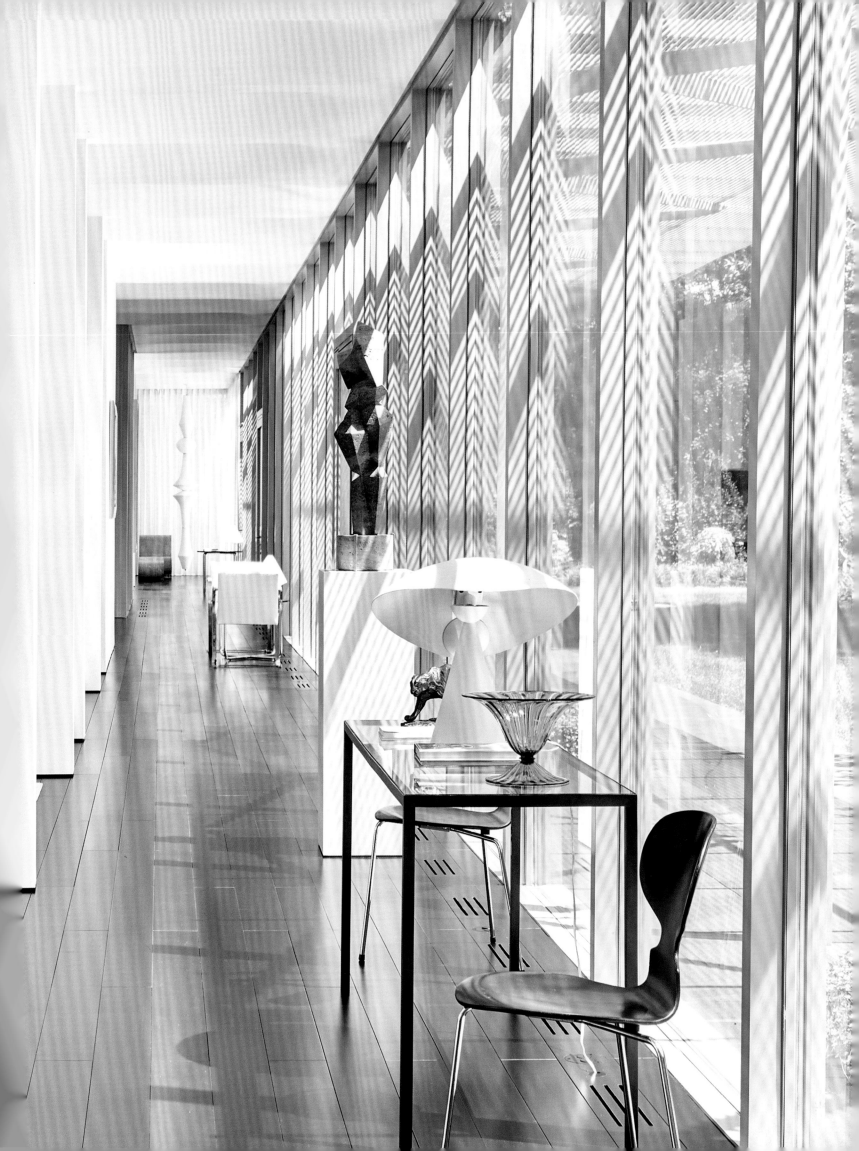

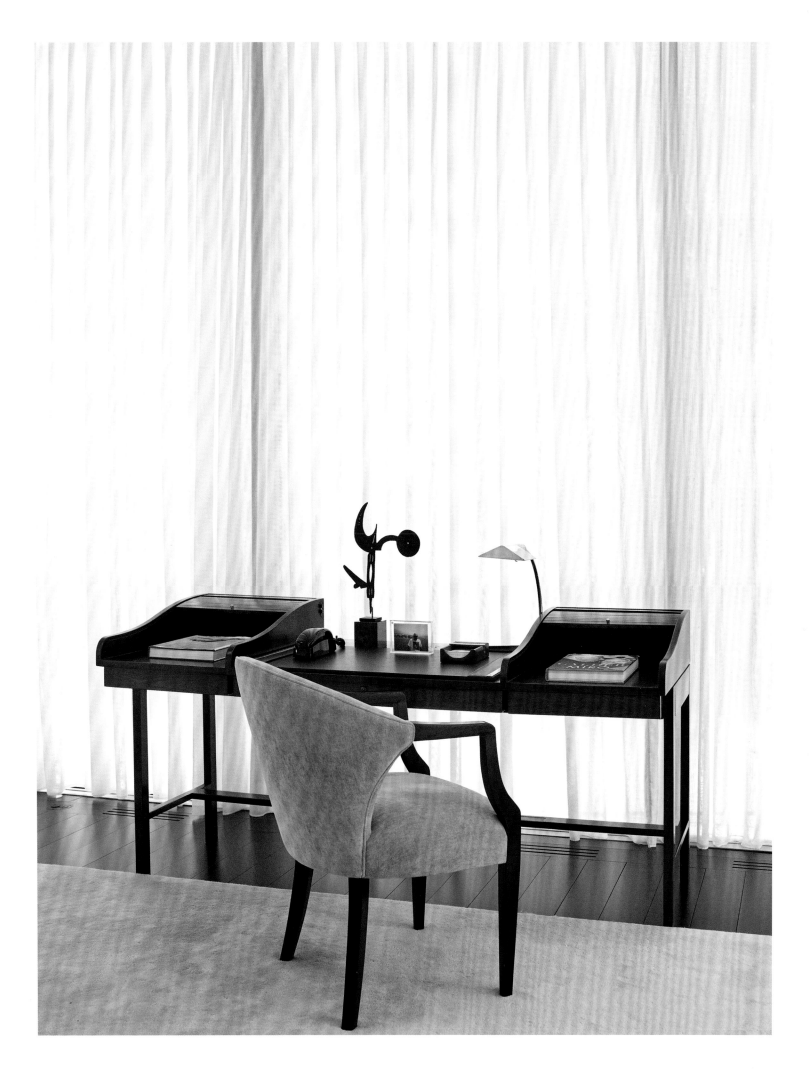

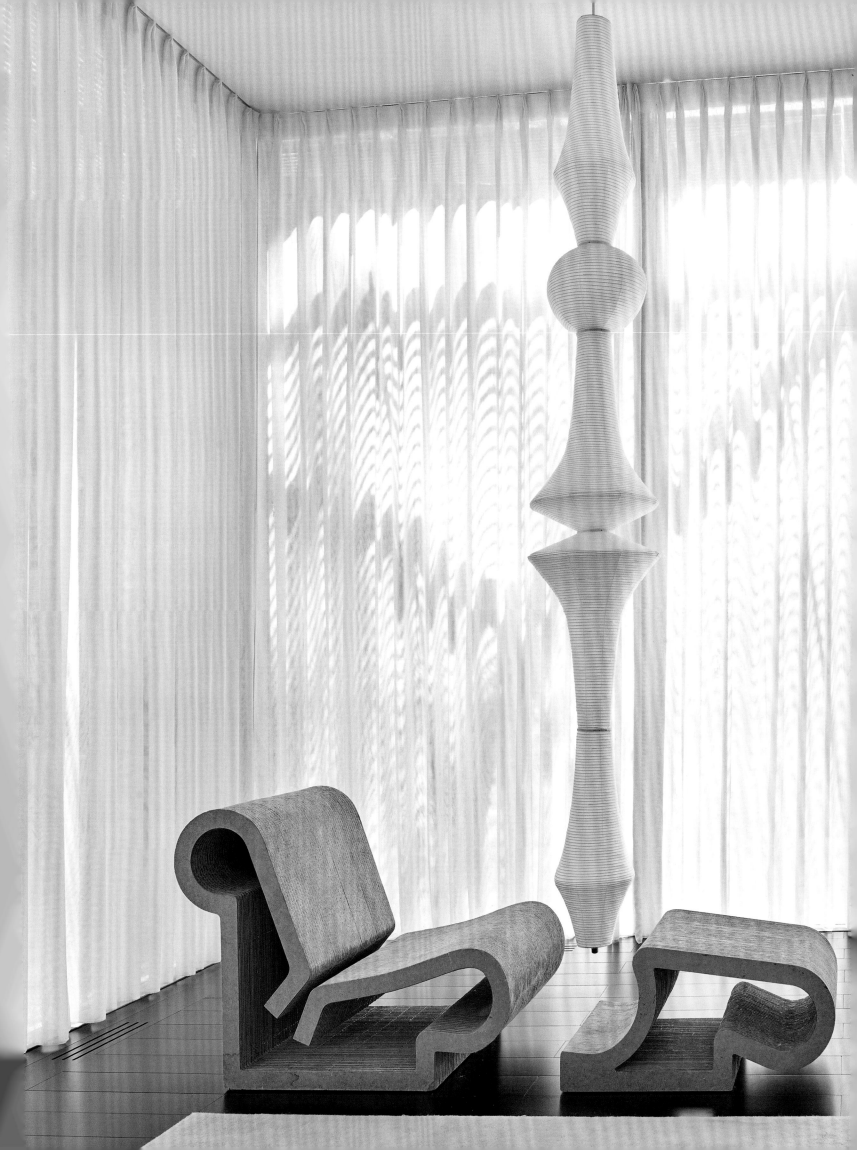

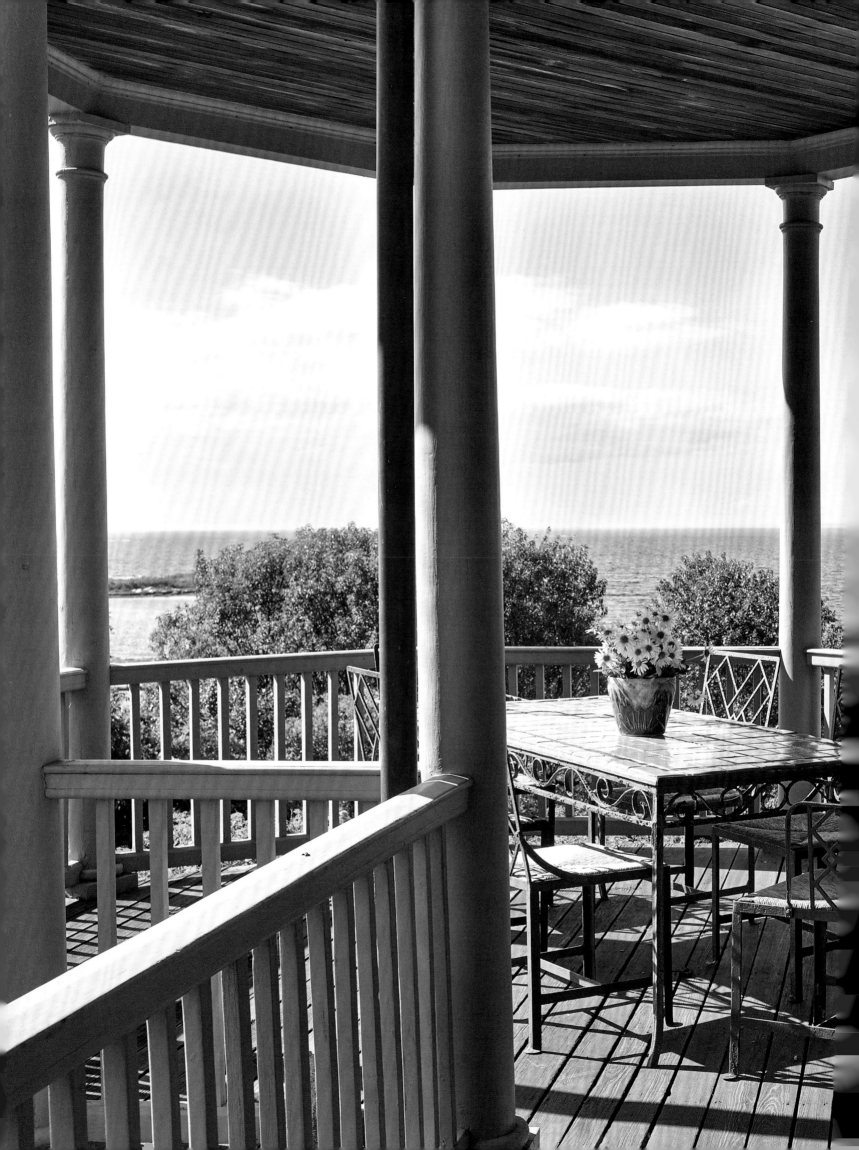

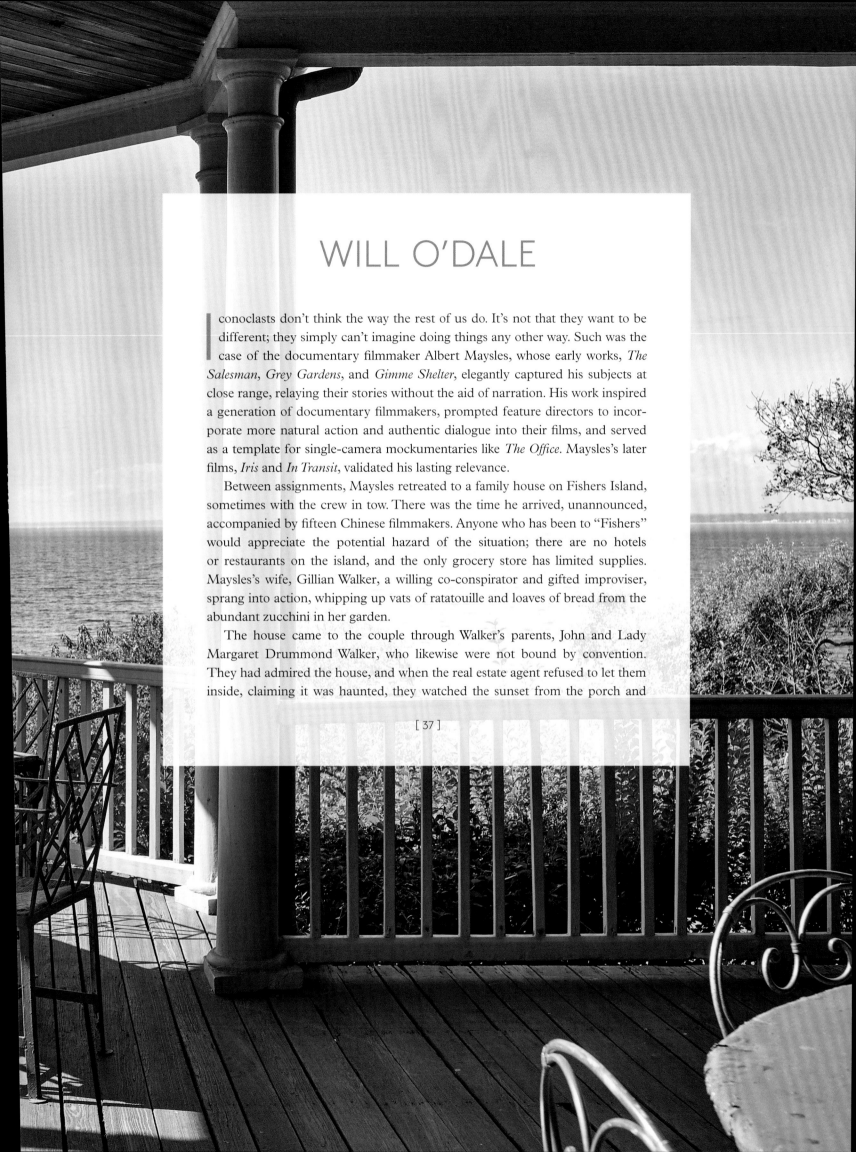

WILL O'DALE

Iconoclasts don't think the way the rest of us do. It's not that they want to be different; they simply can't imagine doing things any other way. Such was the case of the documentary filmmaker Albert Maysles, whose early works, *The Salesman*, *Grey Gardens*, and *Gimme Shelter*, elegantly captured his subjects at close range, relaying their stories without the aid of narration. His work inspired a generation of documentary filmmakers, prompted feature directors to incorporate more natural action and authentic dialogue into their films, and served as a template for single-camera mockumentaries like *The Office*. Maysles's later films, *Iris* and *In Transit*, validated his lasting relevance.

Between assignments, Maysles retreated to a family house on Fishers Island, sometimes with the crew in tow. There was the time he arrived, unannounced, accompanied by fifteen Chinese filmmakers. Anyone who has been to "Fishers" would appreciate the potential hazard of the situation; there are no hotels or restaurants on the island, and the only grocery store has limited supplies. Maysles's wife, Gillian Walker, a willing co-conspirator and gifted improviser, sprang into action, whipping up vats of ratatouille and loaves of bread from the abundant zucchini in her garden.

The house came to the couple through Walker's parents, John and Lady Margaret Drummond Walker, who likewise were not bound by convention. They had admired the house, and when the real estate agent refused to let them inside, claiming it was haunted, they watched the sunset from the porch and

deemed the setting so beautiful that they bought the house immediately, calling it Will O'Dale in honor of Chester Dale, who had left the couple a surprise inheritance, which they used to purchase the place.

"A lot of the furniture that came with the house when my grandparents bought it is still here," says daughter Sara Maysles, the de facto family historian. Never-ending additions, found at the Fishers Island thrift shop and in markets near the family's Harlem townhouse, ensure that the house remains a living, breathing testament to the family's richly textured life. "We find things everywhere and they just fit in. When we repaint, we try to stay true to the original colors as well," Sara says. A kaleidoscope of velvety plum, tangerine, sapphire, and butter can be seen in the family's home movies. Al always had a camera going, a reality to which the family was resigned, knowing that filming things was how he made sense of the world. "We claimed he hid behind the camera to avoid household work, but the truth is he loved to help around the house. He repaired everything with epoxy glue and he loved pulling weeds in the garden," Sara says. Al was as well known for rebuilding cameras as he was for reworking clothing, retreating to an upstairs sewing room to replace buttons with zippers, which made jackets easier to put on and take off during shoots. "He sewed name tags on everything, even on his socks, because he was obsessed with the fact that he never got to go to summer camp," Sara recalls.

Al and Gillian's children are all gifted artists who have inherited their parents' open arms and individualism. On any given weekend, the house is filled with a parade of friends and their growing family, which now includes two toddlers, Albert and Elijah. There are long walks on the beach, foraging for blueberries and rose hips, and croquet and badminton matches, a nod to Gillian's English heritage. Drawers are filled with art supplies, and on cold evenings they roast pizzas and summer fruits over the living room fire. "Nothing's planned but there are always things happening," says Sara.

PAGES 36–37: After being mesmerized by a sunset over Hay Harbor, seen here, John and Lady Margaret Drummond Walker purchased the house with a surprise inheritance left to them by friend and arts patron Chester Dale. They named it Will O'Dale in his honor.

OPPOSITE: The wicker furniture in the entrance hall was found at the Fishers Island thrift shop. An assortment of hats, accumulated over the years, belong to no one and are used by everyone. Hallways are painted Pompeian red, a leftover from the Fox family, who built the house.

PAGES 40–41: A photograph of John Walker, Gillian's father, can be seen on the middle shelf, to the right of the fireplace in the living room. The trophies on top of

the bookcase were won by John Walker for golfing and by Albert and Gillian's son, Philip Maysles, for windsurfing. Over the mantel are flower paintings by Albert's mother-in-law, Lady Margaret Drummond Walker. On the mantel is Gillian Walker's collection of flower vessels, including one of General MacArthur's head, an antiwar statement. The reliefs on the wall to the left are by New York artist Mimi Gross, a family friend. The two small chairs are reserved for the family's youngest members, Albert and Elijah.

PAGES 42–43: The dining room chairs were painted by Lady Margaret Drummond Walker in the style of the American folk artist Peter Hunt. The hutch is from John and Lady Margaret Drummond Walker's house in England.

PAGE 44: Tiles from India surround a recently added stove in the kitchen. A William Morris fabric, a favorite of Gillian Walker, covers cabinets. The soapstone sink is original to the house and was written about by *Harper's Bazaar* editor Sylvia Wright, whose family once owned the house.

PAGE 45: In the entrance hall, badminton rackets and croquet balls and mallets reference the house's croquet lawn, which is surrounded by a wildflower garden.

PAGES 46–51: Surviving letters indicate that the Fox family, who built the house, chose bedroom colors to imitate the sea, the sky, and the ocher fields of August. When repainting the house, the Maysles family takes cues from remaining fragments of the original colors, which were washed on wet plaster.

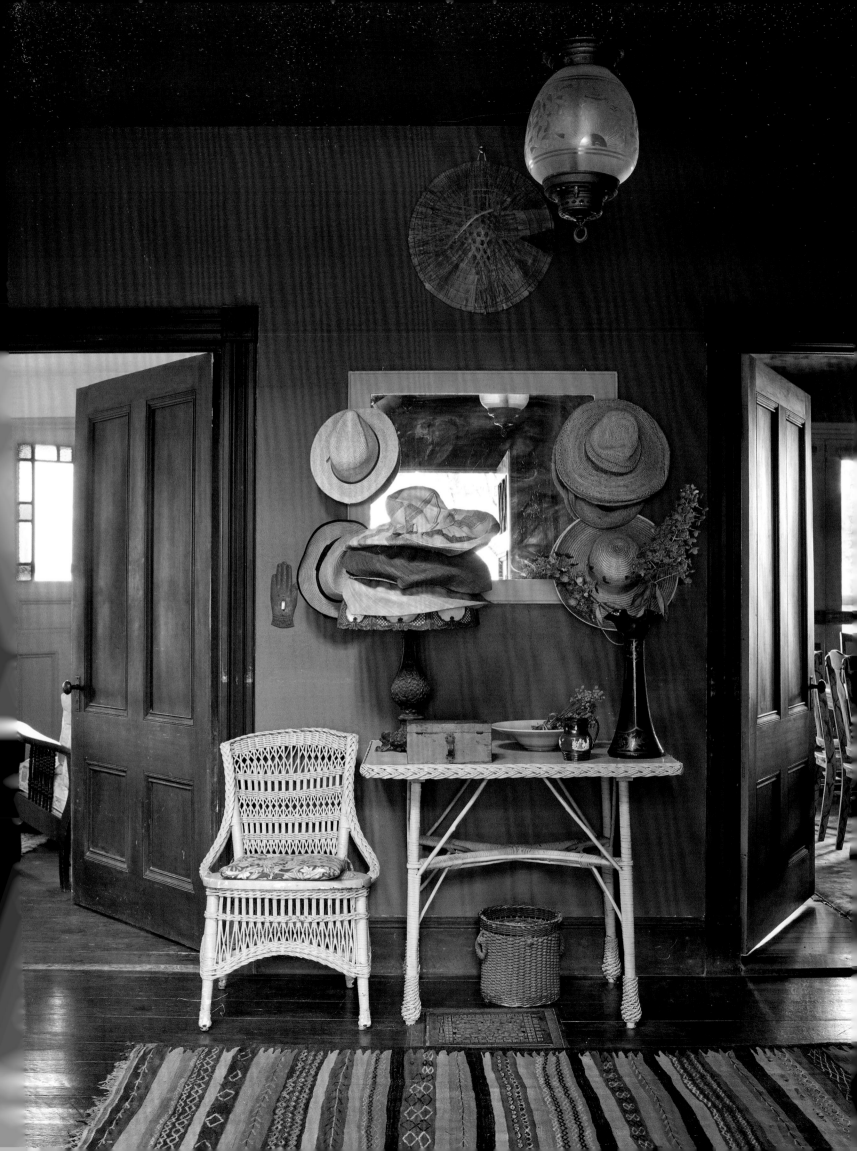

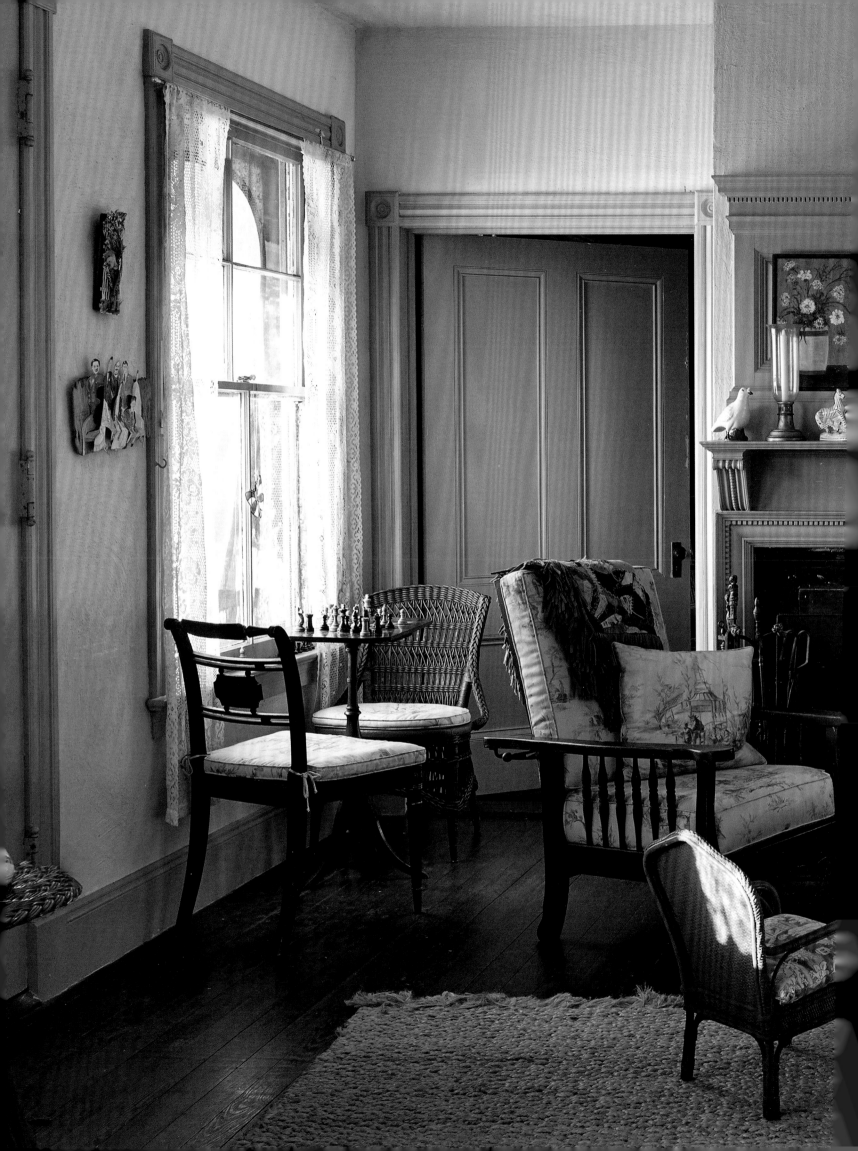

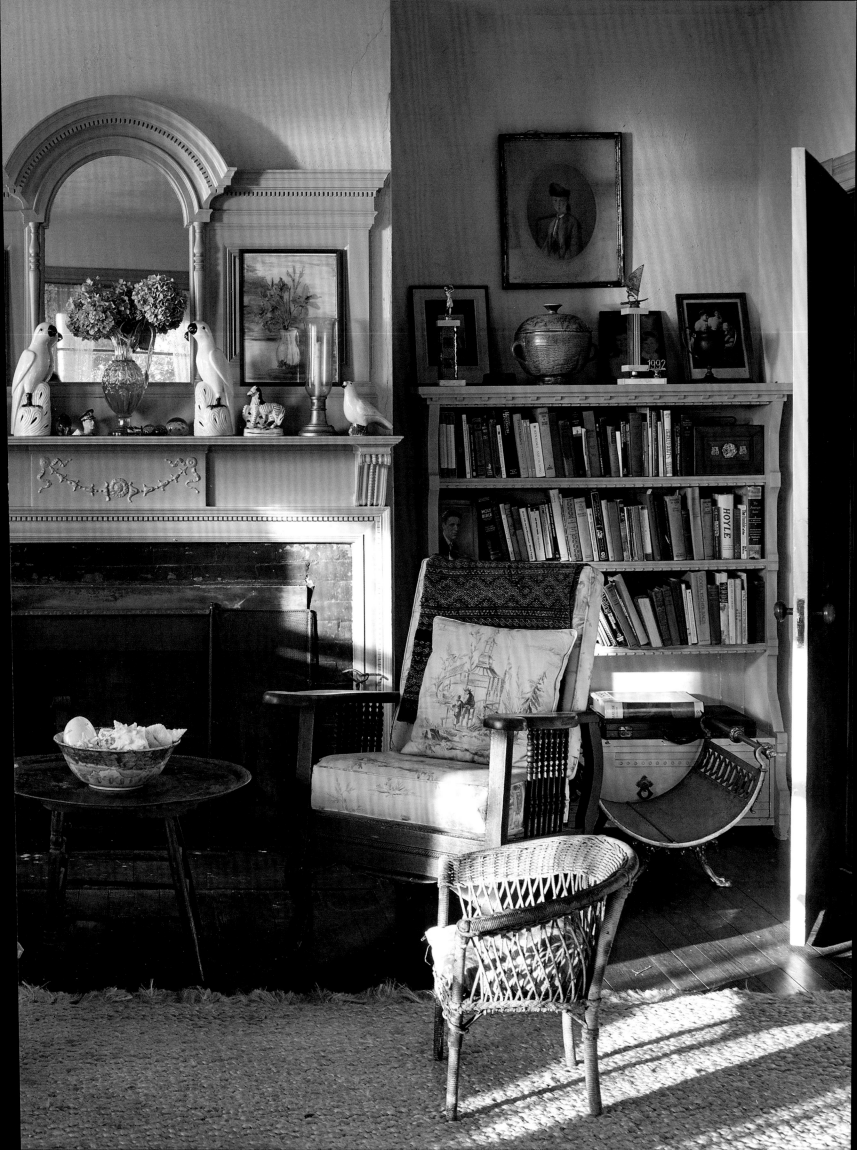

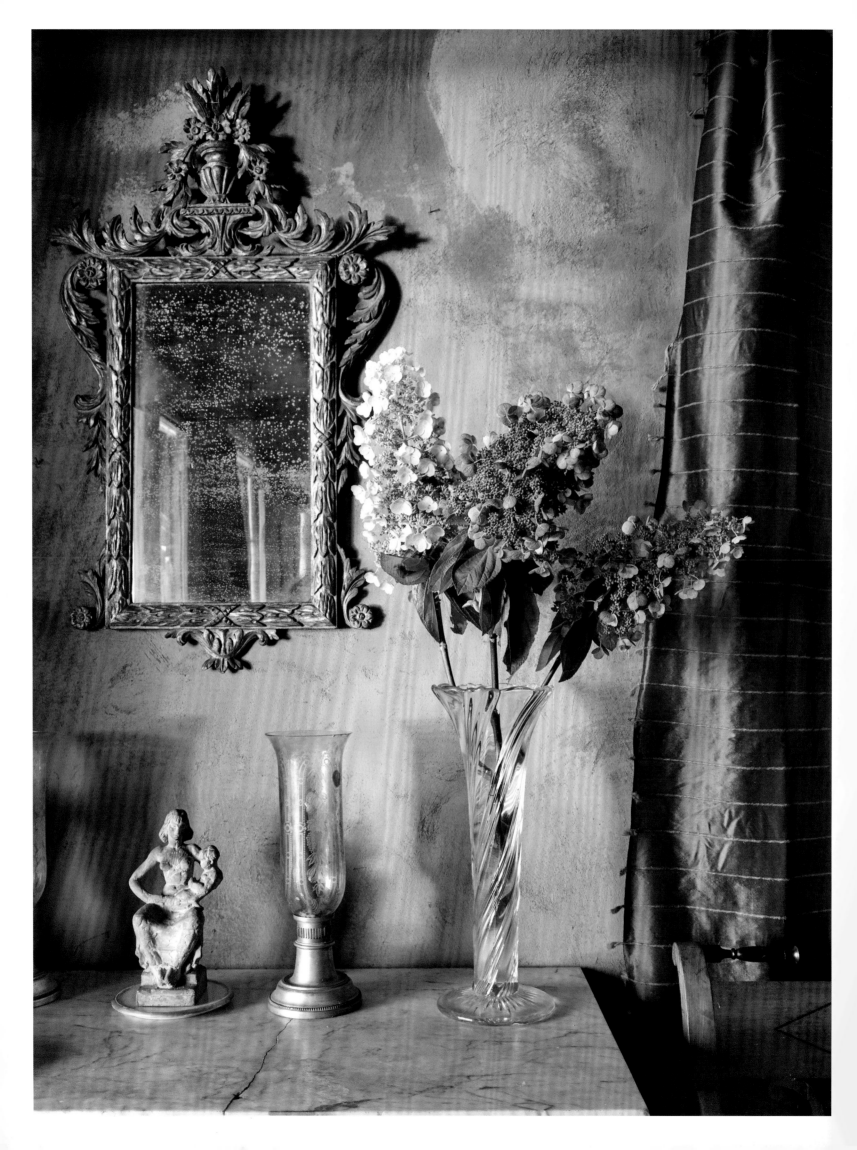

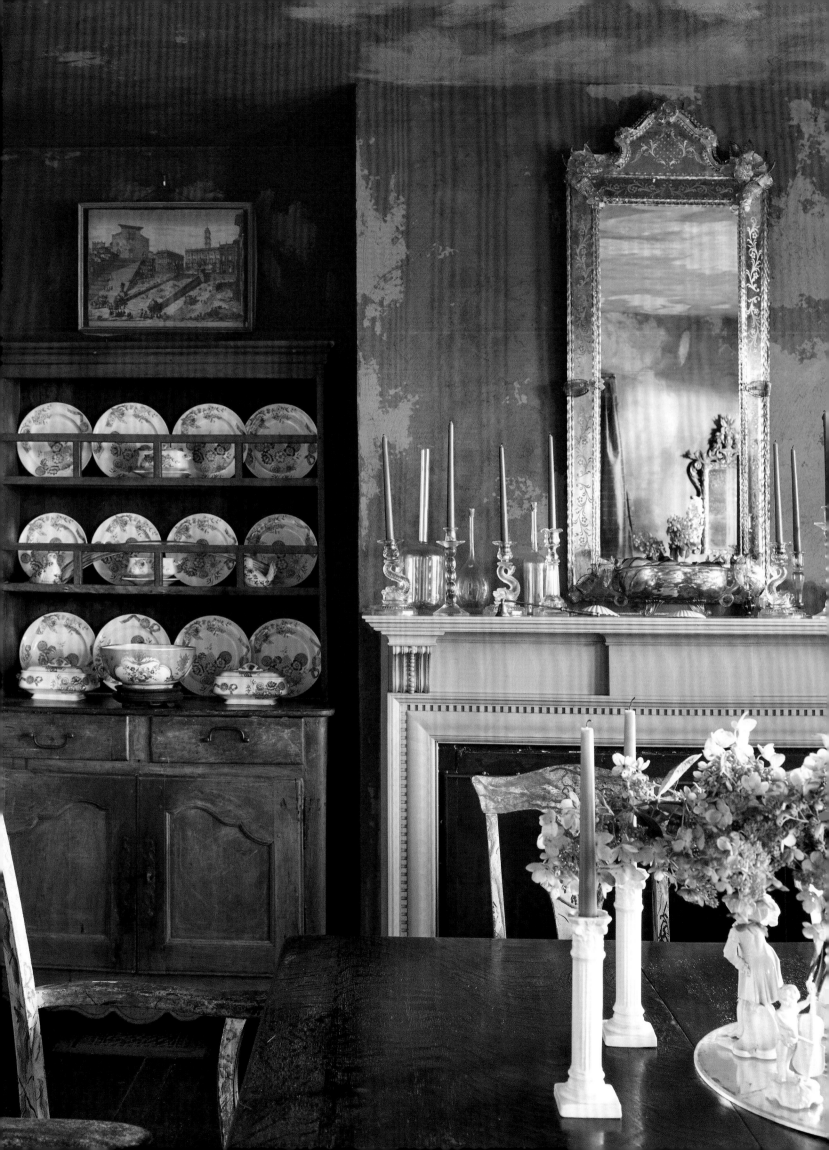

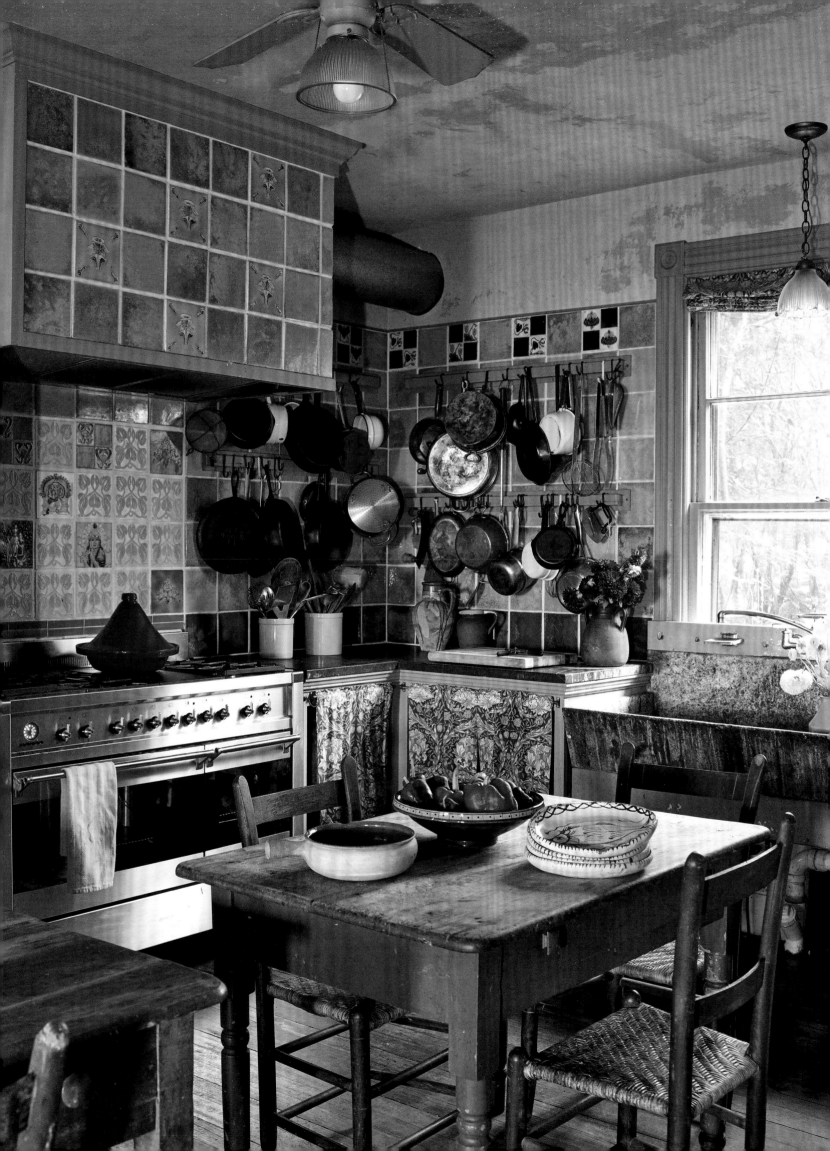

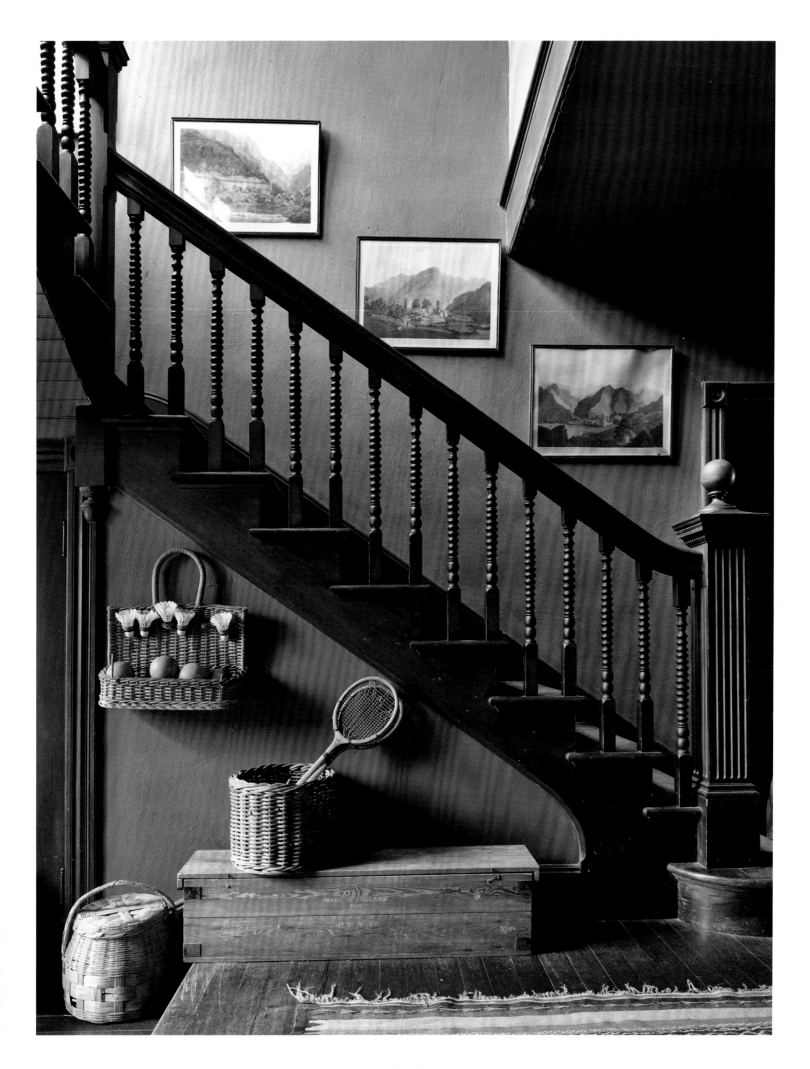

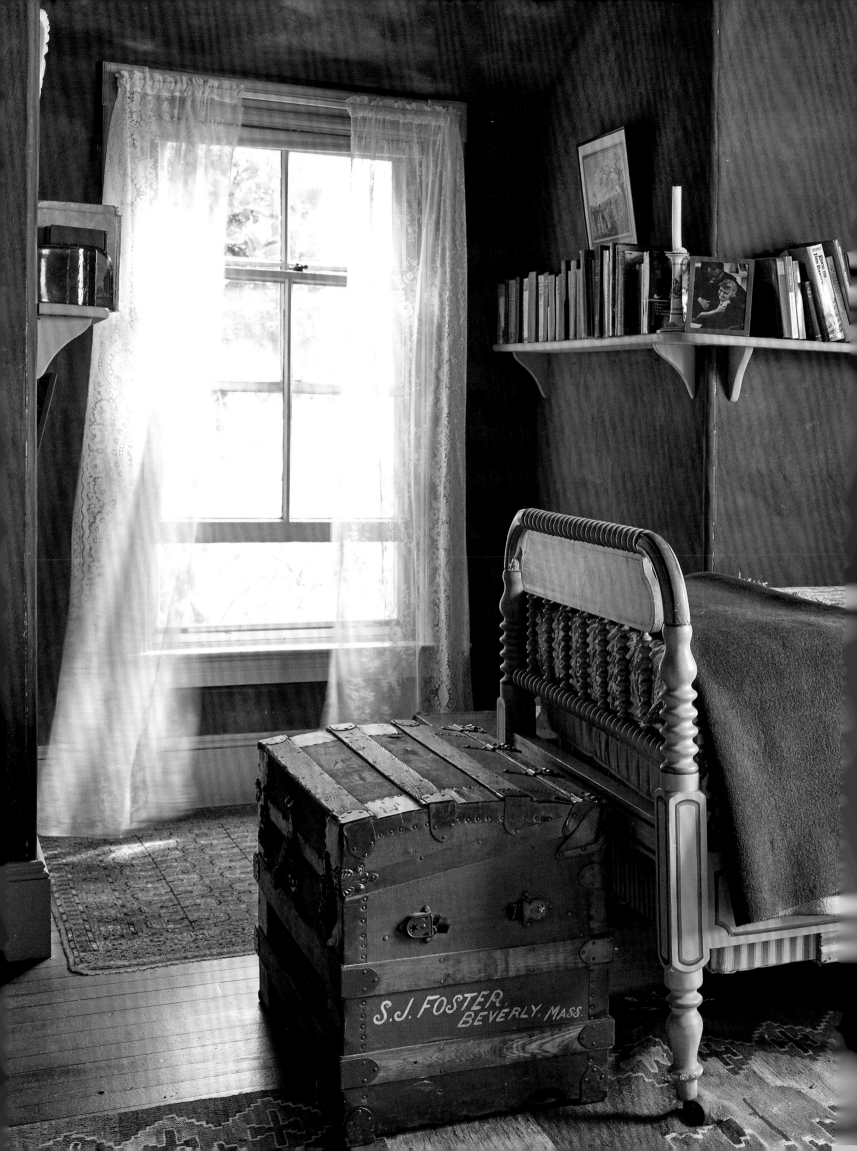

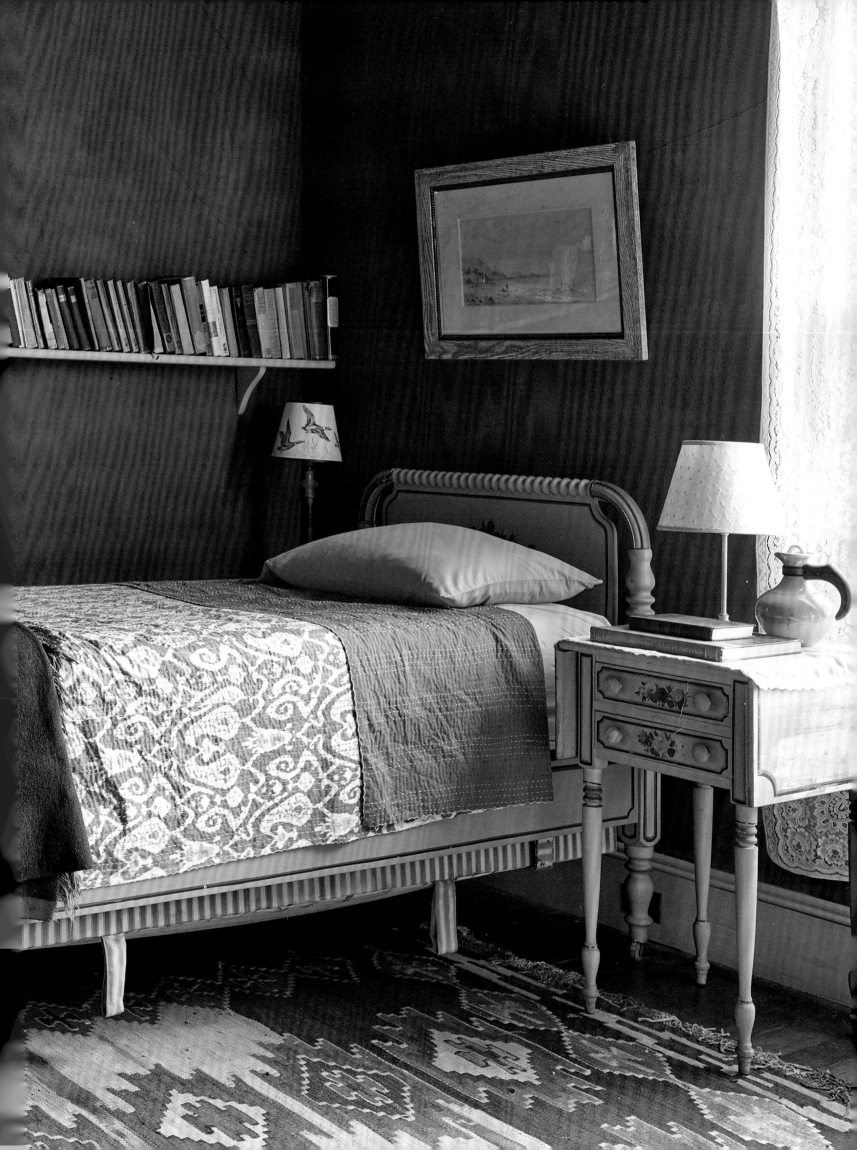

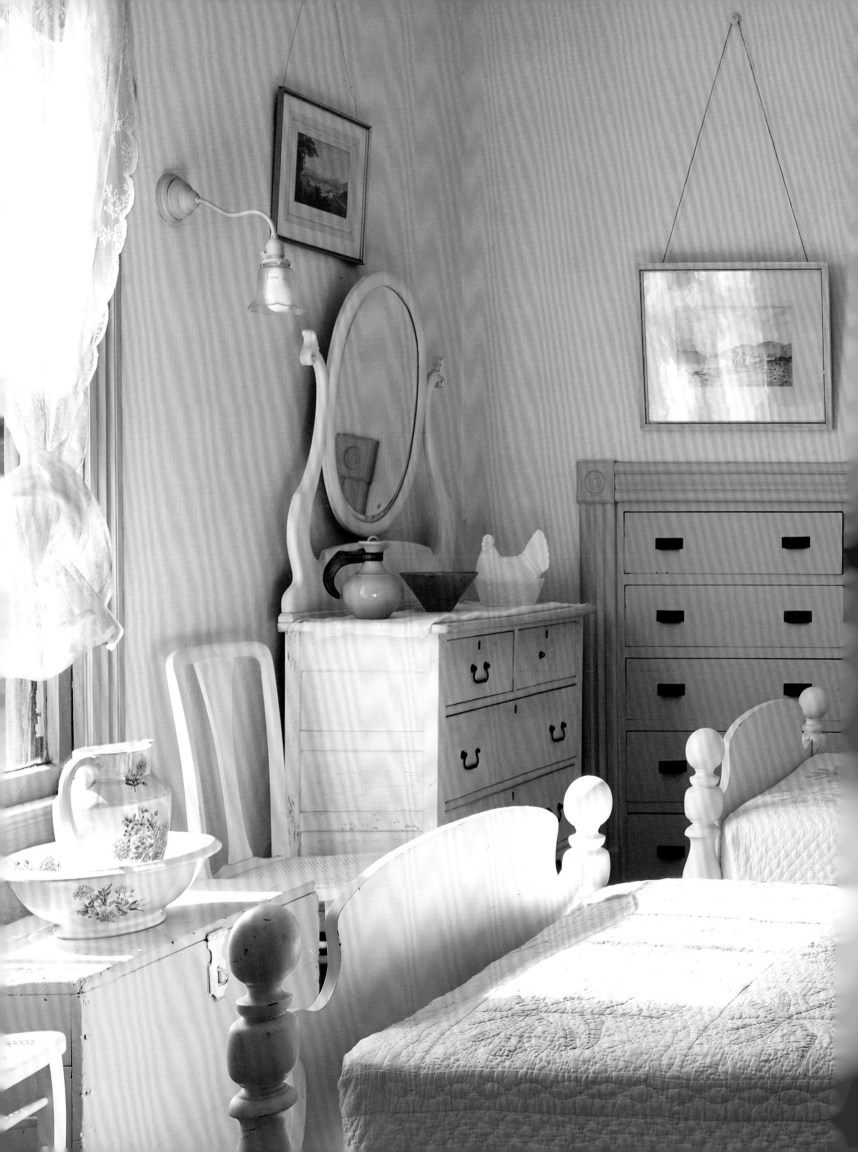

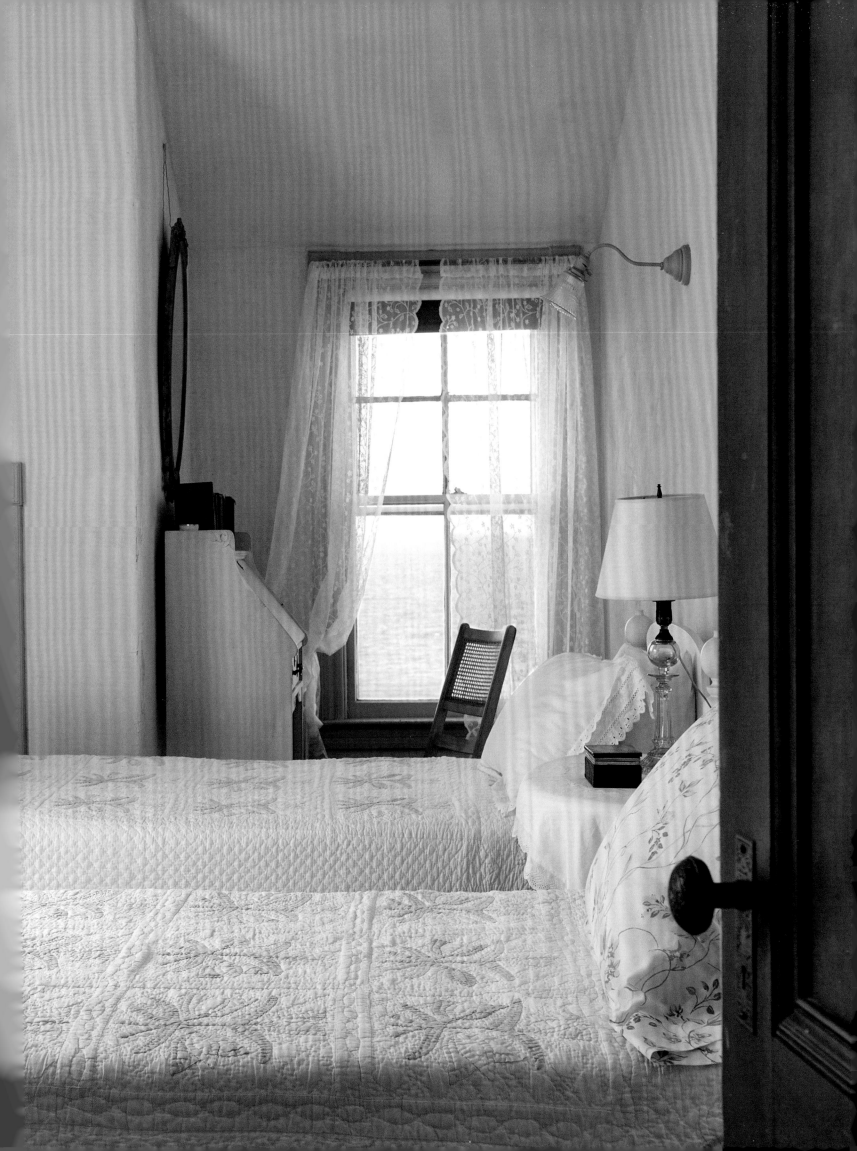

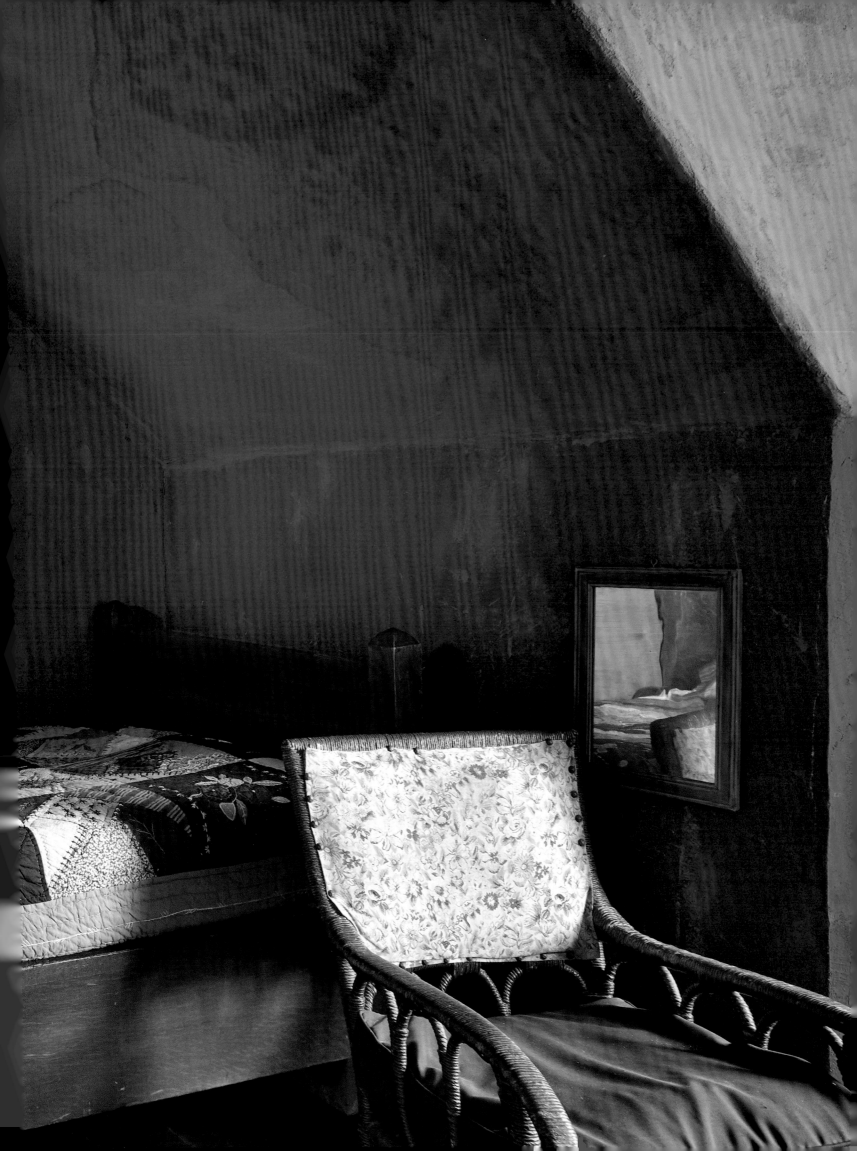

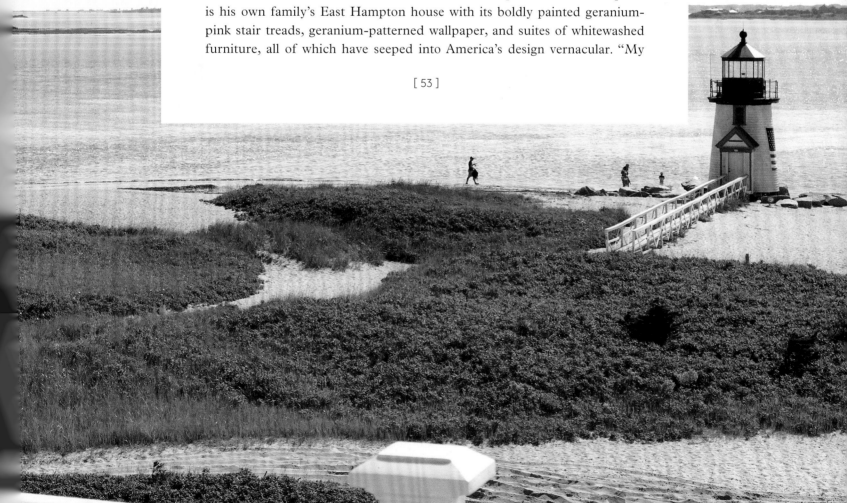

DRIFTWOOD

If you close your eyes and conjure the idyllic all-American summer house, chances are you'd imagine something like this sprawling shingled affair in Nantucket's Brant Point neighborhood. Its peaked roofs, rows of white-shuttered windows, and enormous back porch, with its picturesque view of the ferries cruising into bustling Nantucket Harbor, all speak to the life-affirming optimism of its inhabitants.

The house has been in the same family since the 1960s, and the owners grew up swimming and sailing Rainbow catboats off its dock, peddling lemonade to tourists who passed the house en route to the Brant Point beach and lighthouse, and riding bikes to the Dreamland Theater. As the family grew to include grandchildren and great-grandchildren, two contiguous cottages and a boathouse were seamlessly folded into the property, creating a family compound.

Though there was never any need for the interiors to compete with the magical setting, years of sand-covered feet and wet bathing suits had left their marks, and the time came to freshen things up. The family's three grown daughters unanimously agreed to entrust the project to their long-time friend the designer Tom Scheerer, who has a natural genius for imbuing generations-old houses with a sublime take on the present. A case in point is his own family's East Hampton house with its boldly painted geranium-pink stair treads, geranium-patterned wallpaper, and suites of whitewashed furniture, all of which have seeped into America's design vernacular. "My

[53]

grandmother didn't waste more than a week of pleasure decorating the house," Scheerer says.

Enlivening the interiors of an entire compound took slightly more than a week, of course, but the process transpired with equal ease. "Tom would hold up two fabrics and say, 'Here are the choices. If I were you, I'd go with this one.' And we did. We totally trusted him and loved the way he mixed things," says one of the sisters.

Neither the designer nor his clients believed in discarding pieces that were already at hand, so they prioritized the main house, relegating anything that no longer tied in with the new décor to the cottages and the boathouse. Scheerer proposed a distinctive deep-green-and-white color scheme to unify the main house and suggested replacing more formal damasks and silks with durable cottons, linens, and chintzes. Wool rugs were replaced with sisal, and brown dining room chairs were painted white, "a classic summer house trick I learned from my own mother," says Scheerer.

Though the interiors are visibly refreshed, and the ferries pass by more often than they used to, life on the compound remains much the same. On any given summer weekend, four generations of the family are scattered across the property. In this family, remarkably, all things are equal, and no one has dibs on a particular room. "We all have our preferences, but we move around, depending on who is coming and going."

PAGES 52-53: A classic Nantucket Shingle Style family house overlooks the Brant Point lighthouse.

OPPOSITE: Interior designer Tom Scheerer freshened the entrance hall with his signature mix of classic elements and whimsical details, including a shell mirror and painted floors.

PAGES 56-57: The family swims, sails, windsurfs, and kayaks off the harborside dock.

PAGES 58-59: The living room features a summery mix of Lee Jofa's Hollyhock chintz, sisal rugs, and wicker furniture. The curtains are Surat Stripe from Madeaux by Richard Smith. Kathryn Lynch's striking oil on paper, *Sun on Coecles Harbor*, hangs over the sofa.

PAGES 60-61: In the dining room, white chairs and woodwork pop against "gardenia leaf" green walls, a color scheme suggested by Scheerer to unify the house. The chair cushions are covered in Hable Construction's Stripe in ivy. On the shelves surrounding the doorway into the dining room is a collection of carved birds by Nantucket artist Pat Gardner. The Nantucket lightship baskets were made by the matron of the house and her daughters.

PAGE 62: In the master bedroom, the Island Raffia wallpaper in San Marino beige from Phillip Jeffries was hand stenciled. The fabric covering the headboard and hanging above the bed is Lorraine by Quadrille.

PAGE 63: A guest bedroom lined in a Quadrille wallpaper overlooks the Brant Point lighthouse.

PAGES 64-65: The living room of the boathouse, which overlooks the Coast Guard station, carries through the green-and-white color scheme of the main house next door.

PAGES 66-67: A bay in the boathouse was turned into a catchall family room with art and souvenirs from various family members. The flags were a gift from a friend's Dionis Beach shack. The large landscape painting is by local artist and family friend Illya Kagan.

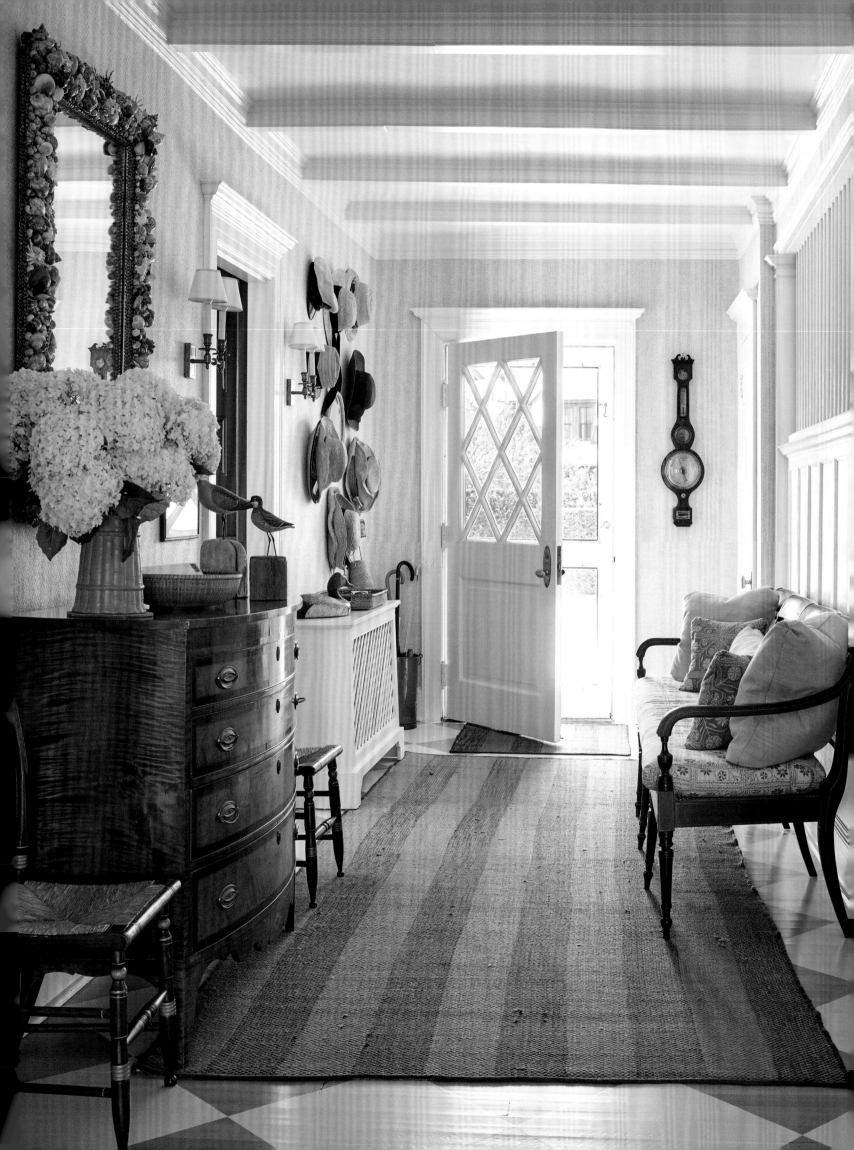

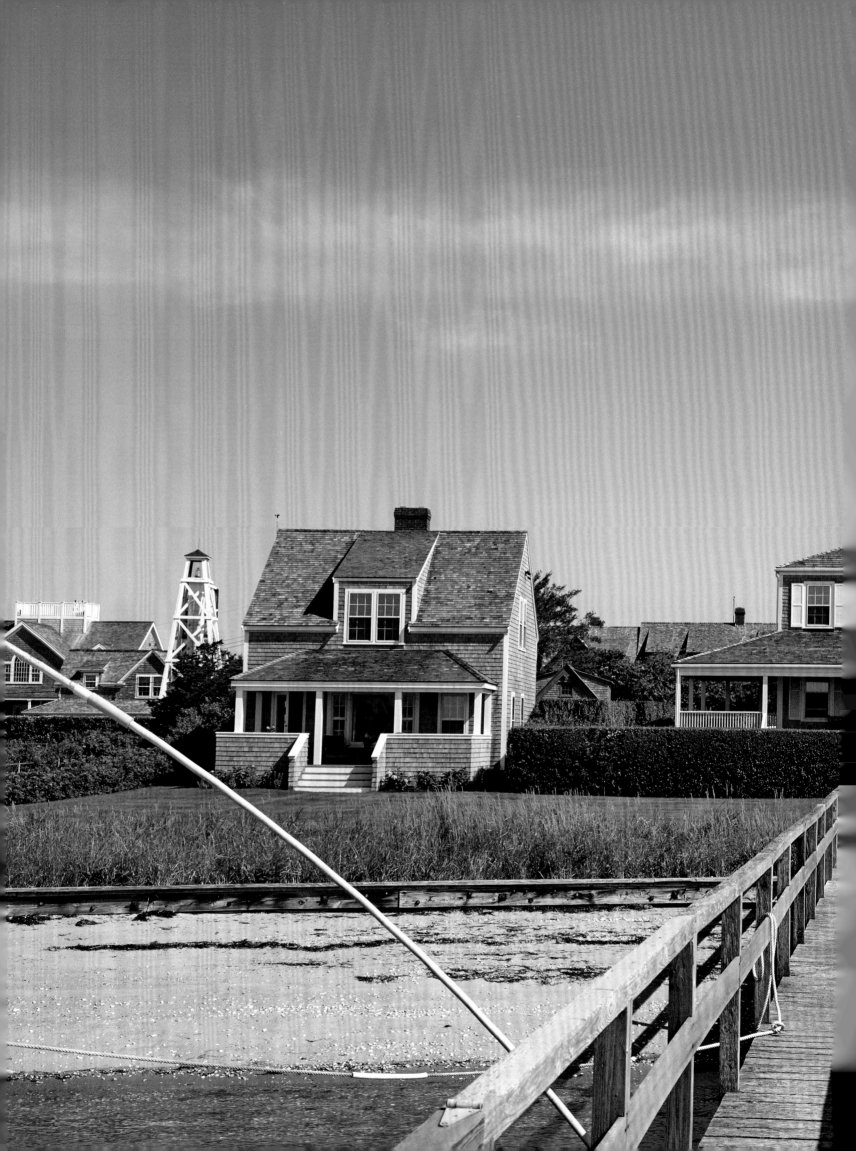

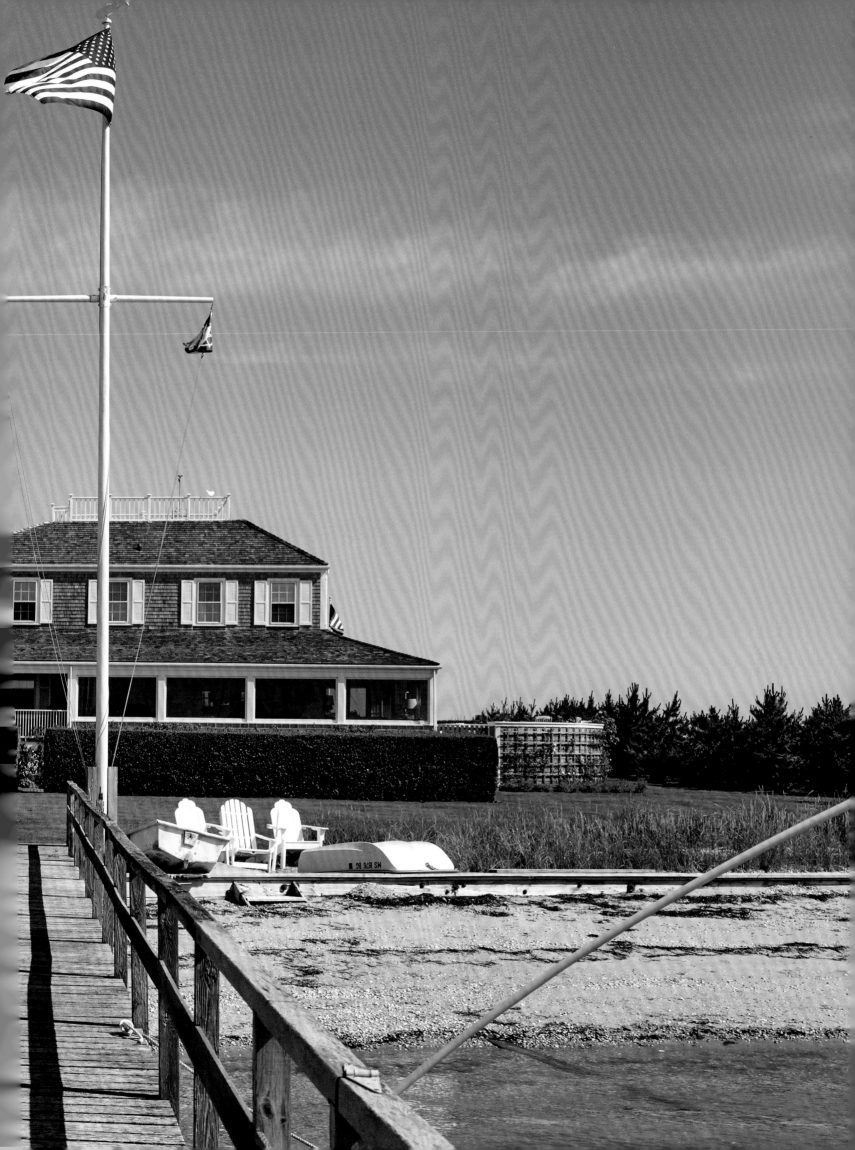

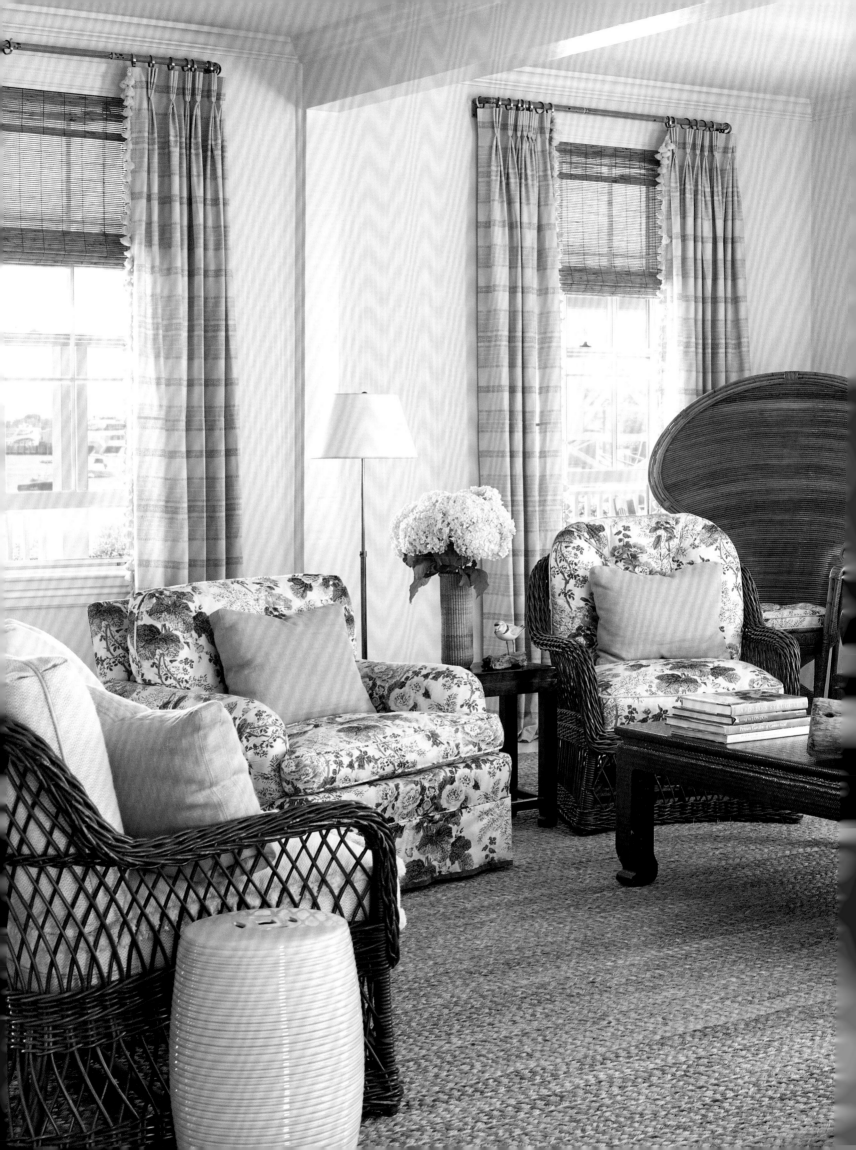

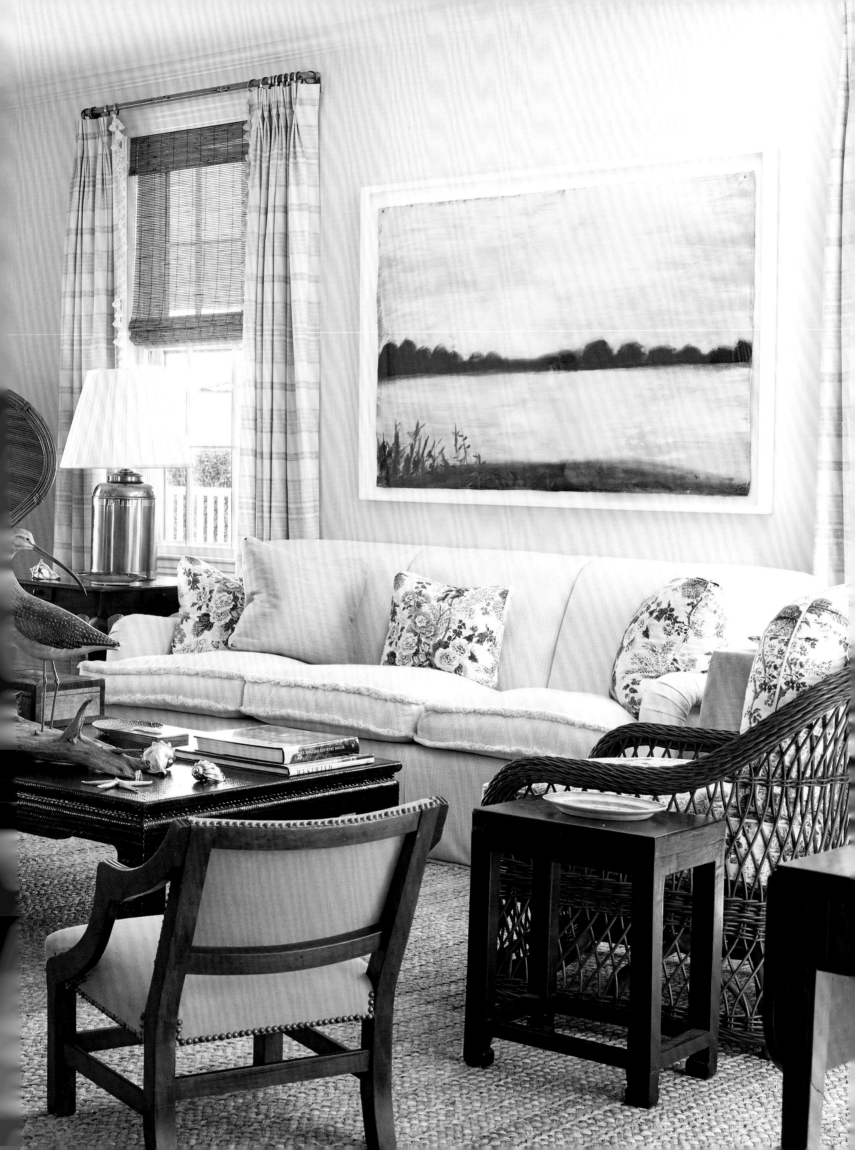

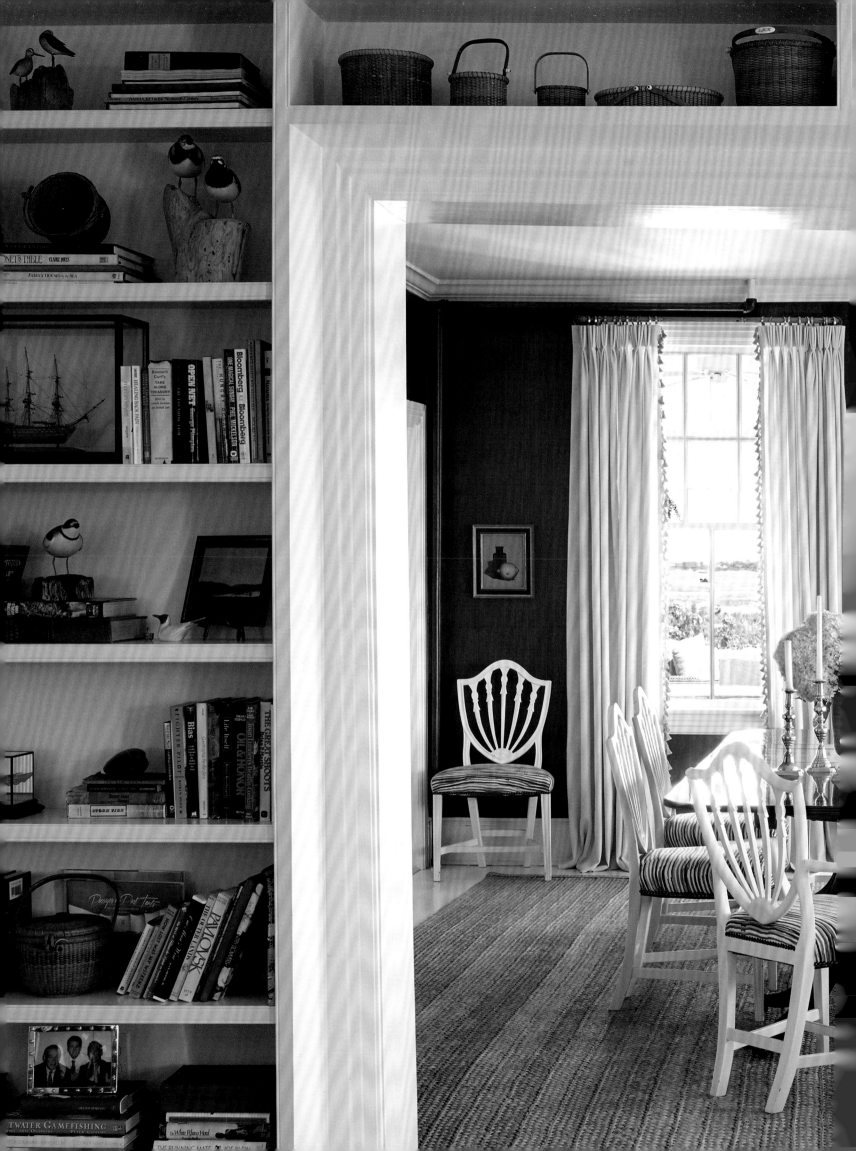

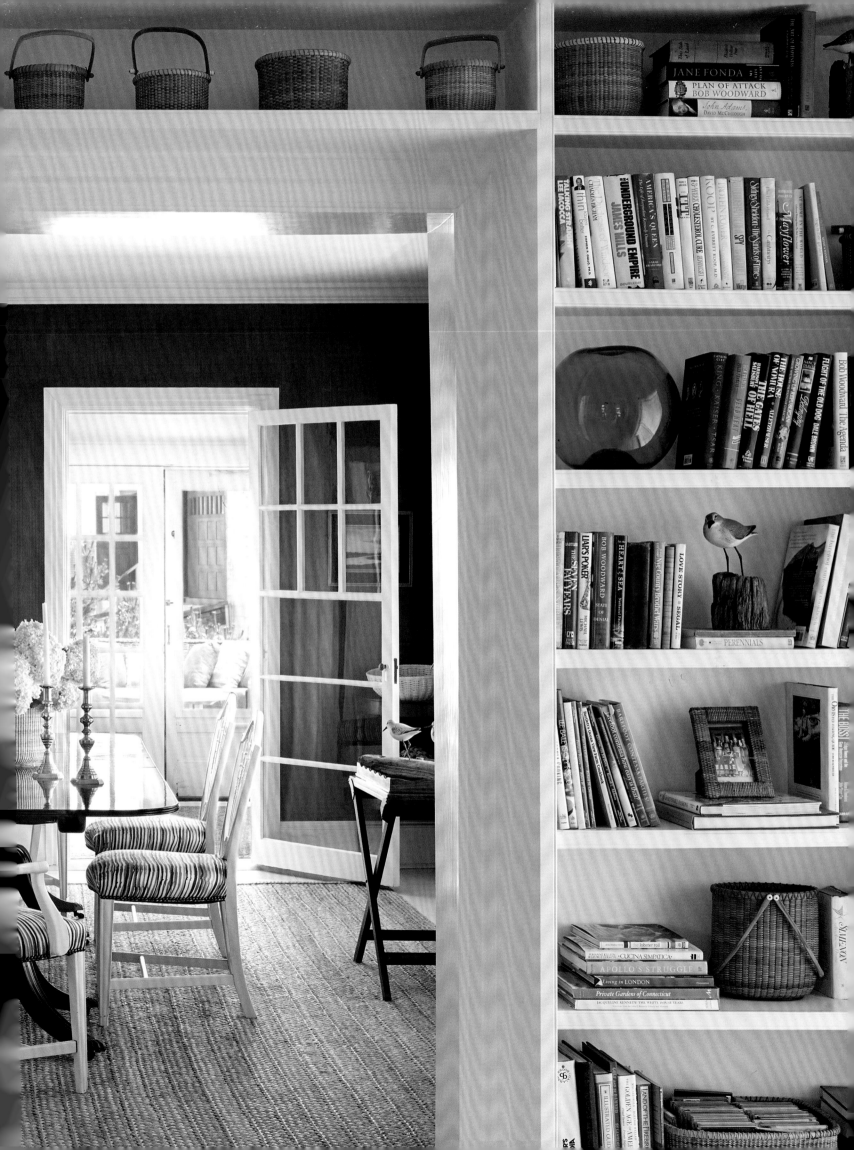

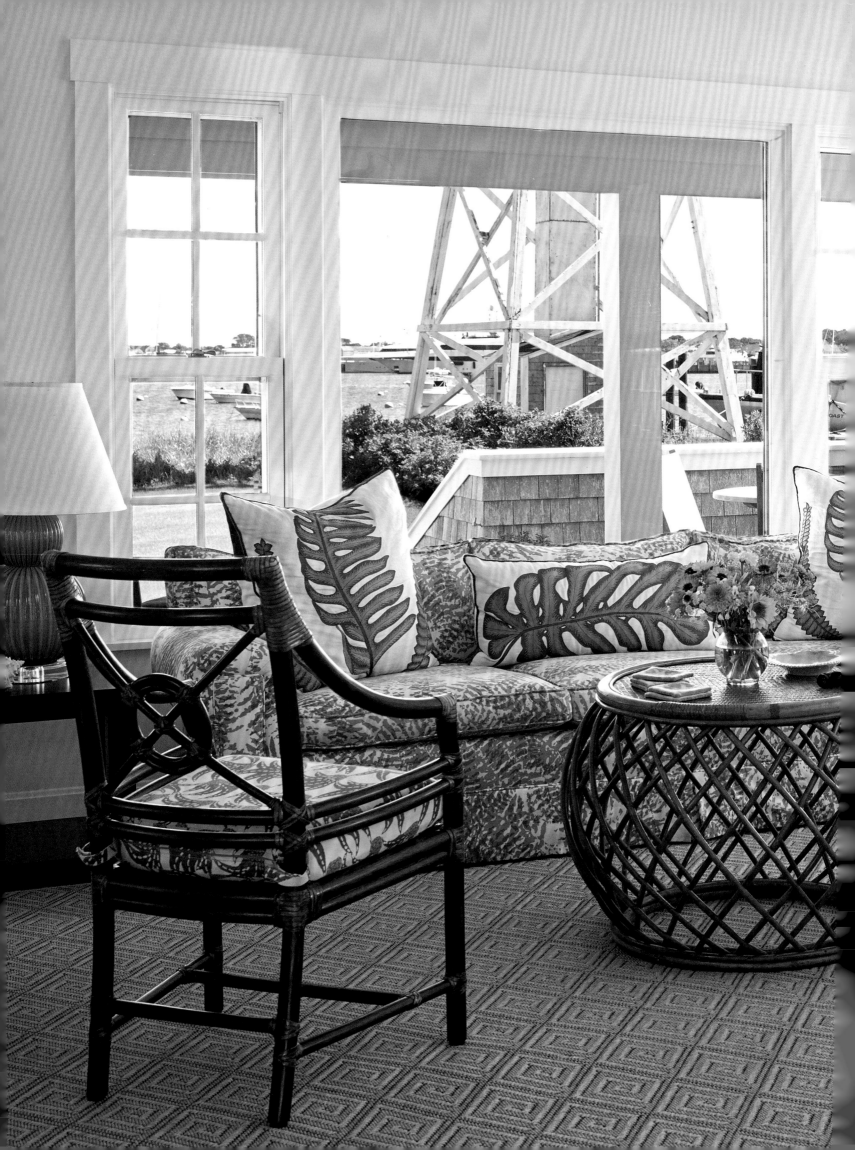

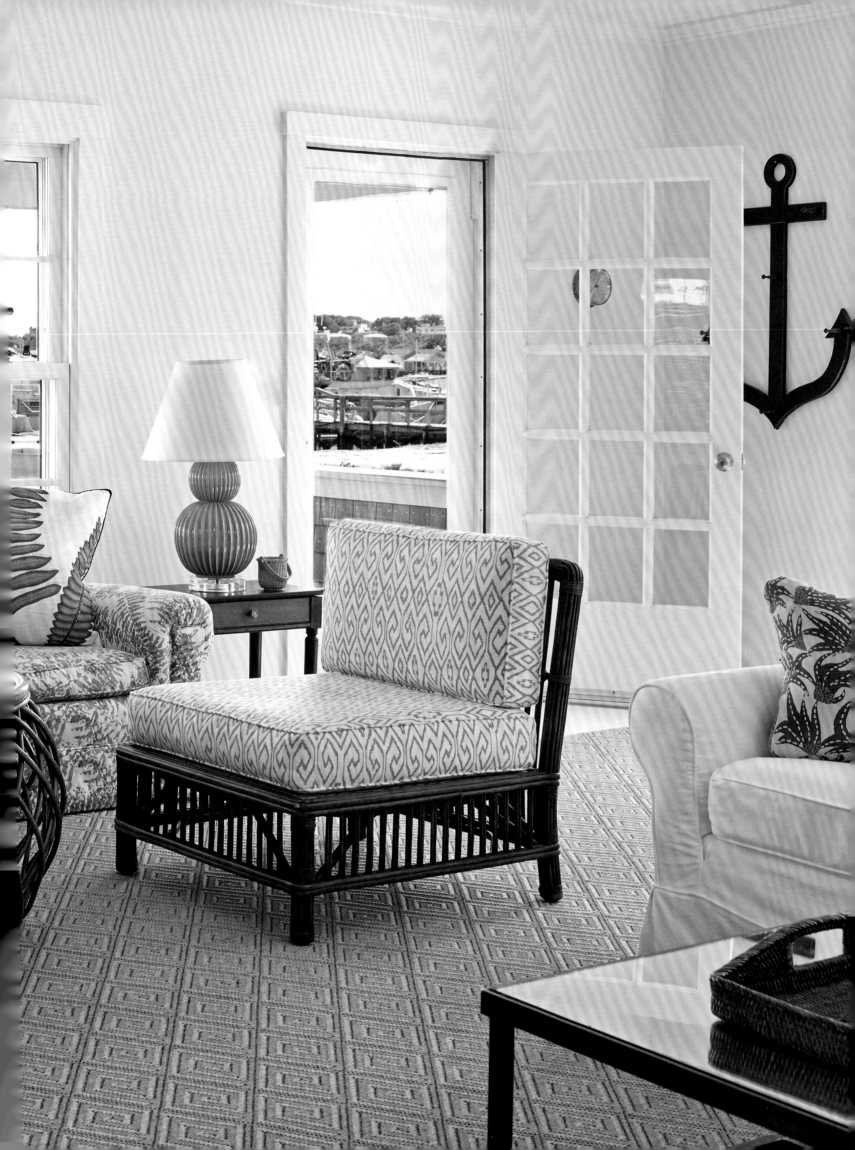

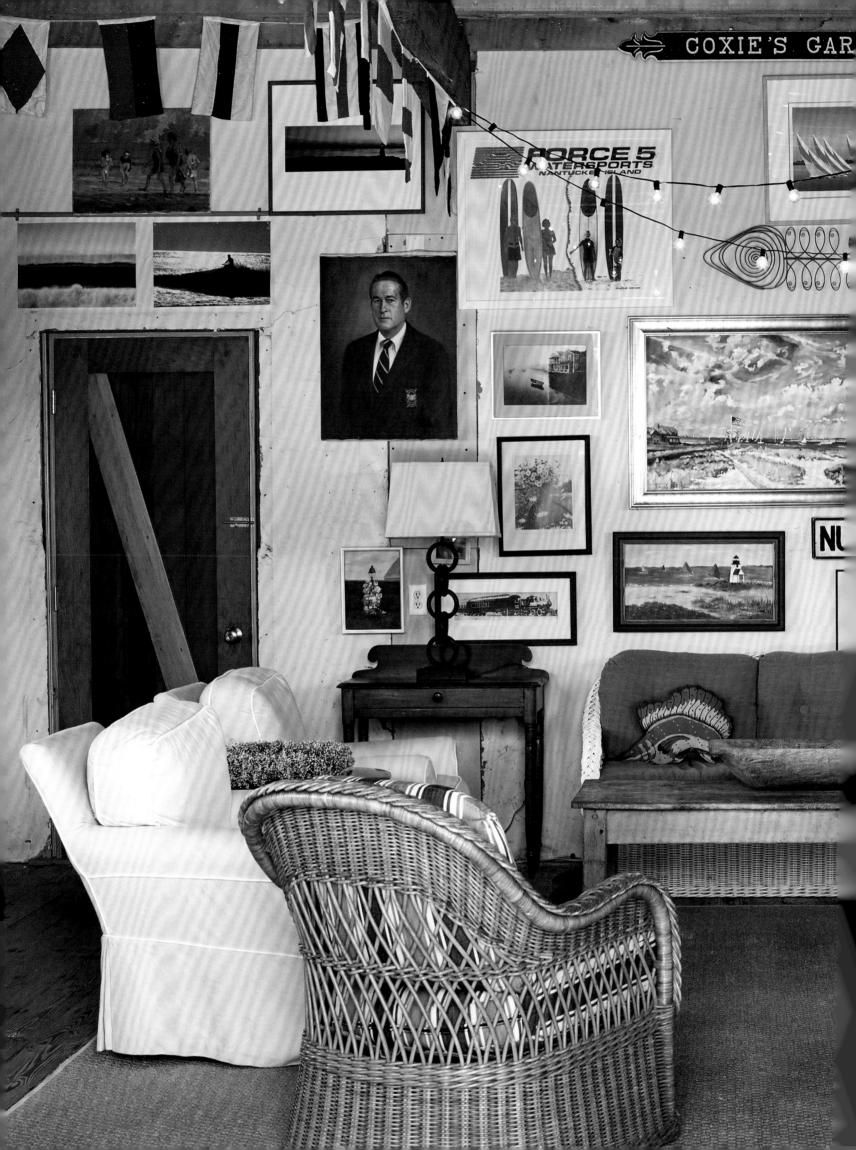

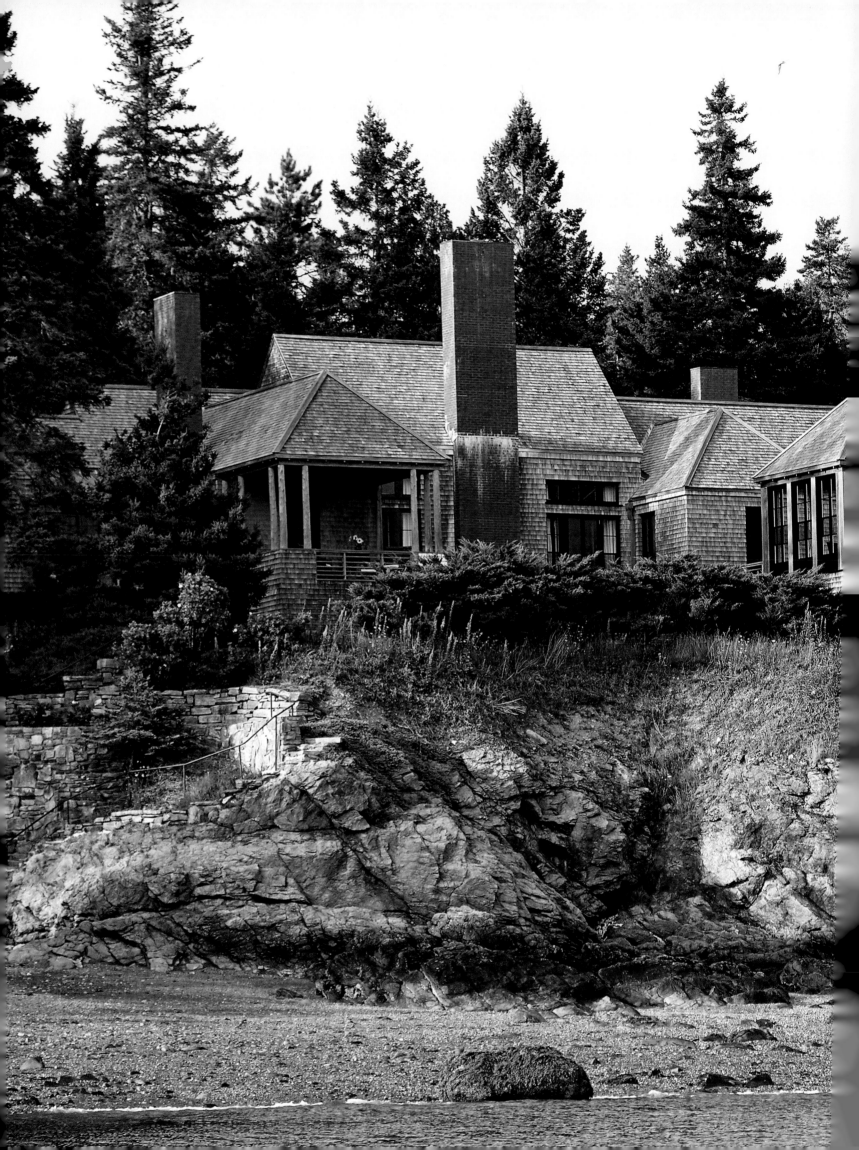

CLEAN LINES
AND FINE
CRAFTSMANSHIP

When Mark Brady, a venerable dealer of old master paintings and drawings, sold his historic Maine farmhouse and its accompanying fifty-five acres, he purchased a single-acre lot overlooking Frenchman Bay. Working within decidedly smaller parameters, he applied the same scholarly discipline demanded of his profession to create a house that reflects his love of the state's natural beauty.

To articulate his vision, Brady turned to his friend the architect Len Morgan, a fellow perfectionist known for his penchant for clean lines. "This was one of Len's early projects, but he already had the maturity of taste and sense of restraint," says Brady, whose directives were simple but definitive: a shingled house with a shingled roof that would not block passersby from seeing the bay. "Everyone walks here and they all say hello. I didn't want to spoil anyone's view."

Morgan answered with a series of pavilions centered on a thirty-foot-long great room. The "Lantern," a gazebo-like porch jutting out from the dining room provides 360-degree views of Frenchman Bay, the Porcupine Islands, and Cadillac Mountain. It is an ideal spot to relax alone or convene for a drink.

[69]

Hallways have water views, prompting the sensation of being on an elegant ocean liner.

High-level craftsmanship prevails inside, particularly in the great room, which is paneled in seamless Douglas fir. It references the area's tradition of boat-building and was in fact executed by the local construction team Bellows Woodworks, headed by Dexter Bellows, who, along with Morgan, selected the placement of boards by length and markings, turning the construction process into a Rubik's Cube. Artworks hang from chains that descend from a bronze rail at cornice height, allowing Brady to rotate the art without damaging the walls.

Uniform white wool draperies frame the library, dining room, living room, and bedroom windows, creating a serene tone throughout the house. A mix of European, Anglo-Indian, and Asian antiques lends an eclectic flair. In the great room, a single red sofa adds a dash of color. The result is a house that is both elegant and artful and so discreet that it dissolves into the landscape, suiting its owner to a T.

PAGES 68–69: When Mark Brady purchased the property on Frenchman Bay, he called upon architect Len Morgan to design a shingled house in alignment with its natural surroundings.

OPPOSITE AND PAGES 72–73: A gazebo-like porch off the dining room frames vistas of Frenchman Bay, Cadillac Mountain, and the Porcupine Islands. Called the "Lantern," it features twelve pairs of French doors and offers a 360-degree view.

PAGE 74: An elegantly paneled entrance hall heralds things to come.

PAGE 75: In the library, movable clip-on lamps permit a variety of lighting options. The little painting on one of the shelves is a trompe l'oeil of a marble relief by the nineteenth-century French painter Camille-Auguste Gastine.

PAGE 76: The great room is paneled in Douglas fir. The sofa and its striped pillows provide the only vivid color. A Noguchi paper lantern reigns over the room, which is thirty feet long and twenty feet tall at its highest point.

PAGE 77: A portrait of Jacques Bosch, the most famous Catalan classical guitarist of the nineteenth century, by the French painter Bernard de Gironde, hangs from chains in the great room.

PAGE 78: In keeping with the rest of the house, the kitchen is paneled. The countertops are Corian. The brown-and-gray pottery on the lower left shelves of the island is by the late Denis Vibert, a local artisan. The blue-and-white dishes to the right were made by Gull Rock Pottery in Hancock, Maine. It was run for years by Kurt Wray, a scientist from Boston.

Charles Ryskamp, the former director of the Morgan Library and the Frick Collection, an old friend of Mark Brady's, urged him to commission a set of dinner plates from Kurt. They feature a charming motif of Mount Desert Island on Frenchman Bay.

PAGE 79: A painting of Hancock Point by Marc de Montebello hangs in the dining room, which has two separate terraces, one of which leads to the "Lantern." Brady and his friend the antique dealer Angus Wilkie spotted the nineteenth-century Anglo-Indian dining table with its distinctive ebony and calamander top on London's Pimlico Road.

PAGES 80–81: In the master bedroom, a nineteenth-century English mahogany bench contrasts with a modern four-poster bed from Ralph Lauren Home. Beyond the French doors is a private pocket garden.

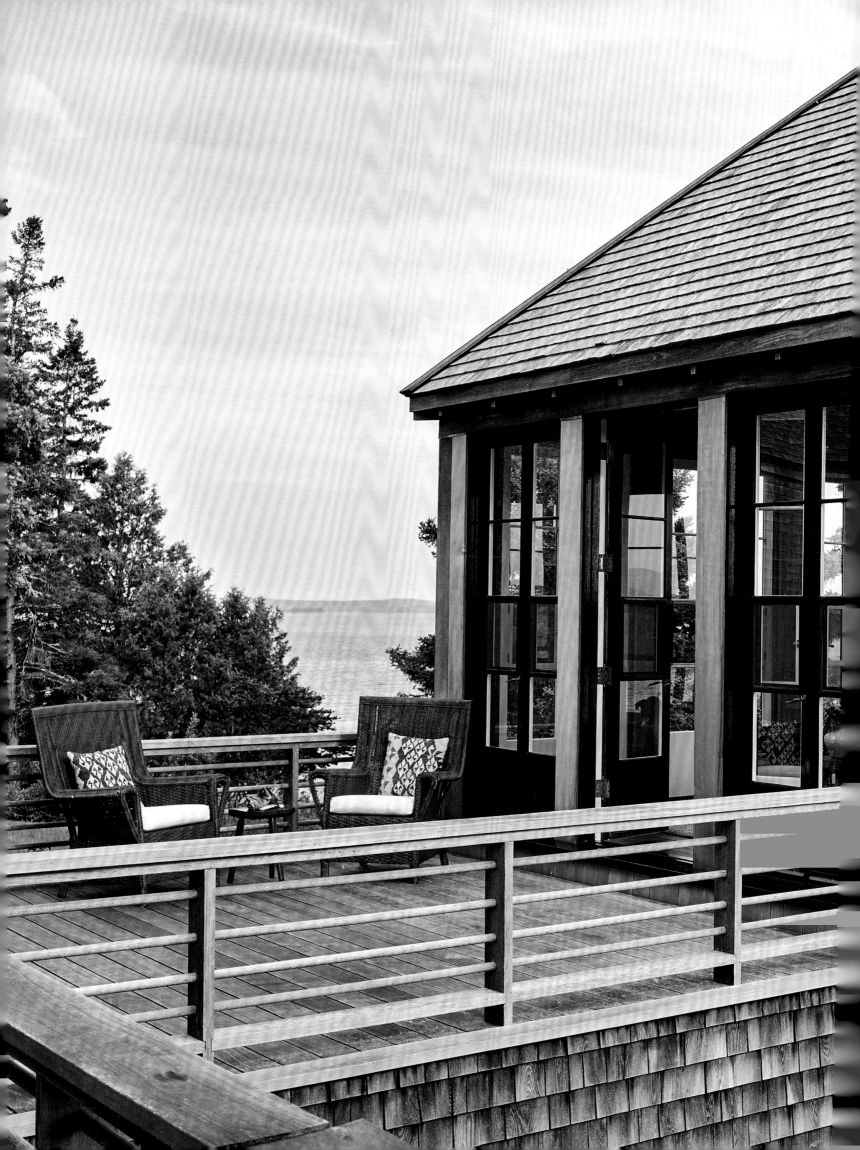

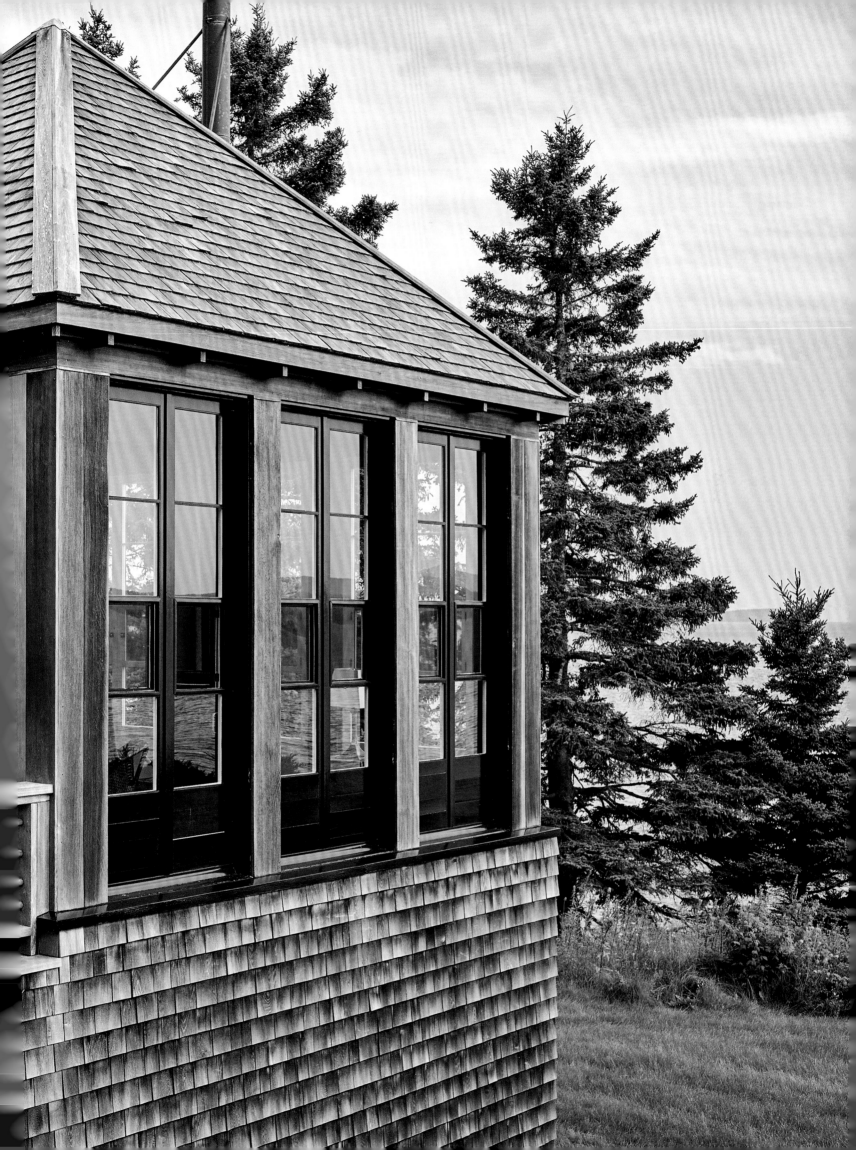

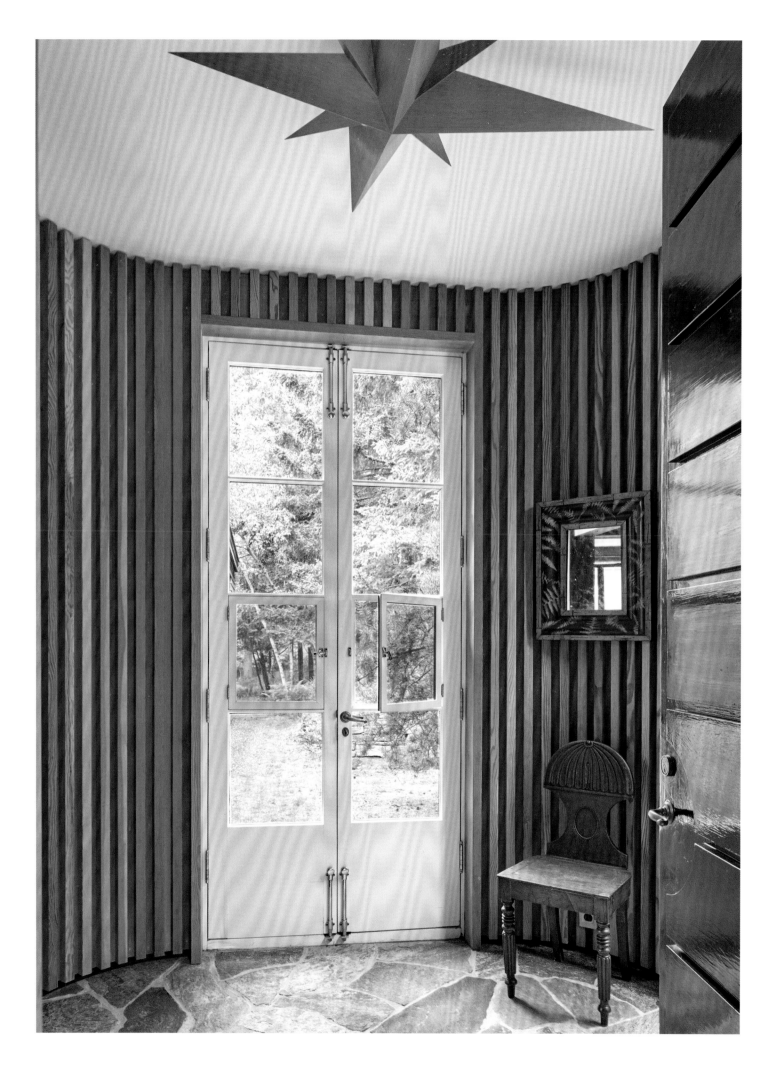

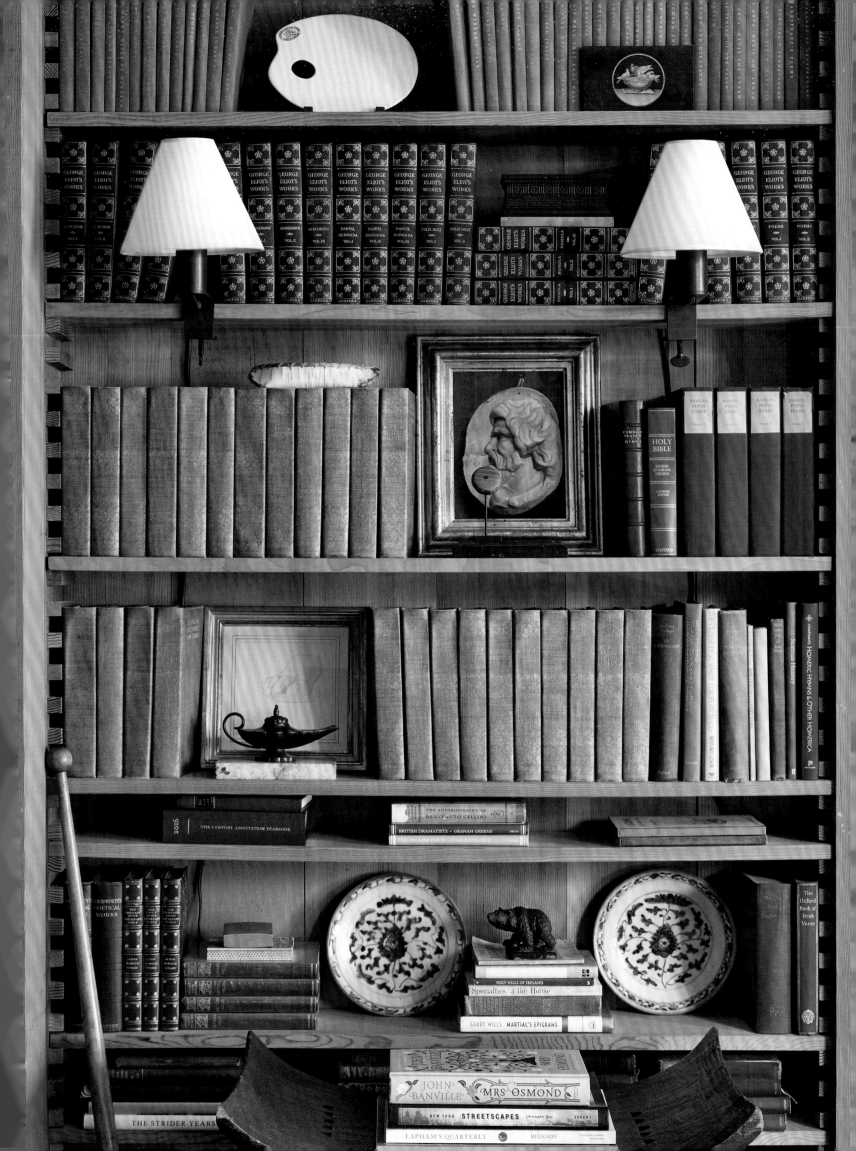

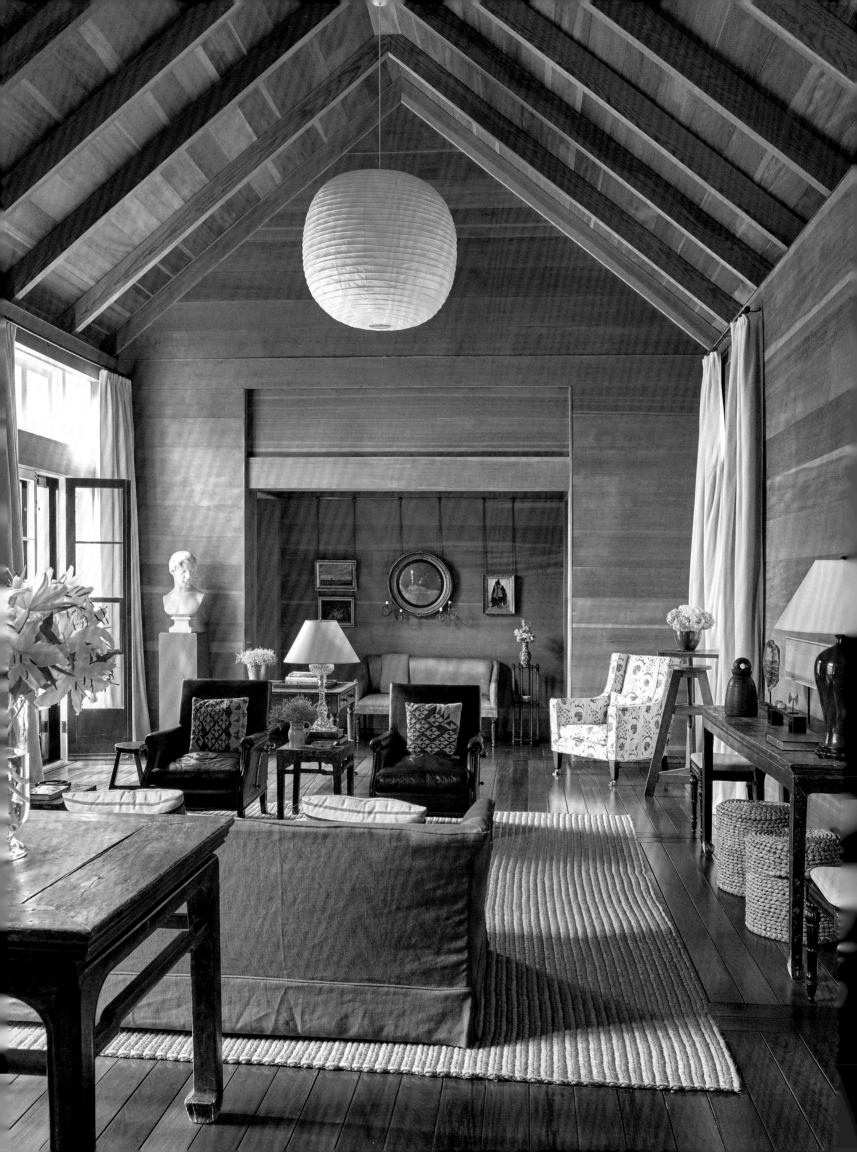

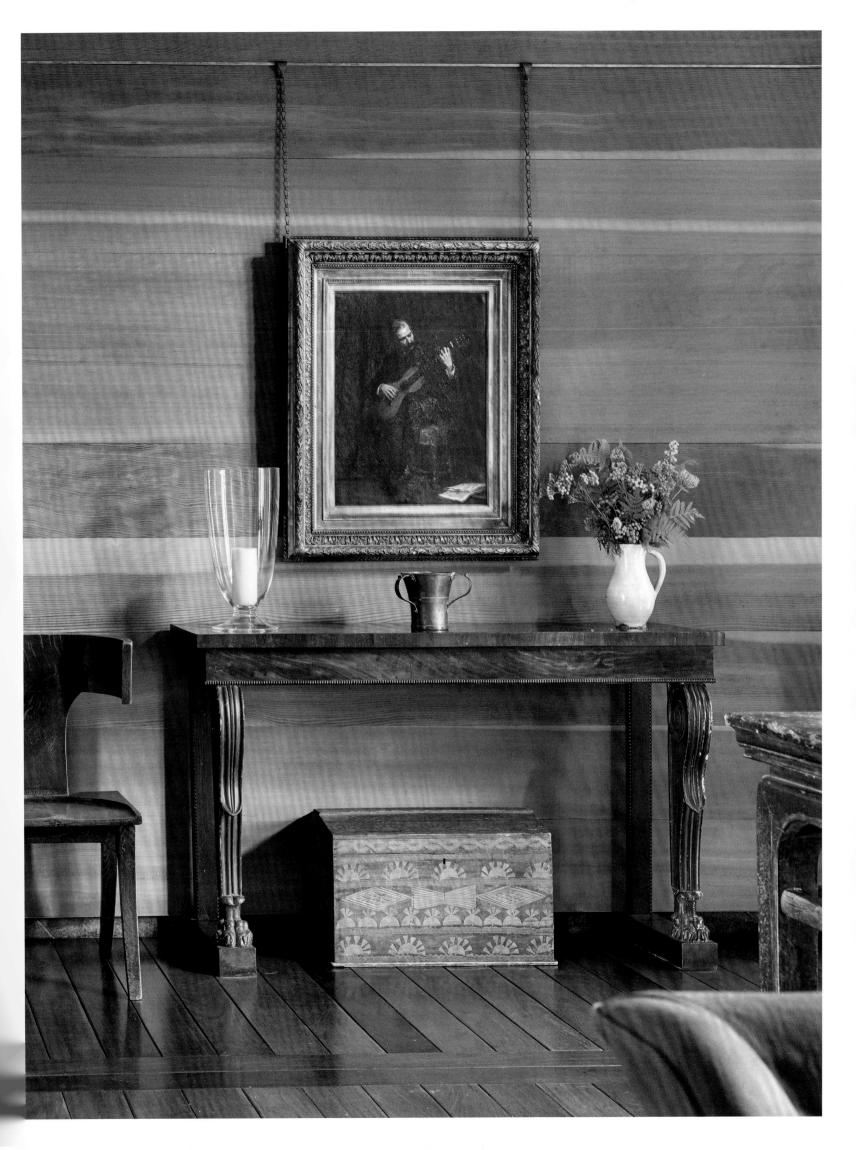

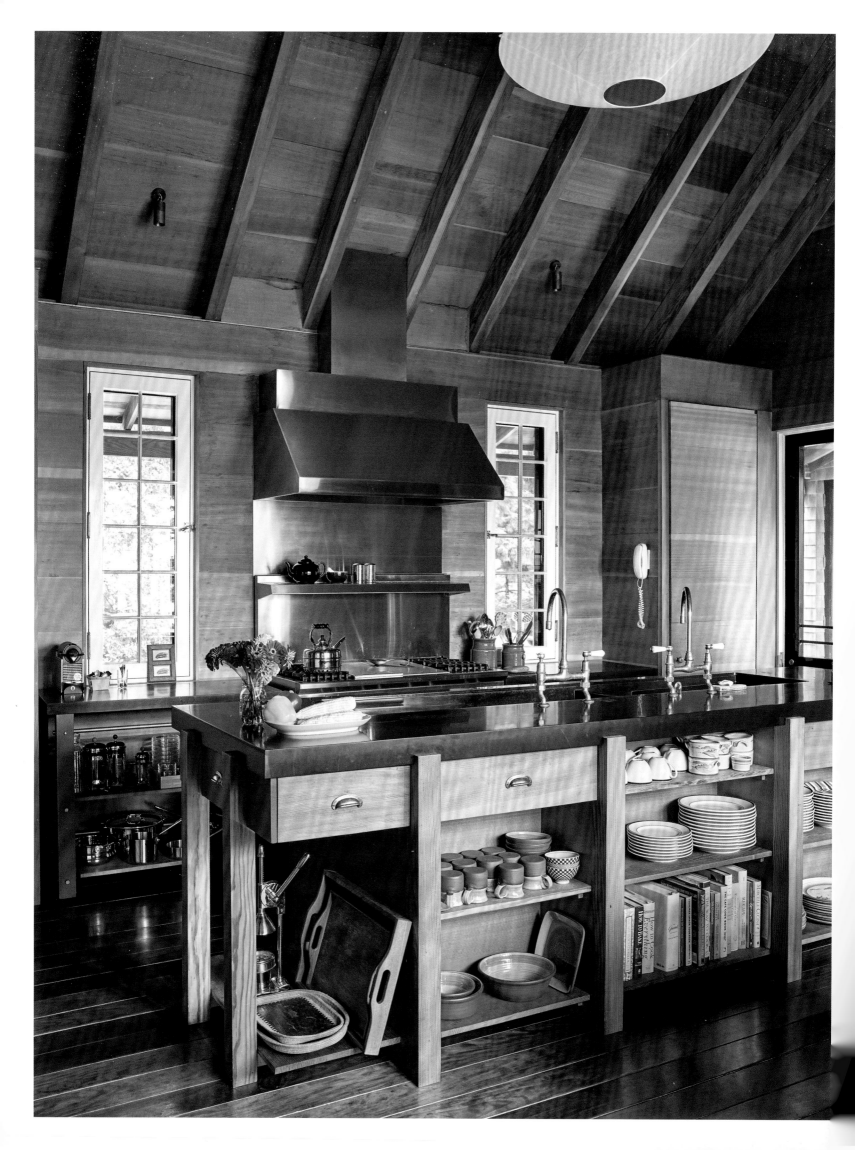

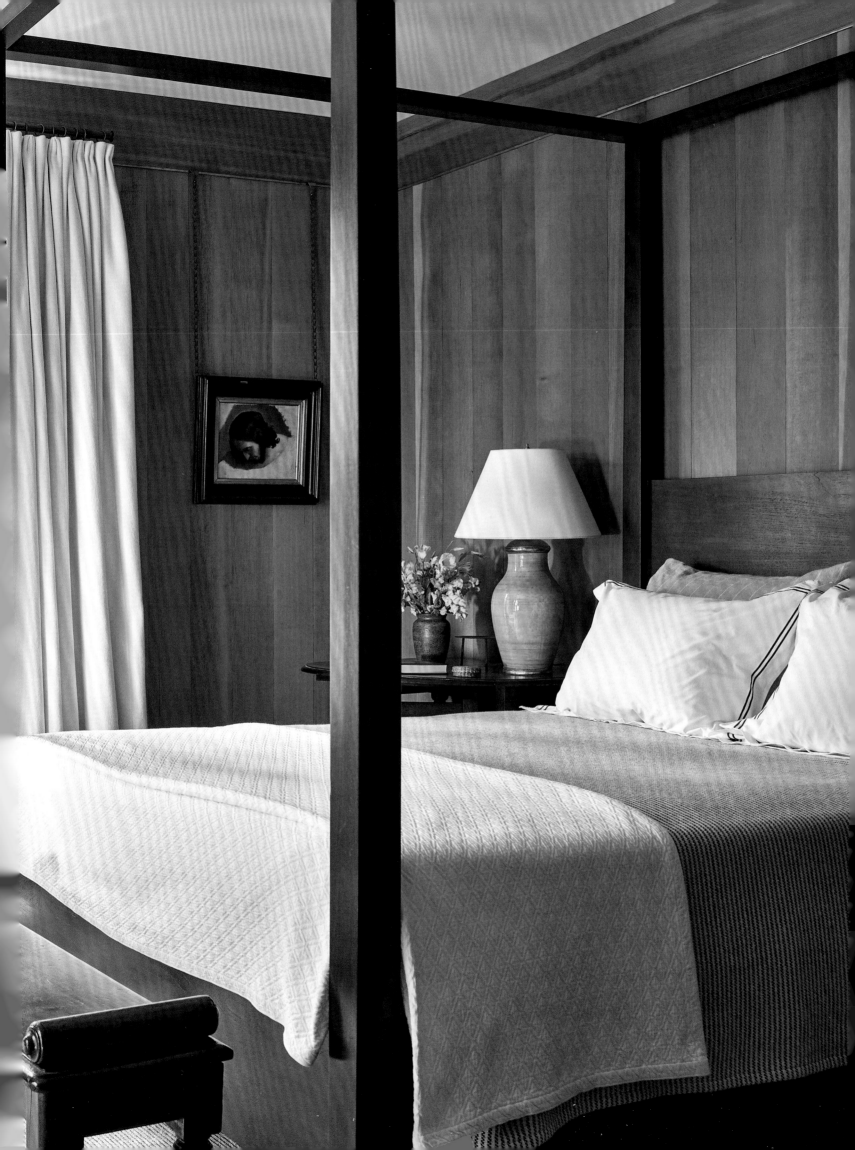

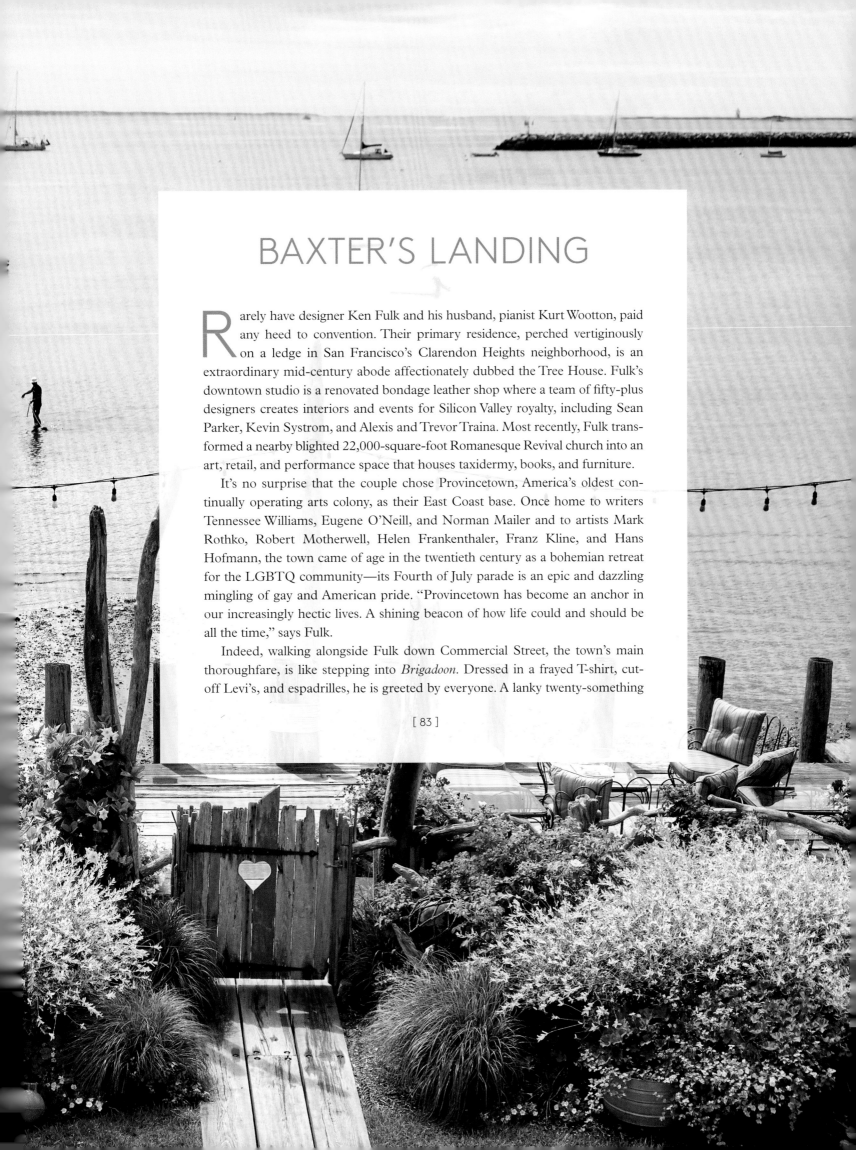

BAXTER'S LANDING

Rarely have designer Ken Fulk and his husband, pianist Kurt Wootton, paid any heed to convention. Their primary residence, perched vertiginously on a ledge in San Francisco's Clarendon Heights neighborhood, is an extraordinary mid-century abode affectionately dubbed the Tree House. Fulk's downtown studio is a renovated bondage leather shop where a team of fifty-plus designers creates interiors and events for Silicon Valley royalty, including Sean Parker, Kevin Systrom, and Alexis and Trevor Traina. Most recently, Fulk transformed a nearby blighted 22,000-square-foot Romanesque Revival church into an art, retail, and performance space that houses taxidermy, books, and furniture.

It's no surprise that the couple chose Provincetown, America's oldest continually operating arts colony, as their East Coast base. Once home to writers Tennessee Williams, Eugene O'Neill, and Norman Mailer and to artists Mark Rothko, Robert Motherwell, Helen Frankenthaler, Franz Kline, and Hans Hofmann, the town came of age in the twentieth century as a bohemian retreat for the LGBTQ community—its Fourth of July parade is an epic and dazzling mingling of gay and American pride. "Provincetown has become an anchor in our increasingly hectic lives. A shining beacon of how life could and should be all the time," says Fulk.

Indeed, walking alongside Fulk down Commercial Street, the town's main thoroughfare, is like stepping into *Brigadoon*. Dressed in a frayed T-shirt, cut-off Levi's, and espadrilles, he is greeted by everyone. A lanky twenty-something

[83]

dodges us on his vintage bike. "Welcome home, Ken," he shouts as he regains his balance. Cult découpage artist and design retailer John Derian hails us from his front porch, insisting we all come by later for "stoop drinks," essentially a roving happy hour. "Kurt works at John's shop on weekends," says Ken as we walk away. As if on cue, Kurt appears out of nowhere. "I do it for the discount," he says, half joking. As it turns out, it's Ken and Kurt's anniversary. A college student working the cash register where we order take-out lunch magically produces a muffin stabbed with a glowing candle, and an impromptu sidewalk celebration ensues.

The couple met twenty years ago in a laundromat on Boston's Newbury Street. "I thought he was stealing my towels. Turns out we had the same burgundy-and-green Ralph Lauren towels. The rest, as they say, is history," says Fulk. The couple began visiting Provincetown, eventually purchasing a former boarding house, the back porch of which was held up with a car jack. Despite its decrepit condition and the fact that by then they were living across the country, an extraordinary construction team renovated the house in under a year, forever stitching the couple into the community fabric.

The interiors demonstrate Fulk's deft ability to artfully mix the luxurious and the idiosyncratic to powerful effect. A self-portrait by Larry R. Collins hangs on a powder-room door in the entrance hall, and the couple's prized dog paintings line the bedroom hallway. Fabrics range from grain sacks to damask. The ceiling fixture in the library is crafted from a salvaged brass boat hatch. One of the bedrooms boasts a canopy bed from Marjorie Merriweather Post's Adirondack camp. The view from the upstairs windows is of Provincetown Harbor and Long Point—the very tip of Cape Cod. At low tide, the couple's beloved English Cream Golden Retrievers, Duncan, Ciro, and Sal, play in the water, while Kurt and Ken collect seashells, driftwood, beach glass, and quahogs to decorate their dockside bar.

PAGES 82–83: Baxter's Landing, Ken Fulk and Kurt Wootton's East Coast escape in Provincetown, Massachusetts, looks out across Provincetown Harbor toward Long Point, the very tip of Cape Cod.

OPPOSITE: English Cream Golden Retrievers Duncan, Ciro, and Sal, along with wirehaired dachshund Wiggy, wait expectantly on the back porch of Baxter's Landing, which was built in the early 1800s and once operated as a boarding house.

PAGE 86: In the entrance hall, the nineteenth-century English campaign chest was found at the Battersea Park fair. Next to it hangs an eighteenth-century portrait. A self-portrait by Larry R. Collins hangs on the door leading to the powder room.

PAGE 87: In the library, a ceiling fixture is a repurposed boat hatch. The wing chair was found at Chelsea Antiques. Grain-sack pillows rest on an antique brass bed that doubles as a sofa. The walls and ceiling are painted in Benjamin Moore's Dash of Curry.

PAGES 88–89: In the living room, a nineteenth-century scroll-arm sofa upholstered in a Ralph Lauren Home fabric contrasts with a whimsical nineteenth-century pink armchair. An antique Khotan rug is underfoot. Walls are painted in Farrow & Ball's Setting Plaster.

PAGES 90–91: In the dining room, nineteenth-century English chairs surround a nineteenth-century gateleg table. The mural of Provincetown Harbor was painted by Rafael Arana. The lusterware displayed on the shelves of the hutch was found at Brimfield.

PAGE 92: The couple's prized collection of dog portraits lines the bedroom hall.

PAGE 93: The antique canopy bed in this bedroom is from Top Ridge, Marjorie Merriweather Post's Adirondack camp.

PAGES 94–95: The bed in the guest bedroom, referred to as the Captain's Room, is from Dodie Rosekrans's Venetian palazzo and was purchased at auction.

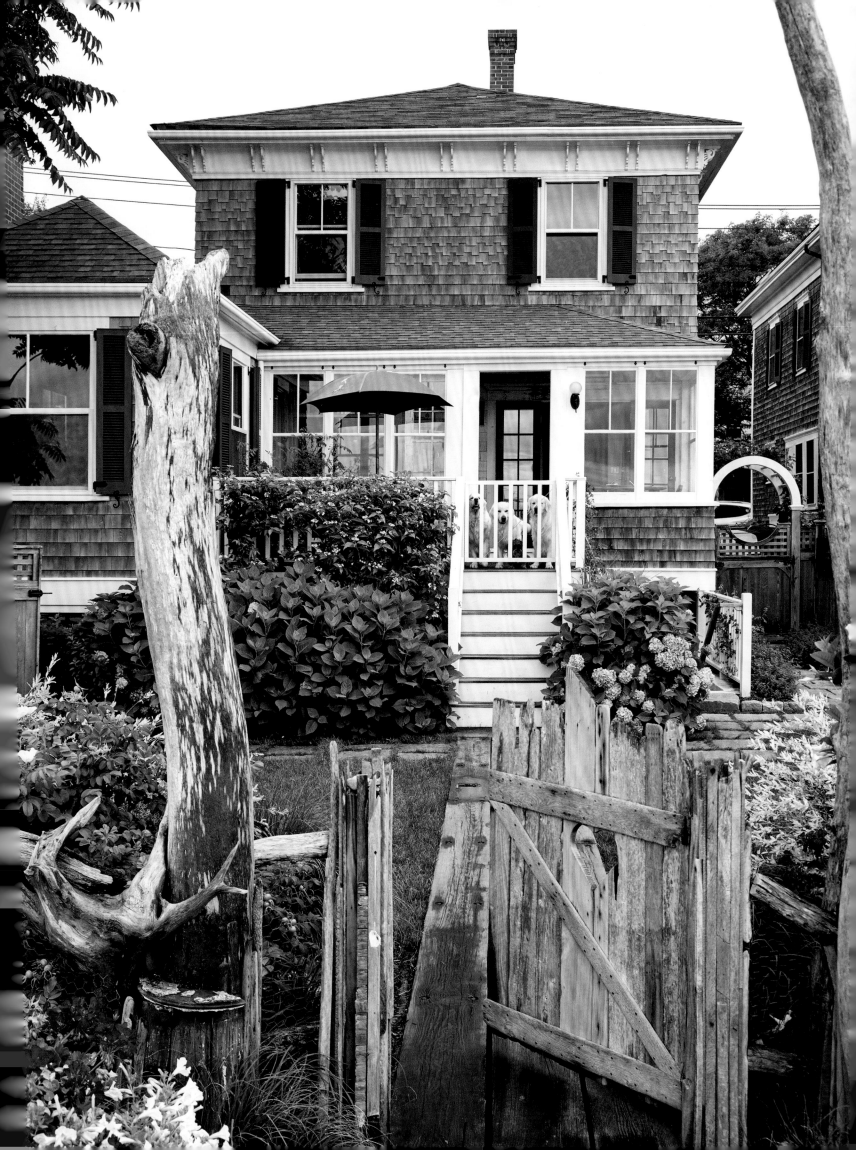

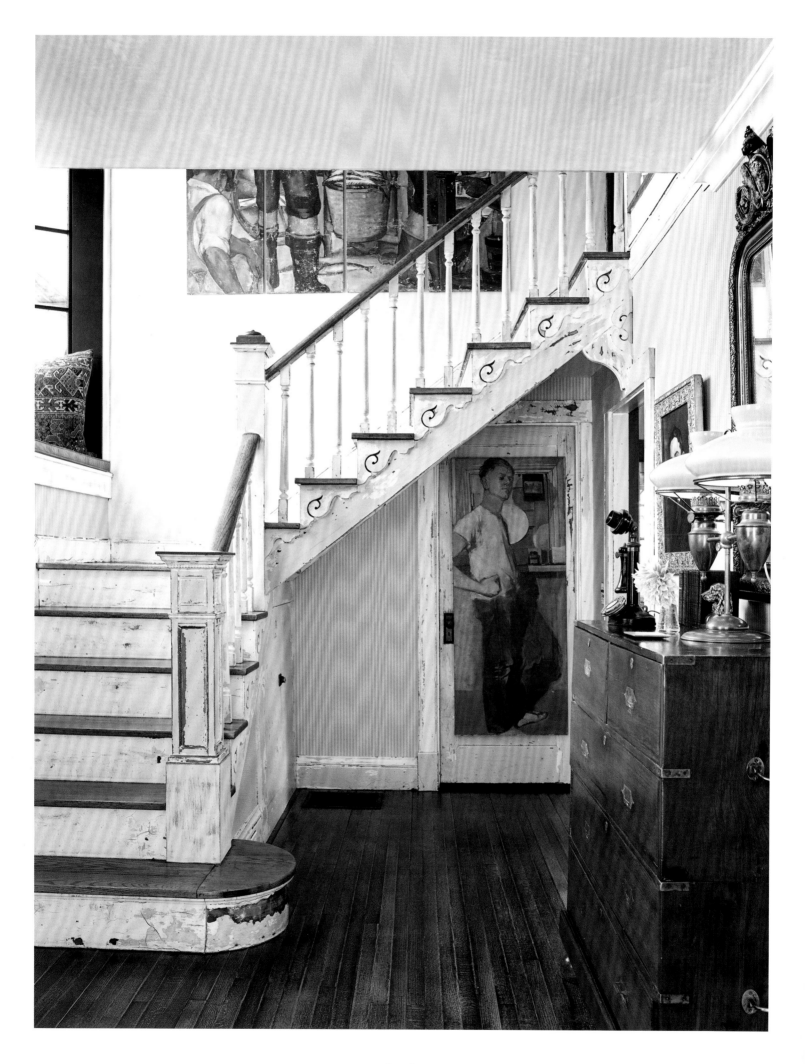

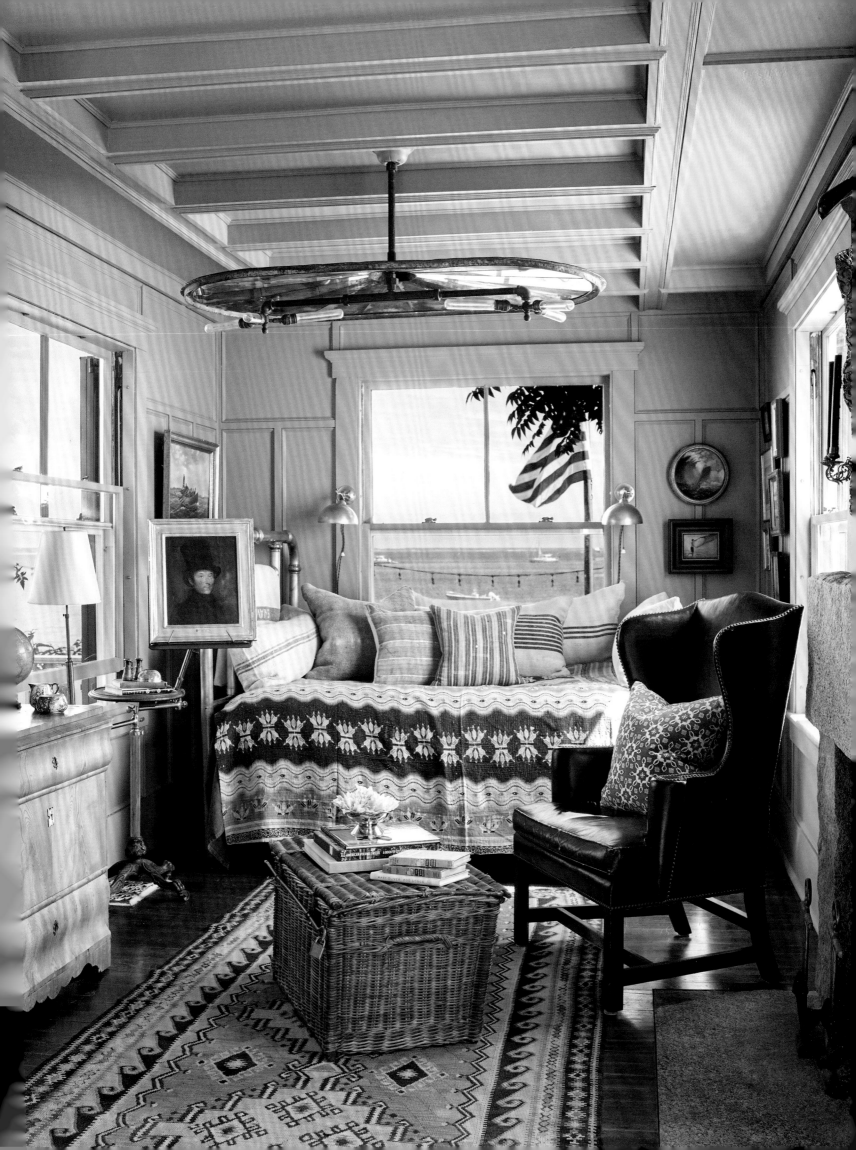

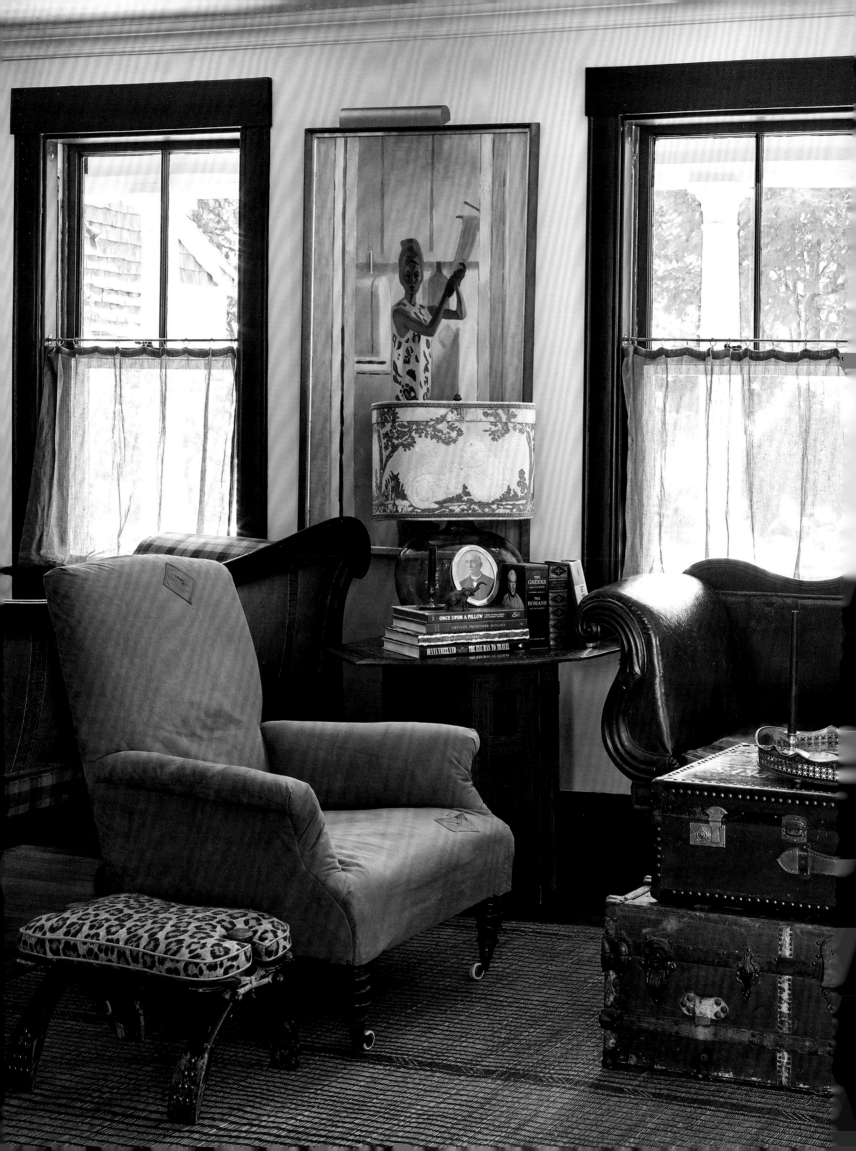

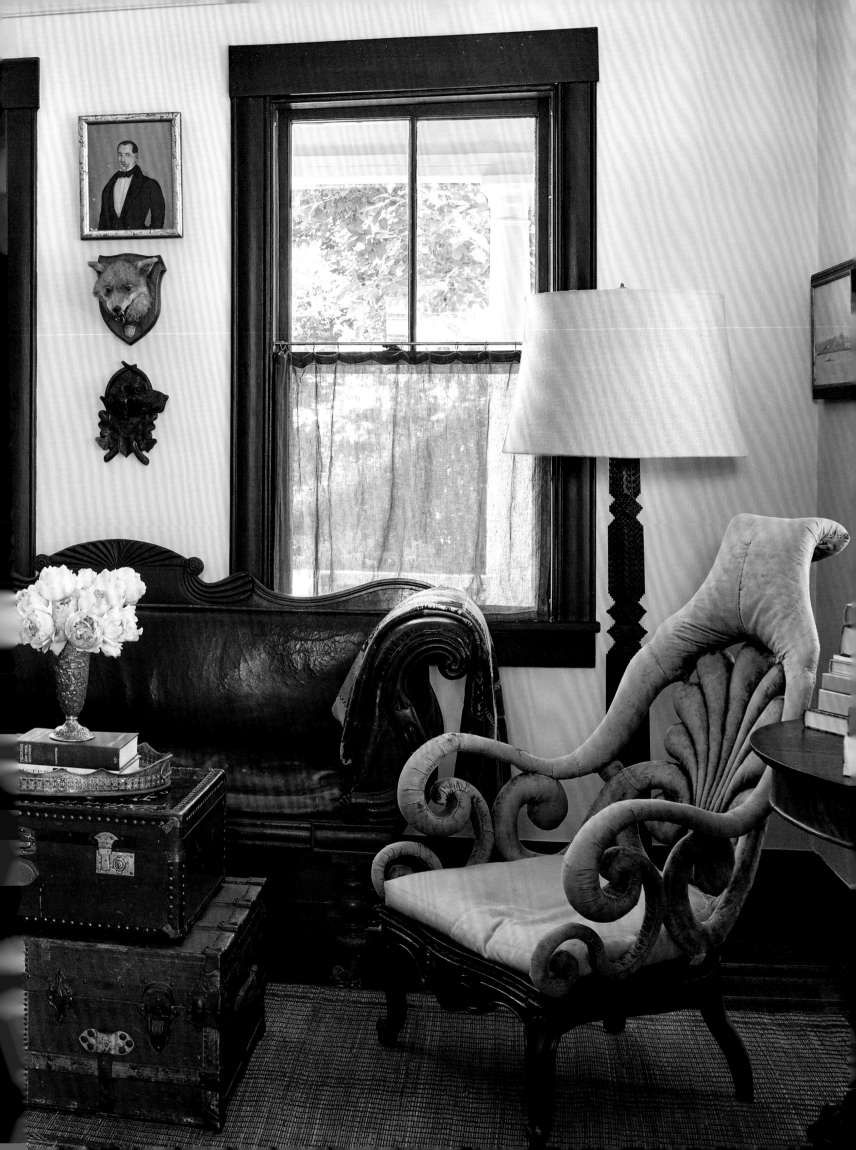

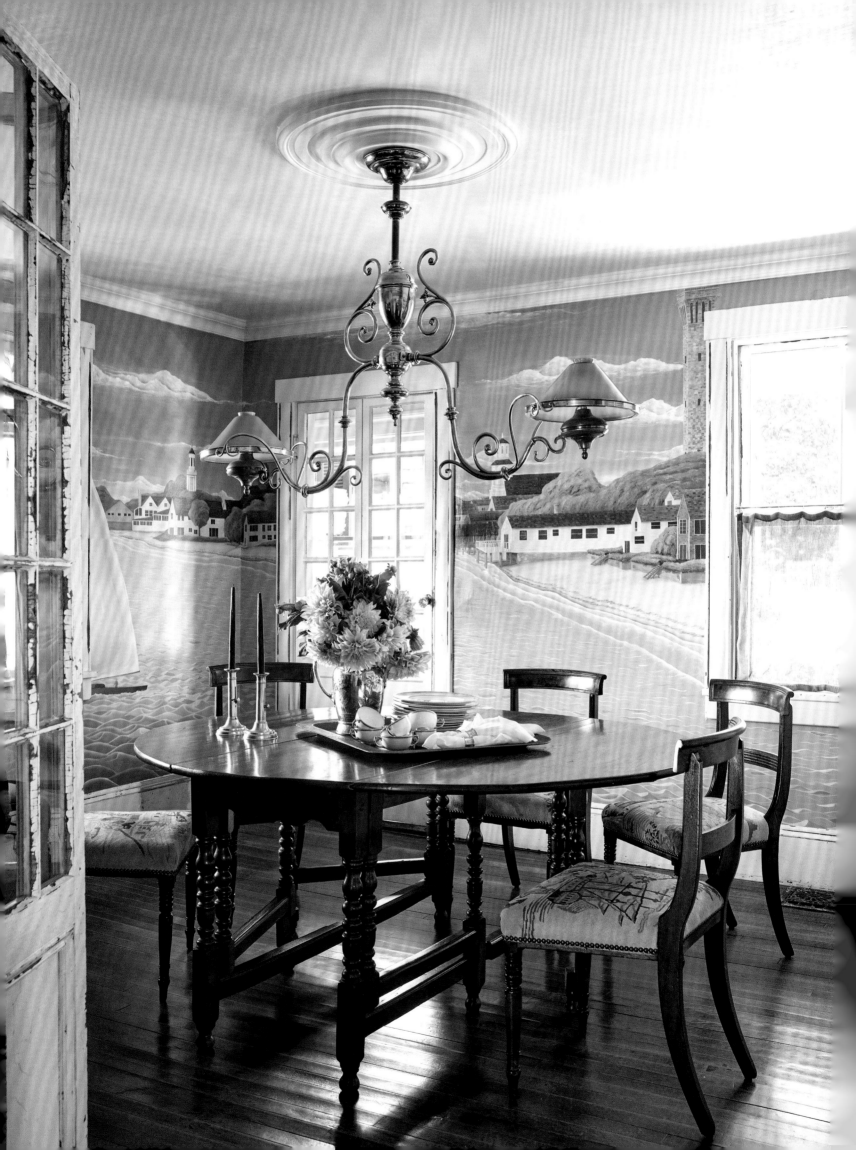

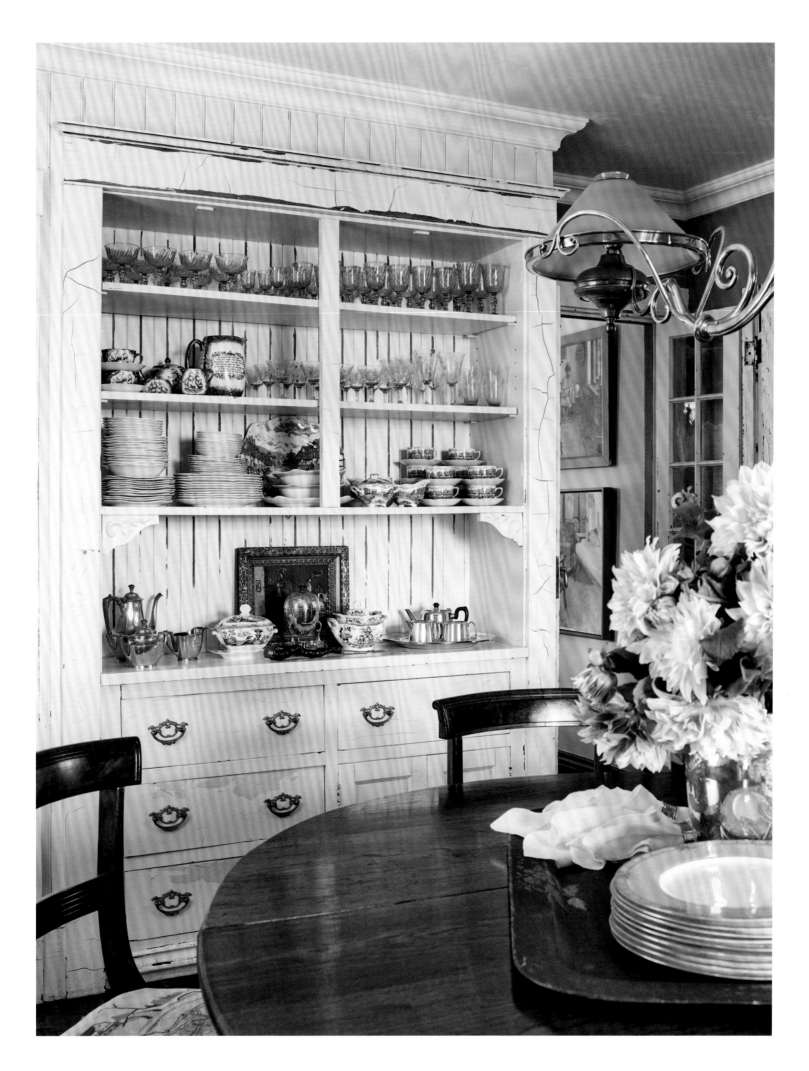

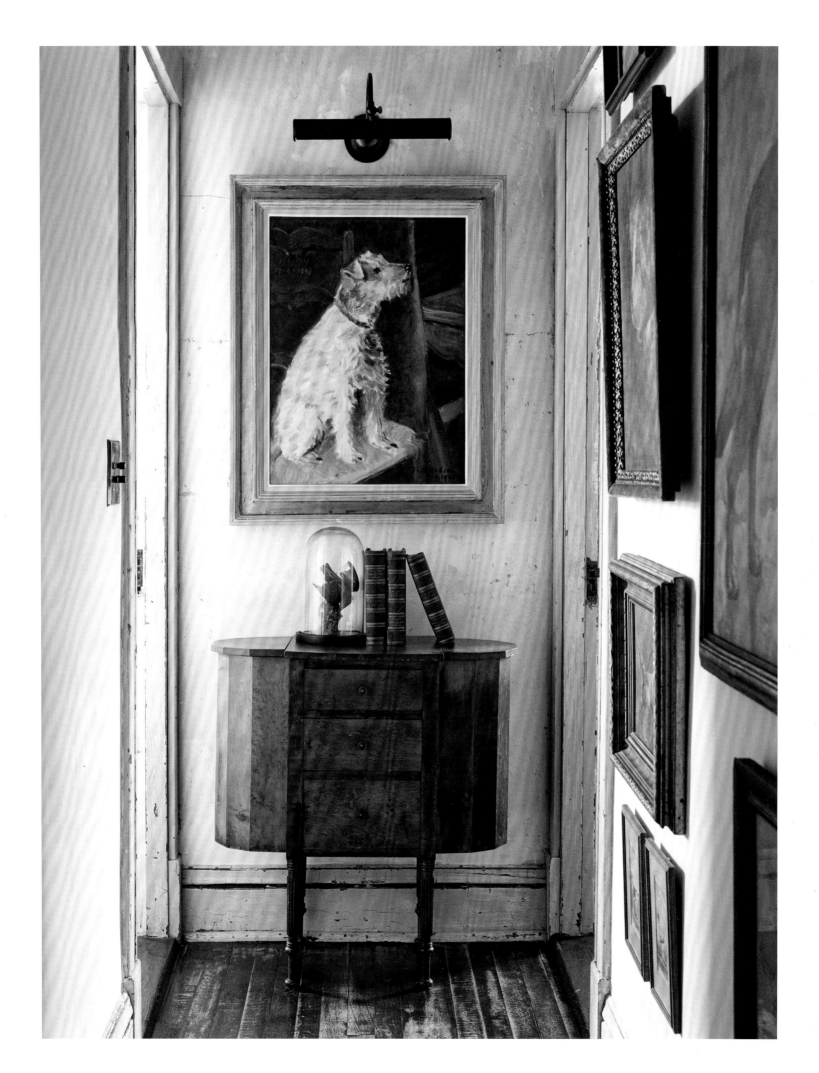

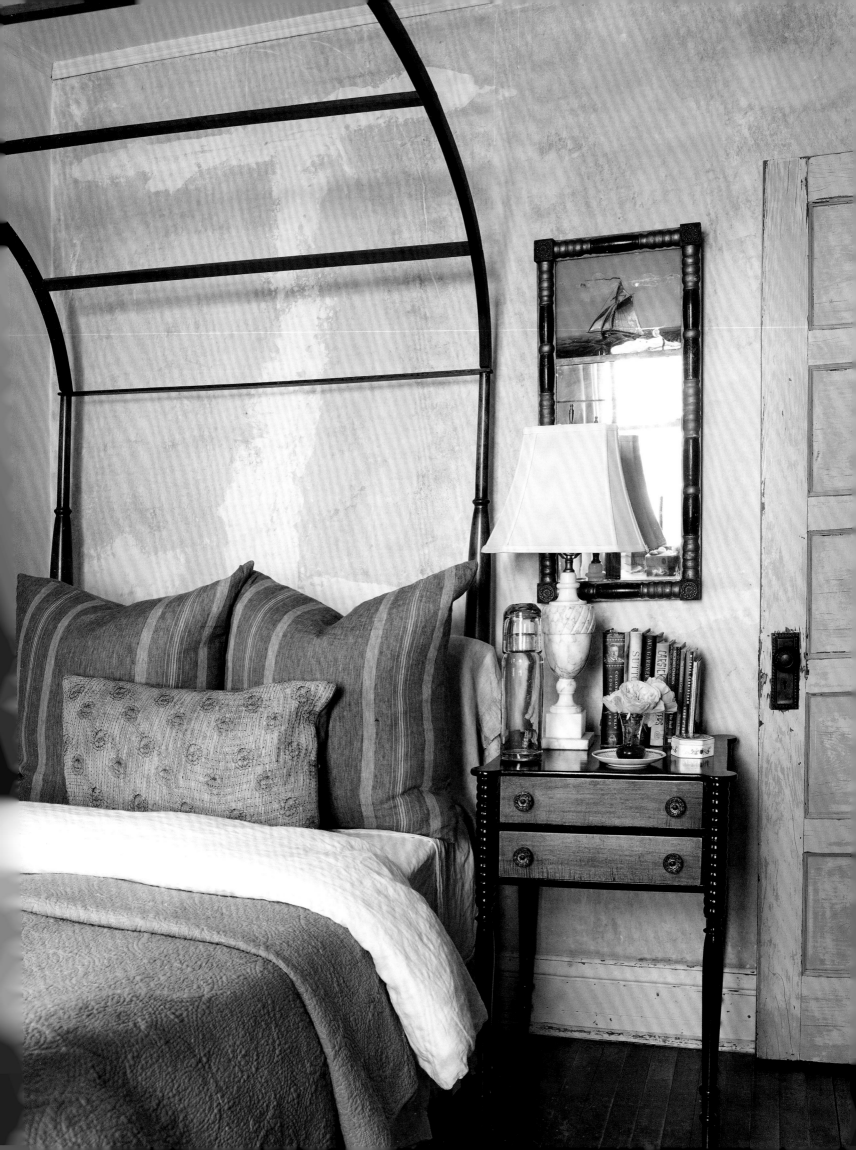

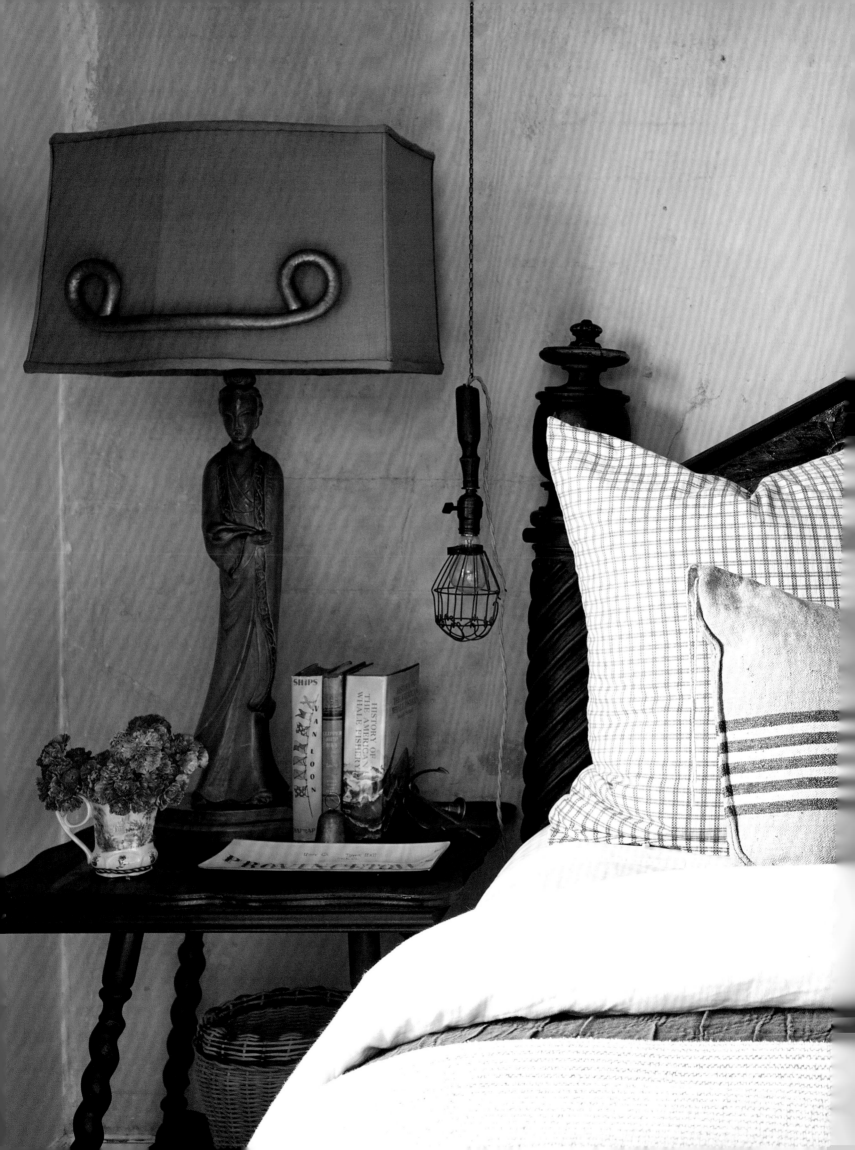

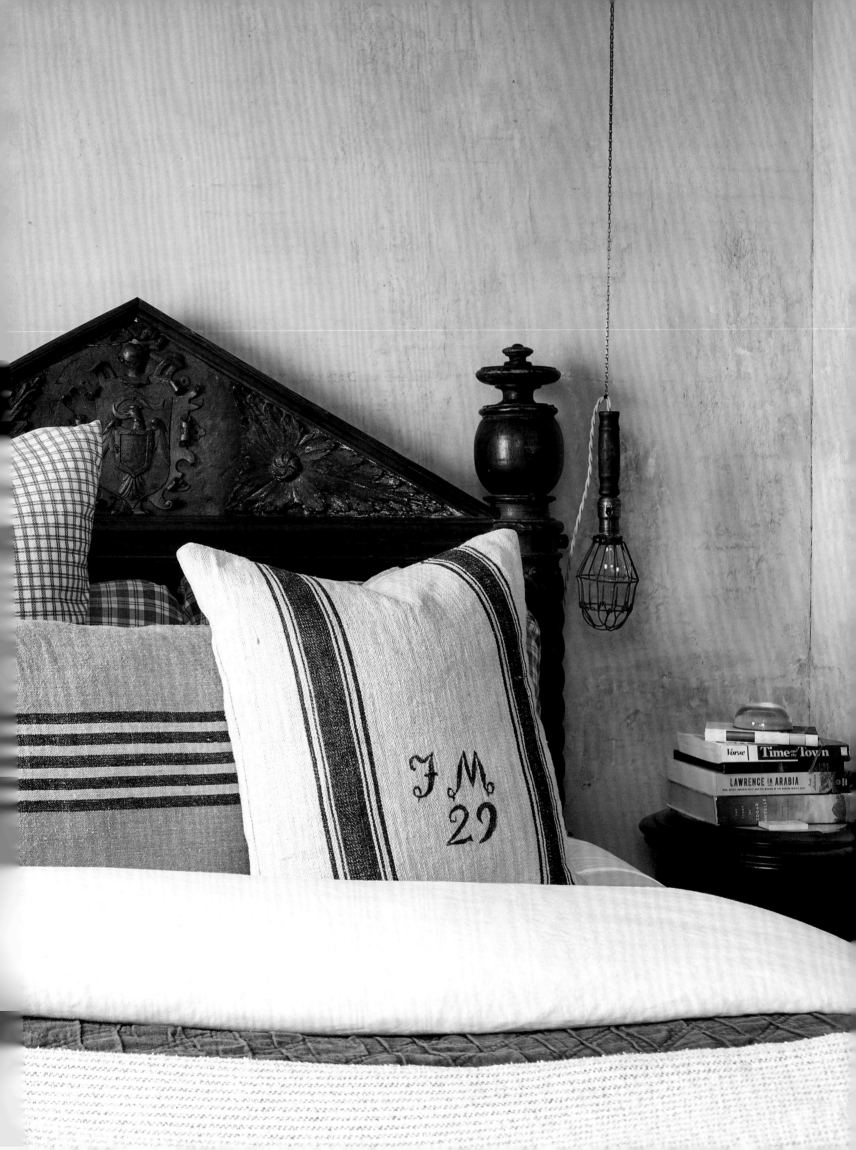

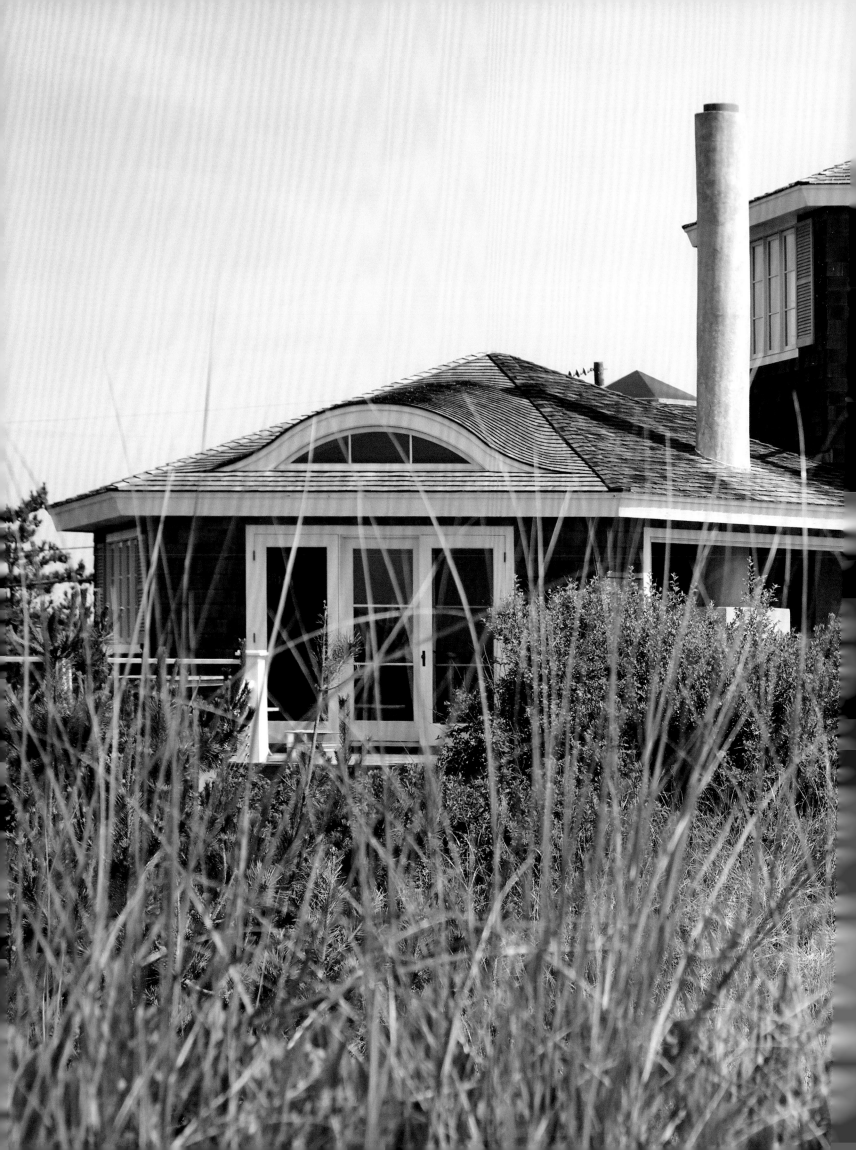

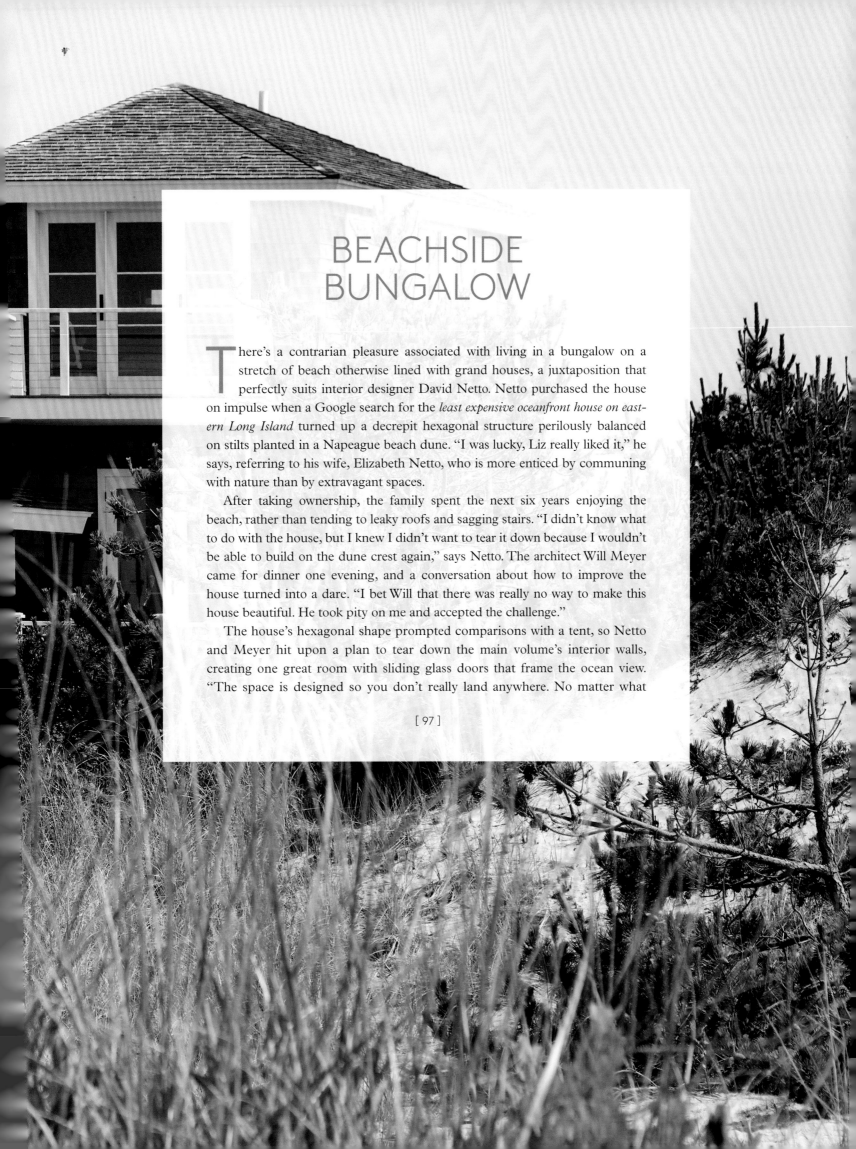

BEACHSIDE
BUNGALOW

There's a contrarian pleasure associated with living in a bungalow on a stretch of beach otherwise lined with grand houses, a juxtaposition that perfectly suits interior designer David Netto. Netto purchased the house on impulse when a Google search for the *least expensive oceanfront house on eastern Long Island* turned up a decrepit hexagonal structure perilously balanced on stilts planted in a Napeague beach dune. "I was lucky, Liz really liked it," he says, referring to his wife, Elizabeth Netto, who is more enticed by communing with nature than by extravagant spaces.

After taking ownership, the family spent the next six years enjoying the beach, rather than tending to leaky roofs and sagging stairs. "I didn't know what to do with the house, but I knew I didn't want to tear it down because I wouldn't be able to build on the dune crest again," says Netto. The architect Will Meyer came for dinner one evening, and a conversation about how to improve the house turned into a dare. "I bet Will that there was really no way to make this house beautiful. He took pity on me and accepted the challenge."

The house's hexagonal shape prompted comparisons with a tent, so Netto and Meyer hit upon a plan to tear down the main volume's interior walls, creating one great room with sliding glass doors that frame the ocean view. "The space is designed so you don't really land anywhere. No matter what

[97]

you put in there, it's very hard to stop anyone from walking toward the ocean," says Netto.

The same level contains a small bedroom wing with enticing color-coded doors. "White for the bathroom and coat closet and three colors for the three bedrooms—left and right are my children's rooms, so they get the fun colors of yellow and orange, and the center is a sort of grown-up blue that leads to the guest room," Netto says.

To access the master bedroom, one passes through Netto's office, also used as a family room. "It's not a big house, so we have to double up when it comes to function. Many people think of this as the TV room, but it's also my office. When I finish something, I just move from the desk to the sofa and reward myself by watching a movie."

The master bedroom sits at the top of the house and has sweeping views of the ocean and Napeague Bay. "You can see weather coming from the bay or the ocean. The house rocks a bit when the wind really gets going. And when a wave pounds ashore, you feel the shock coming up through the pilings."

Despite the house's sublime makeover, the true measure of its success is how well it works for his family. Though everyone has his or her favorite place to escape, it feels completely communal. People come and go freely and no one worries about sitting on this or putting a cup down on that. Thanks to its connection to nature, the family never loses sight that it's a summer house—no more, no less—and the real star of the show remains the beach.

PAGES 96-97 AND OPPOSITE: "The house was built by someone interested in geometry," says interior designer David Netto of his hexagonally shaped beach bungalow. Reimagined with the help of architect Will Meyer, it is tucked into the dunes on Long Island's East End.

PAGES 100-101: Netto and Meyer envisioned the heart of the house as a wooden tent. "I painted the pole purple as a nod to Jean Prouvé. I probably got the idea to wrap it with a rope from the Lobster Inn." The main room is divided into a living area and a dining area. The window behind the fireplace reminds Netto of an aquarium. Whitewashed fir boards are used throughout the house. A Finn Juhl chair sits near the fireplace. The rug is from Hollywood at Home. The dining table, which also serves as a countertop and a crafts and homework surface, was created by putting together two West Elm Parsons tables.

PAGES 102-3: Netto embraced the hexagonal shape of his office by installing a boomerang-shaped sofa from Vioski in L.A., covered in a Jennifer Shorto fabric. "Entire

days go by when I'm on the phone and don't go outside to the beach—and it really is a wonderful place to write." An artwork by Konstantin Kakanias rests in front of a self-portrait by Netto's daughter Madelyn.

PAGE 104: "I was working on a project with [interior designer] Jacques Grange and he said, 'David, I think your desk is by Dupré-Lafon.' I was in my twenties and had just bought it from a great dealer in New York called Robert Altman. I knew it wasn't, but Jacques' saying that made me feel very good, I must say. It took me years to figure out that the desk is by Maxime Old." Purchased in 1997, it has been in every apartment he lived in before landing here, where it's used as a desk and as a catchall for children's drawings, model boats, wooden obelisks, and Jimmy Marble's banner *Time Cools All Jets*. The wall lamp is by Atelier de Troupe.

PAGE 105: An Arne Jacobsen chair, which Netto purchased at auction in Stockholm, pulls up to a Prouvé Granito table in his office. The Rose Tarlow fish was a gift from his staff. The lamp is from Wyeth.

PAGE 106: A root console from ABC Carpet & Home sets the tone of the house in the entrance hall. A work by Tony Caramanico rests on the console behind a watercolor by Madelyn Netto.

PAGE 107: In the bedroom hallway, a Simon Pearce sculpture sits on a table from West Elm. Netto painted the bedroom doors in punchy colors: orange and yellow for his daughters, Kate and Madelyn, blue for the guest room. "I still remember the phone call my younger daughter, Madelyn, made to her sister, Kate, when she saw the house for the first time: 'Kate! You have an orange door, and I have a yellow door!' Success!"

PAGES 108-9: The master bedroom is like a separate villa on top of the house. The bathtub, located right in the room to take maximum advantage of the view, mixes with a Louis XV chair from Gerald Bland, an Alexandre Noll sculpture, and a Charlotte Perriand table and chair.

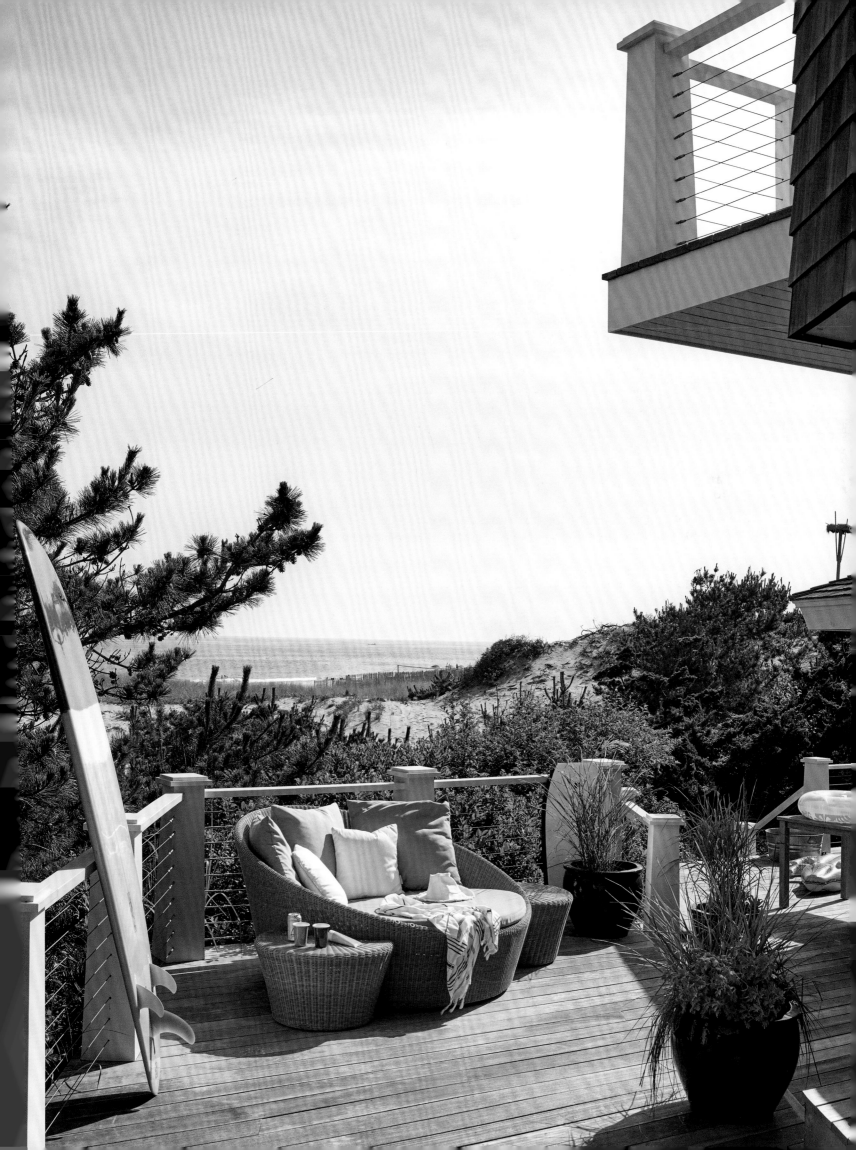

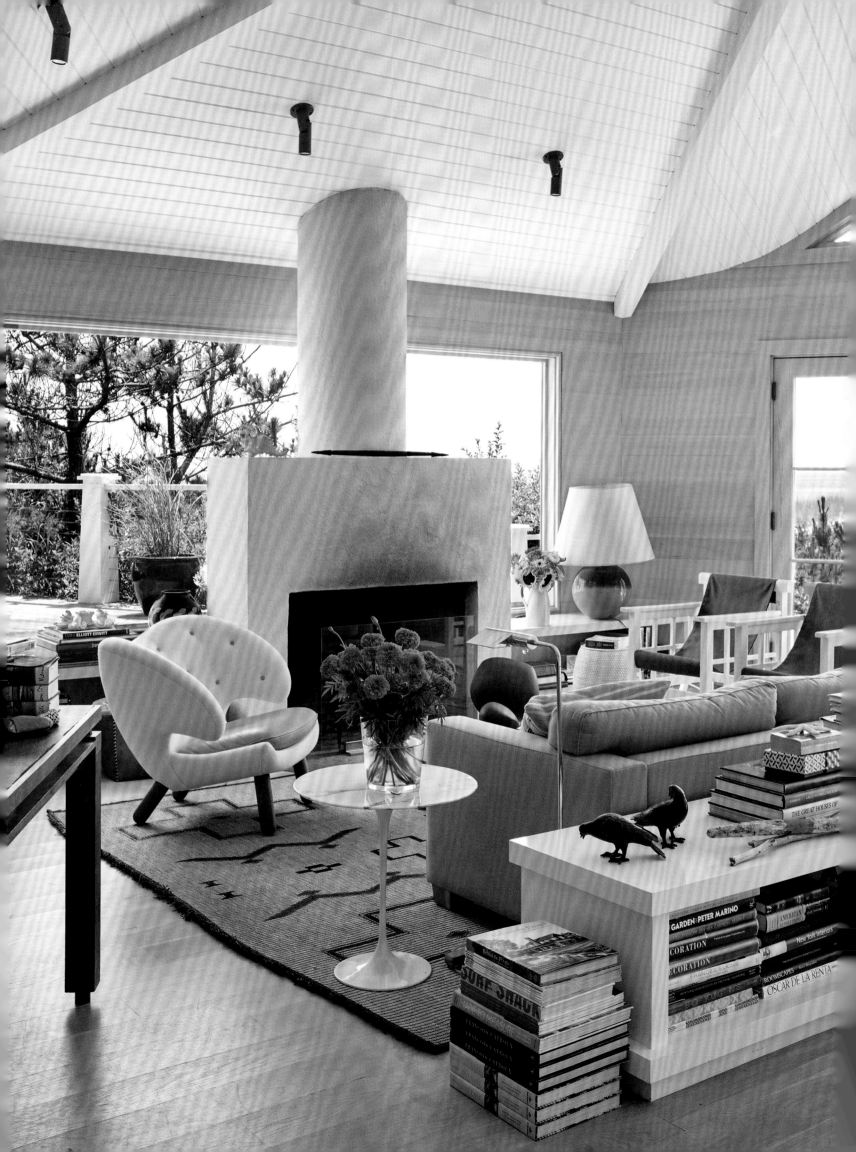

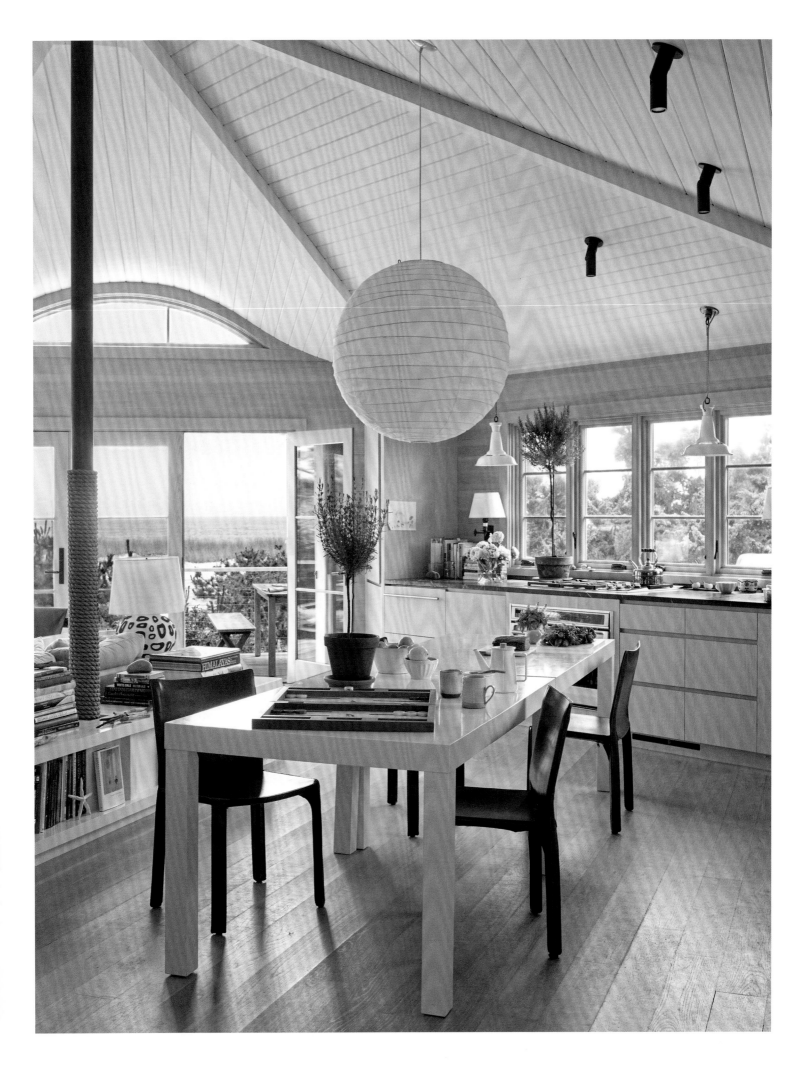

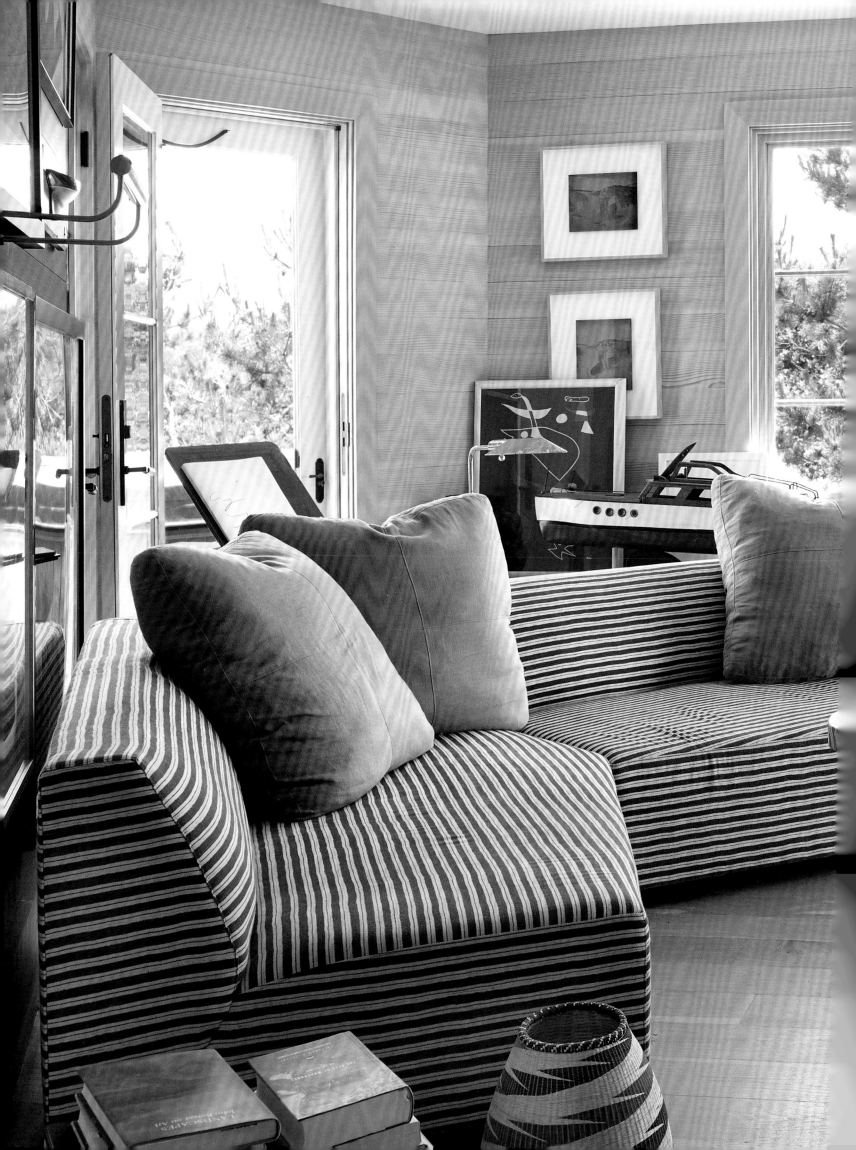

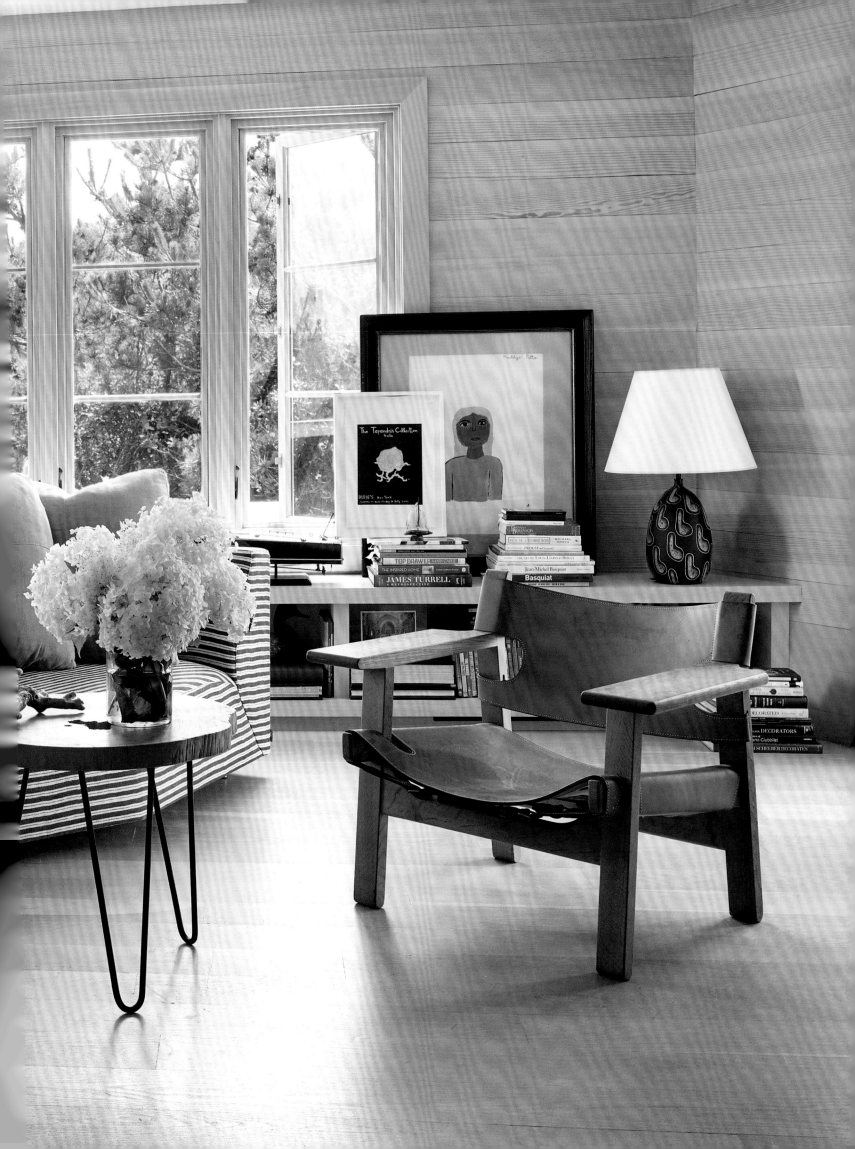

The Terendris Collection
BIBIE'S New York

TOP DRAWER
THE INSPIRED HOME
JAMES TURRELL
A RETROSPECTIVE

Basquiat

Jean-Michel Basquiat

DECORATED

DECORATORS

SCHEERER DECORATES

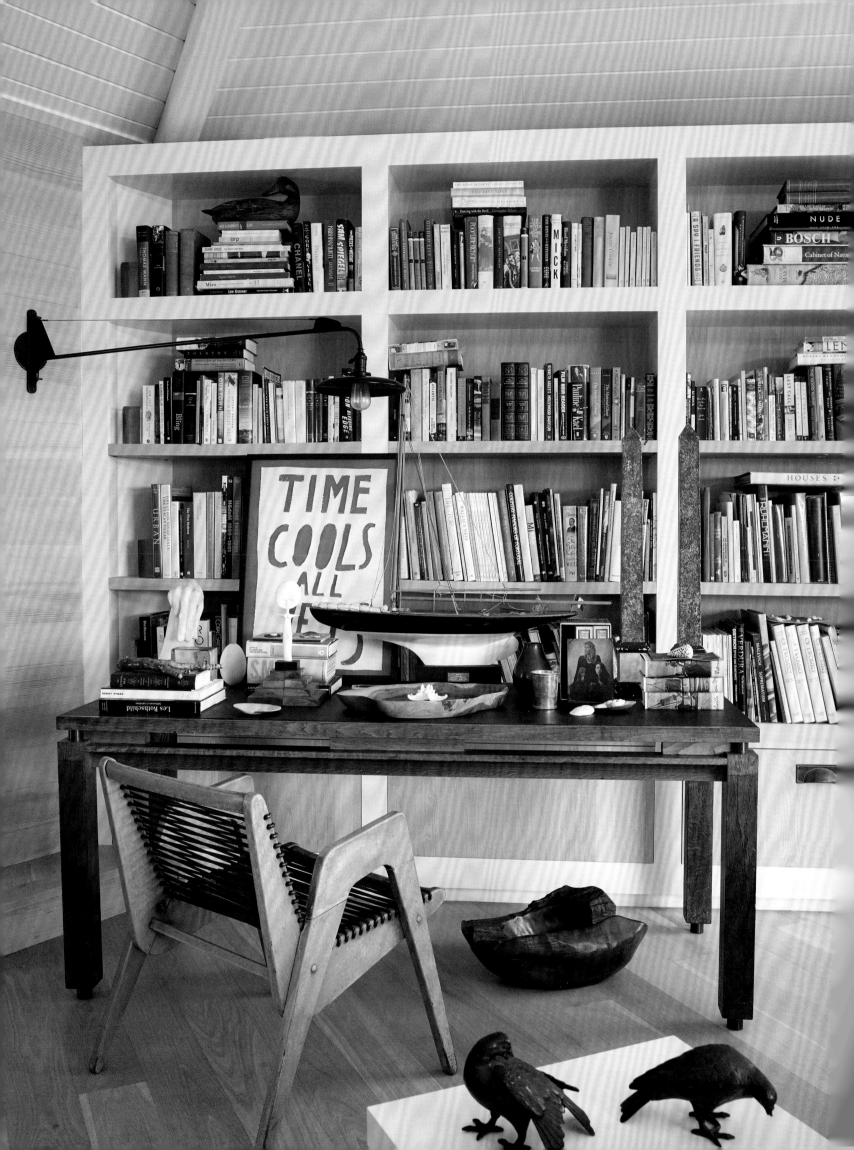

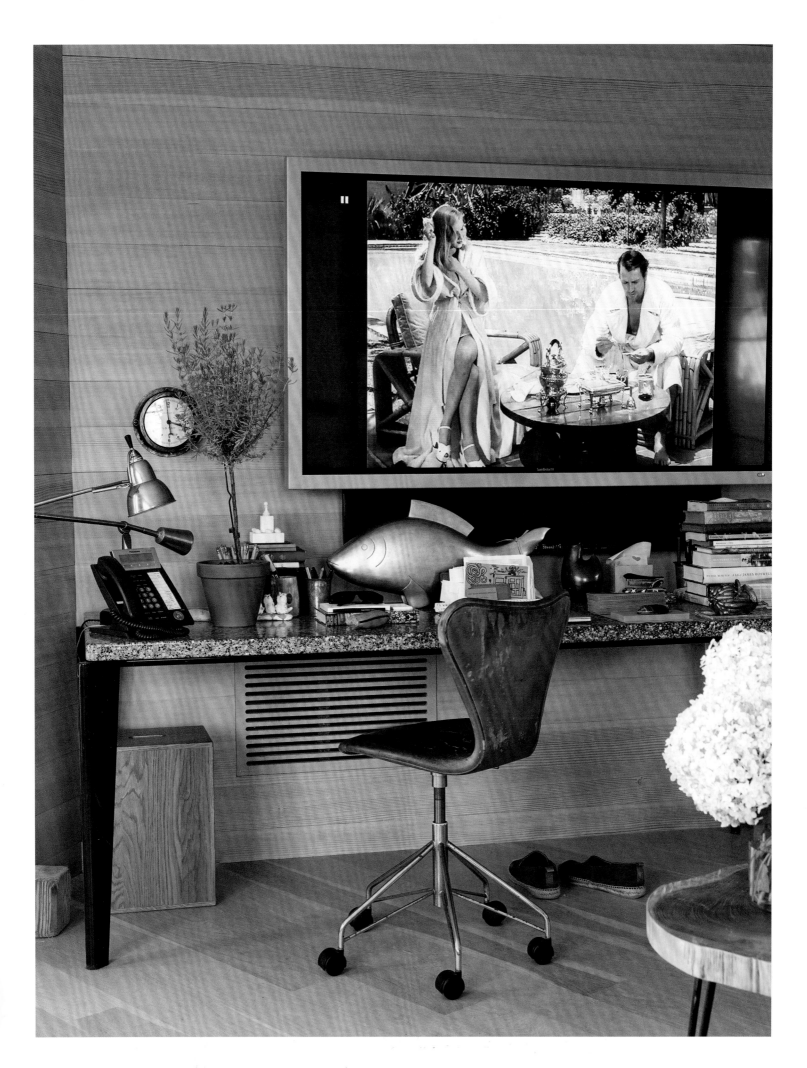

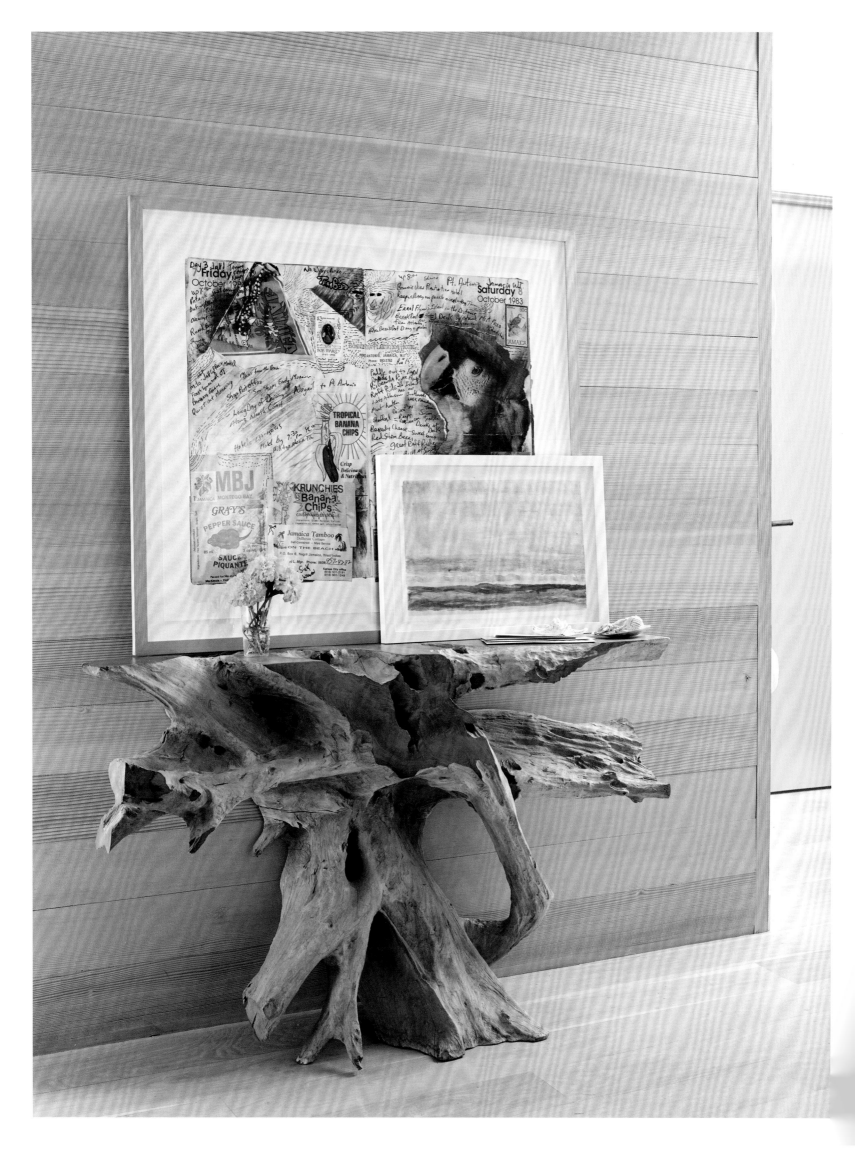

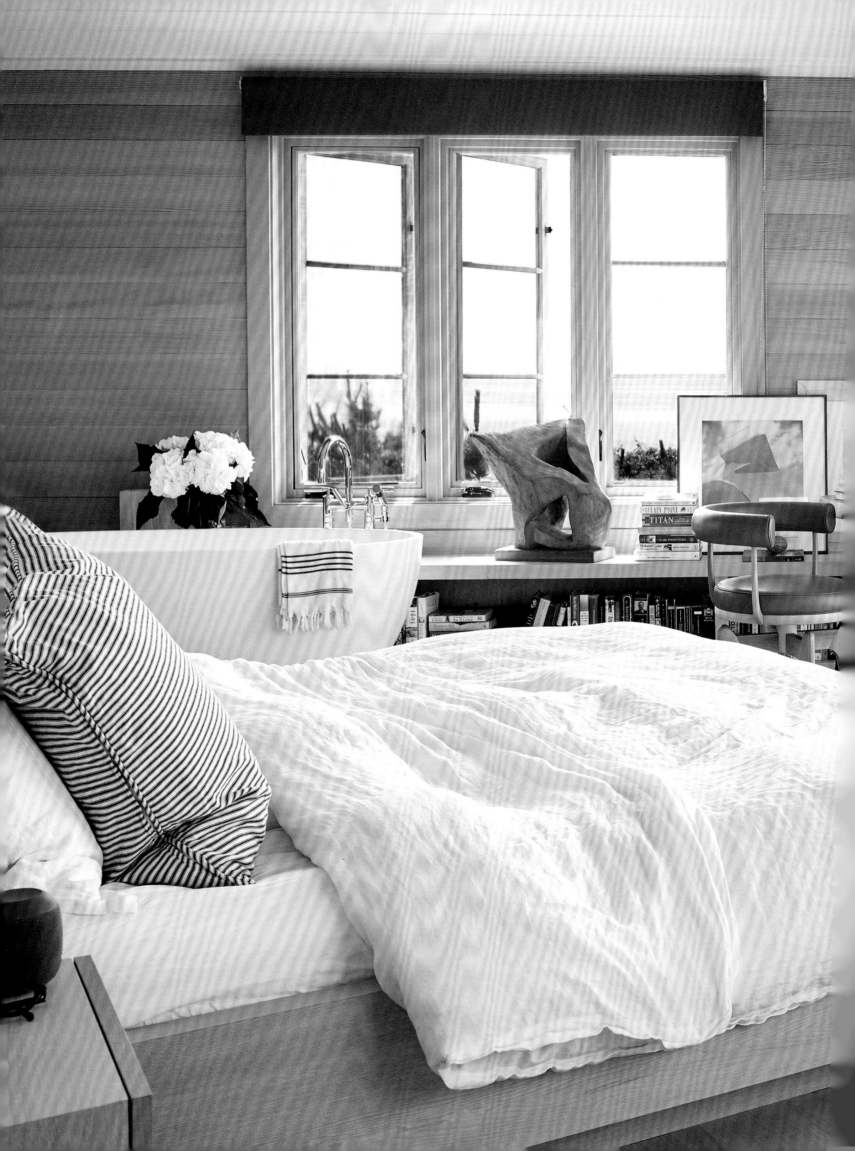

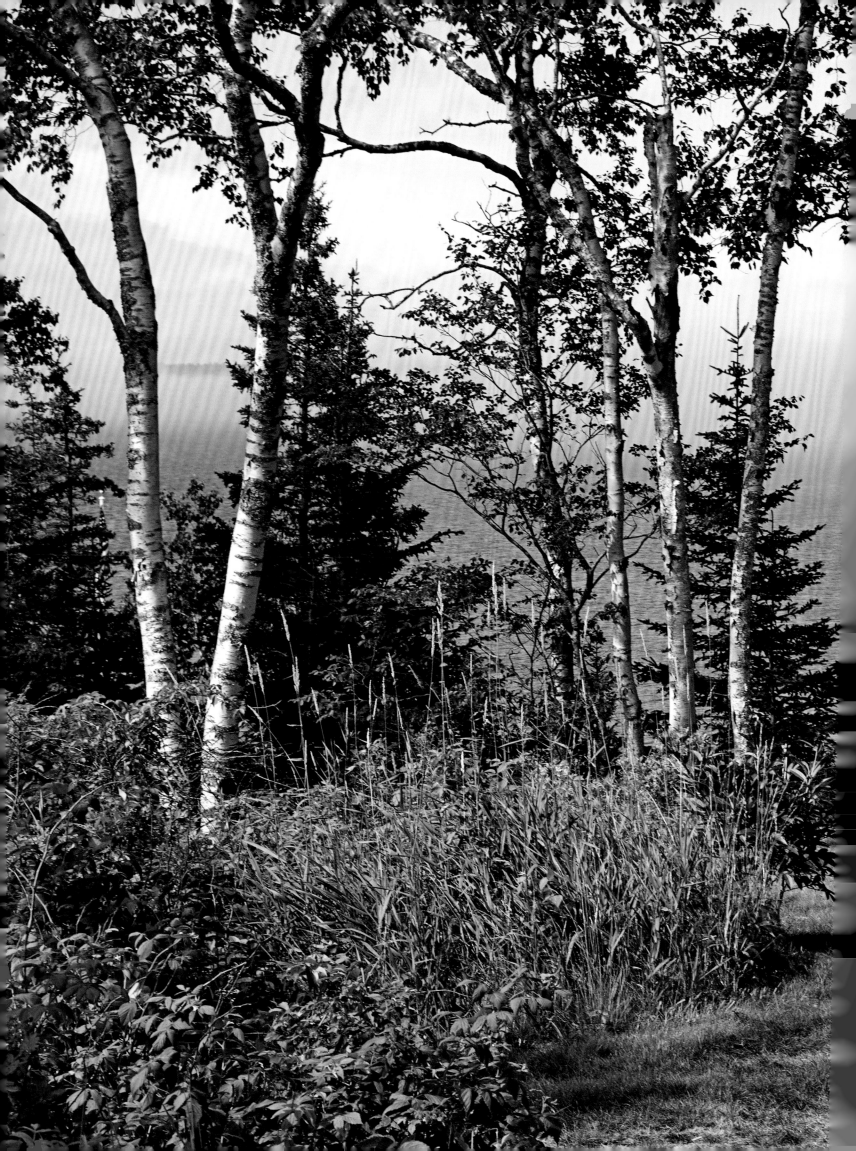

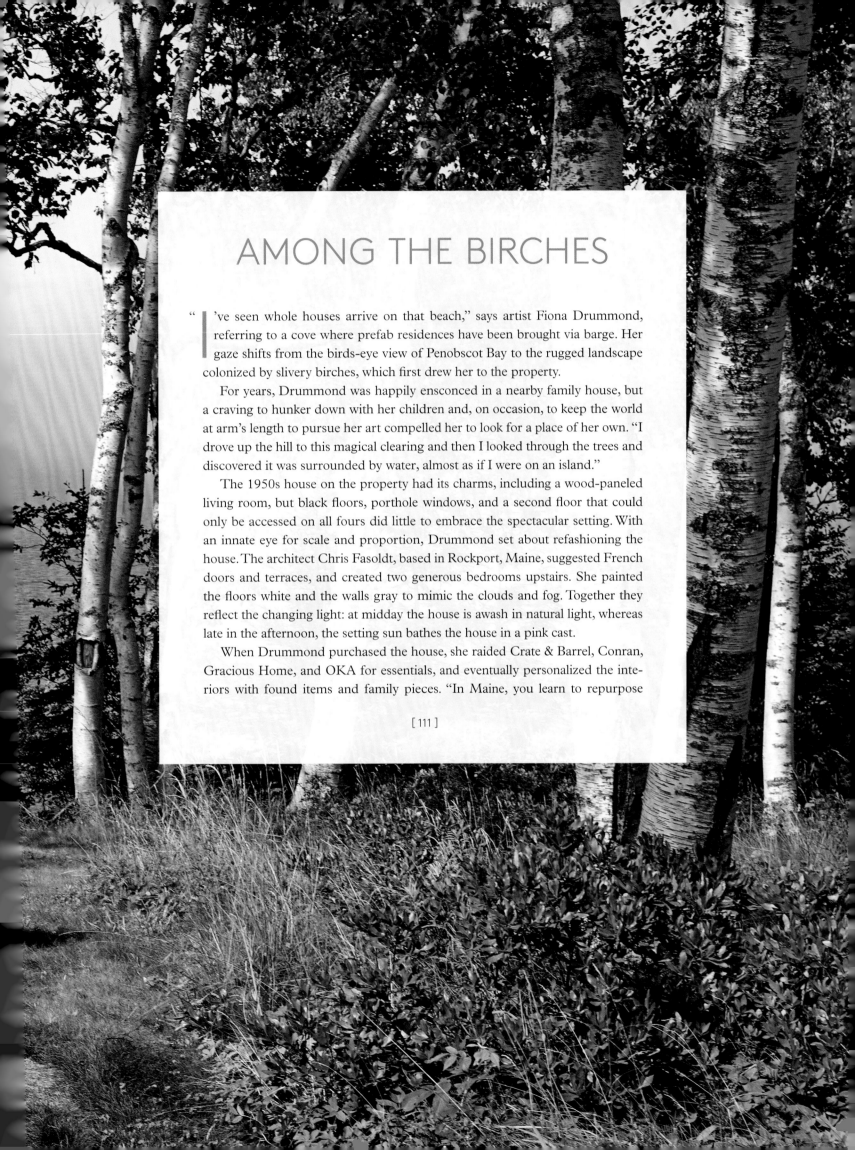

AMONG THE BIRCHES

" I 've seen whole houses arrive on that beach," says artist Fiona Drummond, referring to a cove where prefab residences have been brought via barge. Her gaze shifts from the birds-eye view of Penobscot Bay to the rugged landscape colonized by slivery birches, which first drew her to the property.

For years, Drummond was happily ensconced in a nearby family house, but a craving to hunker down with her children and, on occasion, to keep the world at arm's length to pursue her art compelled her to look for a place of her own. "I drove up the hill to this magical clearing and then I looked through the trees and discovered it was surrounded by water, almost as if I were on an island."

The 1950s house on the property had its charms, including a wood-paneled living room, but black floors, porthole windows, and a second floor that could only be accessed on all fours did little to embrace the spectacular setting. With an innate eye for scale and proportion, Drummond set about refashioning the house. The architect Chris Fasoldt, based in Rockport, Maine, suggested French doors and terraces, and created two generous bedrooms upstairs. She painted the floors white and the walls gray to mimic the clouds and fog. Together they reflect the changing light: at midday the house is awash in natural light, whereas late in the afternoon, the setting sun bathes the house in a pink cast.

When Drummond purchased the house, she raided Crate & Barrel, Conran, Gracious Home, and OKA for essentials, and eventually personalized the interiors with found items and family pieces. "In Maine, you learn to repurpose

[111]

objects from the attic and to make use of what you find," says Drummond. A favorite suzani became the inspiration for the dining room curtains and the table is set with Rothschild Bird china from her mother and her grandmother. "I convinced my brother he did not need it."

Drummond leads us down a steep slope to the dock at low tide to see her pride and joy, *Moxie*, a 1973 "lobster yacht" built by Jarvis Newman with a Raymond Hunt hull, which she uses to pick up friends from Bangor and to go to the farmer's market in Belfast. "My grandmother's family were very keen sailors," says Drummond, who remembers overnight trips to outer islands spent collecting rocks, which were heated and used to cook steaks, and dining on cucumber sandwiches, deviled eggs, and millionaire's bacon (bacon cooked with brown sugar on top).

When I ask to see Drummond's most recent addition, a freestanding studio designed by her friend Martha Coolidge, a residential and marine architect, Drummond, characteristically modest about her work, demurs but eventually acquiesces. The moment the doors swing open, her artistic gift is immediately apparent. There is a rendering of an implausibly lifelike braid of hair as well as a series of paintings that explore shadows and glow in the dark—works that must take hours of monk-like concentration. Through the window, the papery trunks of her beloved birches absorb the sunset's pink glow. "These trees remind me of my favorite Russian novels, *Anna Karenina*, *War and Peace*, *Dr. Zhivago* . . . and they are present in Russian paintings too," Drummond muses as we walk back to the main house, taking in the natural beauty of a rarefied refuge.

PAGES 110–11: A house in Maine overlooks Cape Rosier to the east, Castine to the northeast, and many islands, including North Haven, to the south. Fiona Drummond first fell in love with the property's silvery birches, especially the way the papery white bark absorbs a pinkish tint at sunset. There are also oaks, spruce, bayberry, and *Rosa rugosa*.

OPPOSITE: Drummond's beloved dog, Bob, a mix of Lab, Shar-Pei, and Cocker Spaniel, who was found in Courchevel, France, sits at the bottom of the stairs. Hanging in the stairwell is a painting by Mikhail Pavlovich Trufanov of a worker in Leningrad.

PAGE 114: A watercolor of wetlands and birds in the living room belonged to Drummond's grandmother in South Carolina. As a child, Drummond would stand on the sofa to examine the brushstrokes; she credits the painting for her love of watercolors as a medium.

PAGE 115: Chairs by Sister Parish in collaboration with OKA are covered with a fabric called Campobello, named for a

nearby island. The sofa is from Crate & Barrel. Some of the pillows are covered in Drummond's favorite fabric, Schumacher's Botanical Fern. The rug is an Ashley Hicks revisiting of a David Hicks pattern for Stark. The original version covered floors in Drummond's childhood house in the U.K. David Hicks designed a house for Drummond's mother in Paris.

PAGES 116–117: A piece of colored and mirrored Plexiglas hangs above the fireplace in the dining room. Over the console table is one of Drummond's photos of the point just as a huge storm was about to hit. The fabric for the curtains and the cushions for some of the dining room chairs is from OKA and was inspired by a favorite suzani. The console is part of a set from Drummond's previous houses. "When I transitioned the pieces to summer weather and a clapboard cottage in Maine, I simply borrowed from Sister Parish and painted the brown furniture white. It looks kind of skeletal and light—I love that."

PAGE 118: The wood-paneled master bedroom features a balcony that overlooks the bay.

PAGE 119: The wallpaper in the guest room is from Sister Parish Design. The pattern, called Albert, was designed by Albert Hadley. The white nineteenth-century Gothic-style chairs were an impulse buy from the London dealer Rendlesham, who had an amazing shop on the Kings Road in the 1980s.

PAGES 120–21: The drawing resting against the studio wall is one of a series called *Conflation*. This one, in charcoal and pencil on paper, is titled *Troubled Radiance*. Whereas Drummond's photographs deal with the ephemerality of time, her drawings illustrate the craft and time involved in creating an image. "In the photographs, the idea is to accept the limitations of author as subject matter while attempting to compose some sort of clear image. The drawings, on the other hand, speak of authorship in every stroke of the pencil and hand. The resulting image is the opposite of clarity and is a testament to confusion." Drummond also does commissioned paintings of dogs and other animals in a photorealist style that places the subject in familiar surroundings. The sawhorses are from Home Depot.

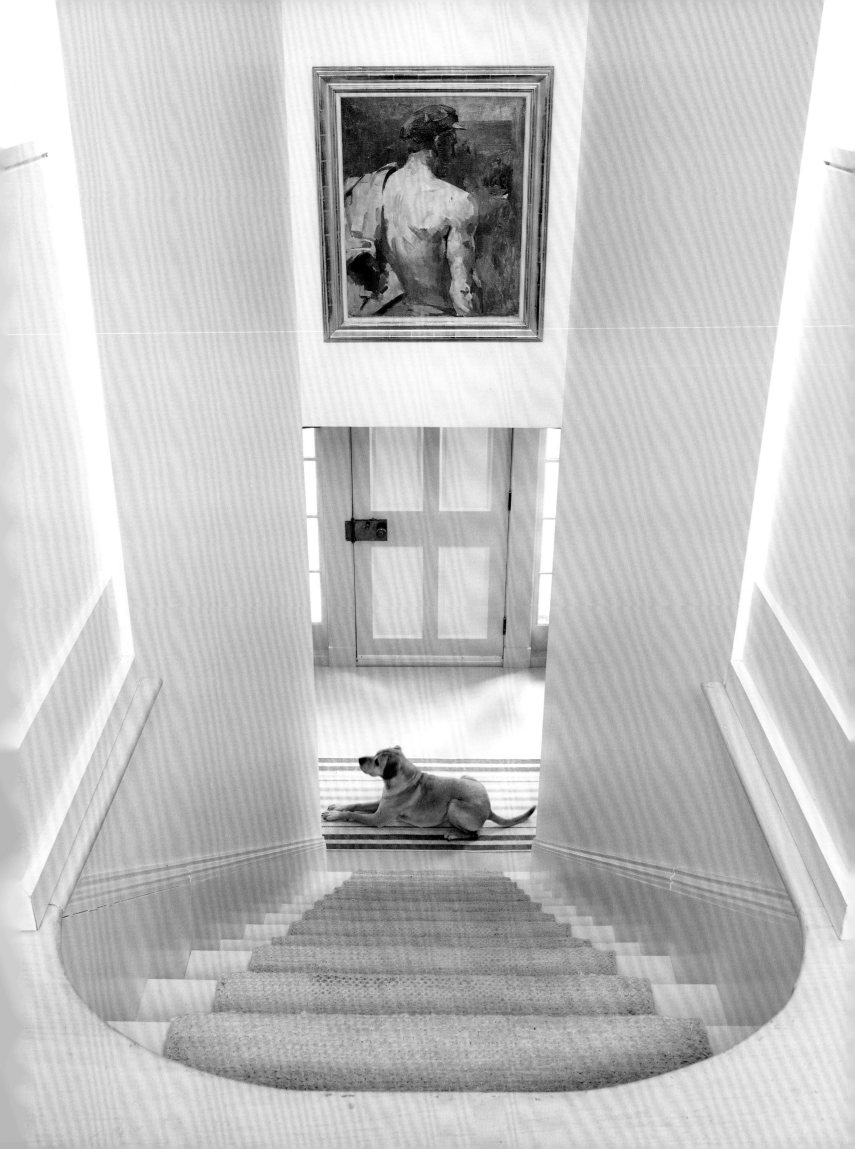

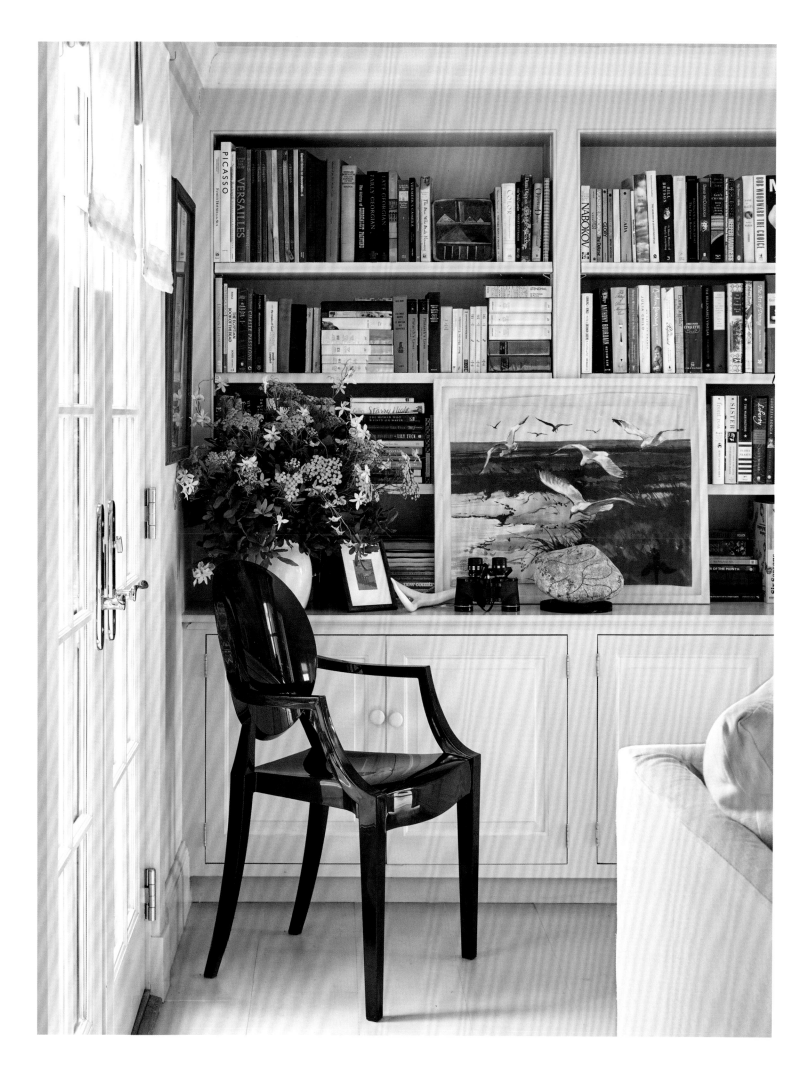

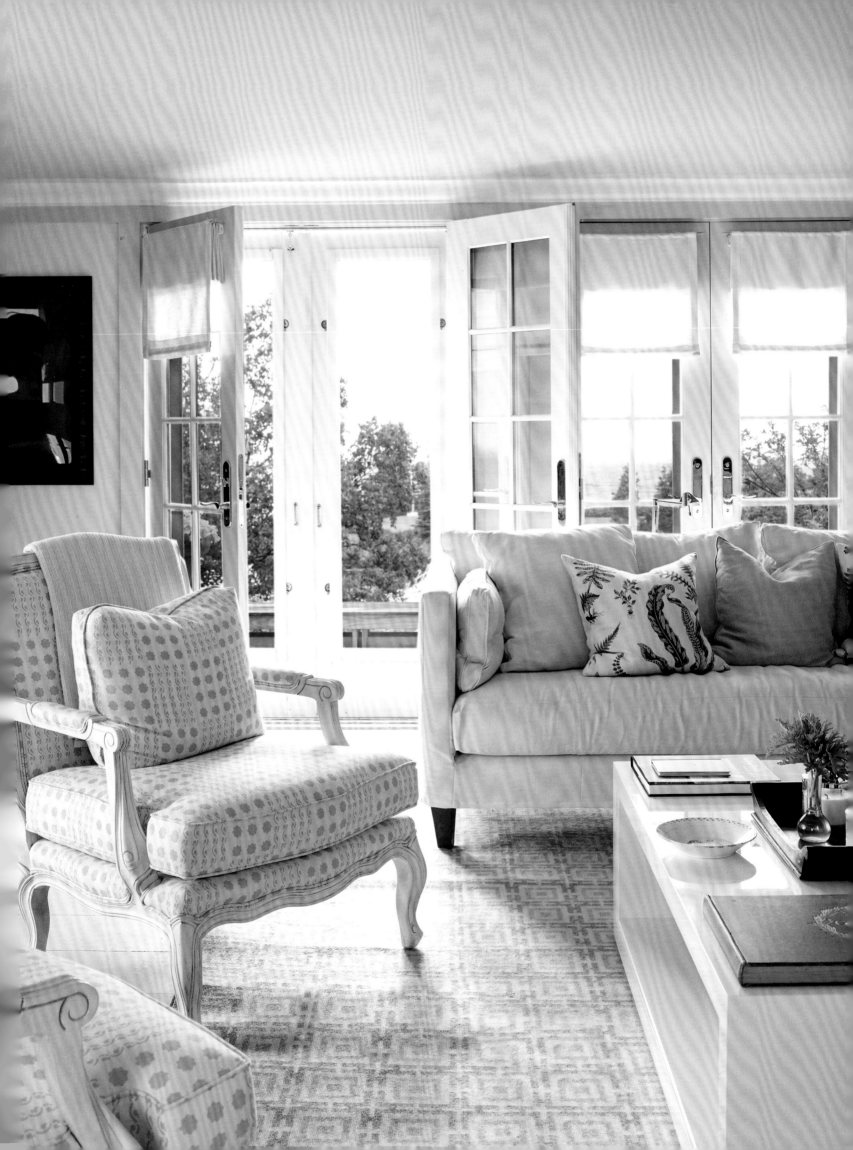

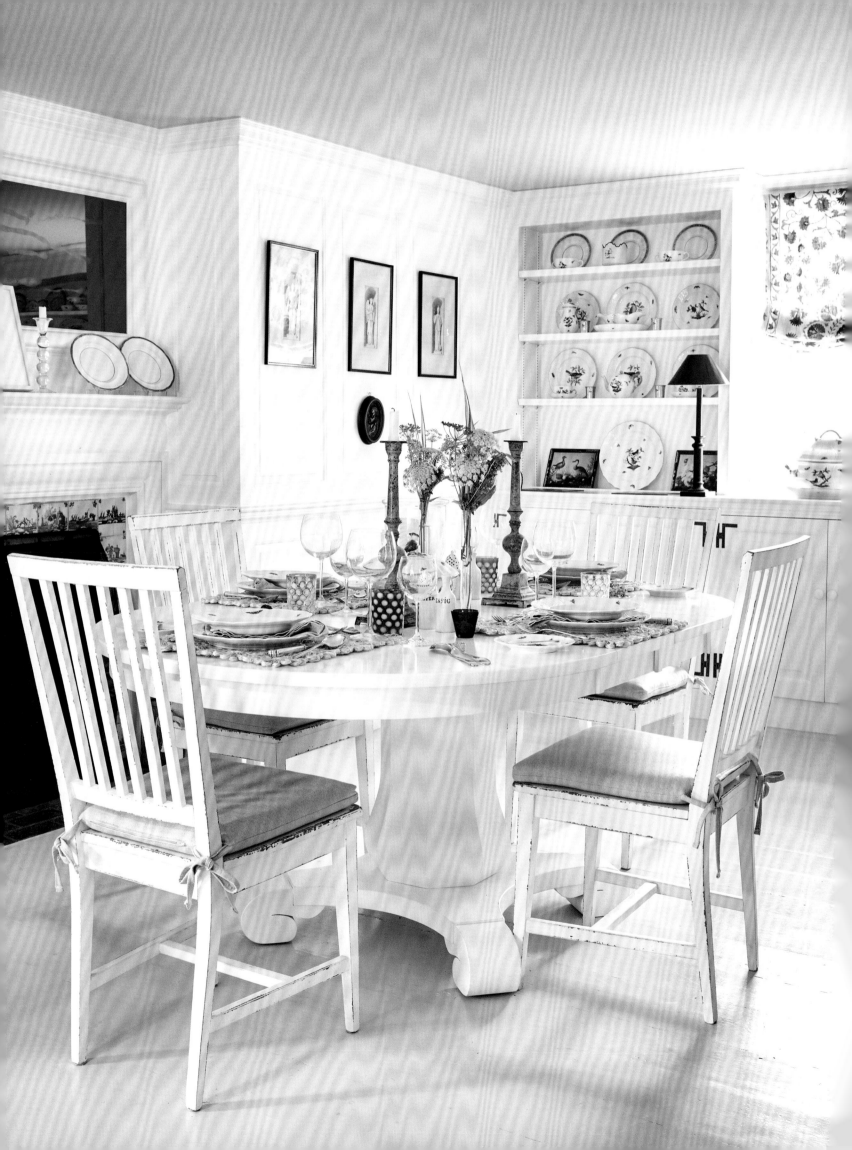

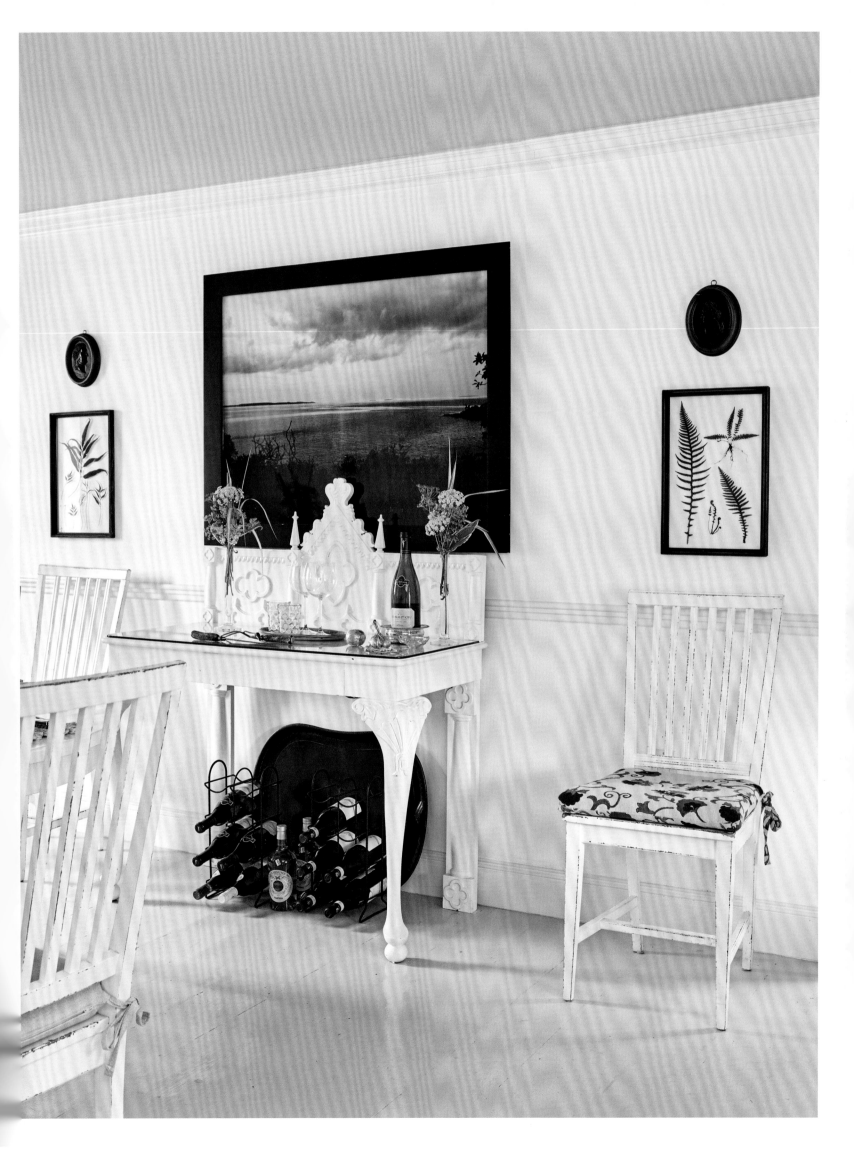

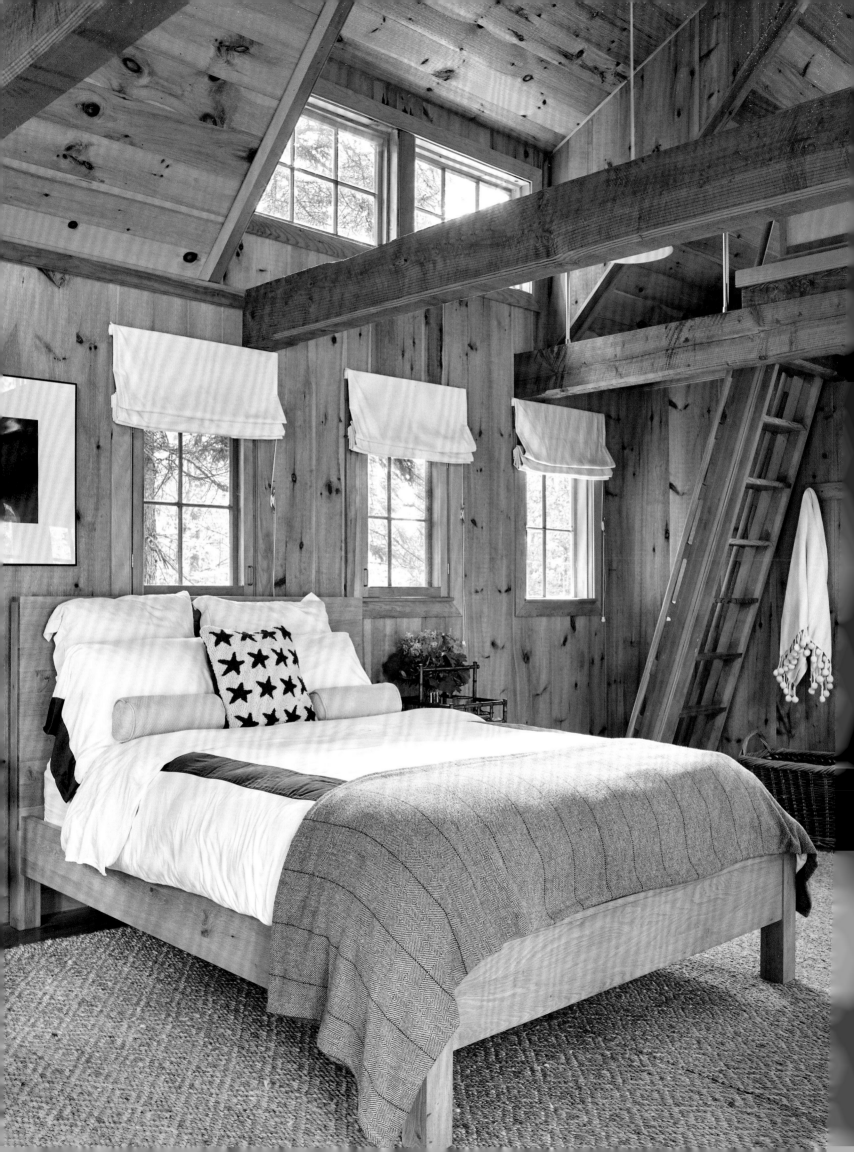

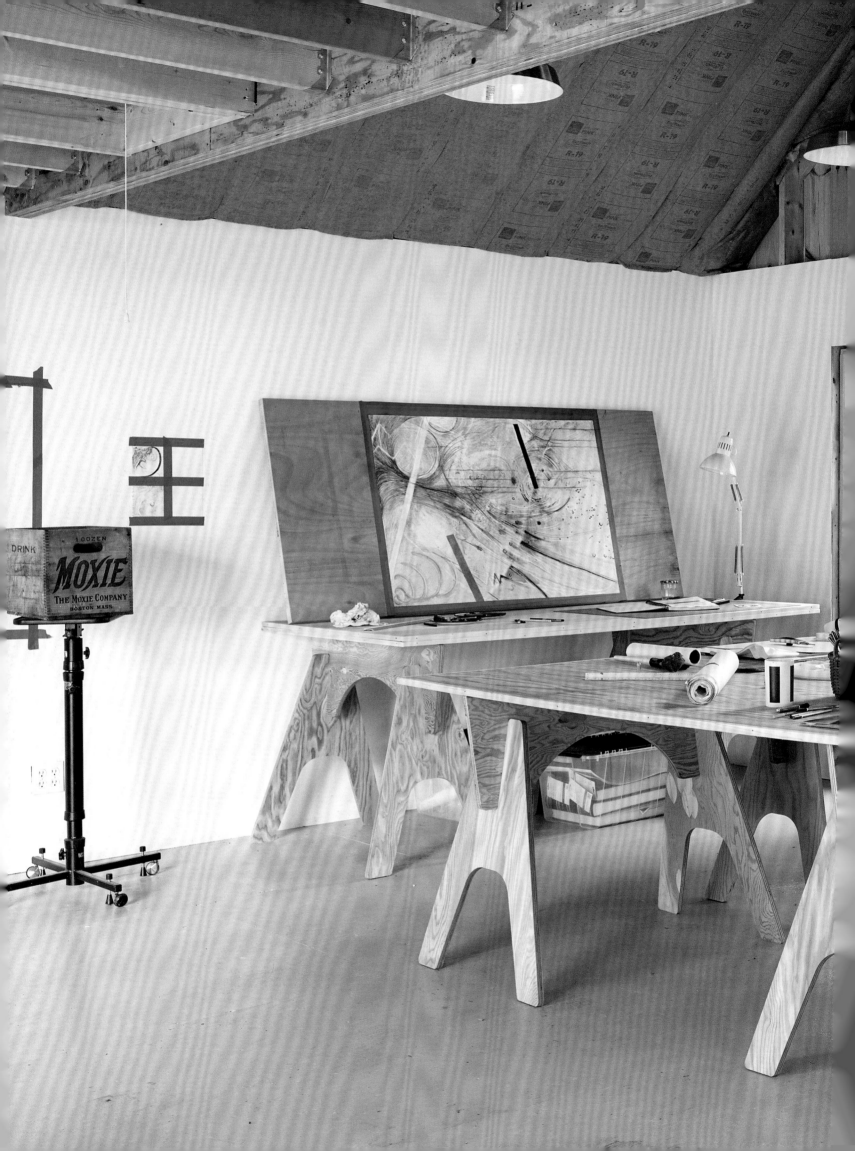

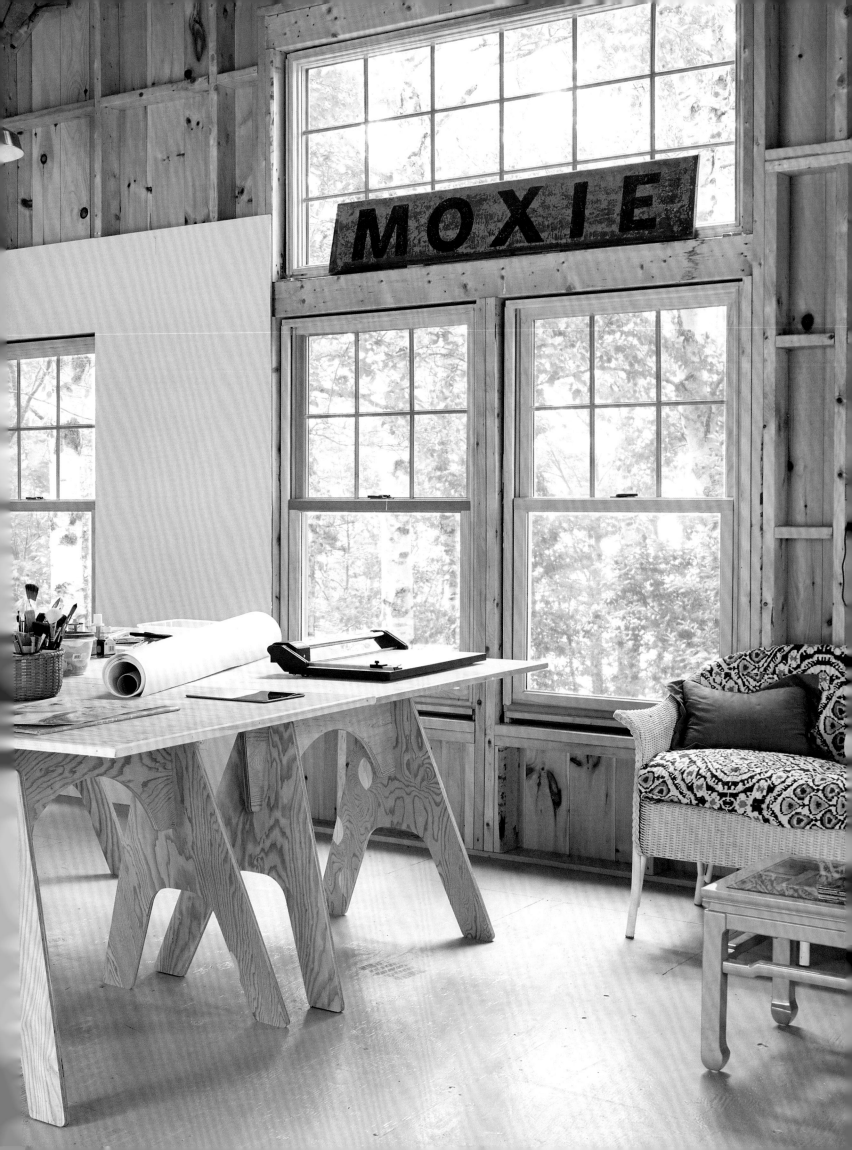

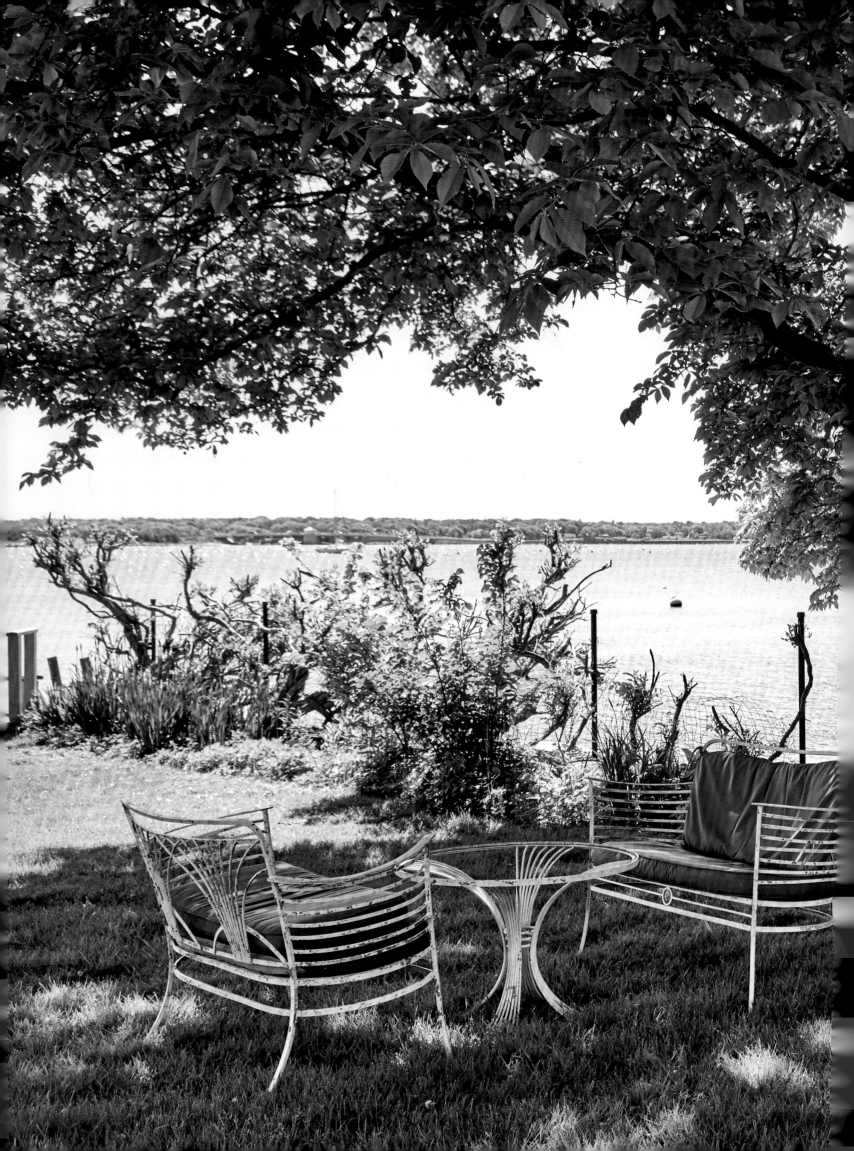

COTTAGES

In the context of summer houses, the term *cottage* has little to do with size. Rather, it implies a cozy intimacy in contrast to the grandeur and expansiveness of the surrounding landscape. Cottage interiors have traditionally included an assortment of painted wicker, cotton chintzes, floral wallpaper, and quirky treasures, the whole of which is greater than the sum of its parts. But whatever the décor, the result is always as original as it is striking.

The cottages on these pages range from a former boathouse—docking bays literally reach into the dining room—that was thoughtfully transformed into an inviting summer house with plenty of space for grandchildren, to a writer's rambling Cape and a painter's art- and antiques-filled, lovingly restored Greek Revival. A Block Island Victorian farmhouse was gently renovated by a creative collective of friends who spent their weekends scraping, hammering, and painting. Each of these cottages possesses the elusive patina that can be achieved only when a house has evolved over time.

WRITER'S COTTAGE

In the 1950s, American literature's first couple, William and Rose Styron, traveled to Martha's Vineyard at the invitation of William's editor, Hiram Haydn, who was alarmed to learn that they summered on nearby Nantucket, considered by some to be far more conservative than Martha's Vineyard. The couple dutifully arrived at the ferry landing with their two-year-old daughter, Sally, in tow. Haydn was nowhere to be found, but *Little Foxes* author Lillian Hellman was chasing her errant black poodle down the dock. Although Hellman had never

formally met the Styrons, she had attended their Roman wedding as a guest of author Irwin Shaw and recognized them immediately. She corralled the Styrons, taking them to her house, where her partner, Dashiell Hammett, author of *The Maltese Falcon* and *The Thin Man*, was on the front porch soaking up the sun. Hellman convinced the Styrons to decamp to Martha's Vineyard permanently before calling Haydn to retrieve his guests. The auspicious introduction set the tone for the Styrons' lifelong love affair with the island.

Bill and Rose, as everyone knew them, happily rented for years until 1965, when Rose learned that a rambling waterfront cottage she had long admired was coming up for sale. It was full of charming quirks: the entrance hall opened directly into the kitchen; the staircase was in the dining room. To buy the place, they had to borrow some money from her family. "Bill had another book coming out soon, so I thought we would be able to pay my family back." Of course, Styron went on to publish such bestsellers as *The Confessions of Nat Turner*, for which he won the Pulitzer Prize, and *Sophie's Choice*, winner of the National Book Award.

From the moment the Styrons moved in, the place was thronged with intelligentsia: Walter Cronkite, Art Buchwald, Mike Wallace, Leonard Bernstein, Mike Nichols, Lionel Trilling, Katherine Graham, and Gloria Steinem all visited, as did Gabriel García Márquez, Philip Roth, and Bill and Hillary Clinton. When Jackie Kennedy brought Caroline and John-John to stay, John-John's rabbit disappeared down a yawning hole in the bedroom floorboards; while the Secret Service detail rescued the pet, John-John went missing at the beach.

Styron tells these stories sitting on the porch overlooking Vineyard Sound in a wet swimsuit and robe, having just emerged from one of her twice-daily swims in the sound. A yellow pad is scribbled with the beginnings of a memoir, "It's very different, much more personal than what I usually write."

Two lanky, shirtless teenage boys run across the lawn, disappearing around a hedge. "I have eight grandchildren," she says with pride. "They hang out in Bill's old writing shack. It used to have 'Verboten' written on the door, so Bill wouldn't be disturbed. Now it's the local teen center."

PAGES 122–23 AND OPPOSITE: Rose Styron's summer cottage overlooks Vineyard Sound, where she swims daily. During the summer, the porch serves as her outdoor office.

PAGE 126: In her book-lined office, Rose's award-winning volumes of poetry, including *From Summer to Summer* (1965), *Thieves' Afternoon* (1973), and *By Vineyard Light* (1995), her daughter Alexandra's critically acclaimed memoir, *Reading My Father*, and an array of family photos have pride of place.

PAGE 127, CLOCKWISE FROM TOP LEFT: A signed poster by the late columnist Art Buchwald, a dear friend of the Styrons; a photograph of the literary first couple; a selection of books scattered on Rose's desk, including one inscribed by Philip Roth; a globe commemorating her work as director of Amnesty International's National Advisory Council.

PAGE 128: Friends come by weekly to play Scrabble, "although there's always someone bowing out for work or travel," says Rose.

PAGE 129: The dining room opens to the porch, her dog Billy's favorite nap spot.

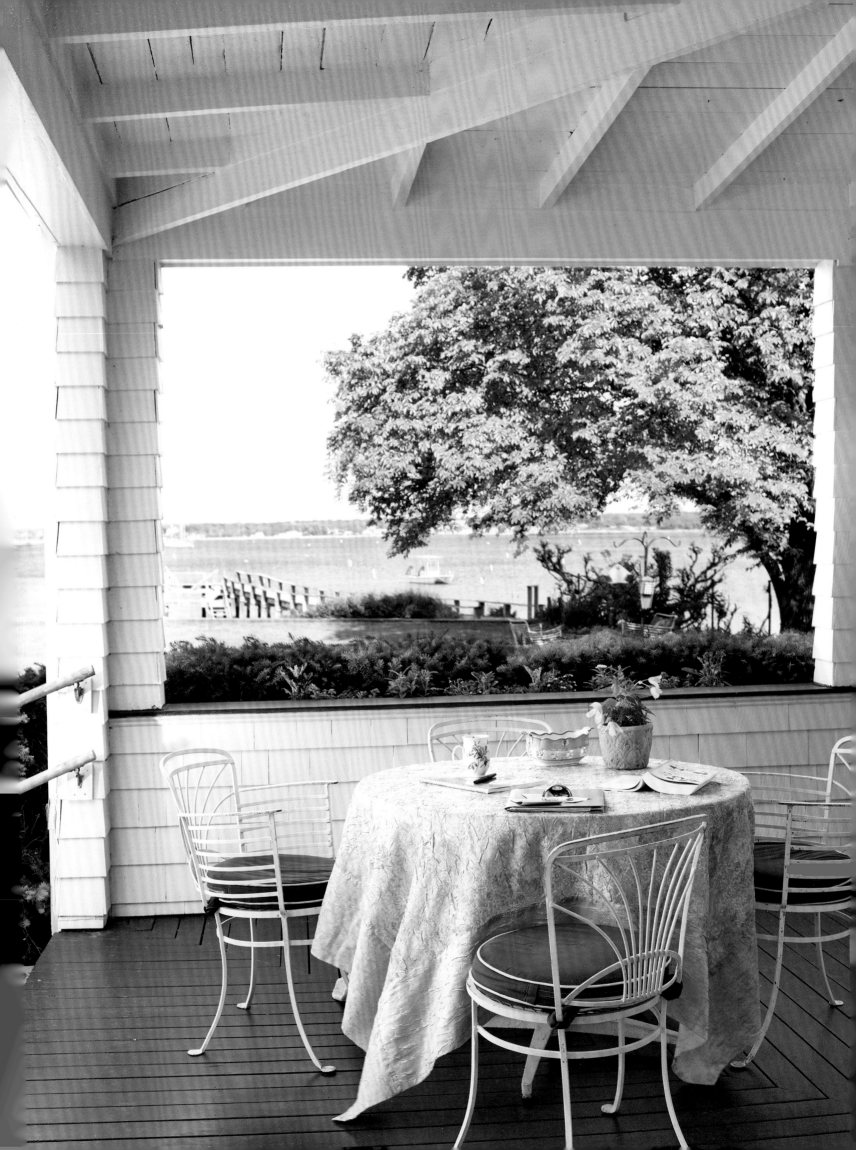

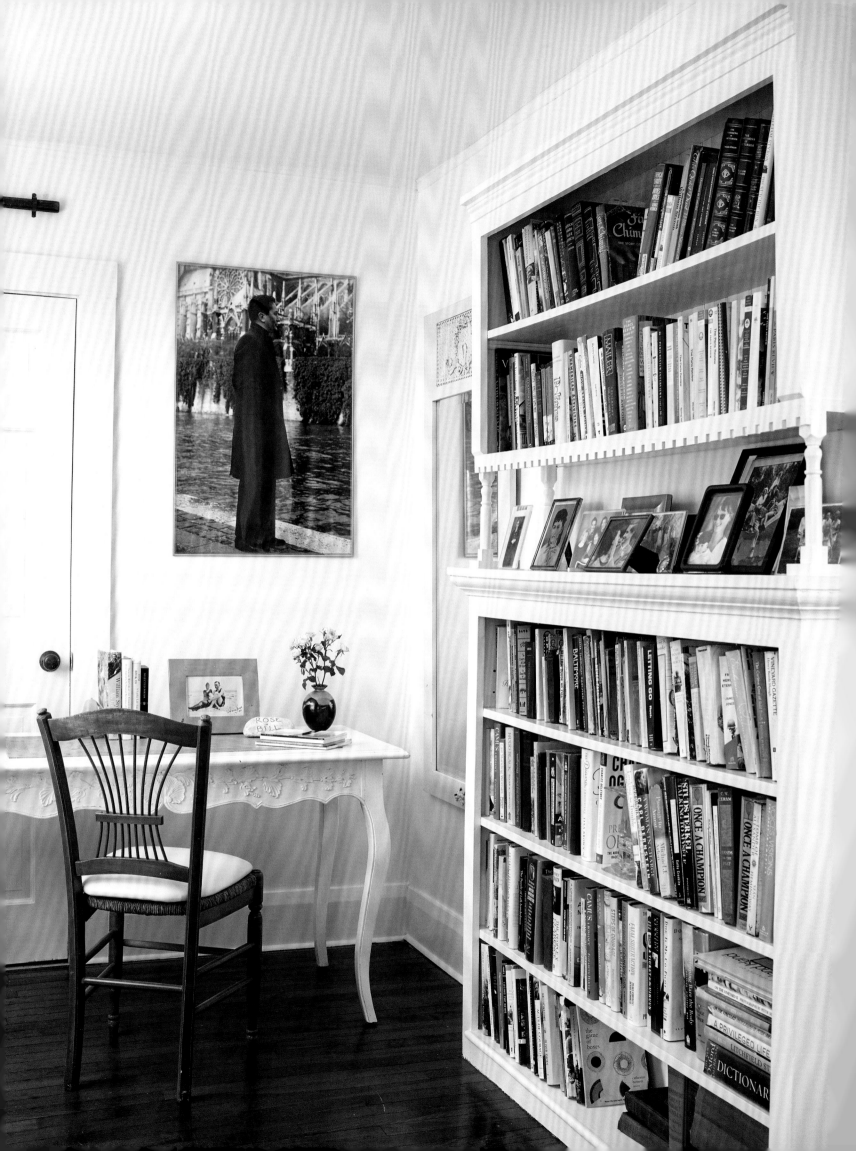

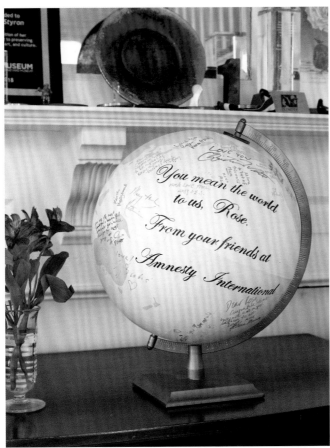

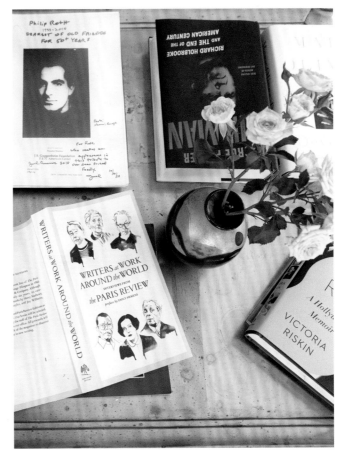

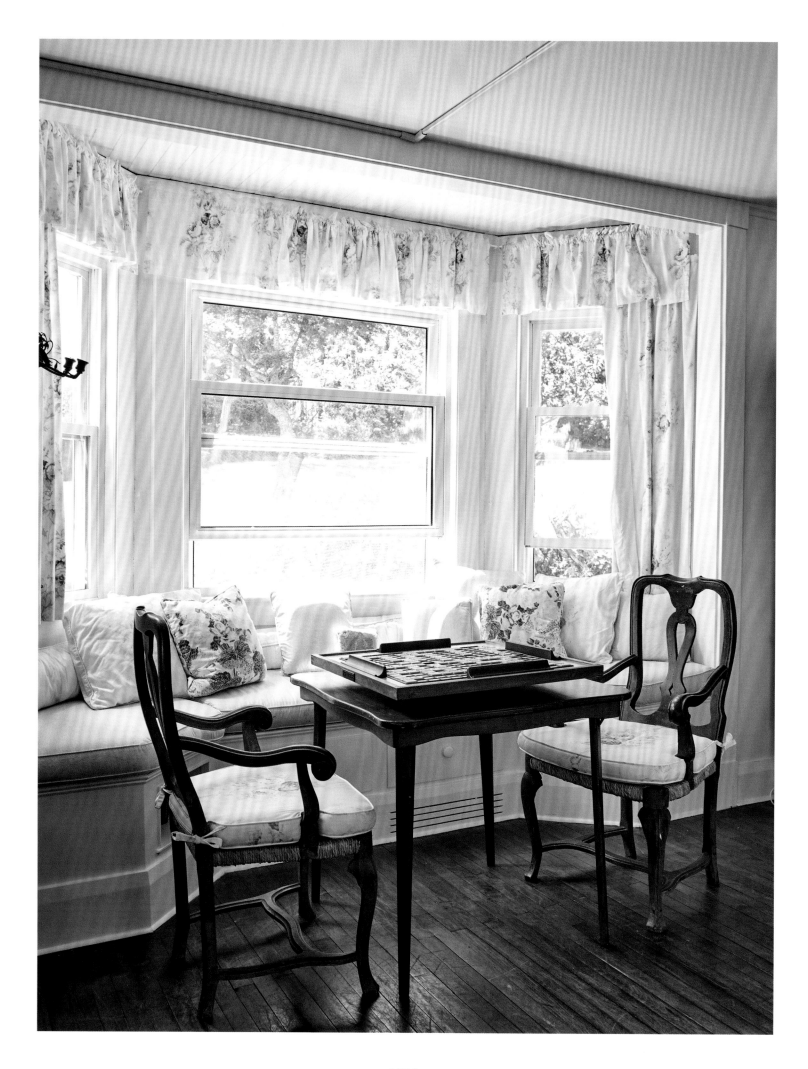

ARTIST'S RETREAT

In 1983, immediately after graduating from Notre Dame's School of Architecture, John Dowd hopped a bus from South Bend to Provincetown to spend the summer painting before embarking on a career of drafting boards and electrical plans. He decided to try his luck selling a few works at a local gift shop where Anton and Joan Schiffenhaus, guardians of Edward Hopper's nearby Truro estate, took note and convinced him to defer architecture and try painting full time. It wasn't long before Dowd became the "poet painter of Provincetown," owing to the romantic quality of his pared-down streetscapes and landscapes.

After ten years of living in minuscule spaces, Dowd was encouraged by his friends to invest his earnings in a permanent spot, specifically an 1820s Greek Revival in desperate need of care. "They said, 'If you don't buy it, we will,' so I decided to make the leap and figured if it didn't work out, I could sell it to them."

Dowd restored the house to its original appearance, removing aluminum siding and wall-to-wall carpets. "I studied architecture in Rome and became very interested in preservation. Luckily, the people across the street were modernizing their house in the opposite direction, so I used their castoff hardware and window casements."

For the interiors, Dowd hit the same country auctions and Brimfield Flea Market that he had frequented as a child with his grandparents, who were antiques dealers in Holyoke, Massachusetts. "Every Friday afternoon we would look at the newspaper and decide where to go."

Walls are hung with works by Provincetown artists dating from the mid-nineteenth to the mid-twentieth century, attesting to the community's reputation as one of America's best-known creative colonies. Dowd's own artwork is relegated to his home studio. Books are everywhere. They range from classics, modern fiction, and poetry to biographies, drama, art, and, of course, architecture, for which Dowd has a continuing passion that he satisfies as president of Provincetown's Historical District Commission.

OPPOSITE: In the living room, the painting over the mantel is by George Elmer Browne, who founded the popular West End School of Art in Provincetown in 1916. A kilim pillow rests on a late Federal wing chair. A Japanese woodblock-print textile covers an Empire chaise.

PAGES 132-33: The living room walls are covered with the art of local painters. An 1837 New England folk portrait hangs adjacent to a 1937 WPA painting of the Provincetown boatyard (partially obscured by the sunflowers) and, above it, an oil painting by Charles Hawthorne, widely credited as the father of the Cape Cod School of Art. A nineteenth-century table sits atop a hand-hooked rug from the same era.

PAGE 134: An Etruscan antefix, a Ptolemaic bust of Ptah, a Prior-Hamblin School portrait of a young sailor, and a lithograph of Robert Motherwell's *Africa 9* rest in front of a 1950s New York Abstract Expressionist painting in the upstairs parlor.

PAGE 135: A nineteenth-century marble bust of Shakespeare looks out of a front window.

PAGE 136: An 1835 map titled "The Extremity of Cape Cod" charts Provincetown. An eighteenth-century crewelwork pillow and hook rug complement a late Federal cherrywood bed.

PAGE 137: In the master bedroom, the curtained, built-in bed suggests a berth on a ship, the sea theme underscored by a folk-art nautical mirror.

PAGES 138-39: The upstairs parlor is grounded by a marble-topped Empire table and two Hitchcock chairs, reminiscent of a tableau in Dowd's grandparents' house. A painting of two boys on the beach by Walter Stuempfig hangs below a work by Stephen Greene.

PAGE 140: A collection of Dowd's sketches and postcards of his works from past exhibitions at the William Scott Gallery hangs in his studio.

PAGE 141: Paintings from Dowd's *Provincelands* series. He is often referred to as the "poet painter of Provincetown" because his pared-down, rigorously composed work has a romantic quality and suggests a narrative that evolves with every viewing.

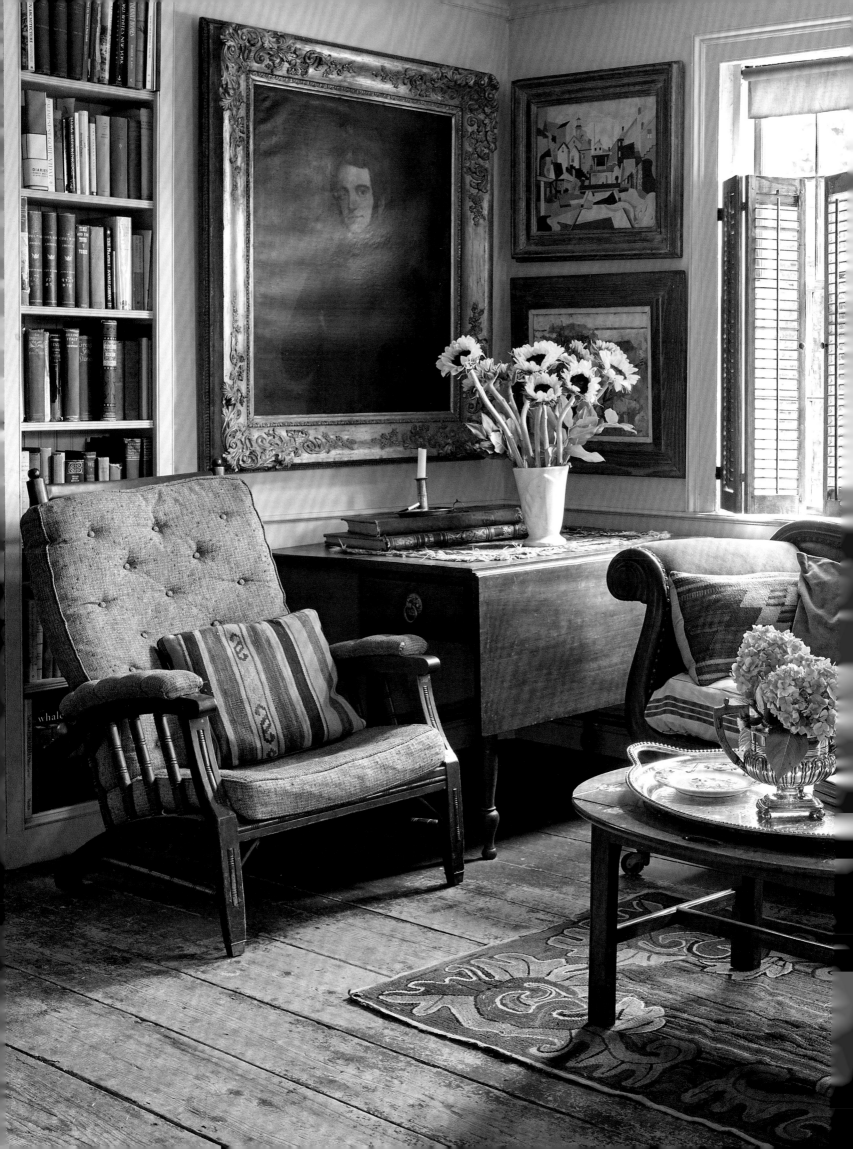

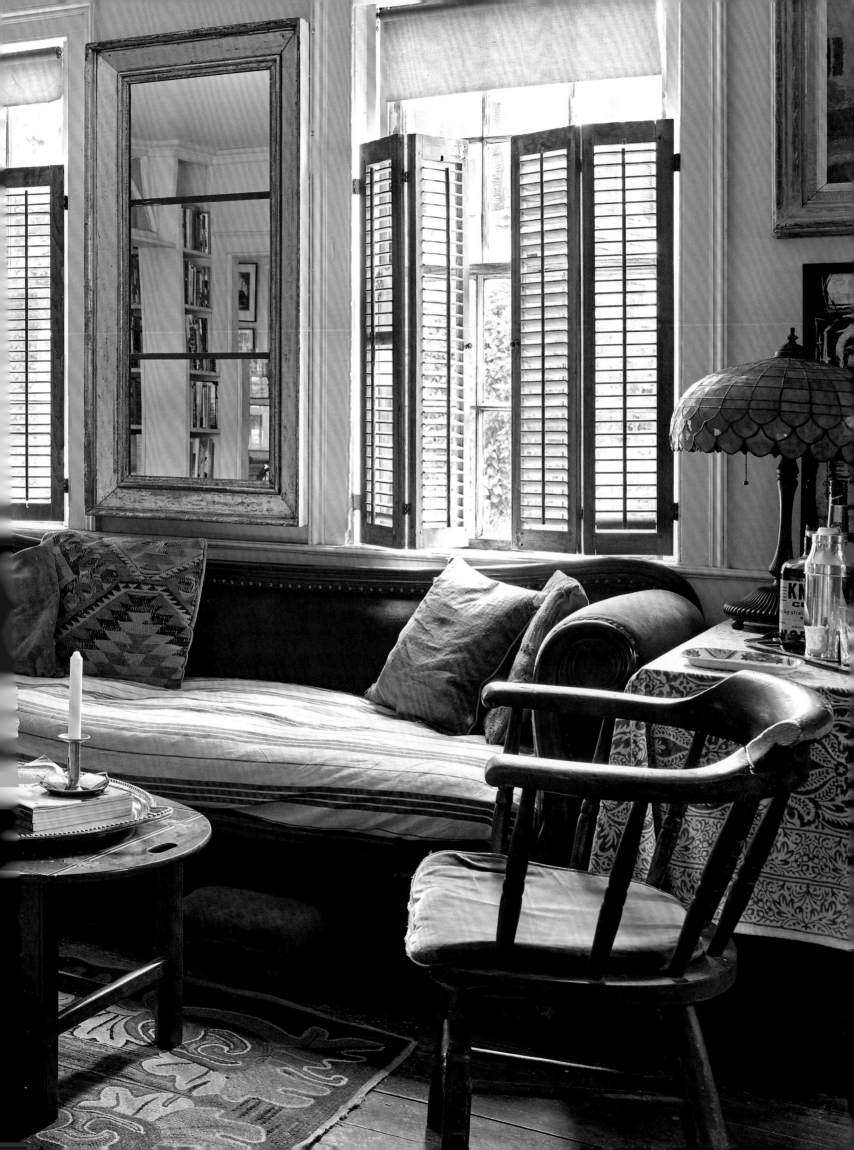

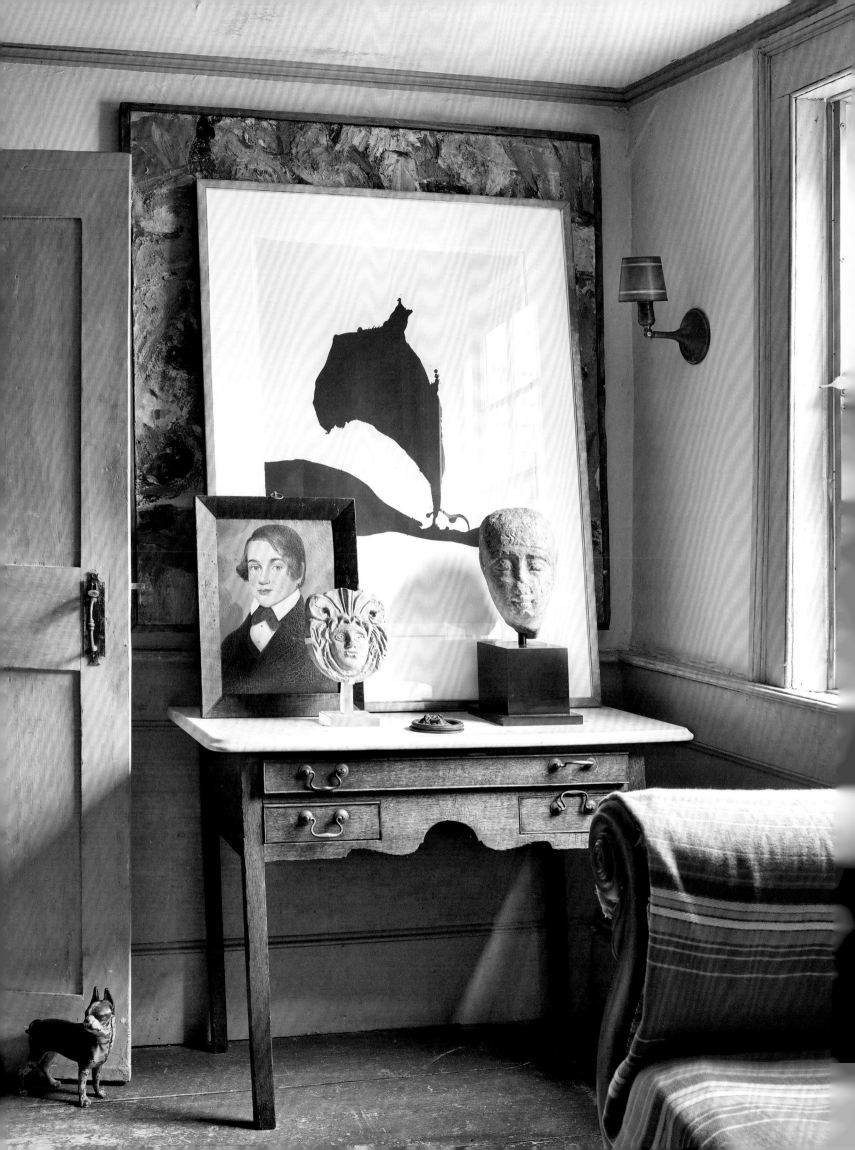

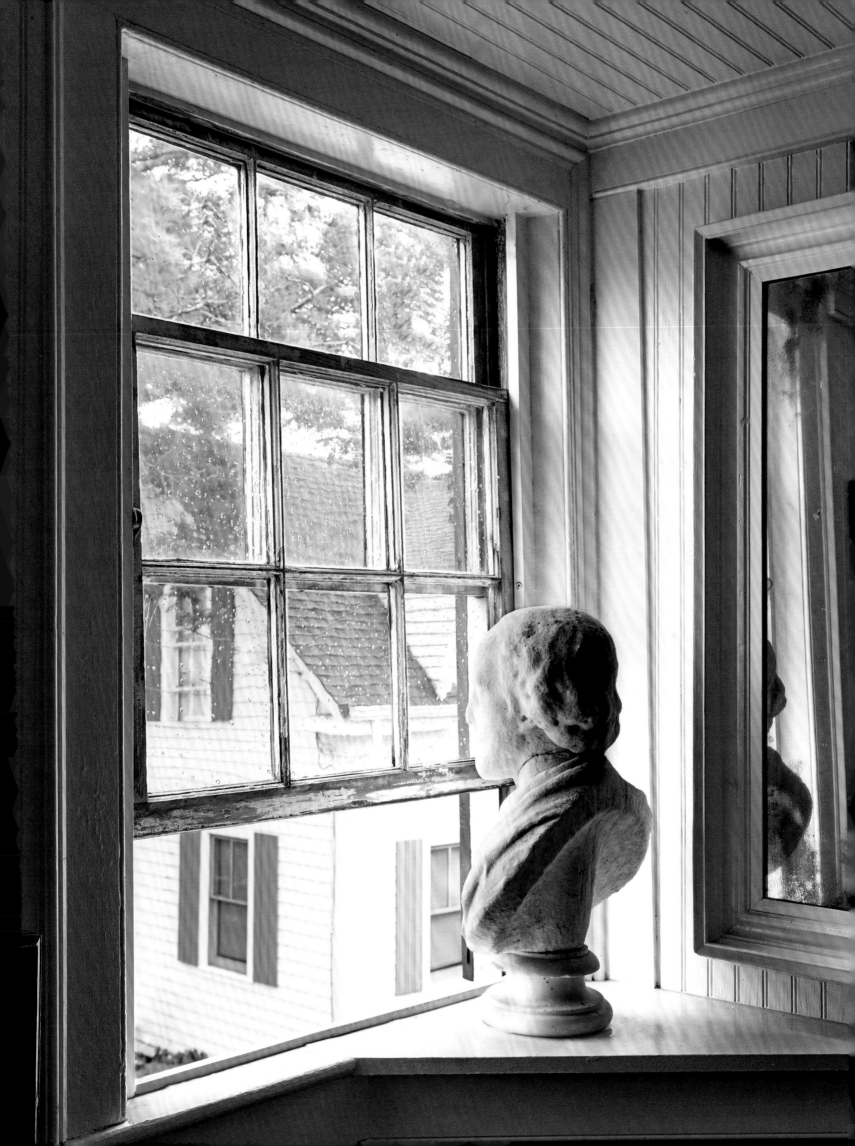

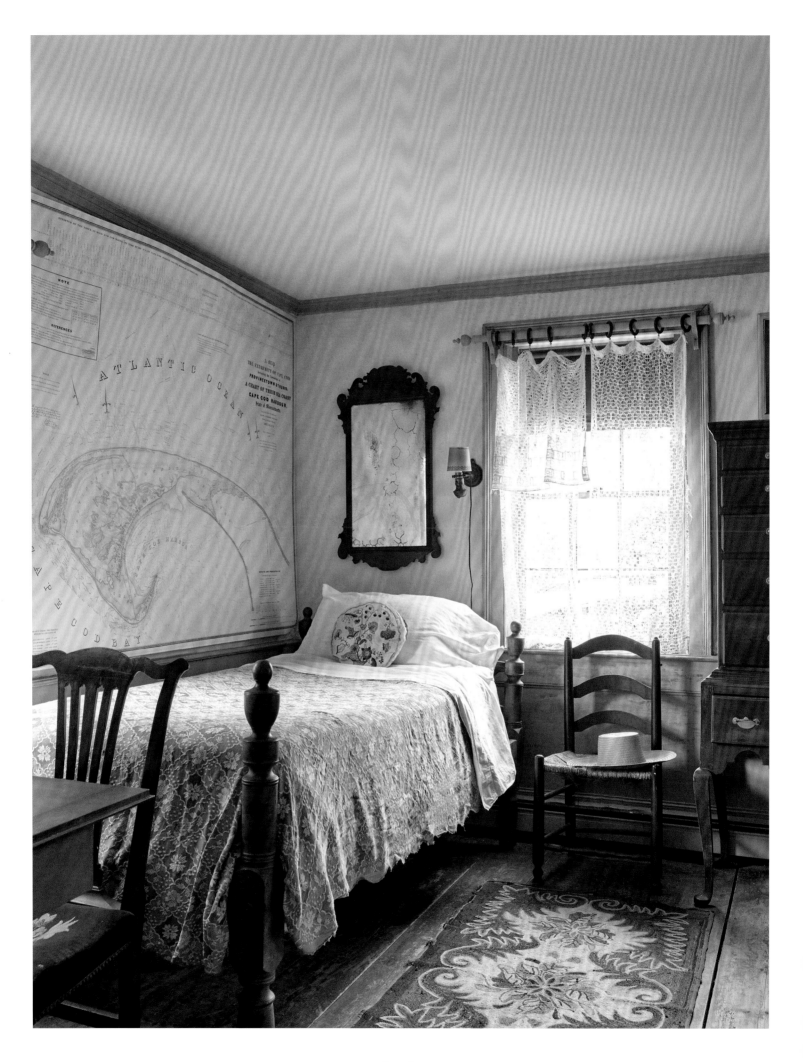

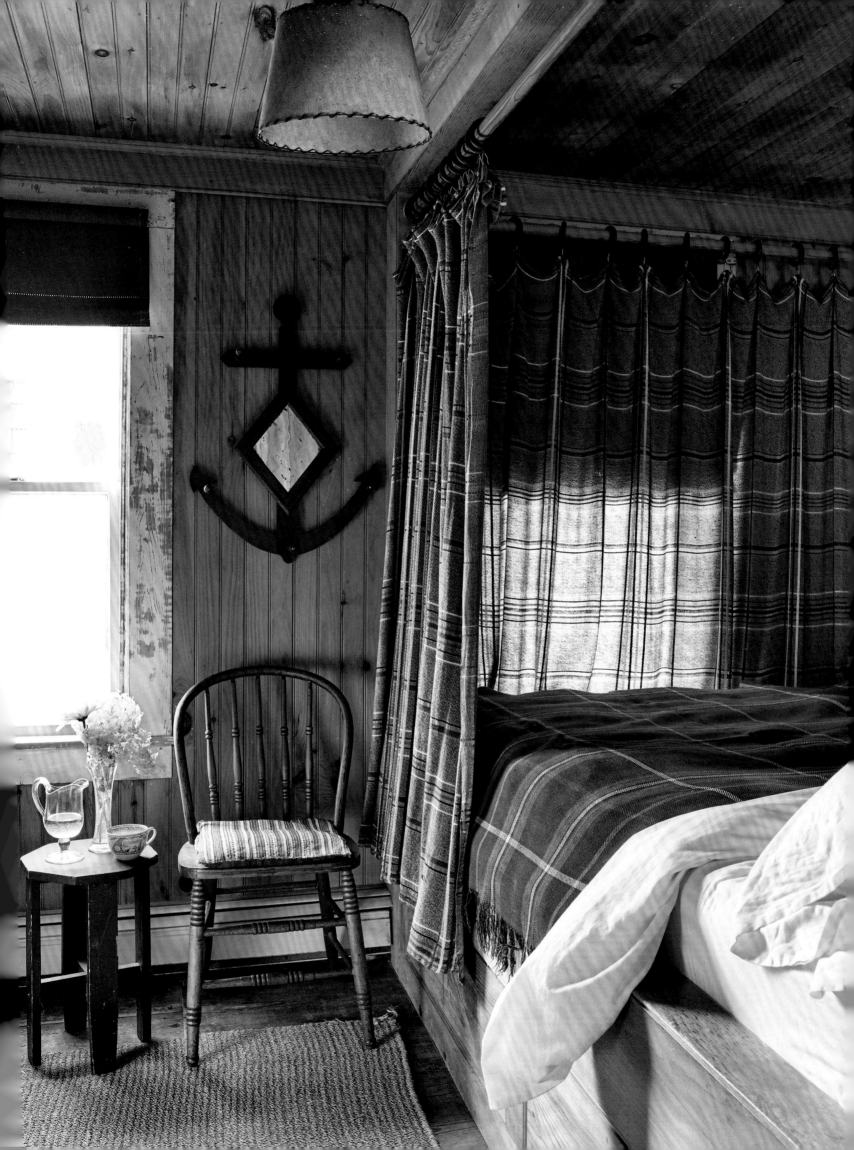

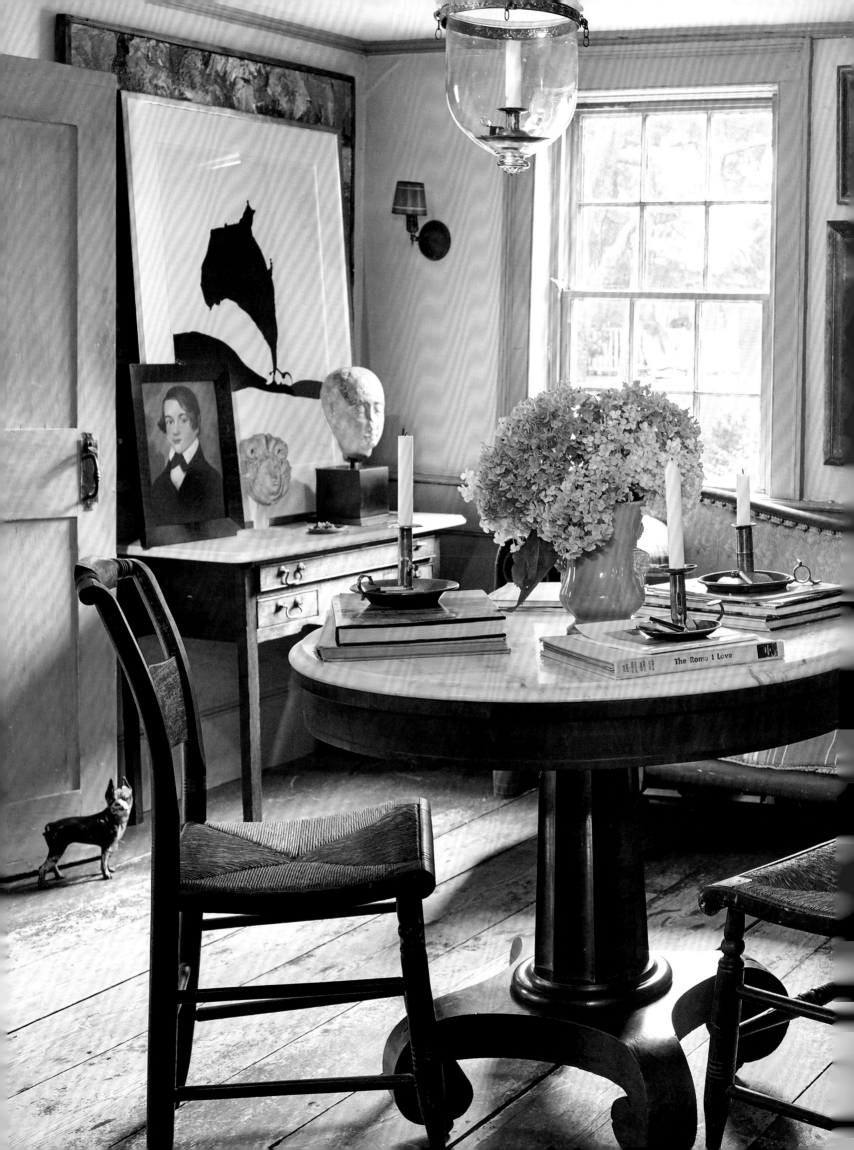

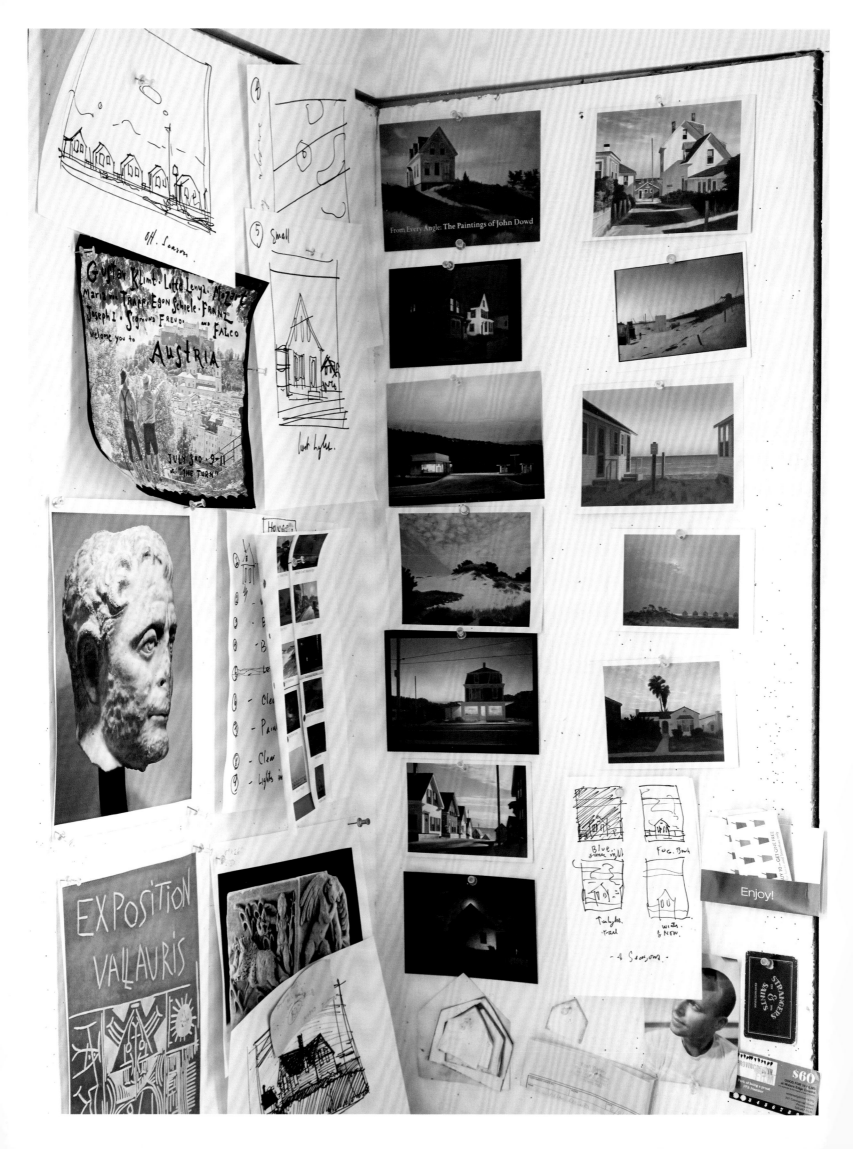

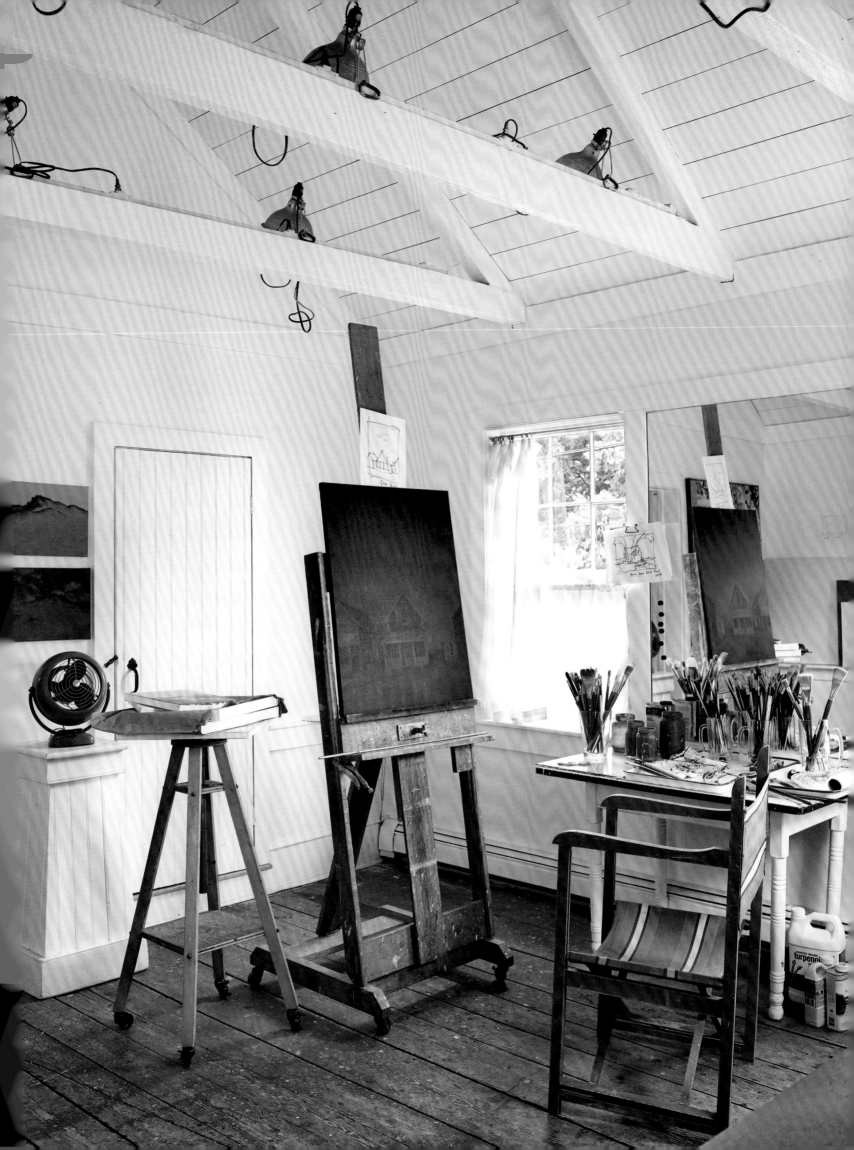

16 NORTH LIBERTY

In a world of short attention spans, fickle tastes, and endless technological advances, Vanessa and Matt Diserio's two-bedroom summer cottage is a study in continuity and simplicity. When the Diserios first purchased the cottage, Vanessa's father, the modernist furniture designer Vladimir Kagan, who had studied architecture, suggested that they combine the kitchen and the living room into one big space and add a shower in the children's bathroom. "We finished the basement and put a half bath there, and it was just enough to get us by, so we never did anything else. I love the ease of it. I can clean it out in an hour. It gets a little tight when our three daughters come home with friends, but our lives on Nantucket have always been about the outdoors," says Vanessa.

It was the island's unpretentiousness that first drew Vanessa's parents in the early 1960s. "They were free spirits and completely self-sufficient, but neither had a steady income. Nantucket was a less expensive option compared to other summer places." Her father's coveted, organically shaped designs are now in the permanent collections of the Cooper Hewitt and the Boston Museum of Fine Art. Her mother, Erica Wilson, a British-born needlework artist whose books and public television programs brought her renown as "America's first lady of stitchery," established an eponymous shop on Nantucket's Main Street, which Vanessa expanded to include housewares and fashion and where she continues to offer needlepoint classes.

As a child, Vanessa and her siblings spent mornings racing Sunfishes while her parents raced their beloved wooden sailboat, the *Korduda*; Vladimir skippered and Erica manned the foredeck. Afternoons were spent at the beach, where they clammed at sunset, "Our family was always the last to leave the beach."

OPPOSITE: The classic Nantucket cottage, built in the 1940s, is located right in town. Toby and Max sit at the front door.

PAGES 144–45: The living room features the family's talents, including needlework by Vanessa Diserio's mother, Erica Wilson; a small chair designed by her father, the modernist furniture designer Vladimir Kagan; and, over the fireplace, an oil painting by Illya Kagan, her brother.

PAGE 146: A luggage rack is one of many of many examples of needlework guru Erica Wilson's work. She trained at the Royal School of Needlework, and examples of her craft are in the permanent collection of the Winterthur Museum.

PAGE 147: In the eighteenth century, crewmen aboard the Nantucket lightships made baskets for their wives and girlfriends. They're still made by local artisans today, and many historical examples are on display at the island's Lightship Basket Museum.

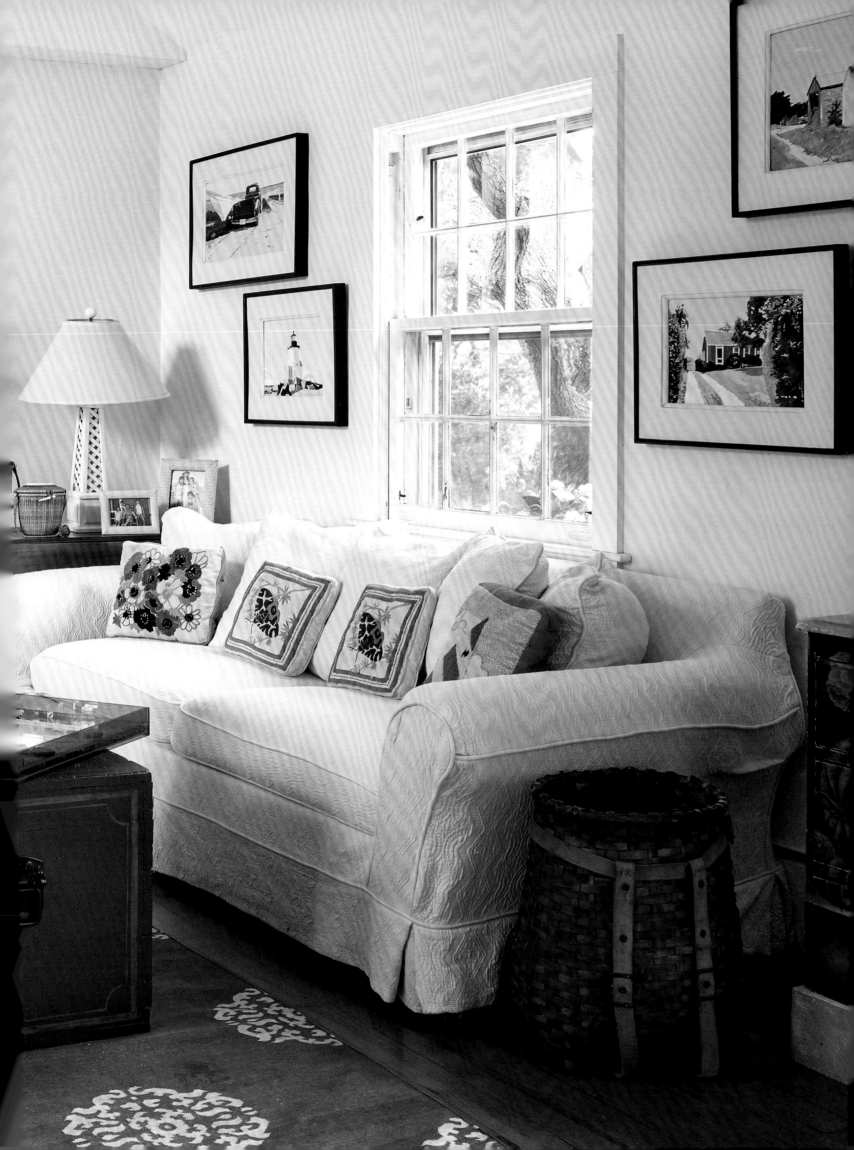

THE BOATHOUSE

Though happily situated in an elegant Southampton house located a stone's throw from both the beach and town, Robert (Bobby) Liberman hankered for a spot where he could sail, fish, and kayak right out his back door. His wife, Barbara, understood his desire, so when a historic bay-front residence came up for sale, she made a lunch reservation at Shelter Island's Sunset Beach, where they often went by boat, and suggested they sail past the listing on the way home.

What they discovered was a magical property on Bulls Head Bay, surrounded by a national wildlife refuge and offering distant views of the Shinnecock Hills. But the current owner had abandoned the renovations mid-construction, exhausted by the arduous process of petitioning for waterfront building permits.

Rather than rejecting the thought of purchasing a construction site, they saw nothing but possibilities and imagined creating an outpost that would not only accommodate Bobby's boats but also incorporate plenty of room for their daughter and her growing family. When the couple learned that the structure had originally been the boathouse of the Hammersley family, who moved there permanently when waves from the hurricane of 1938 washed through their palatial house on Gin Lane in Southampton, they knew they were home and, like the Hammersleys, made the move from the village to the bay.

With construction plans and permits finally in place, Barbara called upon interior designer Mica Ertegun, a natural collaborator whose pared-back elegance punctuated by exuberant touches appealed to a wide range of clients, most famously Bill Blass, Keith Richards, and Carly Simon. They agreed that the structure's authentic nautical touches should remain in place, including the fire hose and the barn boards—painted a jaunty aqua—in the dining room. The heart of the house is the brick-floored, screened-in porch, furnished with overstuffed wicker and baskets of enormous ferns. From there, the couple watch boats pass and birds migrate. Bobby provided the crowning touch; a gozzo boat ordered while on vacation in Capri, which arrived just as the house was nearing completion.

OPPOSITE: A house on Bulls Head Bay was originally L. Gordon Hammersley's boathouse. The Libermans ordered a gozzo boat from Apreamare boatbuilders in Sorrento while they were on vacation in Capri.

PAGE 150: The Libermans found nautical murals commissioned by the home's original owners, the Hammersley family, and hung them in the bedroom hallway.

PAGE 151: The dining room, originally used to store boats and sails, was painted a buoyant aqua.

PAGES 152–53: A screened-in sun porch, with views of Bulls Head Bay and the Shinnecock Hills, is the heart of the house. The wicker furniture is from Oscar de la Renta. The wooden deer are from J. Garvin Mecking.

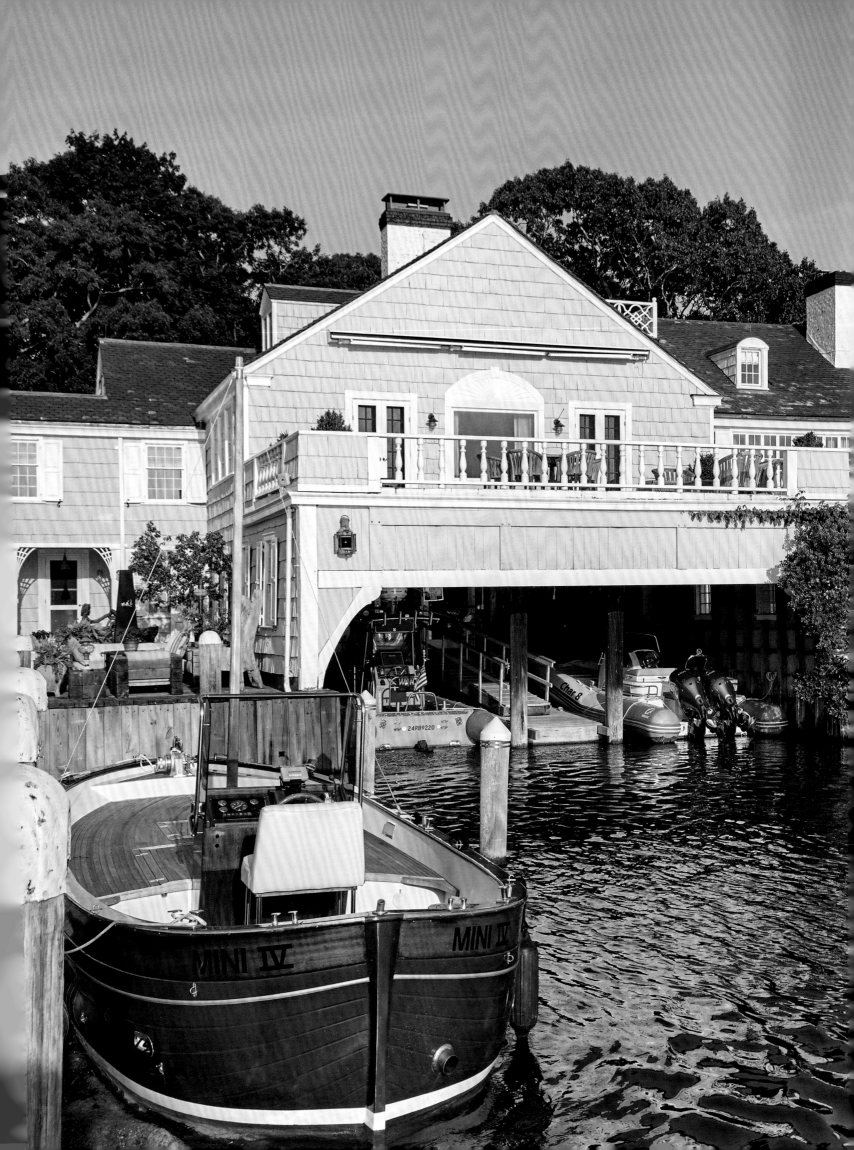

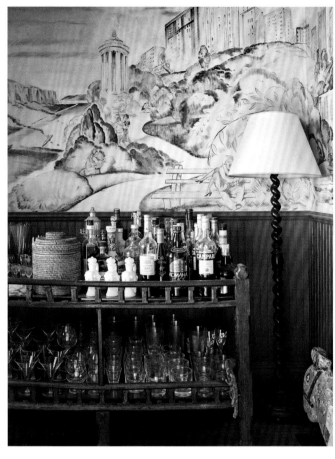

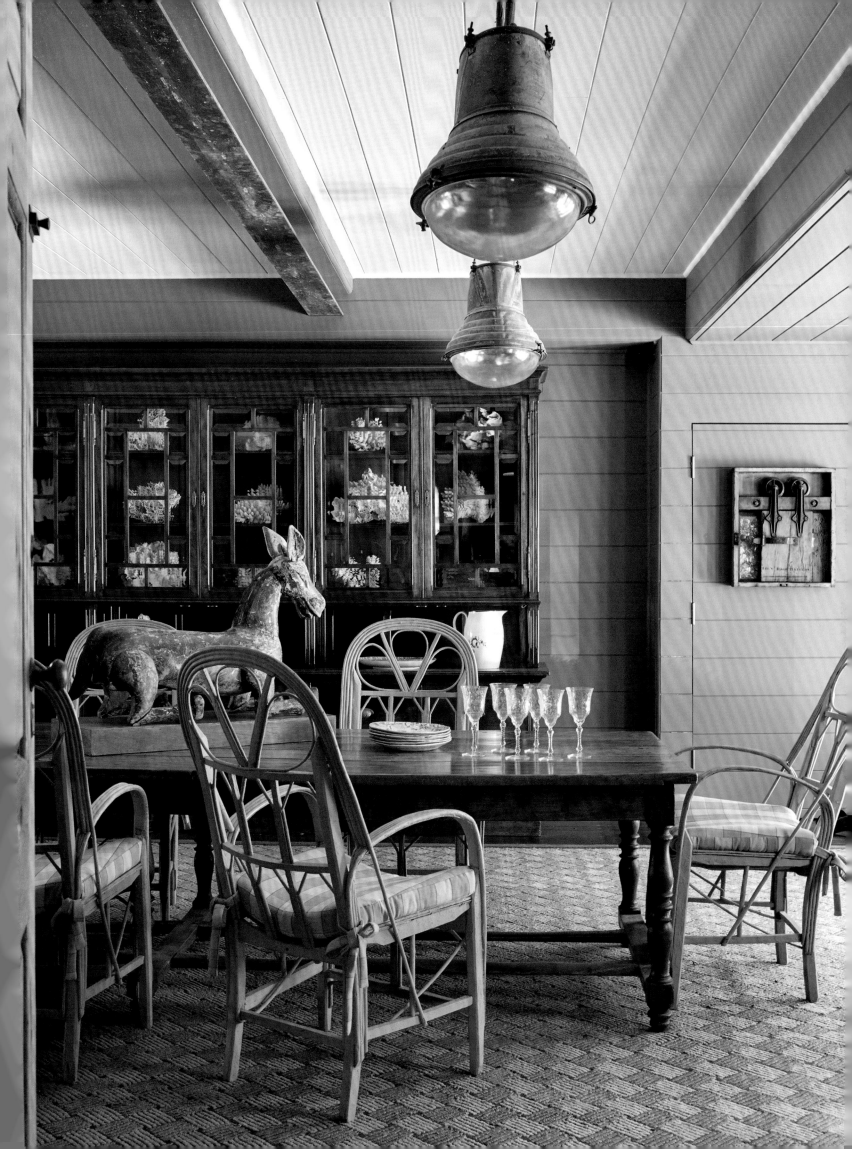

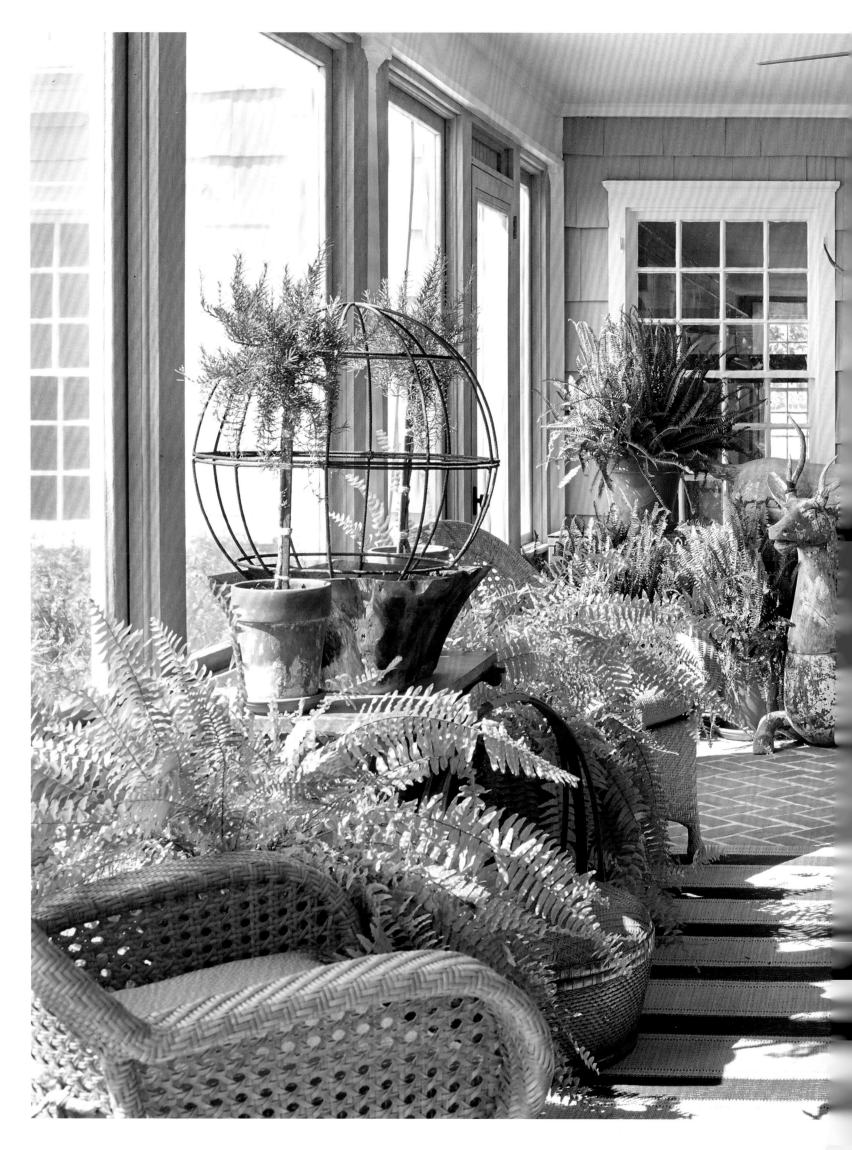

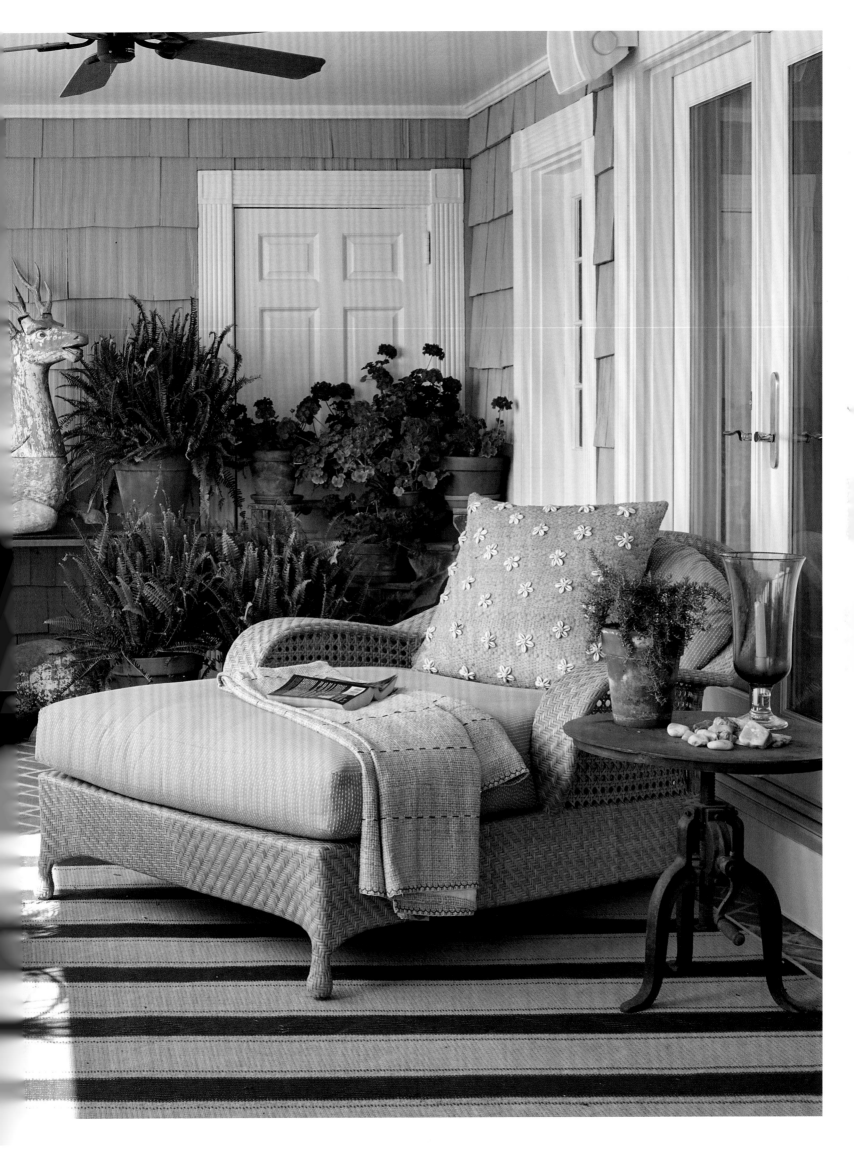

SHARED AESTHETIC

Twenty years ago, in an inspired display of unity and practicality, three friends pooled their assets and bought a quirky Victorian farmhouse on Block Island. Ever since, summer weekends have unfolded with the sweet chaos of a college dorm.

"We don't divide the time we use the house; we just tend to congregate there together, and we don't have any rules at all. Everyone weighs in on everything," explains Michael Rock. All the more remarkable when one considers that each shareholder is a cutting-edge "creative" paid to drive the cultural agenda of international luxury brands, civic buildings, and high-end residences. Rock, a recipient of the Rome Prize in Design, and his partner, Susan Sellers, formerly the head of design at the Metropolitan Museum of Art, are founders of 2x4, the storied New York City creative agency whose clients include everyone from Prada, Kanye West, and Nike to the Cooper Hewitt, LACMA, and MoMA PS1. Both are senior critics at the Yale School of Art. Dan Costa, a Harvard-trained architect who specializes in summer houses, was later joined by his husband, the journalist David Collins. "As designers, we are all keenly aware of various aesthetic choices, but what makes it work is that we all truly respect each other's taste. We share aesthetic references and a love of the New England coast," Rock says.

Rather than attempt to make a design statement out of the house, they defer to its needs. They've added a new wooden roof, replaced porches, finished the attic, refitted bathrooms and the kitchen, redone the horsehair plaster, and planted vegetable and perennial gardens. "The barn had blown down in a hurricane and never been rebuilt, so we had the opportunity to build that from scratch with our own hands, which is something we had always wanted to do." On an island, where practicality is paramount, almost everything they sourced were period materials from salvage yards.

Furniture was likewise scavenged from various family houses in Rhode Island, Bucks County, and Maine. One of the few new pieces is a work by artist David Horvitz that proclaims *Nobody Owns the Beach*. "We love the idea of this incredible, moving natural resource that is free and available to everyone. It really expresses our core ideology about everything," says Rock.

OPPOSITE: The warm, inviting dining room is furnished with pieces scavenged from the owners' houses and those of family members. The wicker sofa, for instance, belonged to Michael Rock's aunt.

PAGES 156–57: The living room is decorated with seascapes that Rock has amassed from various junk shops, yard sales, eBay, and the like.

PAGES 158–59: The kitchen has been entirely rebuilt. The vinyl-tiled floor was replaced with Marmoleum. The old gas stove is from Earthen Vessel, a used-appliance shop in Providence. The enameled kitchen table is from Sellers and Rock's first apartment in New Haven. Sellers assembled the art on the wall from a crumbling Peanuts cookbook that had been in Rock's mother's massive cookbook collection.

PAGE 160: This bedroom is commonly referred to as the Nun's Room because it is so austere; the two beds entirely fill the room. The beds are from Rock's grandmother's house. The painting comes from an old club in Providence.

PAGE 161: "When we bought the house, the attic was completely unfinished," Rock says. "We added the skylights and built in the entire space by ourselves over several years. We bought the complete interior of a condemned schoolhouse in Maine for the beadboard and had it shipped out to the island. We salvaged the floorboards from other areas in the house and barn. The dollhouse was my mother's, built for her by her father."

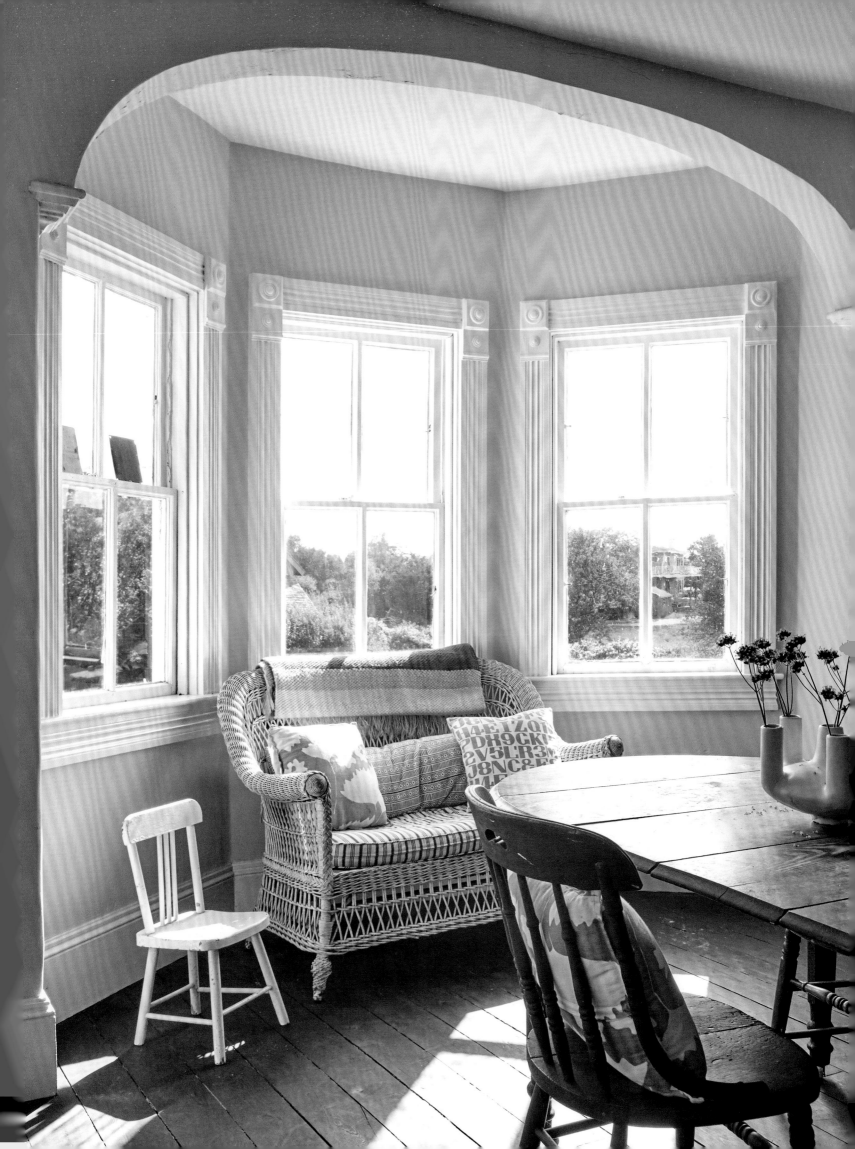

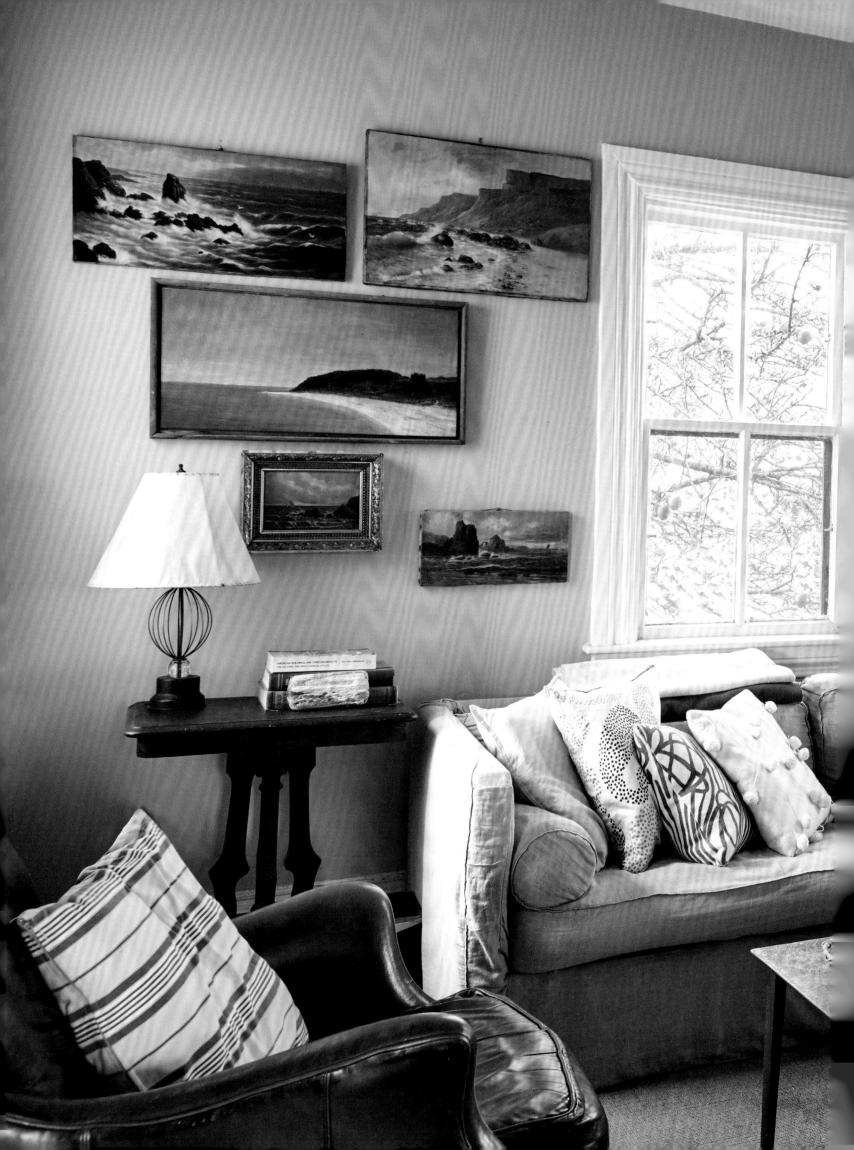

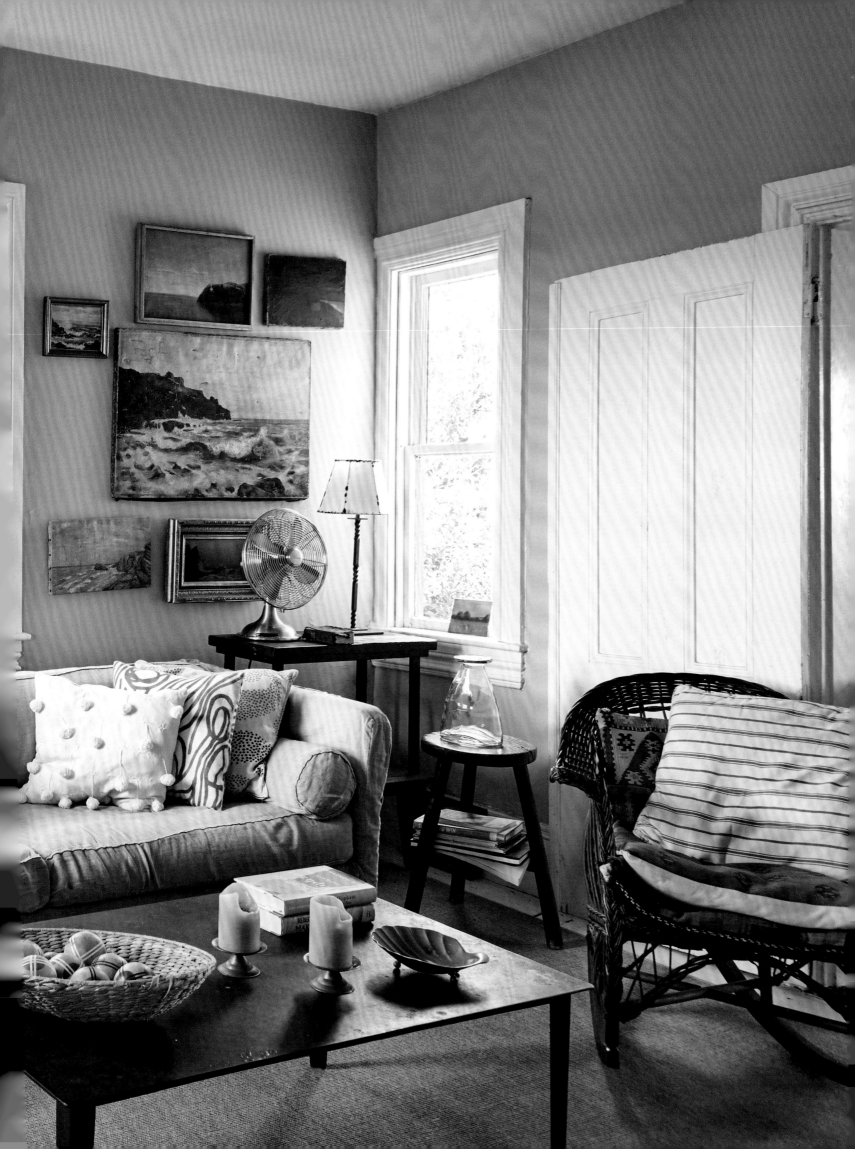

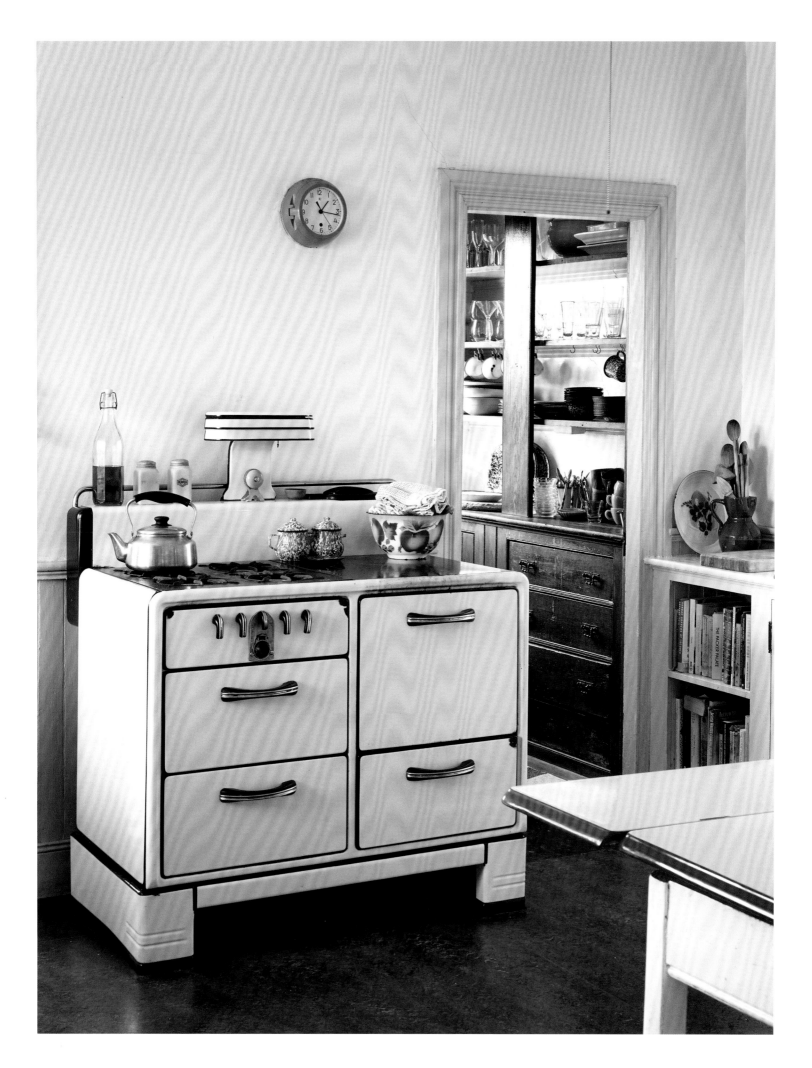

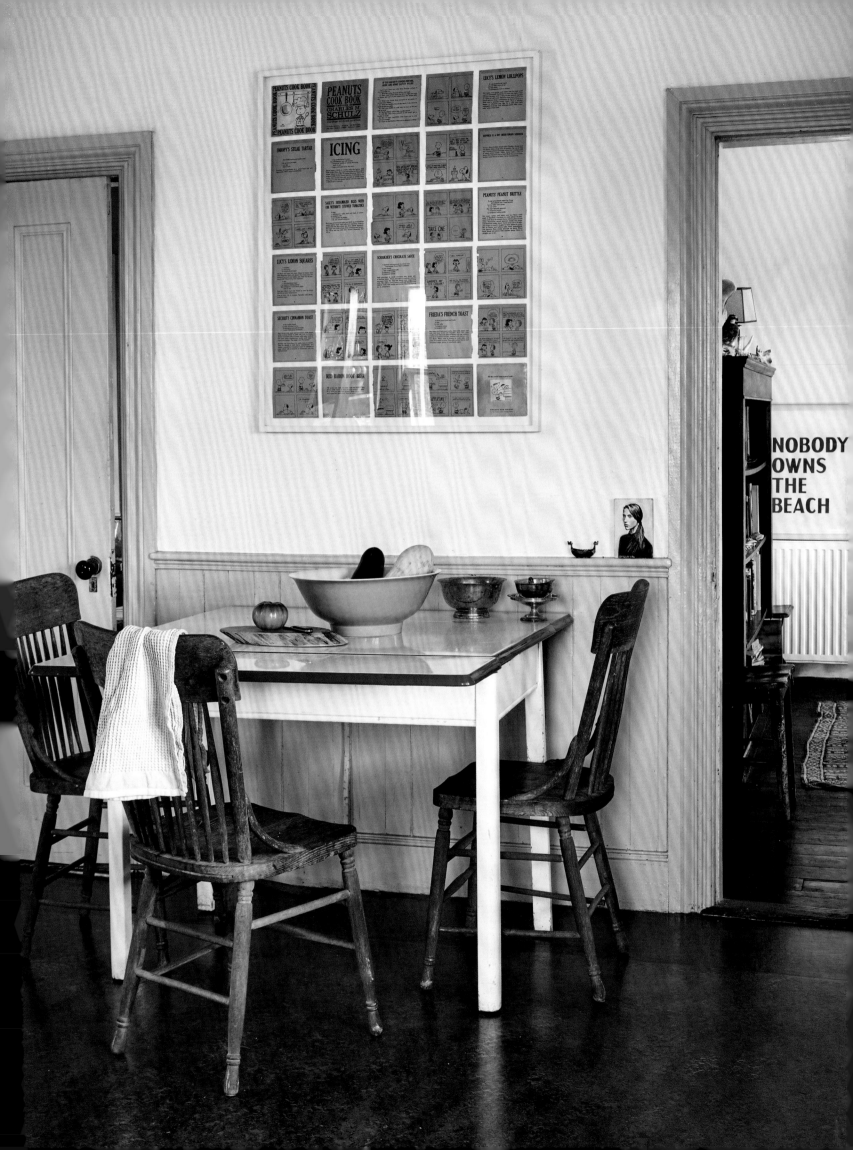

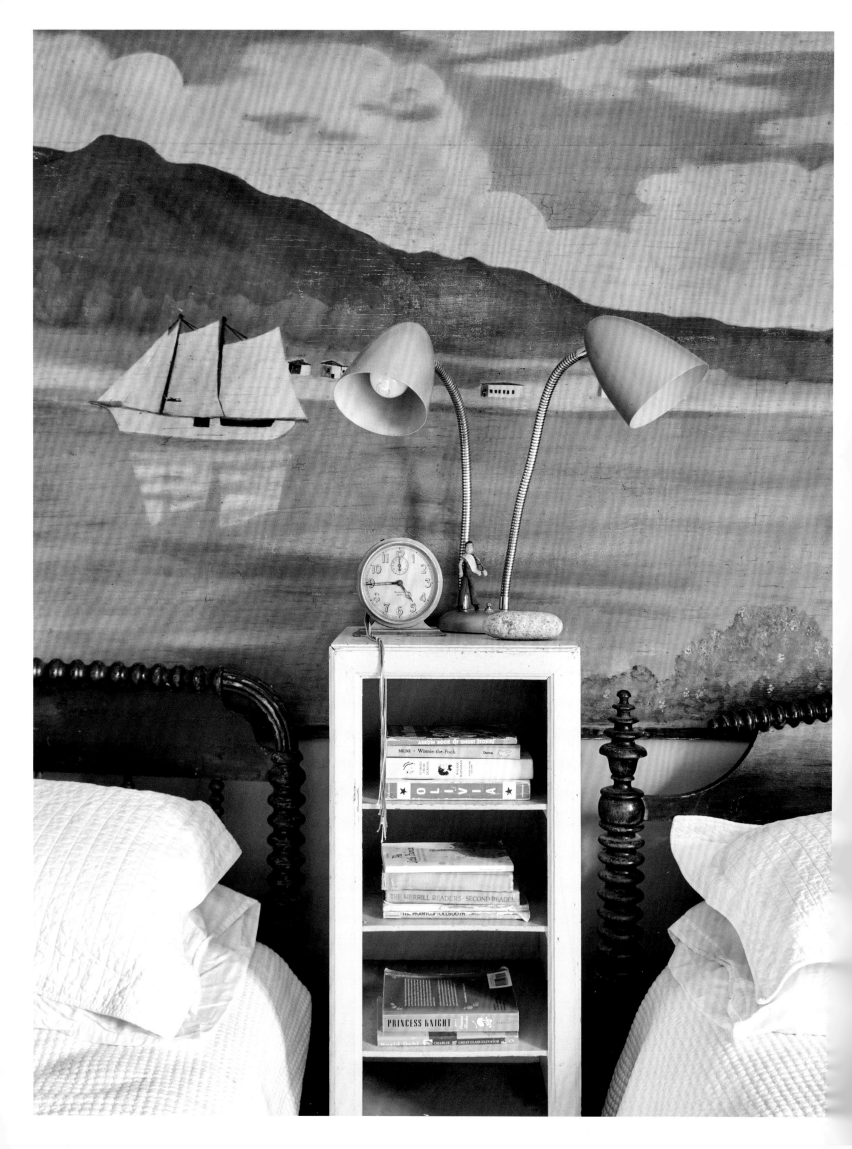

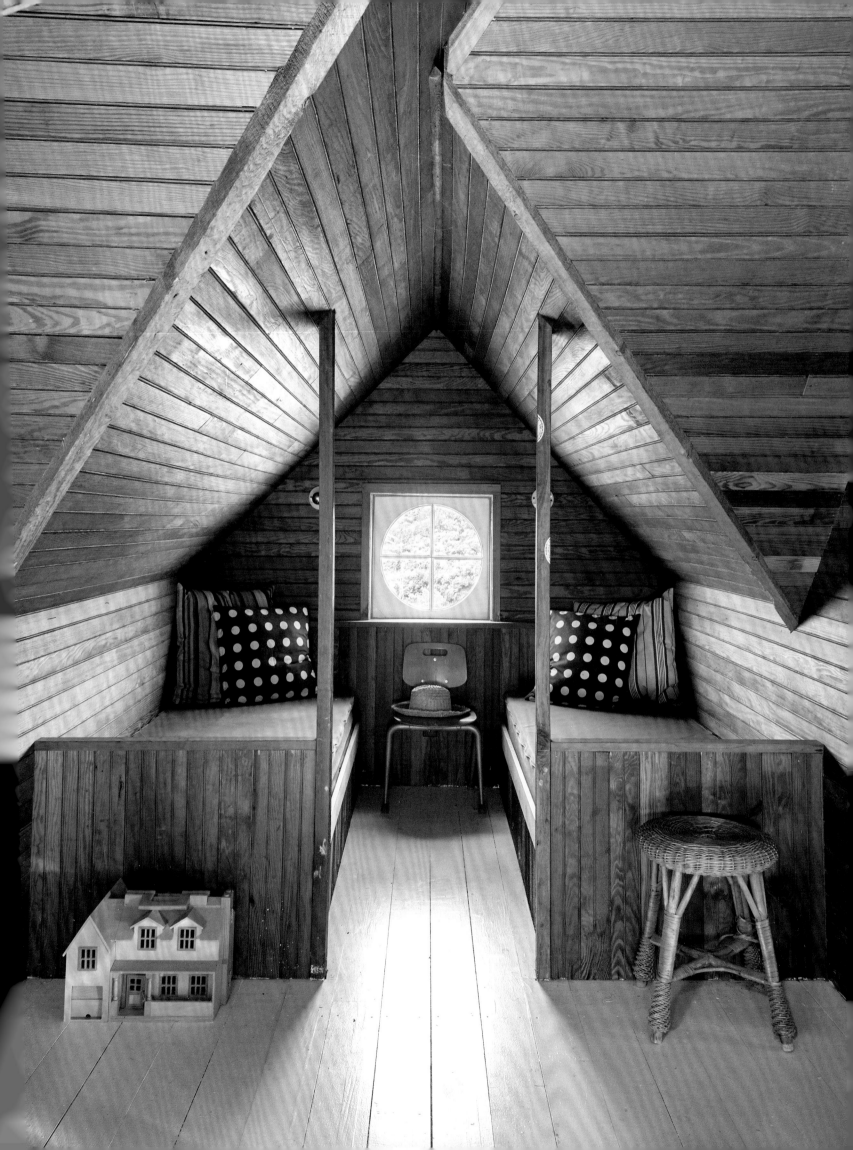

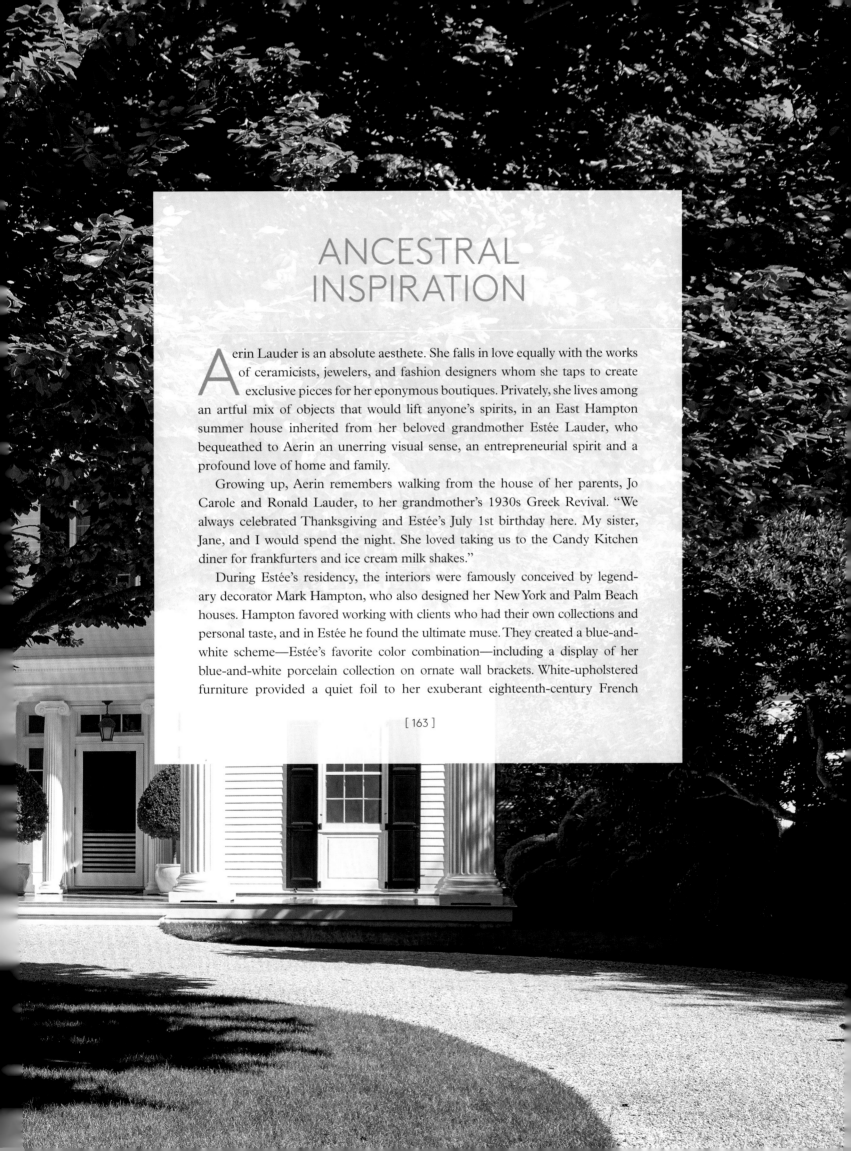

ANCESTRAL
INSPIRATION

Aerin Lauder is an absolute aesthete. She falls in love equally with the works of ceramicists, jewelers, and fashion designers whom she taps to create exclusive pieces for her eponymous boutiques. Privately, she lives among an artful mix of objects that would lift anyone's spirits, in an East Hampton summer house inherited from her beloved grandmother Estée Lauder, who bequeathed to Aerin an unerring visual sense, an entrepreneurial spirit and a profound love of home and family.

Growing up, Aerin remembers walking from the house of her parents, Jo Carole and Ronald Lauder, to her grandmother's 1930s Greek Revival. "We always celebrated Thanksgiving and Estée's July 1st birthday here. My sister, Jane, and I would spend the night. She loved taking us to the Candy Kitchen diner for frankfurters and ice cream milk shakes."

During Estée's residency, the interiors were famously conceived by legendary decorator Mark Hampton, who also designed her New York and Palm Beach houses. Hampton favored working with clients who had their own collections and personal taste, and in Estée he found the ultimate muse. They created a blue-and-white scheme—Estée's favorite color combination—including a display of her blue-and-white porcelain collection on ornate wall brackets. White-upholstered furniture provided a quiet foil to her exuberant eighteenth-century French

pieces. Each room was sprinkled with photographs of friends and family, including shots of Estée with the Aga Khan, Princess Grace, and Nancy Reagan. The result was pure Estée—elegant and warm with distinctive European flair.

After living in the house for a while, Aerin and her husband, Eric Zinterhofer, seamlessly added a wing to accommodate their growing family, creating an eat-in kitchen and family room on the first floor with a master suite and additional guest bedrooms above.

Aerin called upon Daniel Romualdez to gently adapt the interiors to a more contemporary lifestyle. "I loved the house as it was but didn't want it to be a monument to my grandmother. Tastes change and the way people live changes." Clean-lined sofas and chairs covered in both white and richly colored, crisp linens replaced more ornate pieces. Aerin and color master Donald Kaufman created ambient blues and grays for the walls. "I've started leaning toward more neutral backgrounds, as they give me the flexibility to play with various colors. I tried to embrace what my grandmother had done but with a fresh twist. Estée said anything can be beautiful if you take the time," Aerin says as she ties ribbons around bags of candy destined for the guest rooms. Her nieces are coming to spend the night, just as she and her sister did years ago, and Aerin puts treats and flowers by their beds. Elegance and acts of kindness are apparently in the Lauder family genes.

PAGES 162-63: Aerin Lauder's 1930s Greek Revival house in Wainscott, which she inherited from her grandmother Estée, exudes a strong sense of history. Schatzi, the family's Brittany, greets guests.

OPPOSITE: A picnic table under the pergola is set for lunch.

PAGES 166-67: The main living room features antique armchairs and Chinese and Japanese porcelain that belonged to Aerin's grandmother Estée Lauder, whose favorite color combination was blue and white. The sofas are covered in a Brunschwig & Fils fabric, the walls are painted in a custom mix created by Aerin and Donald Kaufman. The rug is by Stark. A blue coffee table adds a fresh pop of color. Aerin ingeniously embedded blue-and-white porcelain plates in another coffee table.

PAGES 168-69: In the airy kitchen, the light fixtures are from Ann-Morris, the stools are vintage Frances Elkins, and the lithograph is by Ellsworth Kelly.

PAGES 170-71: Photographs of Aerin Lauder and her sons by Tina Barney preside over the family room. The fabric covering the walls and the furniture and used for the curtains is Bennison's Palampore in charcoal blue on oyster.

PAGE 172: Victoria Borus of B Five Studio designed the master bedroom, which features walls covered in Michael Devine's Gramercy fabric. The tufted chairs are vintage Edward Wormley. The rug is from Beauvais Carpets.

PAGE 173, TOP LEFT: A chest in the master bedroom originally belonged to Estée Lauder. "I wanted to have something of hers in my bedroom," says Aerin. TOP RIGHT AND BOTTOM LEFT: A portrait of Aerin's mother, Jo Carole Lauder, hangs in a guest room, the walls of which are covered in a Bennison fabric. BOTTOM RIGHT: A secretary on the upstairs landing holds Estée Lauder's collection of porcelain birds, along with Aerin's collection of shells.

PAGES 174-75: The original décor of Estée Lauder's bedroom by Mark Hampton has stood the test of time. The walls, curtains, and upholstery are a Pierre Frey fabric. On the Louis XVI-style dressing table are bottles of scents created by both Estée and Aerin Lauder.

PAGE 176: A sunroom adjoining the living room serves as a quiet reading spot. Bennison's Petronella covers the cushions on the wicker furniture. The solid blue table skirts and pillows are from Tissus d'Hélène in London.

PAGE 177: A tree house was a favorite hideout for Lauder and Zitenhofer's two young boys, who are now grown.

PAGES 178-79: The pool house, added by Aerin Lauder, serves as a summer living room and office.

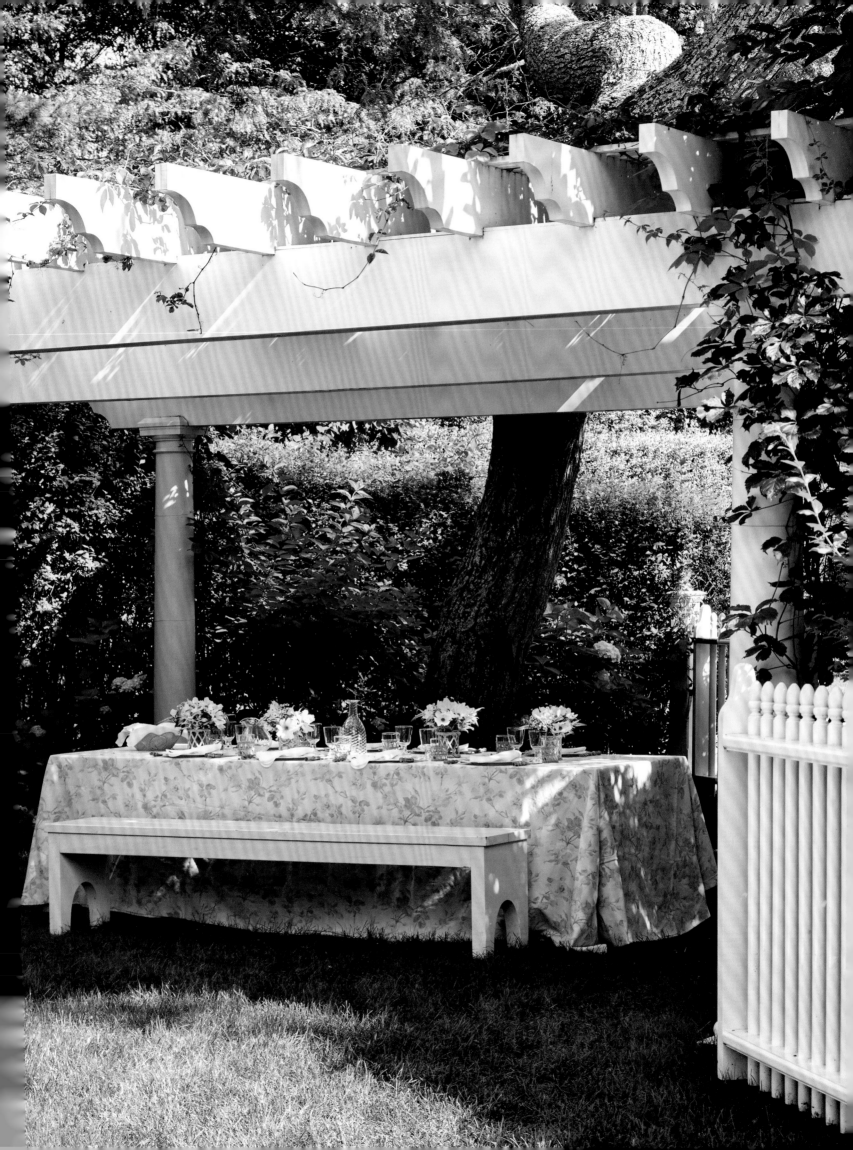

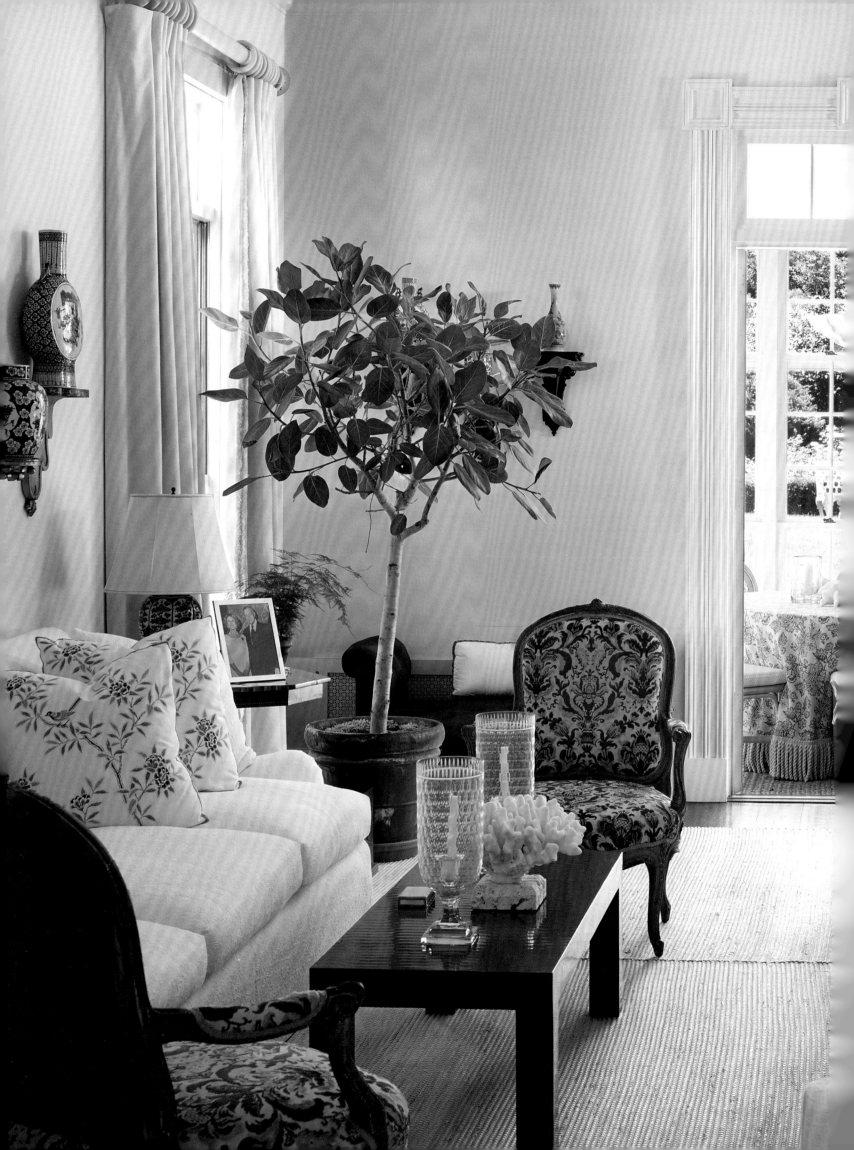

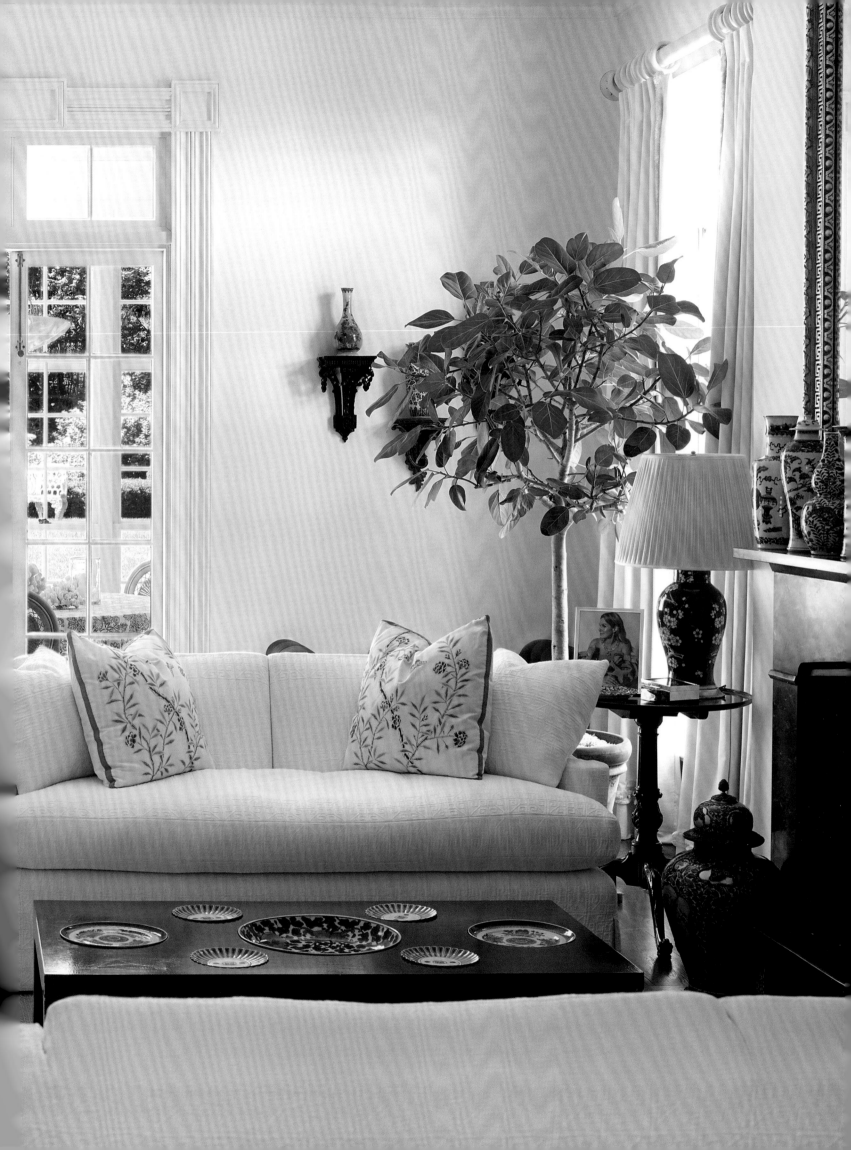

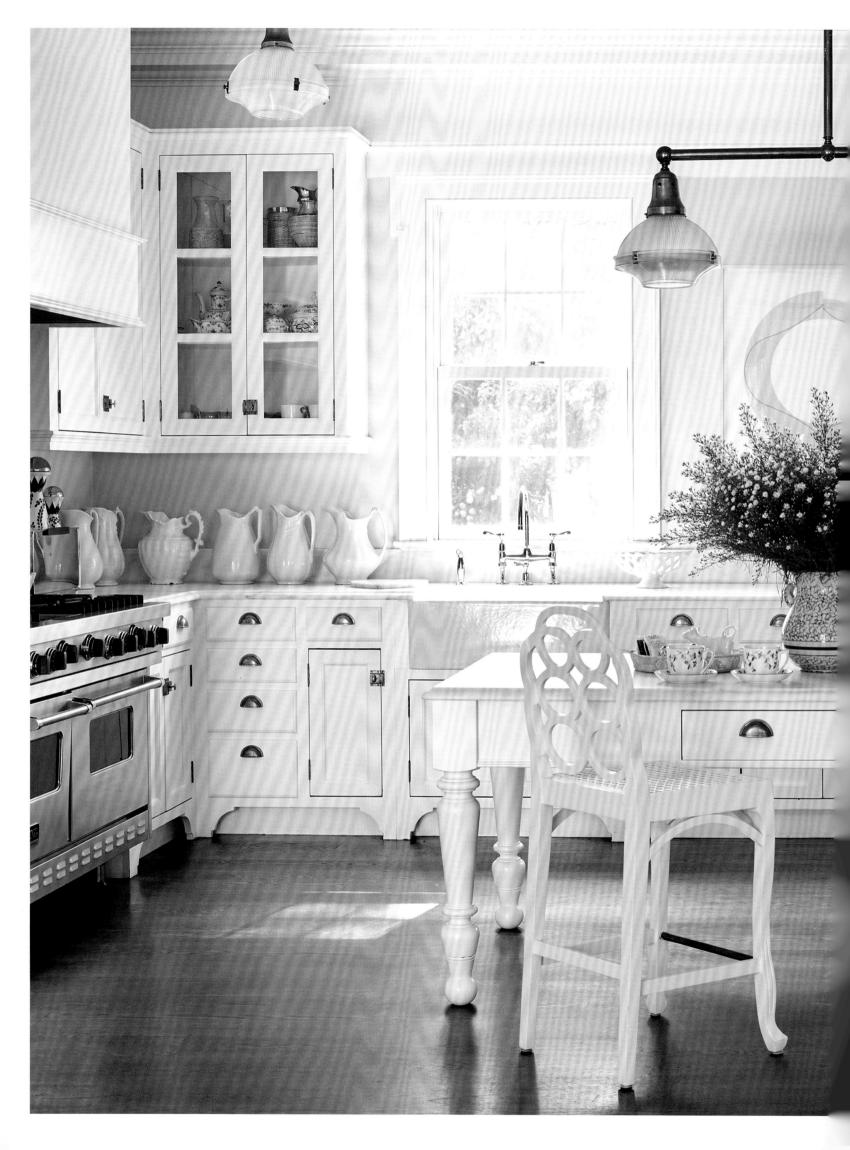

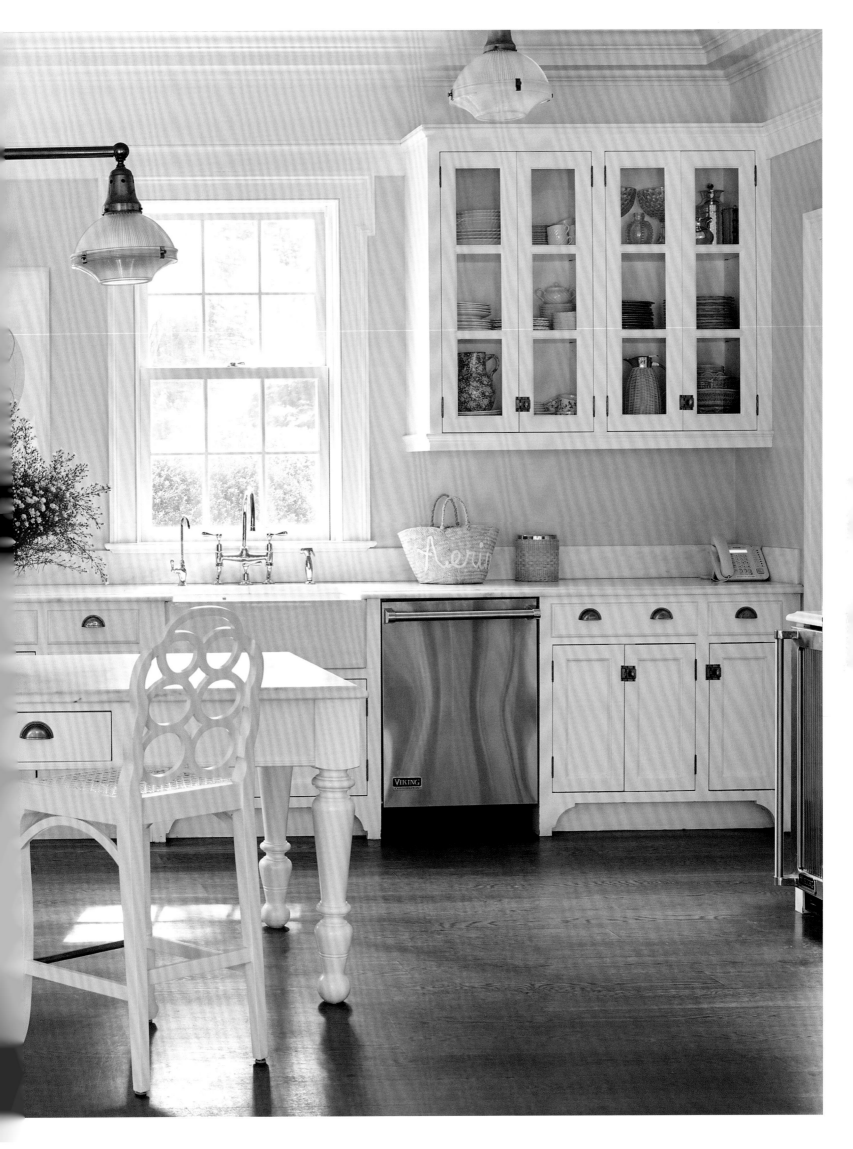

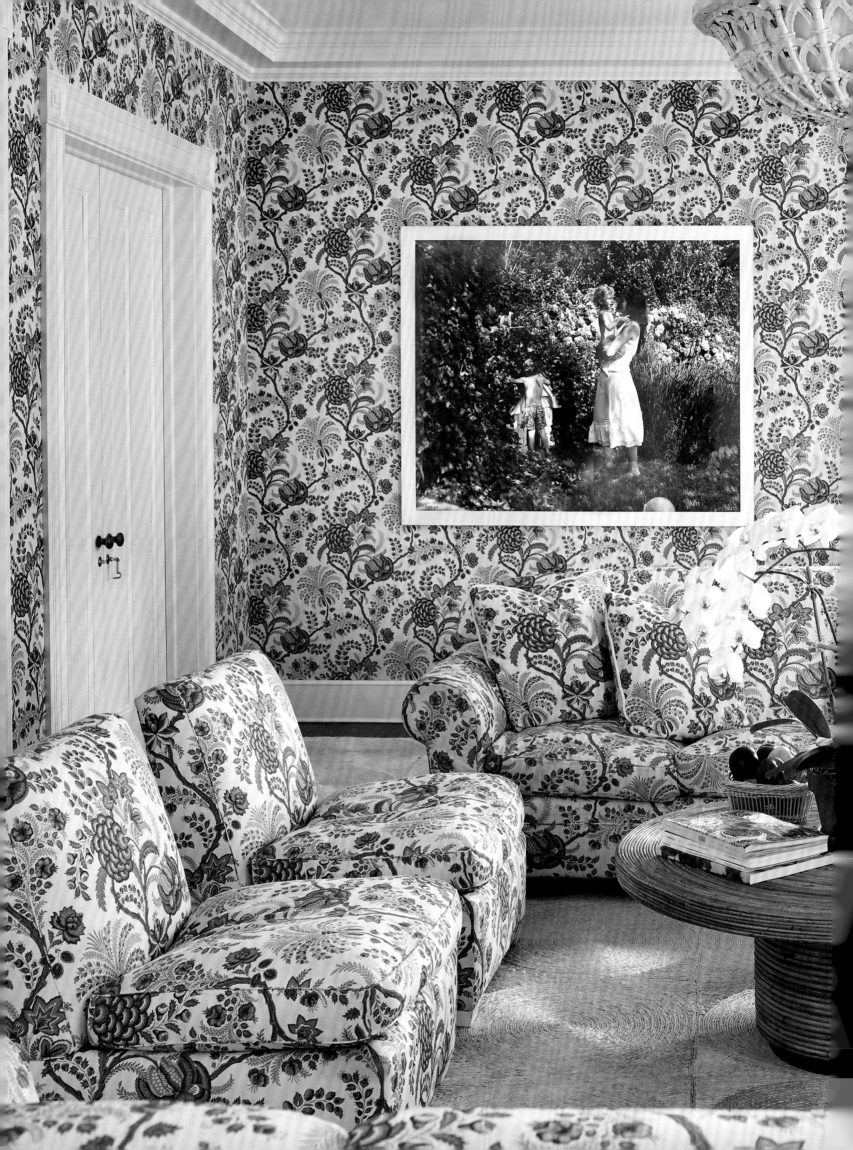

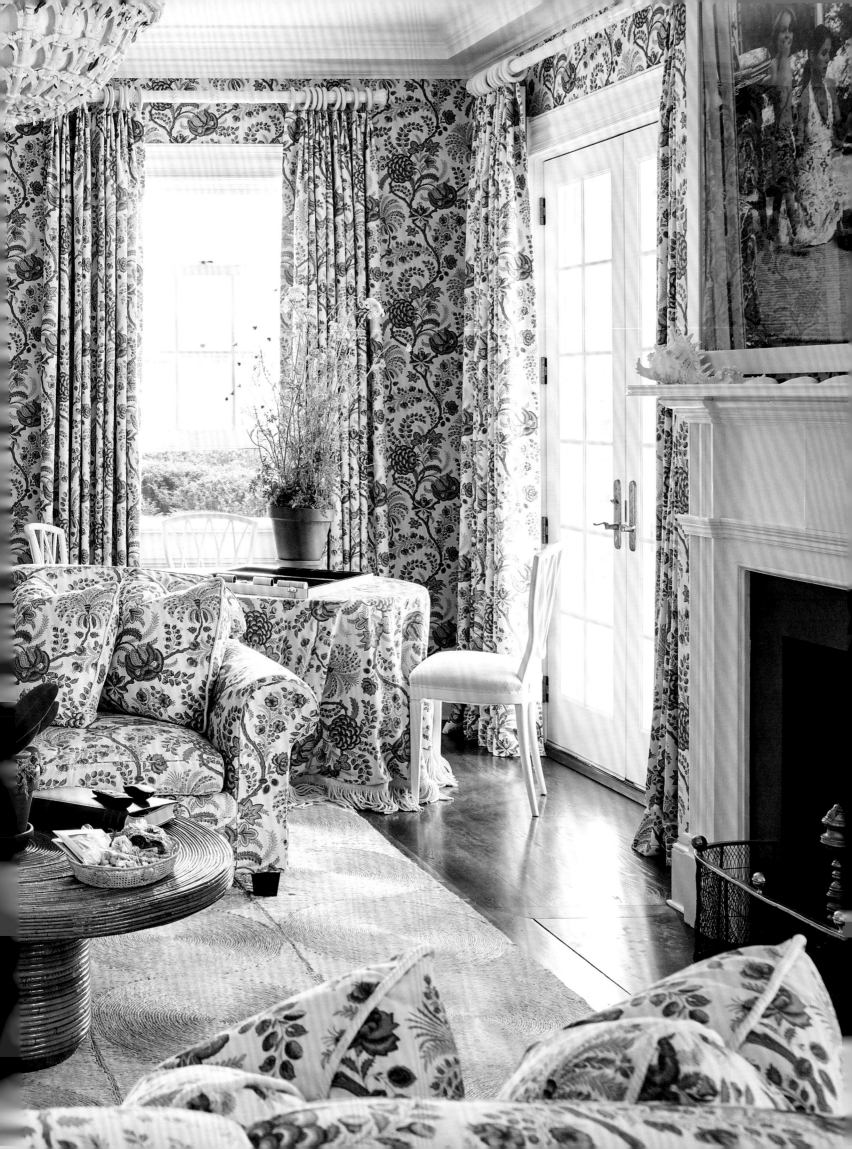

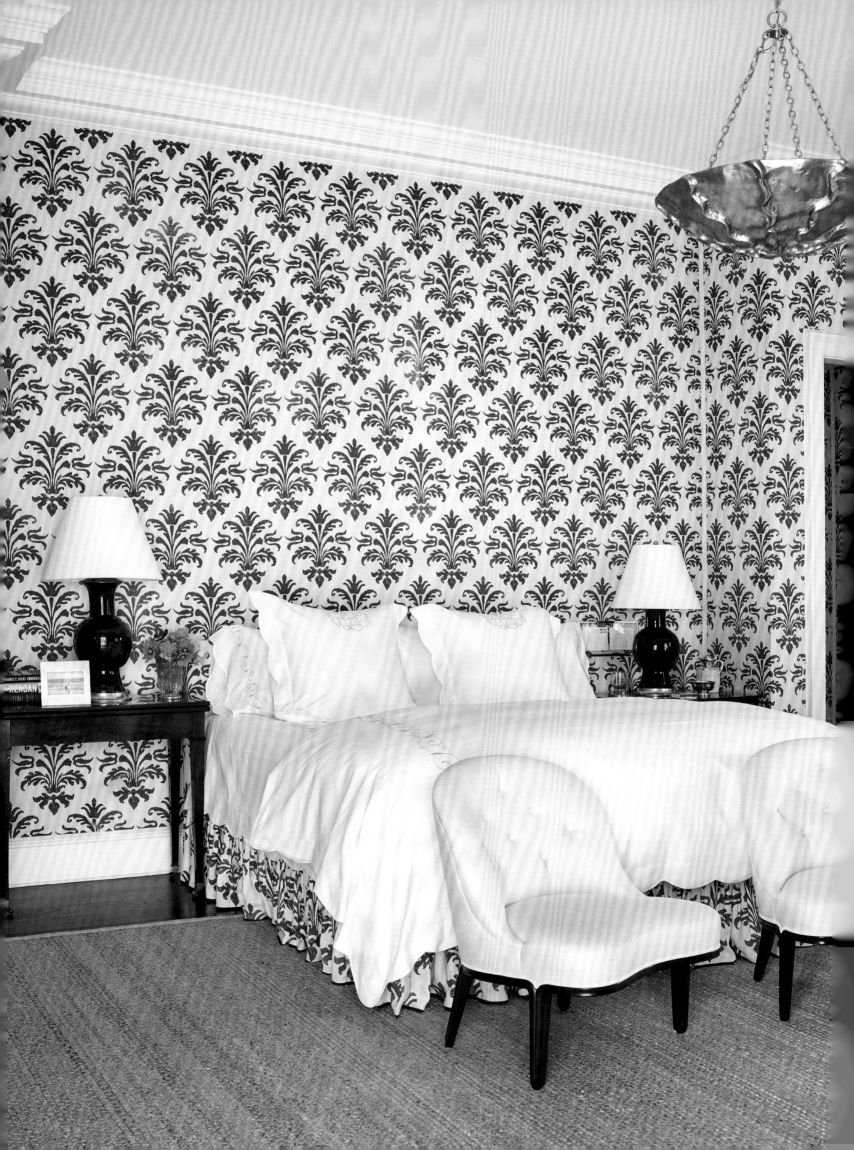

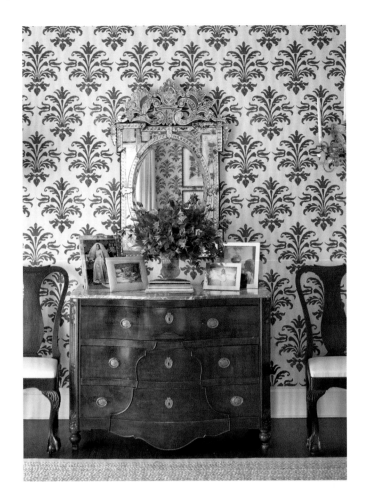

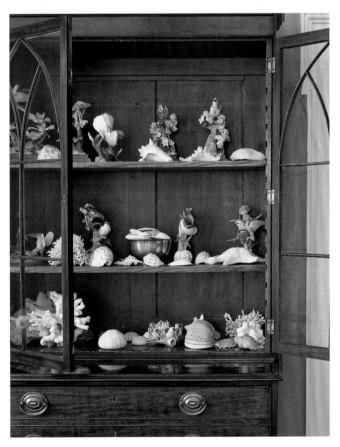

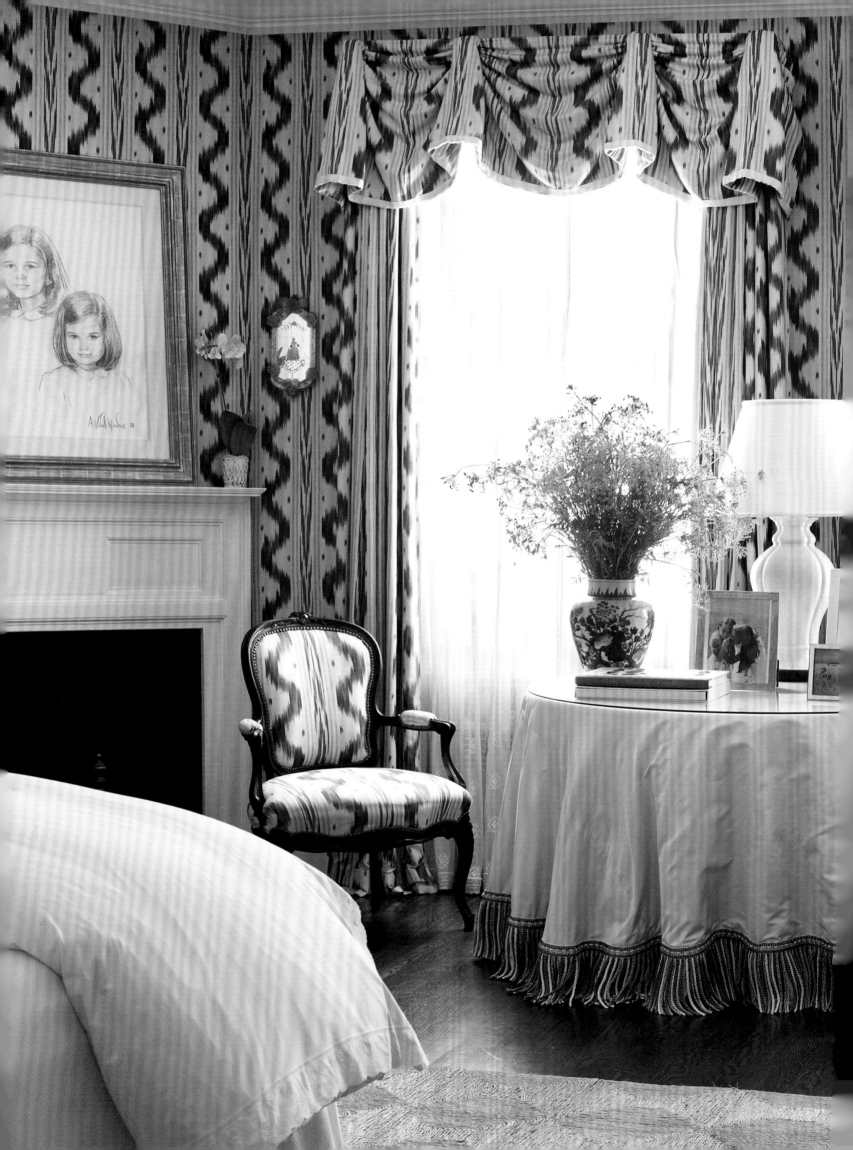

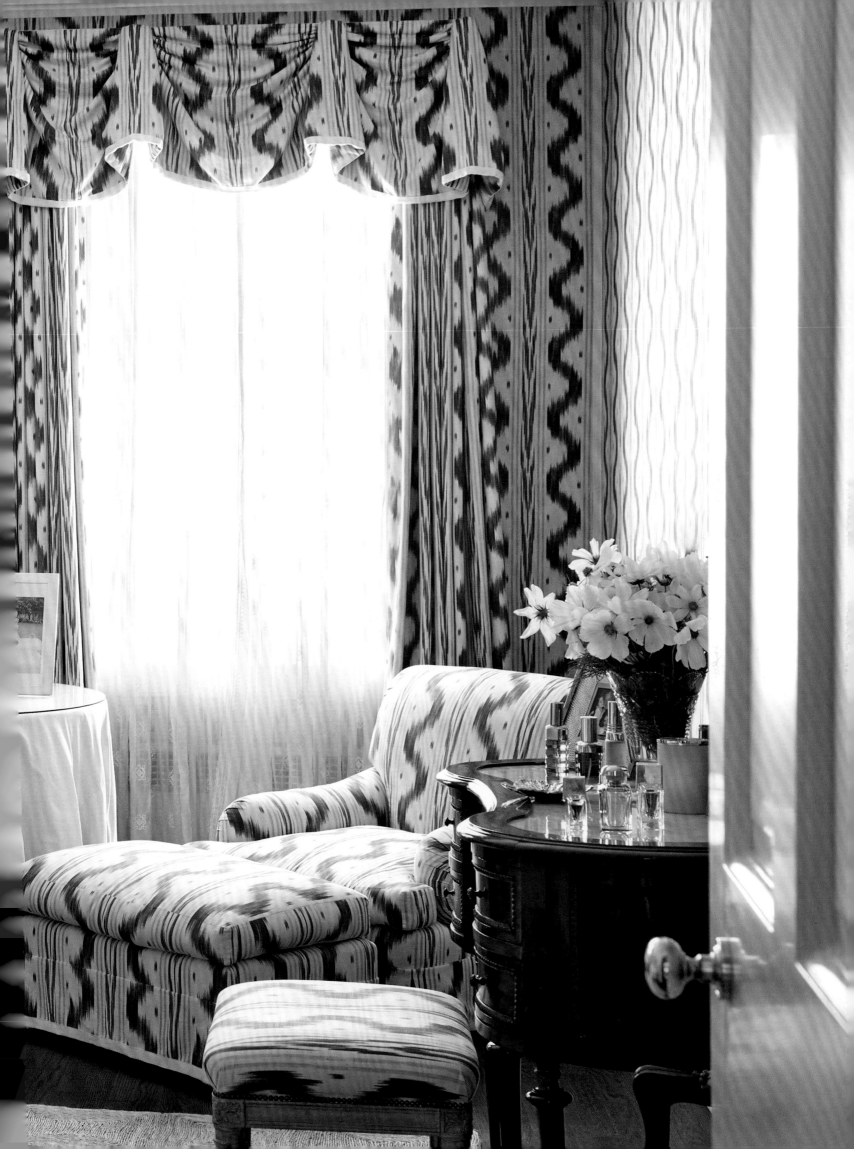

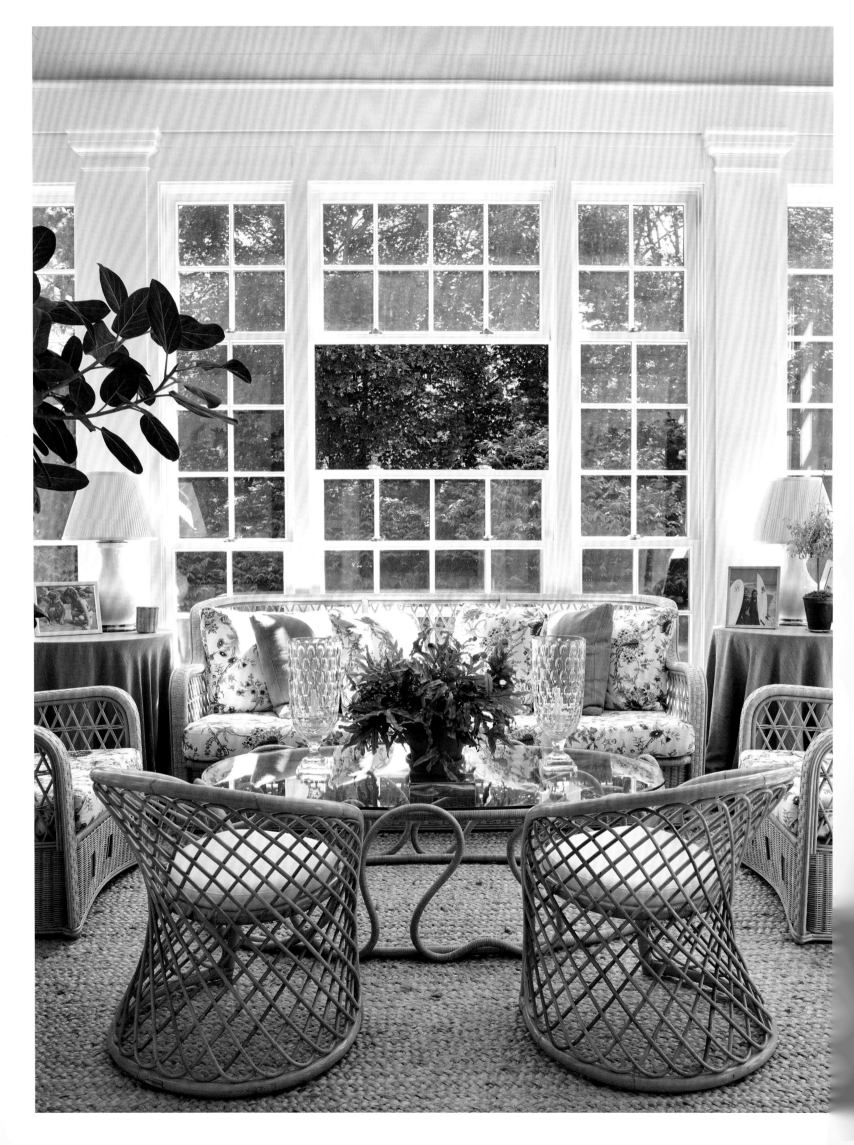

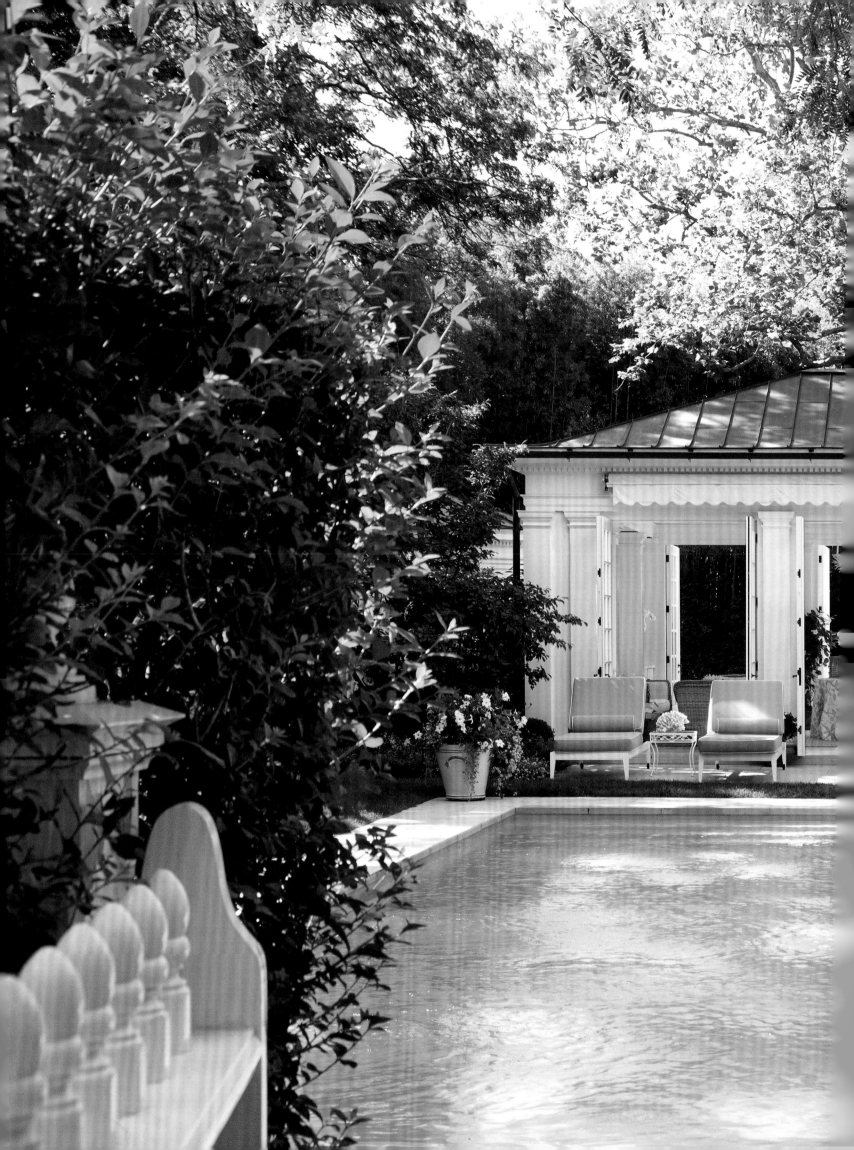

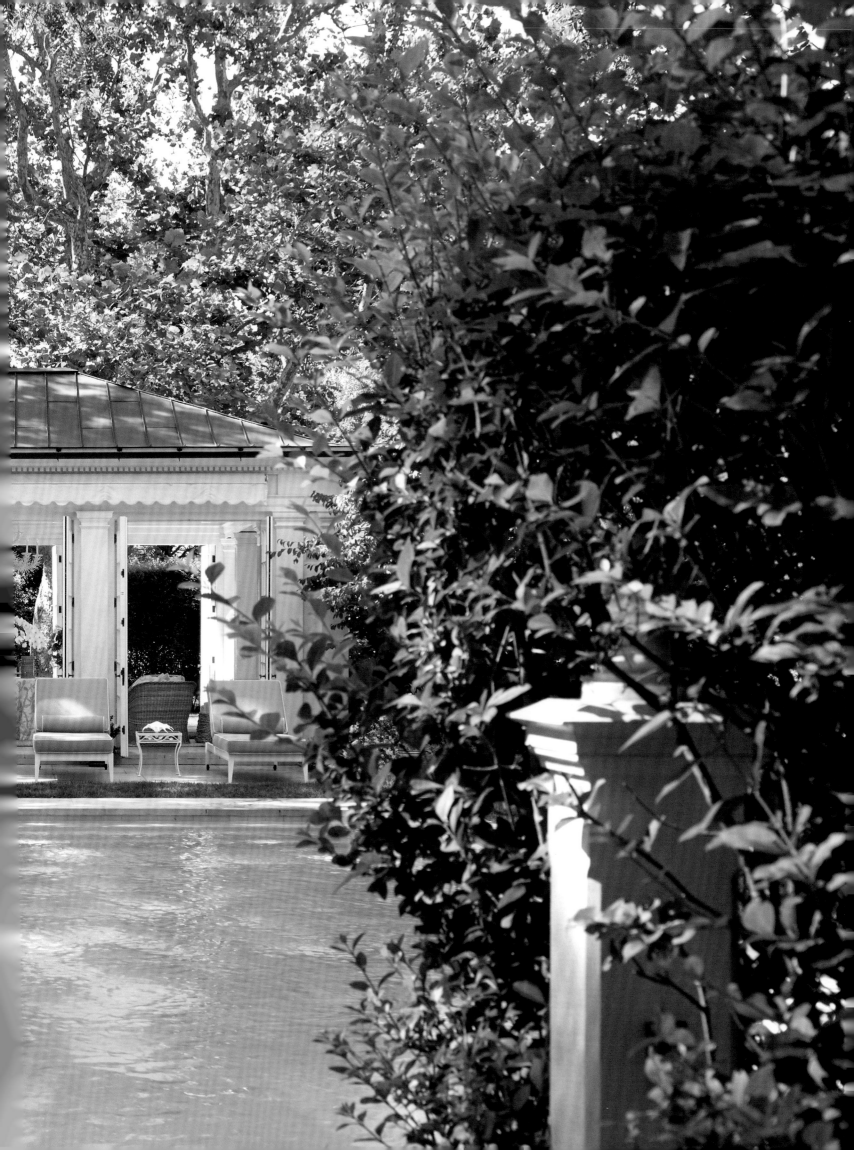

SEA CHANGE

Artist Isamu Noguchi and architect Wallace K. Harrison's 1940 design for a glass-and-birch house, the sinuous lines of which echo the Maine coast on which it sits, embodied the concept "site-specific" long before the term was popularized.

In the mid-1930s, Harrison, one of the lead architects of Rockefeller Center, the United Nations, and eventually Lincoln Center, and a champion of civic art, individual liberties, and the open exchange of ideas, commissioned Noguchi to create the twenty-two-foot-high stainless-steel bas-relief sculpture *News* for the lobby of 50 Rockefeller Plaza. Noguchi's depiction of five journalists was unveiled to great acclaim, but it would be one of his last representational pieces before his work became more abstract and nuanced, a result of the artist's growing obsession with void, change, and hope, after time spent in a Japanese-American internment camp.

About 1940, William A. M. Burden, a scion of the Vanderbilt family, a president of the board of the Museum of Modern Art, and Harrison's close friend, purchased a small peninsula jutting south from Mount Desert Island. He turned to Harrison and Noguchi with the directive to imagine something completely different from the area's typical Shingle Style estates, a structure that would reflect their shared vision for a future of opportunity, individual freedom, and open discourse. Their response was a low-lying house tucked into the coastline that umbilically ties art and architecture with nature and shelter.

[181]

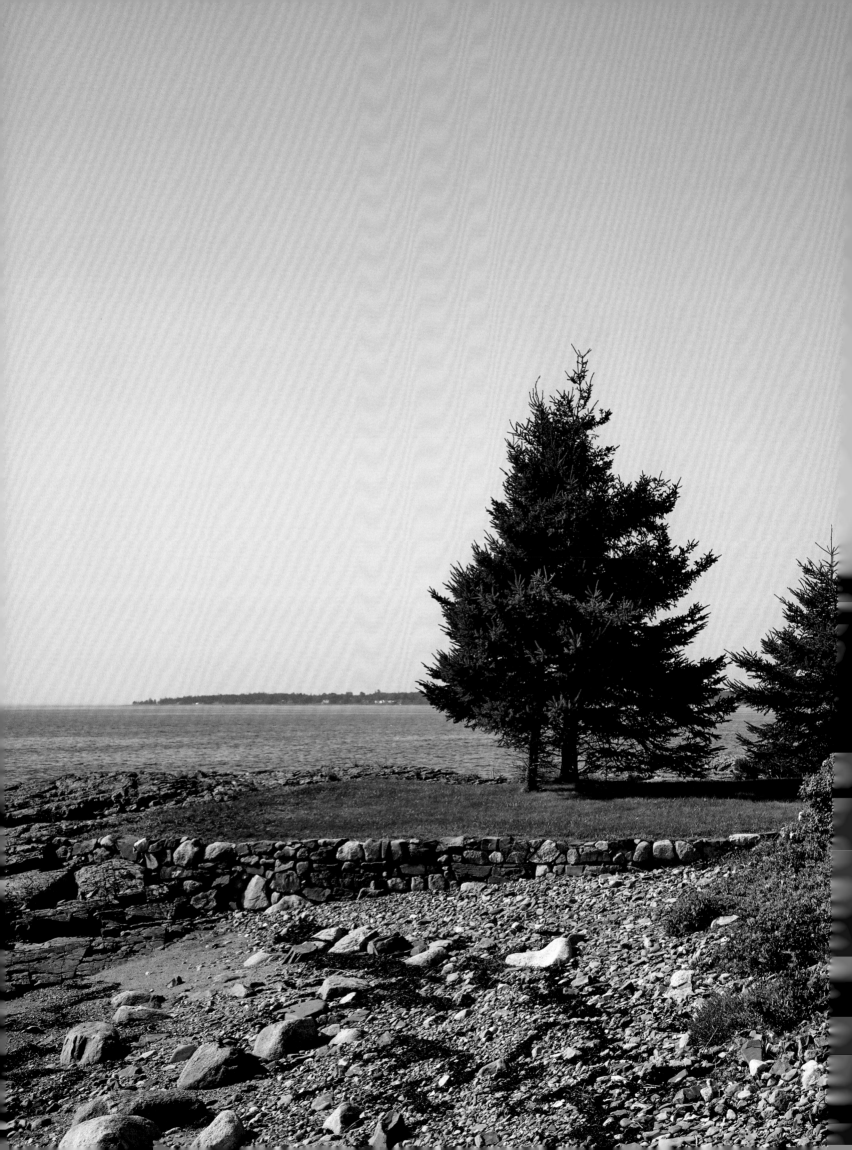

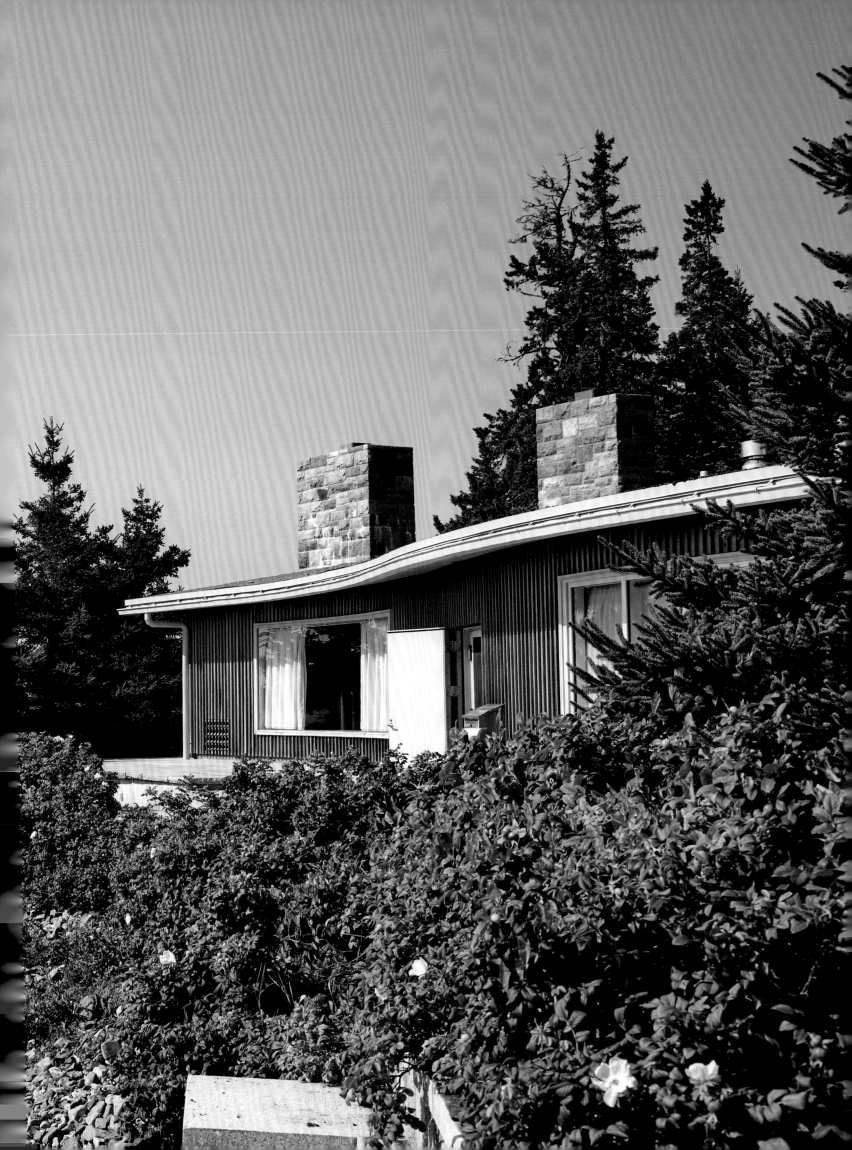

Upon entering, one is immediately struck by the panoramic view through enormous picture windows of the rocky shoreline and Great Harbor beyond, where the horizon is broken only by a small, pine-covered island. A large, open living and dining area curves like an ocean wave and has walls of gray-stained pecky cypress, as well as an undulating fir ceiling. A dining table shaped like a ship's hull continues the sea theme.

In 1996 Ordway Burden, the youngest of William and Margaret Burden's four sons, and his wife, Jean, inherited Sea Change; shortly thereafter, however, it burned to the ground. Having spent almost every summer of his life there, Ordway felt deeply connected to the house and Jean, who had studied architecture, was in awe of Harrison and Noguchi's collaboration. "The place kind of seeped into my skin," she told the *New York Times*. She set about rebuilding, guided by the research of Elizabeth Dean Hermann, an architectural historian, who thankfully had been studying the house, and the photographs of her husband, architect Heinrich Hermann. "I thought I understood the genetic code of the building," Heinrich admitted in the same *New York Times* article.

Heinrich Hermann and the Burdens worked with contractor Dan McGraw of Atlantic Builders; sculptor and woodworker Mark Loftus, who re-created Noguchi's dining table; and master woodworker Jim Robinson, who painstakingly reproduced every curve of the living/dining room's ceiling. Meanwhile, Burden and Hermann tracked down certain obscure materials such as wall panels of Weldtex, a textured plywood also used in Radio City Music Hall.

Those who have been to both the original house and the renovated version cannot tell the difference, a testament to Jean Burden's singular determination to preserve a timeless, if unique, design. In 2009 the house was listed on the National Register of Historic Places, which notes its exceptional modern architecture and a rare Harrison design outside of New York.

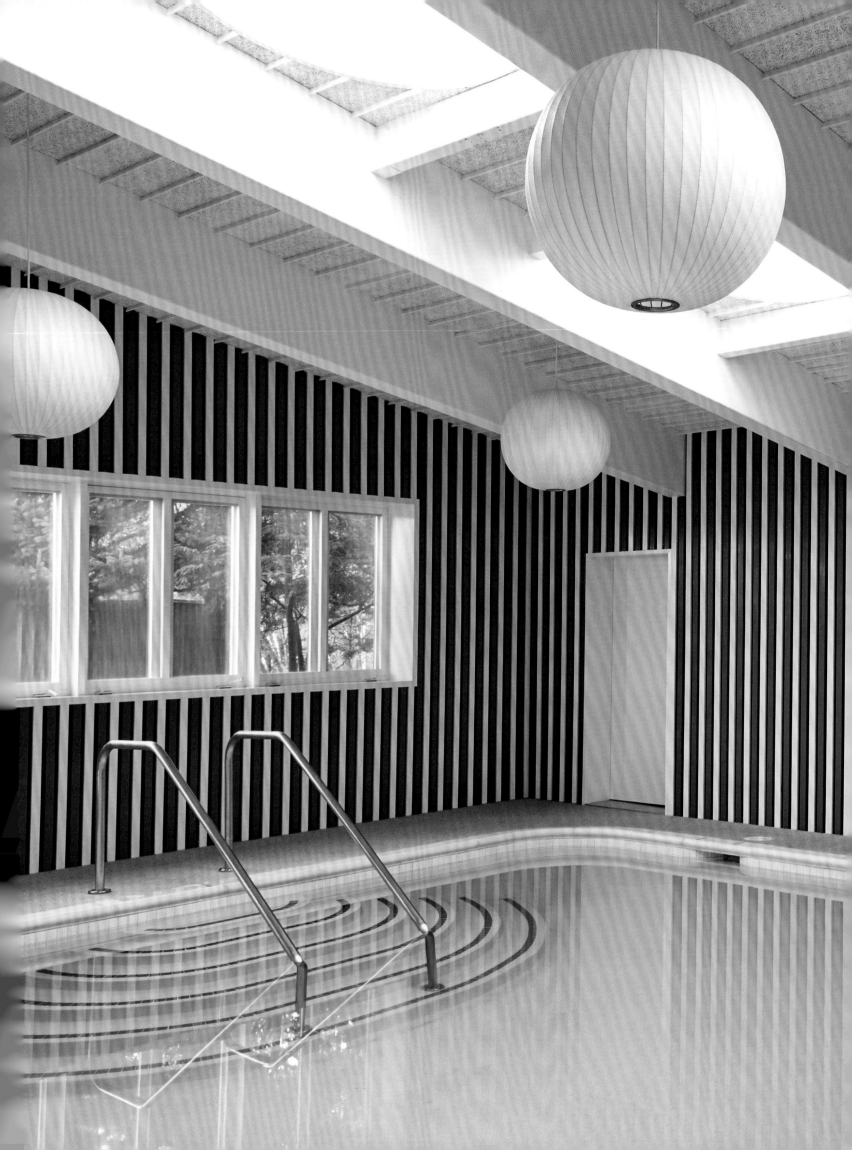

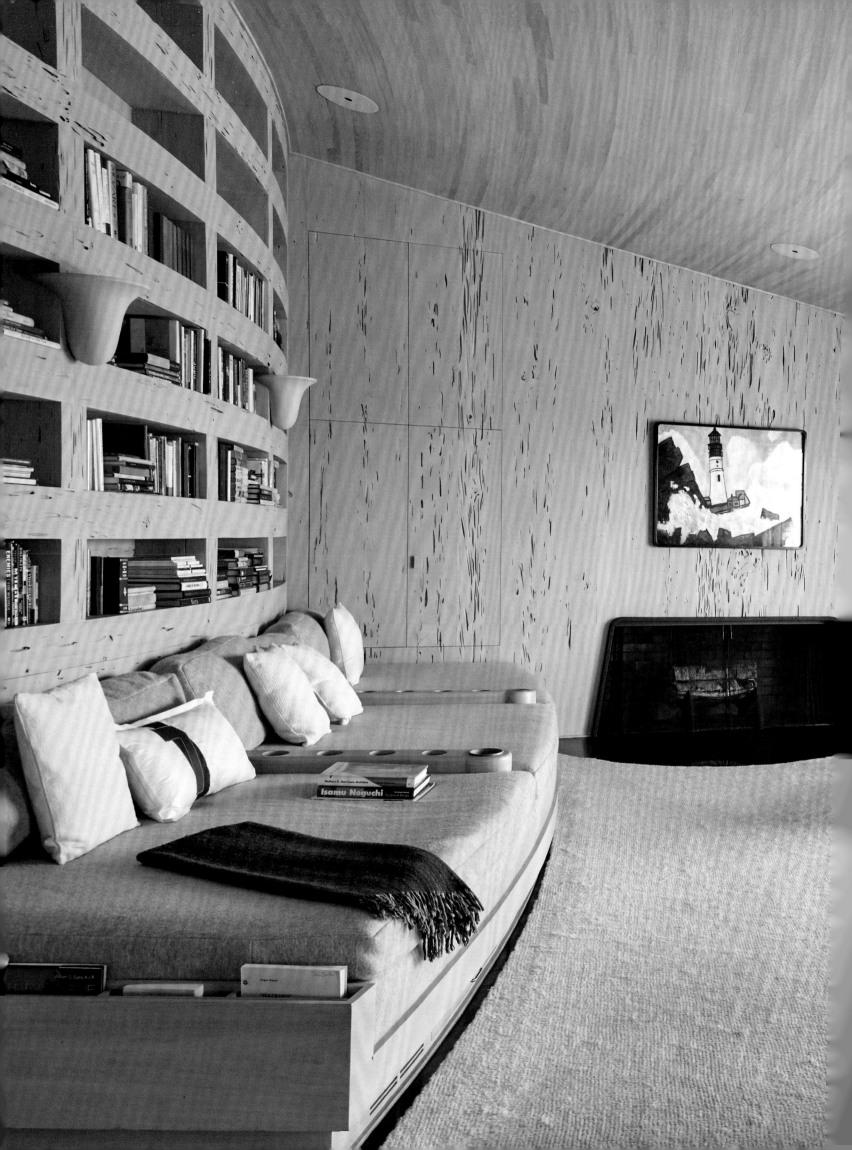

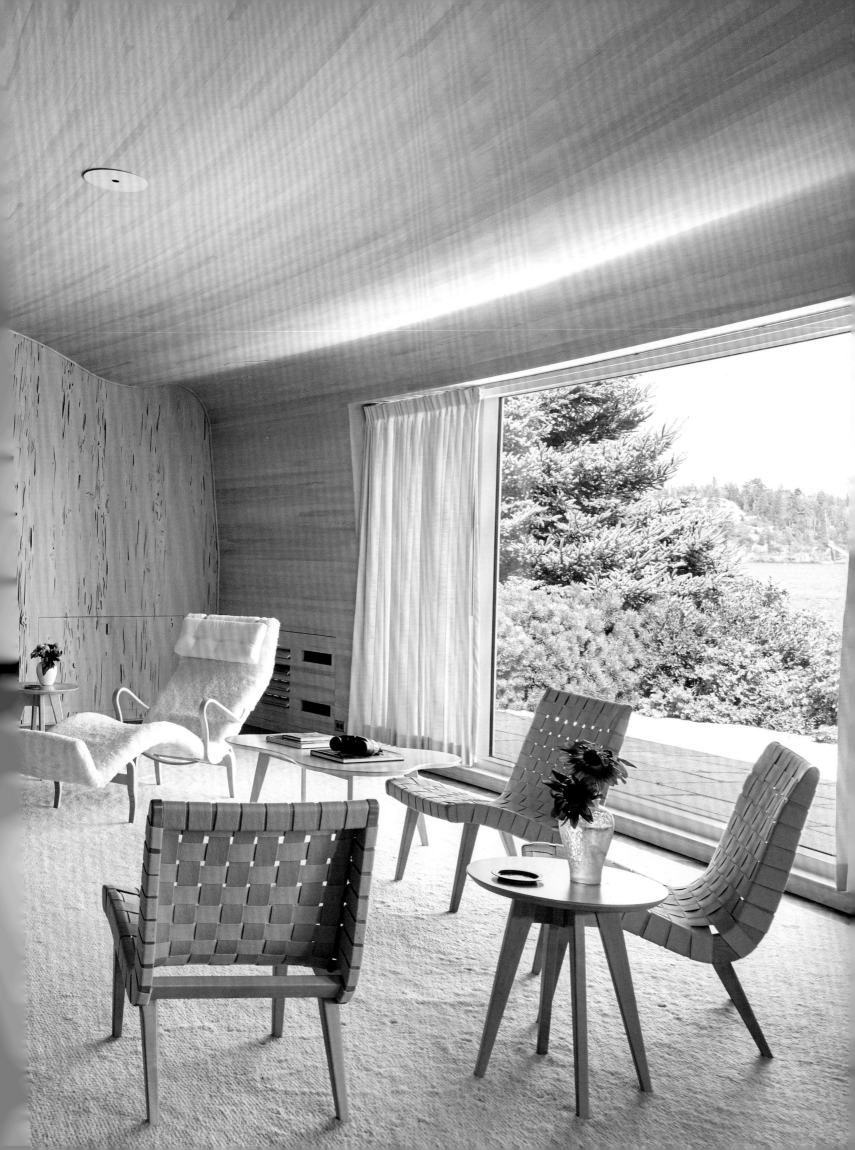

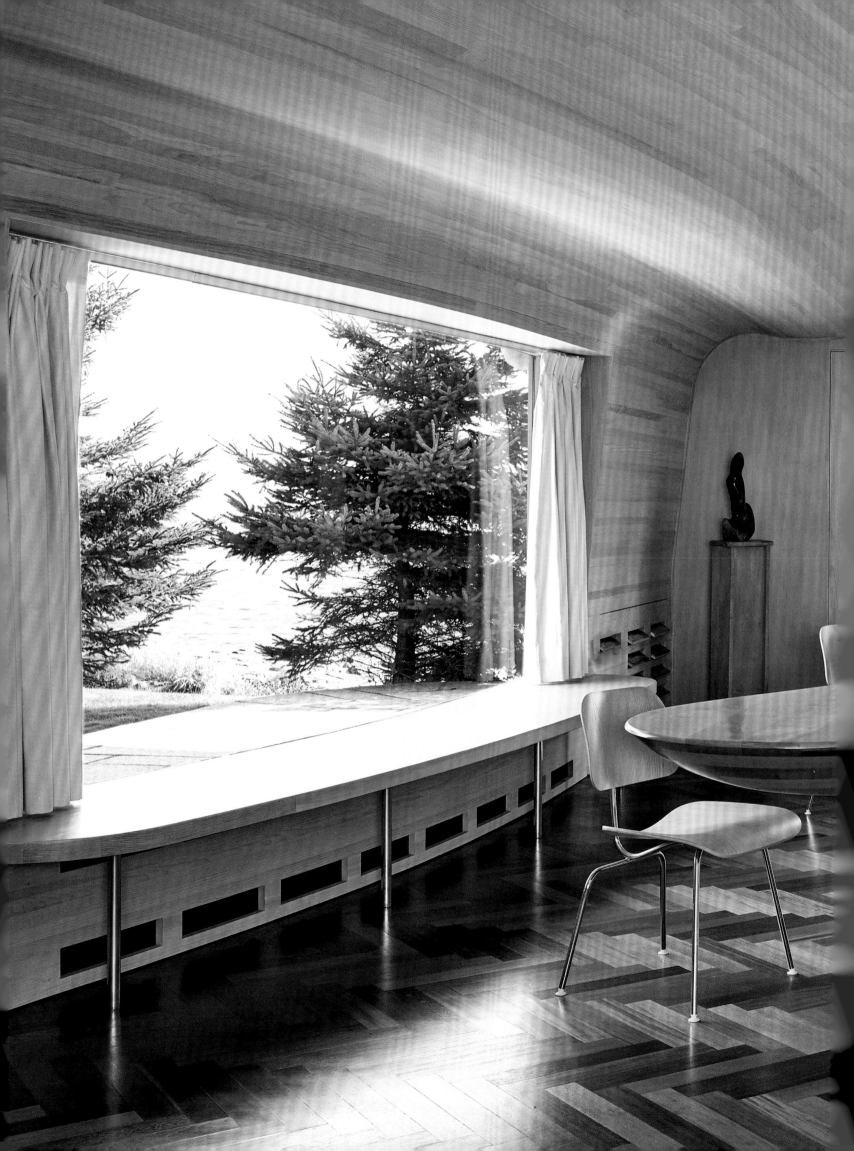

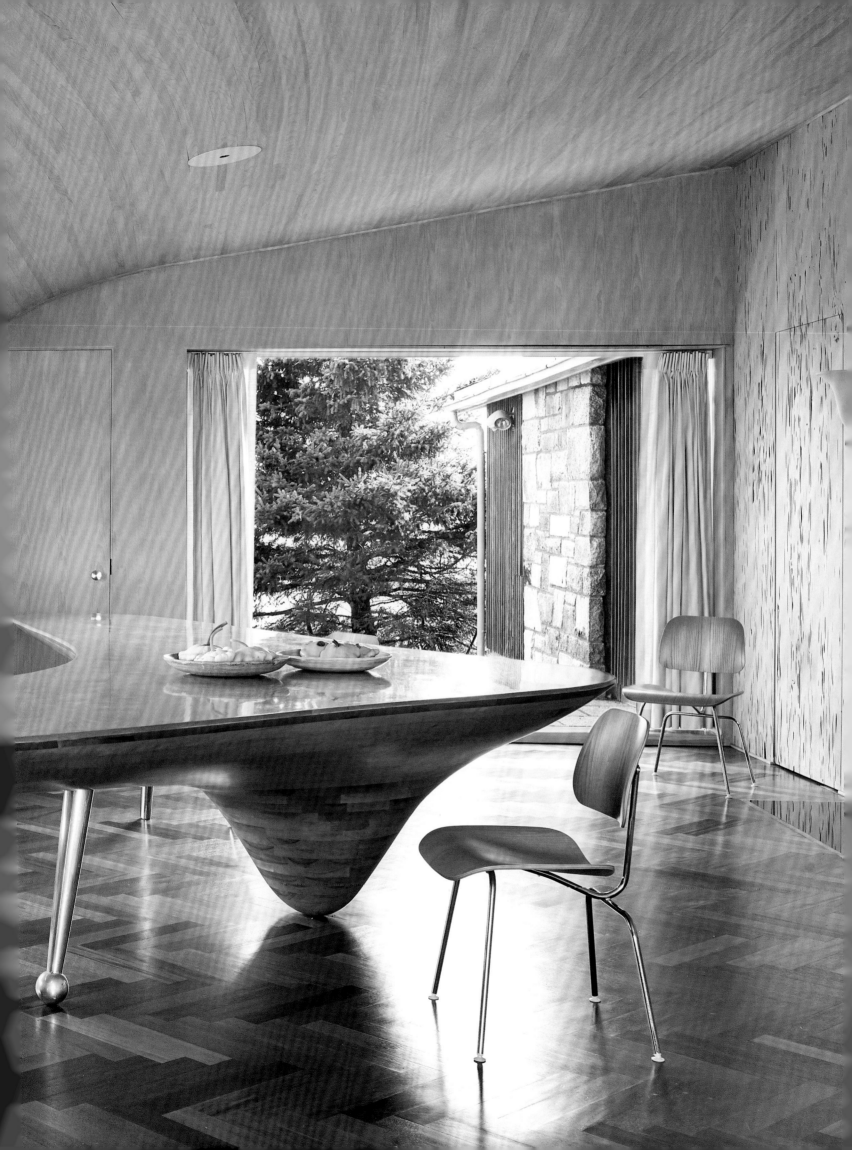

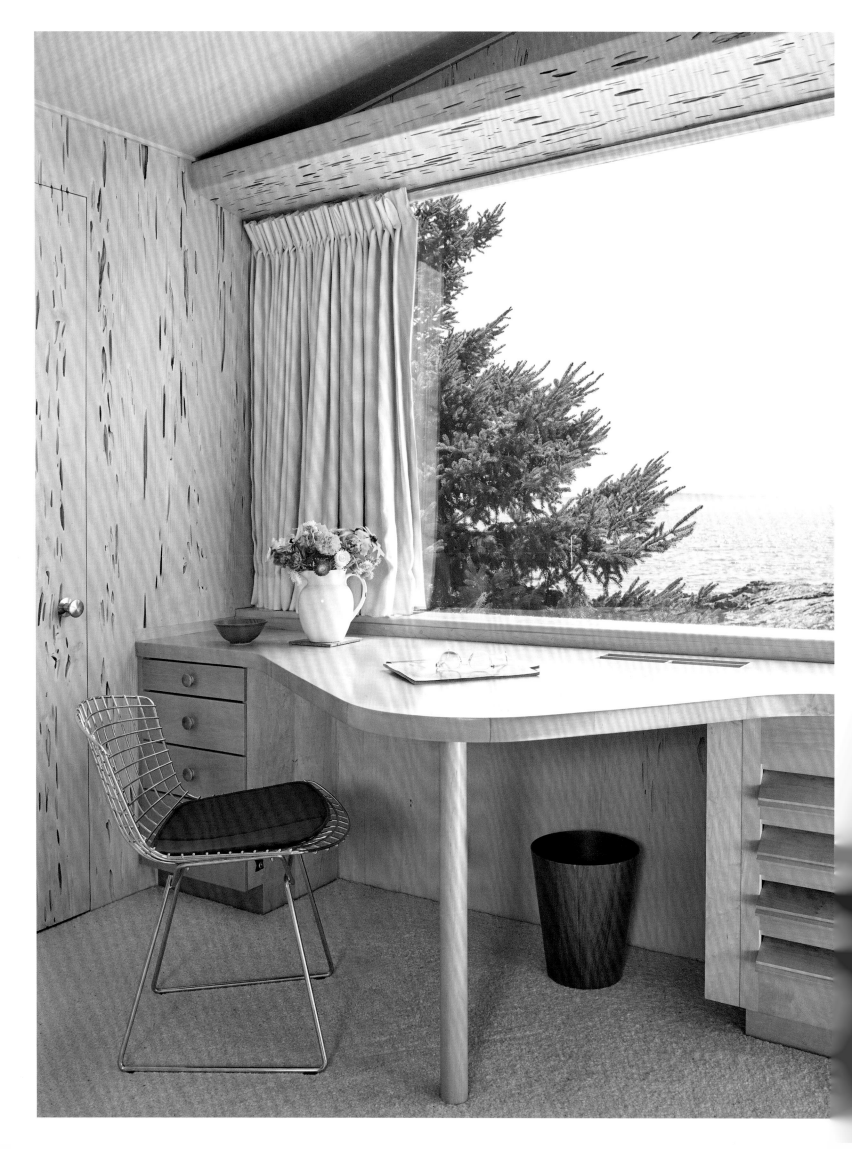

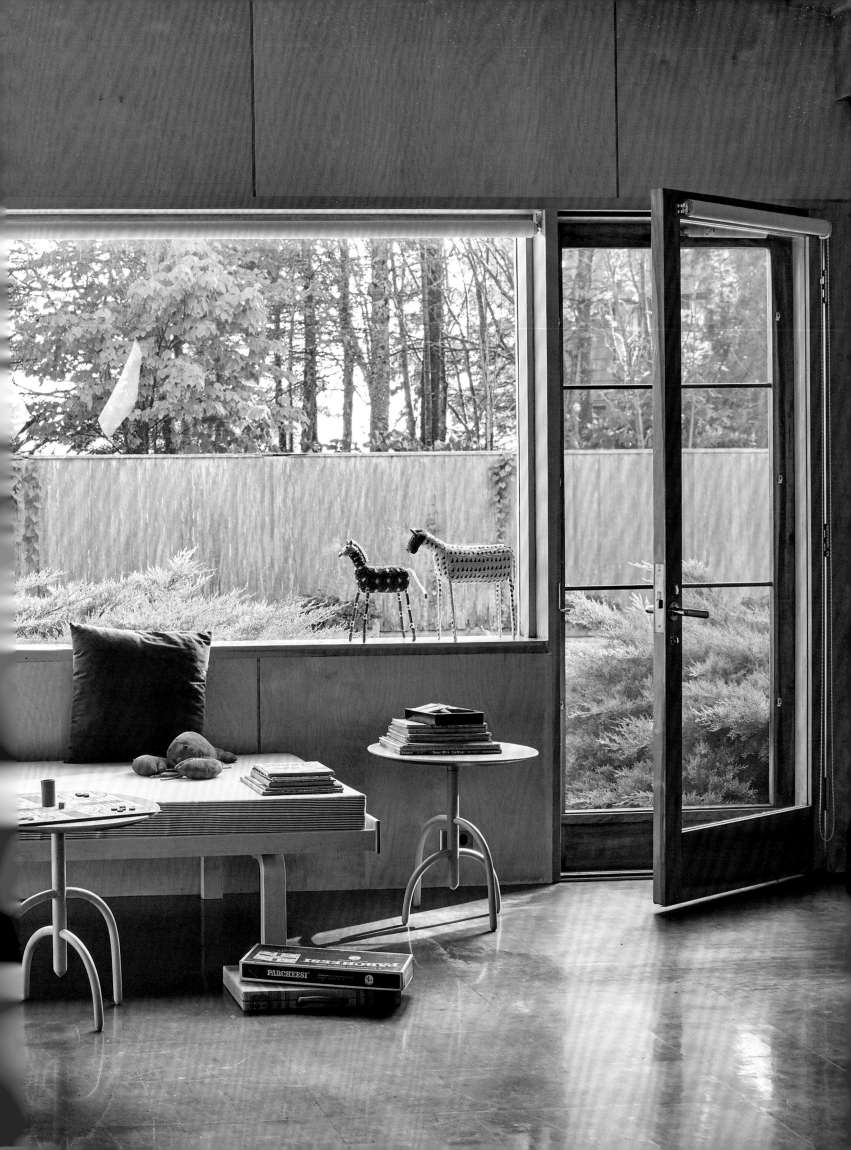

THE SUMMER HOUSE

Apple Bartlett's inviting seaside cottage on an island in Maine has been in the family since 1945. The interiors brim with an artful mix of painted wicker, handwoven baskets, mattress ticking, vintage quilts, and intricately patterned hook rugs, a look instituted by her late mother, Dorothy "Sister" Parish, who reigned over three generations of American design as head of the legendary New York firm Parish-Hadley Associates. When Jackie Kennedy engaged Sister Parish to reimagine the White House interiors, a newspaper mistakenly ran the headline, "Kennedy Picks Nun to Decorate the White House."

"My mother always made everything comfortable, nothing too serious. She just had an 'eye' and the way she mixed things was magical." With Parish's passing, Bartlett knew the time had come to make the house her own, but change has never come naturally or easily to her. Her daughter, Susan Crater, gently prodded her to undertake the process of freshening up and paring down. "She asked me if I would ever think of taking down just one set of curtains in the living room to let in more light. Just for a day, to see if I liked it. I took down the blue-striped pansies but left the dotted Swiss sheers. It made all the difference!"

Emboldened by the experiment—and by the impending visit of *Vogue* editor in chief Anna Wintour, who had rented the place for an island wedding—Bartlett set about redoing much of the house. "There's nothing like a deadline to get you going." What had famously been a riot of chintz became a bright but mostly

solid blend of upbeat pinks, yellows, and greens. "Like my mother, I like whimsical, nothing too serious. But now my motto is: Color yes, clutter no."

Every day, the house is graced by Bartlett's floral arrangements, some ingeniously made of lettuce and cabbage from her beloved vegetable and cutting garden. "On an island, you use what you have."

Bartlett enters and exits through the garage, which doubles as a studio where she makes fantastical collages. "I started making collages after I saw an exhibition in Washington, D.C., of Gloria Vanderbilt's work. I thought, I can do that. My first piece was a simple watermelon. They've become more sophisticated. I work on them in the fall, winter, and spring. Summer is too busy here."

Every summer since 1981, Bartlett has operated one of the few shops on the island, Apple's, a mecca for American country style enthusiasts. "My mother had all these women in Maine sewing constantly. She was a real champion of American crafts, and we like to keep that going." The shop is run out of an old laundry house with three deep farm sinks in the back, not far from Bartlett's house. "It's a perfect place for my kind of shop: chipping windows, slanted floors. My things look very good here. I don't like slick and I don't follow fads. I added clothing five years ago, including caftans and kimono robes. Of course, we carry Susan's spatterware and pillows. They do very well."

Friends swing by as much to peruse the inventory as to check in with Apple and her beloved yellow Lab, Billy, who goes everywhere with her. "I'll see you at tomorrow's exercise class," says a neighbor, opening the door to leave while turning to her friend to exclaim, "Apple can hold a plank for eight minutes."

"I've known these people all of my life," Bartlett says as the screen door slams shut. "I love the air, the smell of the pines, and the ocean, but what I really like is the sense of security here."

PAGES 196–97: The Summer House, as it has been called since 1945, sits in a field amid pines, birches, and a fruit orchard. A sizable cutting and vegetable garden overlooks a befogged cove.

OPPOSITE: A dollhouse populated with ceramic figurines and miniature birdhouses sits on the porch of Summer House. Built as a Cape Cod–style cottage in the nineteenth century, it has been expanded over the years. Bartlett's yellow Lab, Billy, welcomes visitors.

PAGES 200–201: The living room, which was formerly a riot of chintz, is now a more subdued blend of patterns, textures, and colors. The needlepoint-and-velvet-covered slipper chair is one of numerous handmade pieces to be found at Summer House. As in Sister Parish's interiors, handmade objects abound, among them painted lamps (by Parish-Hadley), needlepoint pillows, and an exuberantly patterned hooked area rug. "It

pulls the whole room together," says Bartlett. The sofa, pillow, and tub chair fabrics were designed by Bartlett's daughter, Susan Crater.

PAGES 202–3: Majolica dishes and pitchers line the shelves of a painted Irish cupboard in the dining room. Sister Parish painted the chairs white.

PAGE 204: Bartlett's favorite room is the pantry. The open shelving makes setting the table easy. Many of the pieces were found in the New York's former Mediterranean Shop.

PAGE 205: The whimsically stenciled back staircase is in the original part of the house. It leads to an upstairs bedroom and sitting room.

PAGE 206: Sister Parish always said, "If you ever see a piece of needlework, buy it!" These pillows were a gift from a grateful client.

PAGE 207: Susan Crater's room features an early twentieth-century chaise covered in an American quilt. The family referred to the room as the "Dark Hole of Calcutta."

PAGES 208–9: Sister Parish became known as a proponent of American country style, which prized incorporating such humble materials as mattress ticking, patchwork quilts, and rag rugs. "She put quilts in rooms with important French furniture," Bartlett says. Both canopy beds are family heirlooms.

PAGES 210–11: Many of the fabrics are from Sister Parish Design, founded by Bartlett's daughter, Susan Crater, to resurrect some of Parish-Hadley's custom fabrics and wallpapers, including Kinnicutt (Sister Parish's maiden name), which covers the walls in a guest bedroom. Eliza Crater, Susan's daughter, has joined the company. According to Bartlett, she is a "whirlwind of ideas, and modernity."

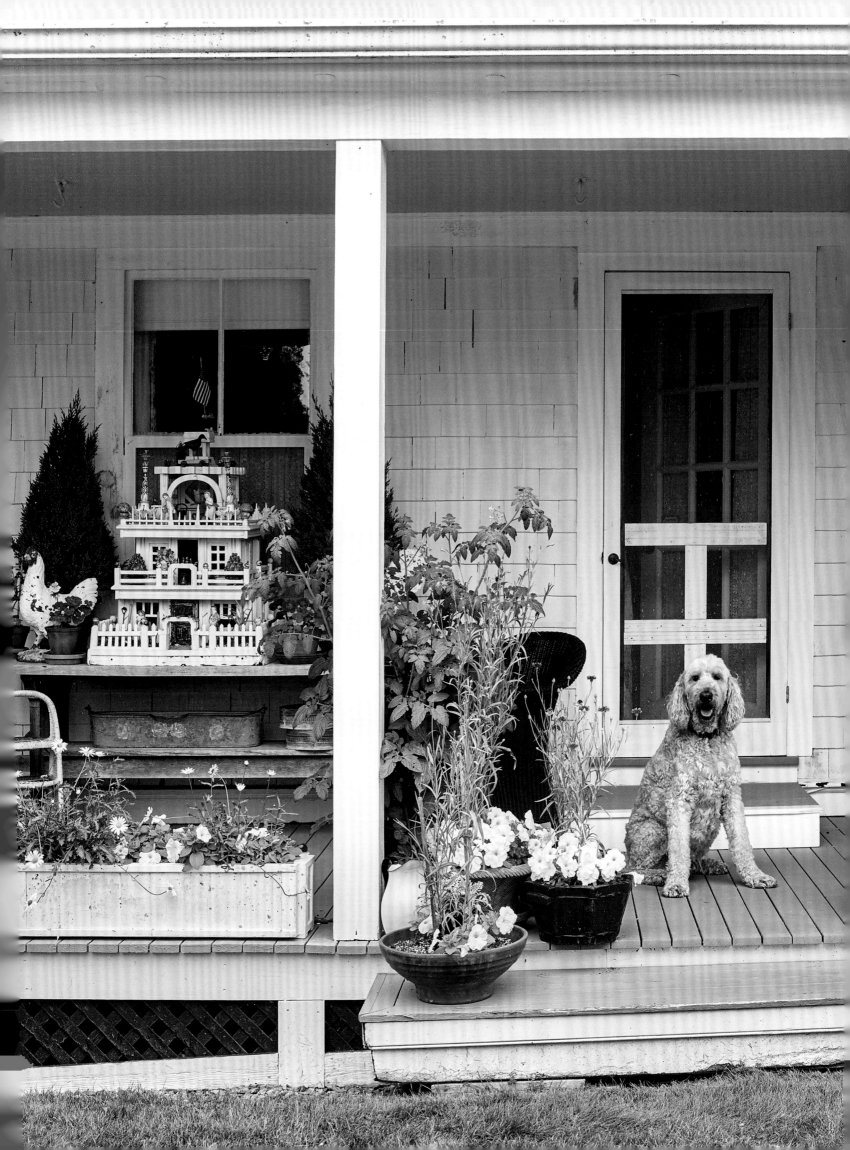

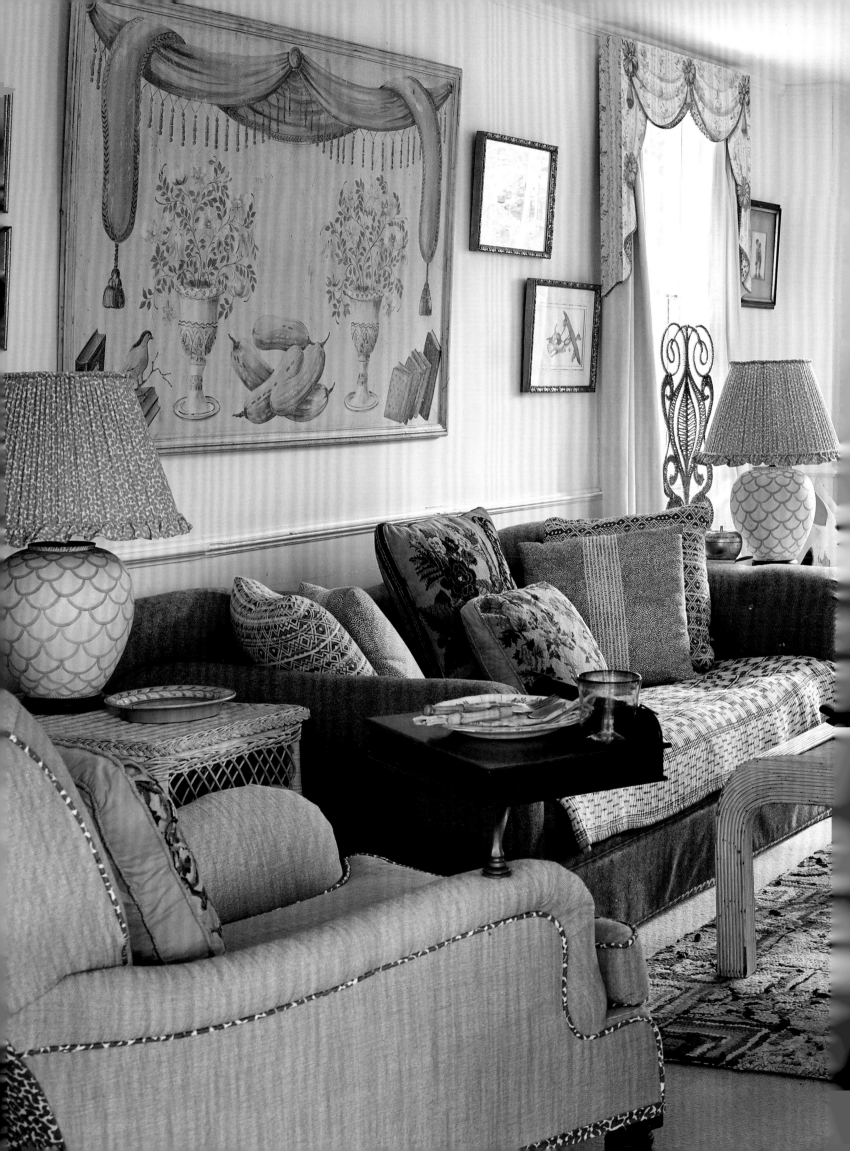

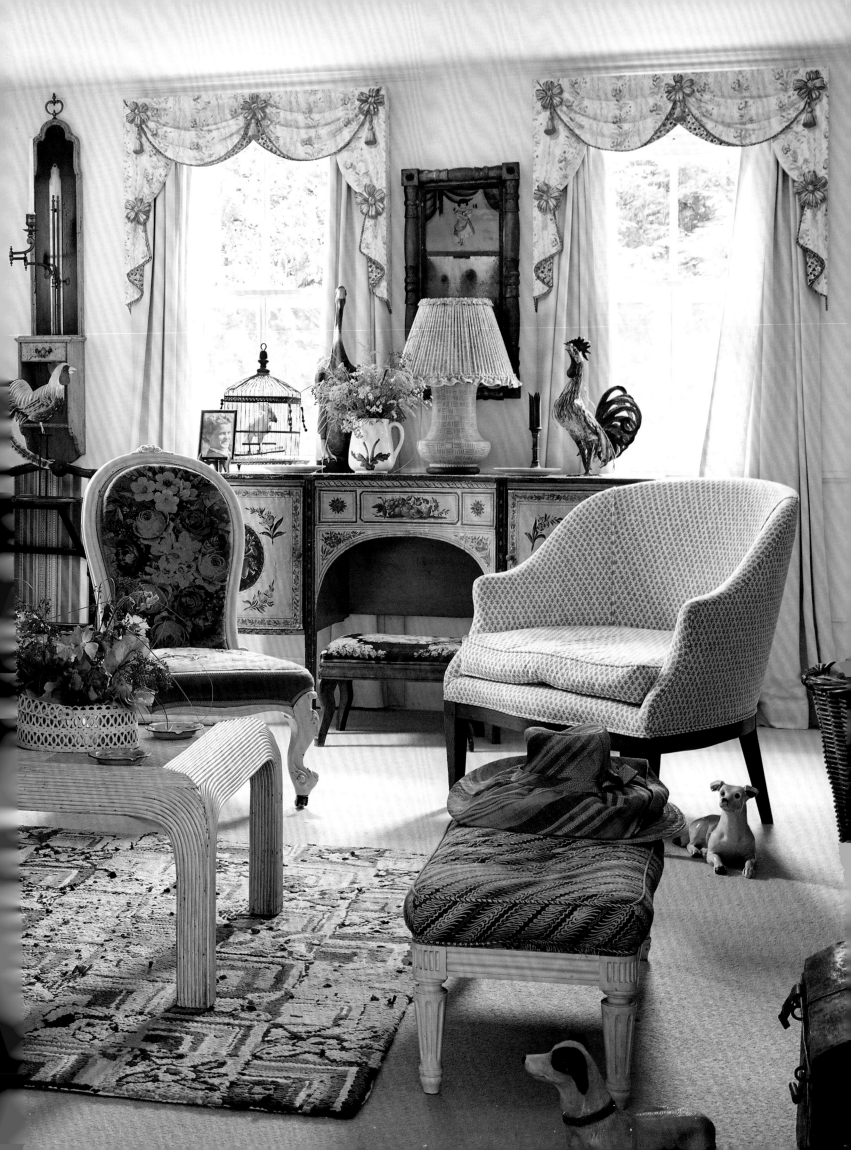

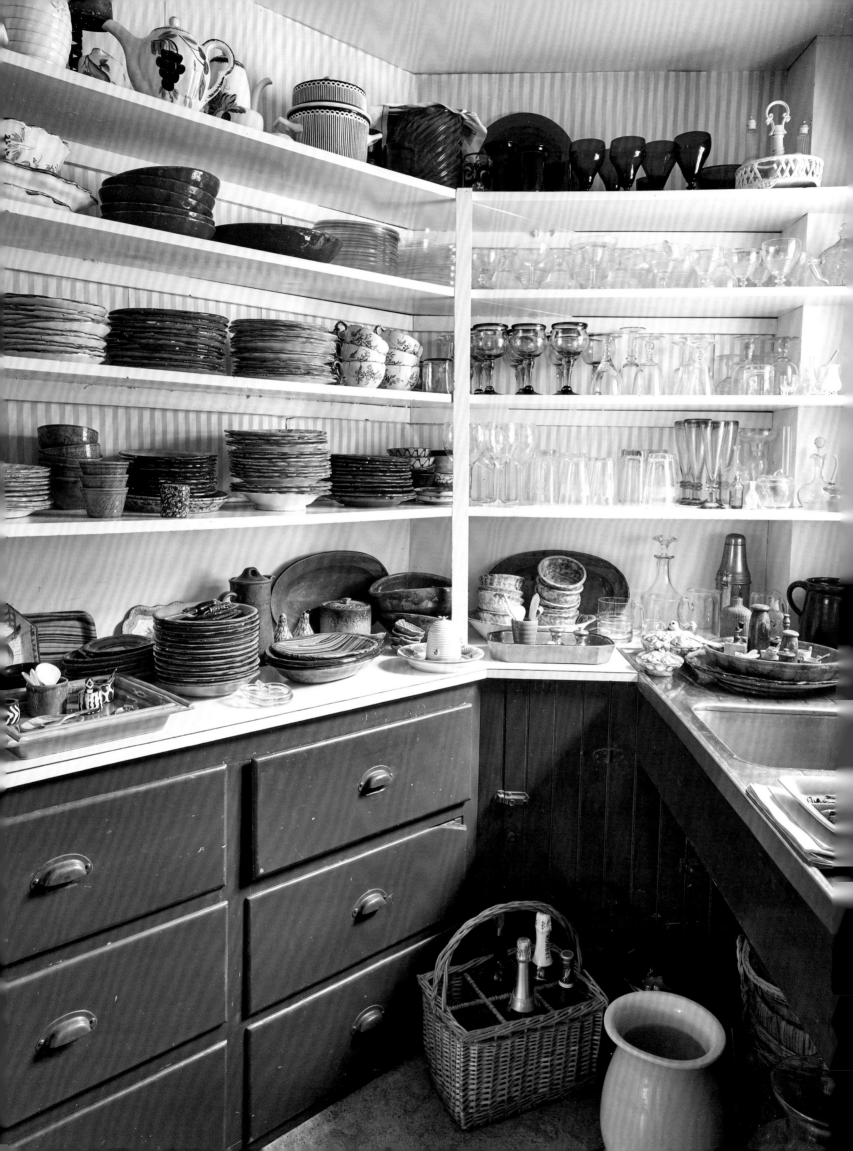

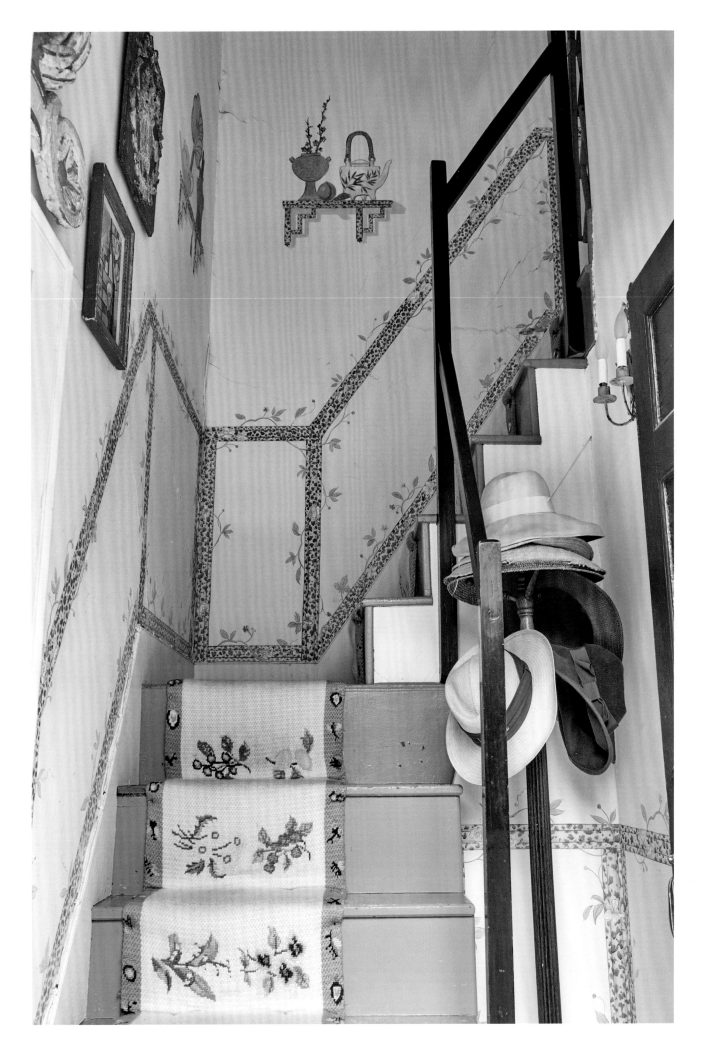

Famed designer Sister Parish
Can be bold but never garish.
Her clients superior
All know their interior
Will be rich but never lavish.

Though a grand or small interior,
Clients calm or in hysteria,
Be they Lords or just plain Mr..
Can all rely on Sister —
Her work is so superior.

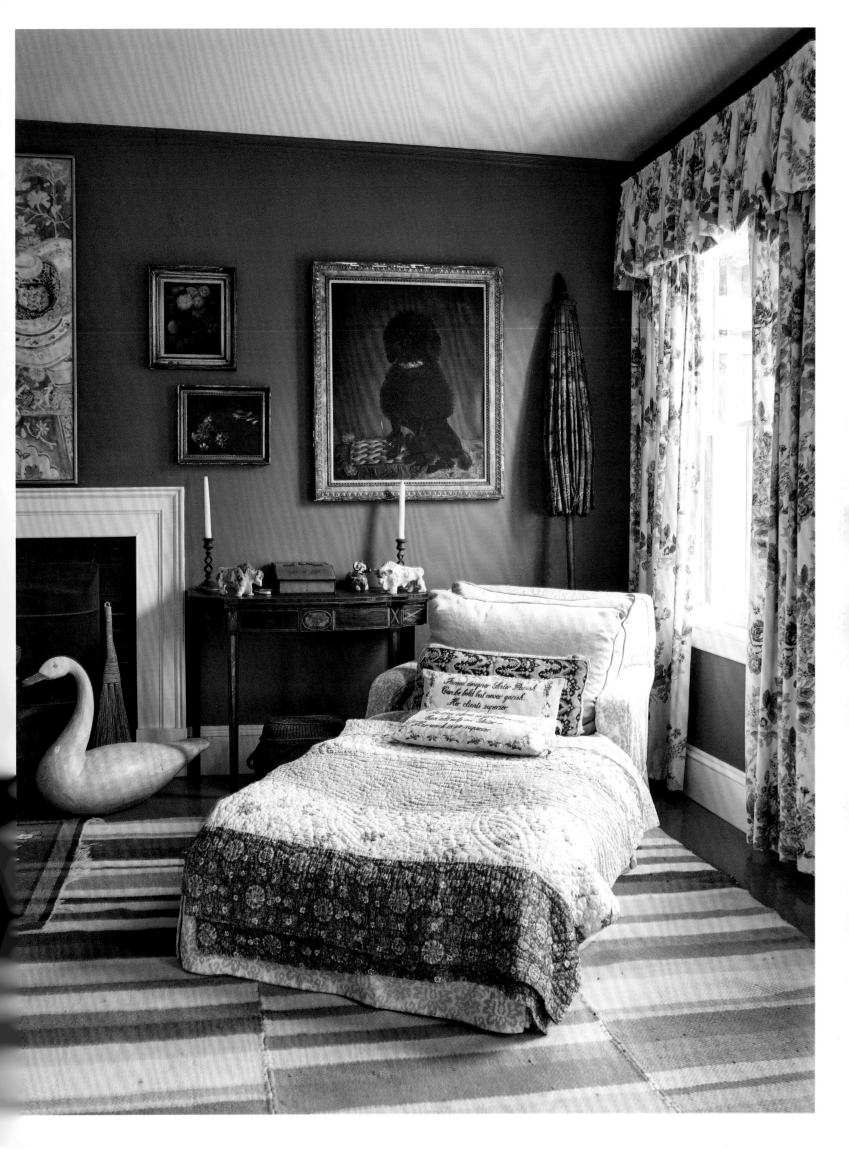

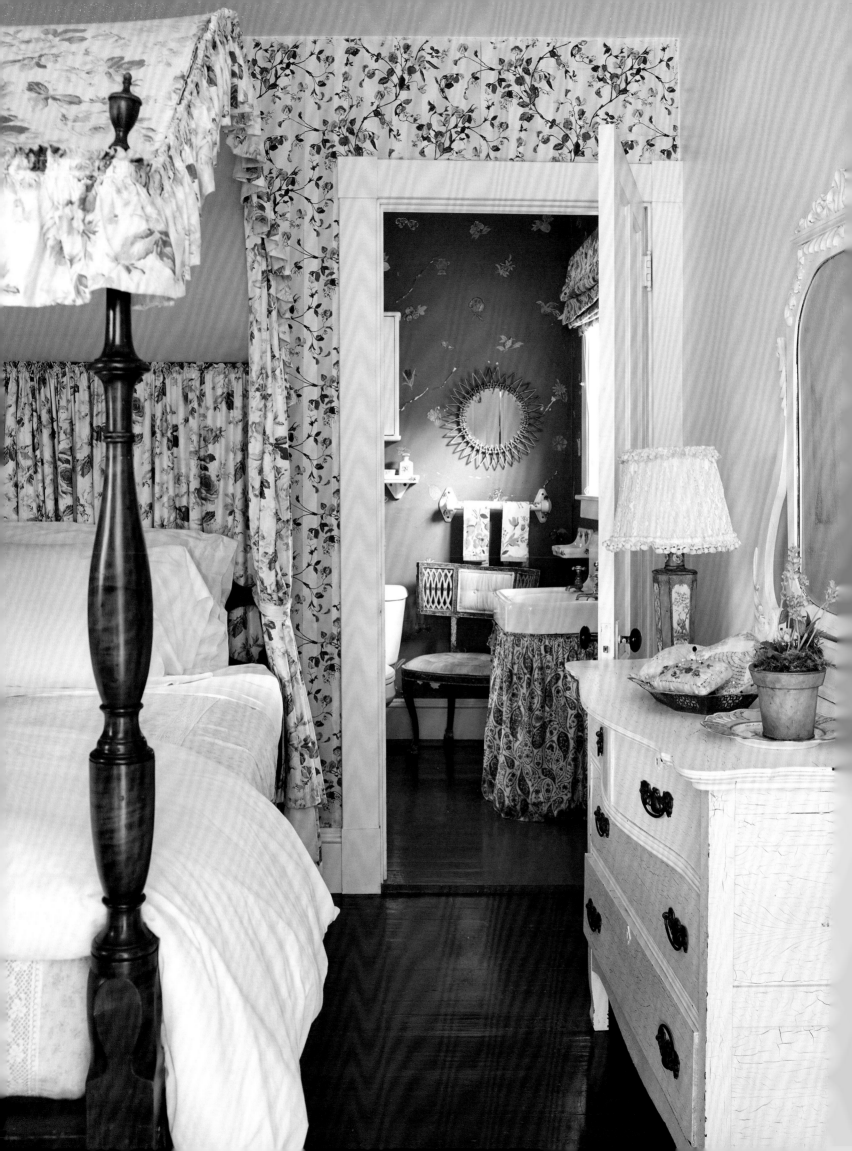

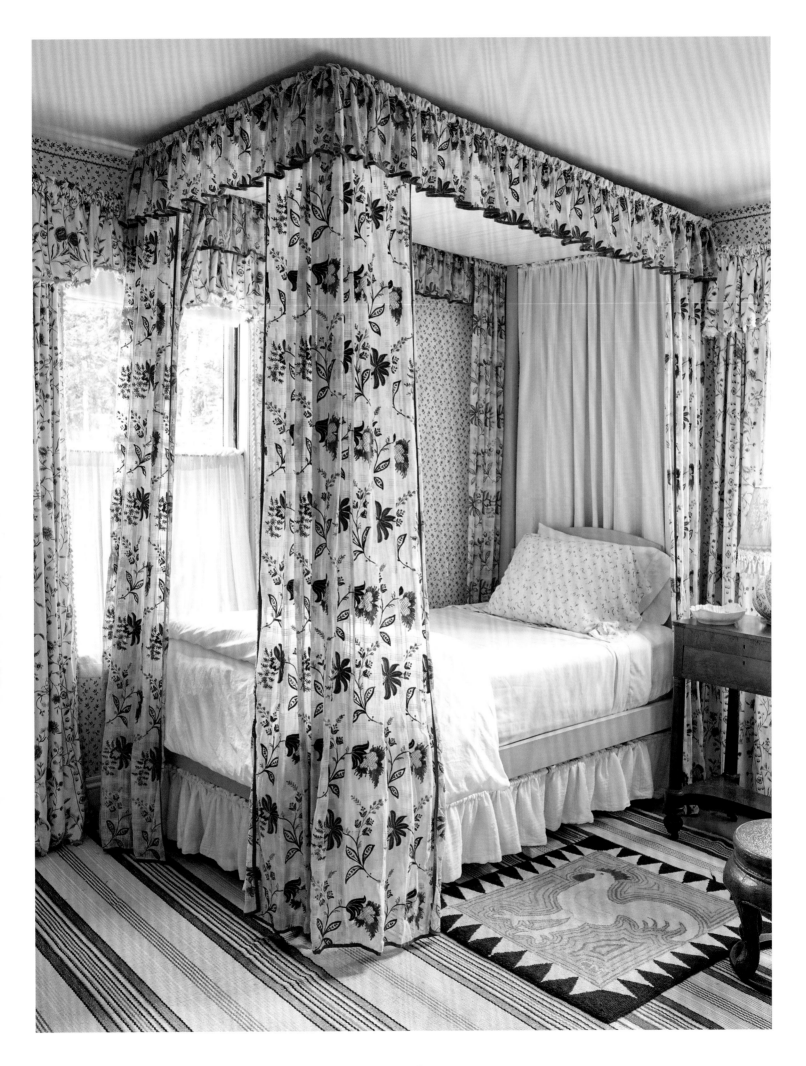

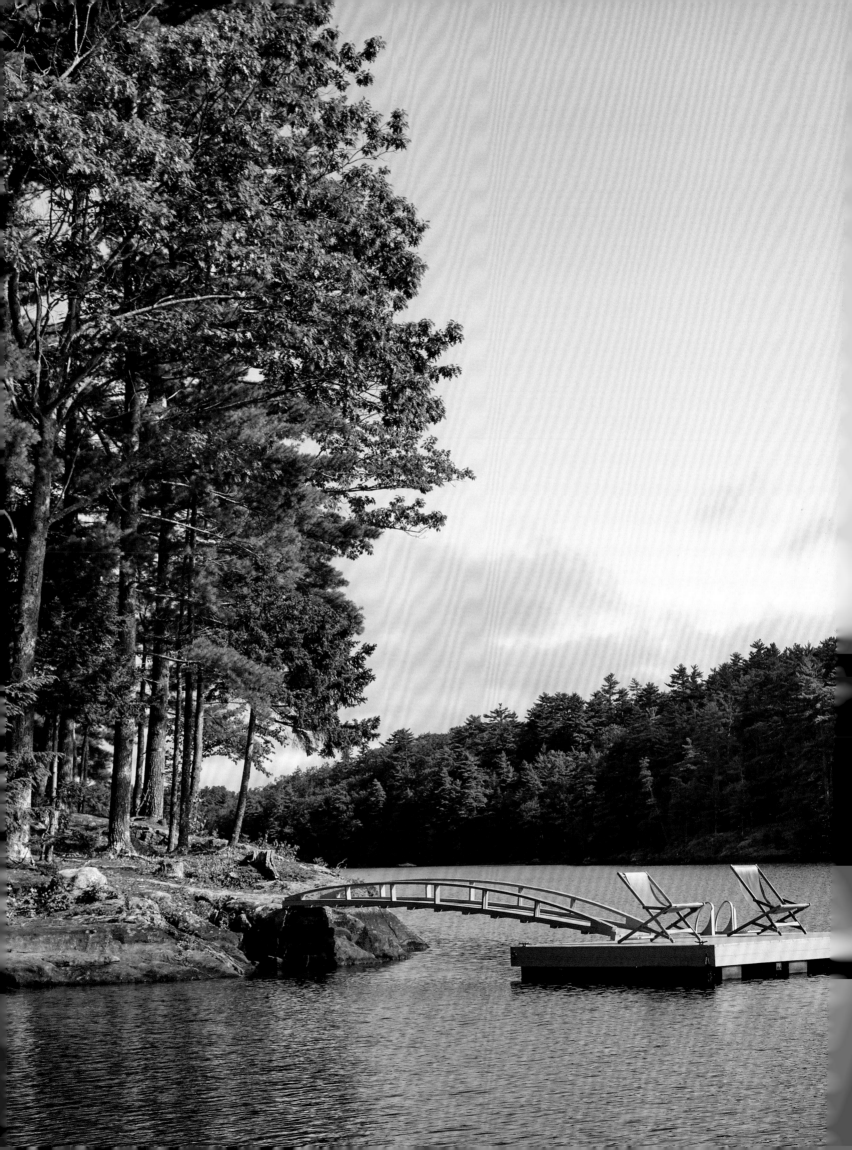

LAKE POINT

The decision to buy a waterfront cottage was not necessarily part of the plan for artists Susan and Rufus Williams, whose lifelong connection to Maine began when they met at Bowdoin College. "Every time we would cross the border into the state of Maine, we would just feel a sigh of relief. So we moved to Maine full time and raised our children there," says Susan. They were happily installed in their "forever house"—a Rockport farmhouse surrounded by small outbuildings on fifty-four acres of gardens, woods, and fields looking toward Penobscot Bay—when a friend invited Rufus to bring his Adirondack guideboat to nearby Megunticook Lake and take it for a spin. As they rowed past an overgrown cottage perched on its own small peninsula, it was "love at first sight. We had a place we dearly loved but felt this little cabin in the woods with its own beach was a once-in-a-lifetime opportunity, so we went for it, not knowing whether we'd end up keeping it."

Upon closer inspection, the couple discovered that the house had a dark wood interior, low ceilings, and small casement windows that let in little light, which would have been a deal breaker for most painters, but the couple was not deterred. They focused instead on the structure's soaring roof lines and good proportions. "We had built our Rockport house, so we had a good sense of space," says Susan. They embarked on a meticulous, ground-up renovation with the guidance of fellow Bowdoin classmate the architect Meg Barclay.

[213]

"Originally, the house had a center stairway with lofts on either side, but we wanted it to breathe," says Susan. The stair and lofts were removed to create one sun-filled great room—a combination living room, dining room, and kitchen. The refrigerator was relegated to an adjoining pantry, which was formed by extending the entrance hall off the great room.

For the interior finishes, they were envisioning roughhewn, handmade surfaces when kismet struck again; on his way to get a haircut in the neighboring town, Rufus saw a sign that read "Free wood." Old barn planks, originally painted white in the 1920s, had faded into a soft, silvery-gray hue. The owner, Rufus discovered, also had an entire old barn ready to be dismantled. Rufus took possession of all of it, and a contractor was able to cover one wall in the great room and a wall in the master bedroom with the gray boards to rustic effect. Almost all of the walls in the house are clad in the boards from the dismantled barn, now painted white.

Creating an anti-monolithic look for the exterior shingles was more of an effort. "In painting, you get so many variations. But when you buy stained shingles, each is identical." Rather than settle for a flat effect, the couple mixed enormous vats of stain, hand-dipping 250 shingles at a time, then drying them on racks in the basement. "We did it all winter, and let's just say there were a lot of logistics involved," remembers Susan fondly. The result is a beautifully mottled, irregular exterior that dazzles but isn't flashy.

"All of our creative efforts went into the house," Susan says. After the major construction projects were completed, the couple managed to return to their art full time. Rufus, a keen observer of nature, paints watercolors and recently assembled a handsome letterpress art book, *Close to Home*, with all the proceeds going to the Knox County Homeless Coalition. Susan paints imaginary landscapes on transparent acetate, many inspired by Lake Point.

PAGES 212–13: Artists Susan and Rufus Williams regularly swim a mile across Megunticook Lake and observe nature, which informs their art, from a floating dock connected to their property by a small bridge.

OPPOSITE: A table and bench, which Rufus fashioned from a felled oak, serves as an alfresco lunch spot amid the property's pine, beech, and oak trees.

PAGE 216: The entrance hall features a photograph of the Williamses' daughter, Margaret, by photographer Cig Harvey.

PAGE 217: This wall in the great room is clad in salvaged barn boards that have aged to a silvery-gray hue. To the left of the fireplace is a James Audubon print and to the right is a work by Joyce Tenneson. The red bench is from Nomad in Cambridge, Massachusetts.

PAGES 218–19: The main attraction of the house is the panoramic view of Megunticook Lake, which transfixes all who enter. The vintage rug is from RugVista. The floor is painted in Benjamin Moore's Black Tar.

PAGES 220–21: Rufus Williams built the dining table. The chairs were found at Ross Levett Antiques in Thomaston, Maine.

PAGE 222: The refrigerator is concealed in a small pantry off the dining area.

PAGE 223: A cozy reading alcove with a built-in window seat was created in a passageway from the great room to the master bedroom.

PAGES 224–25: In the master bedroom, a photograph of Rufus Williams looking out over the lake by Cig Harvey hangs over a chaise. Susan Williams's painting *Indigo* hangs over the bed. Her work is represented by Downing Yudain in Stamford, Connecticut, and by the Caldbeck Gallery in Rockland, Maine. The aged barn boards Rufus serendipitously came upon line the wall behind the bed.

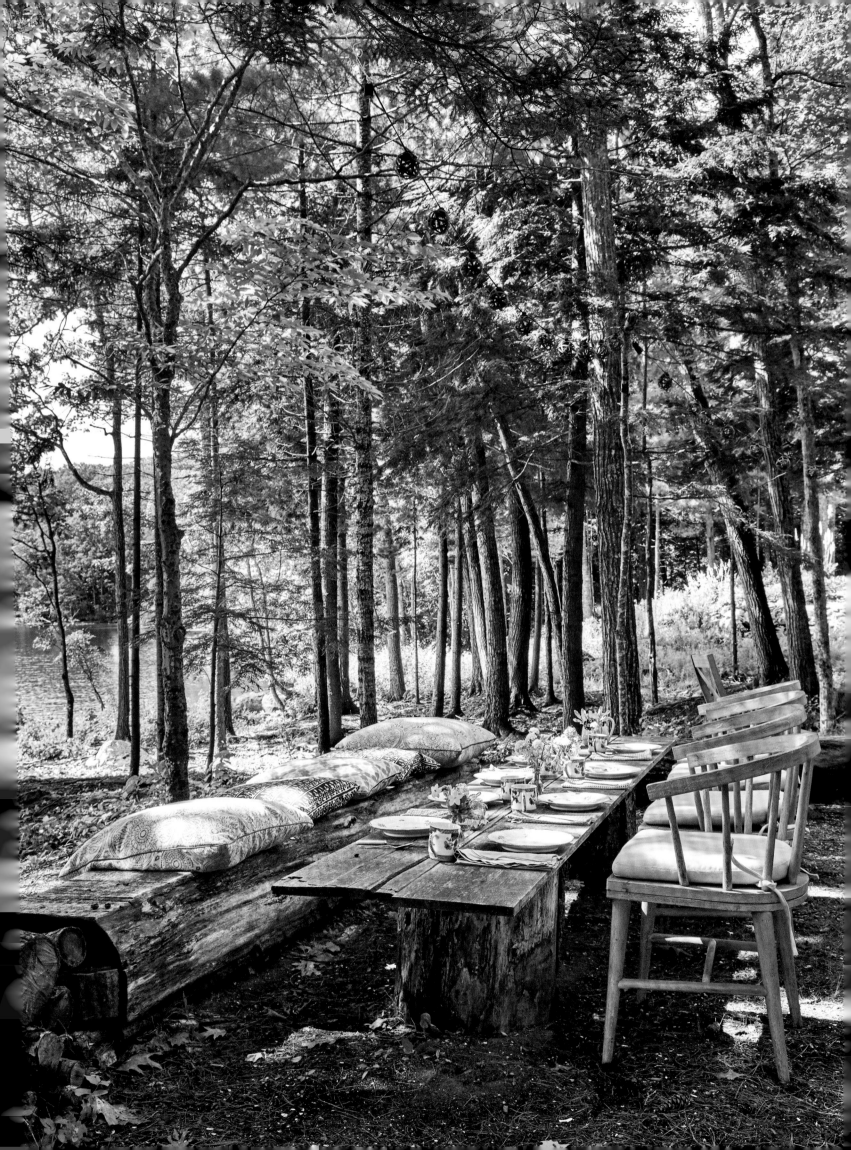

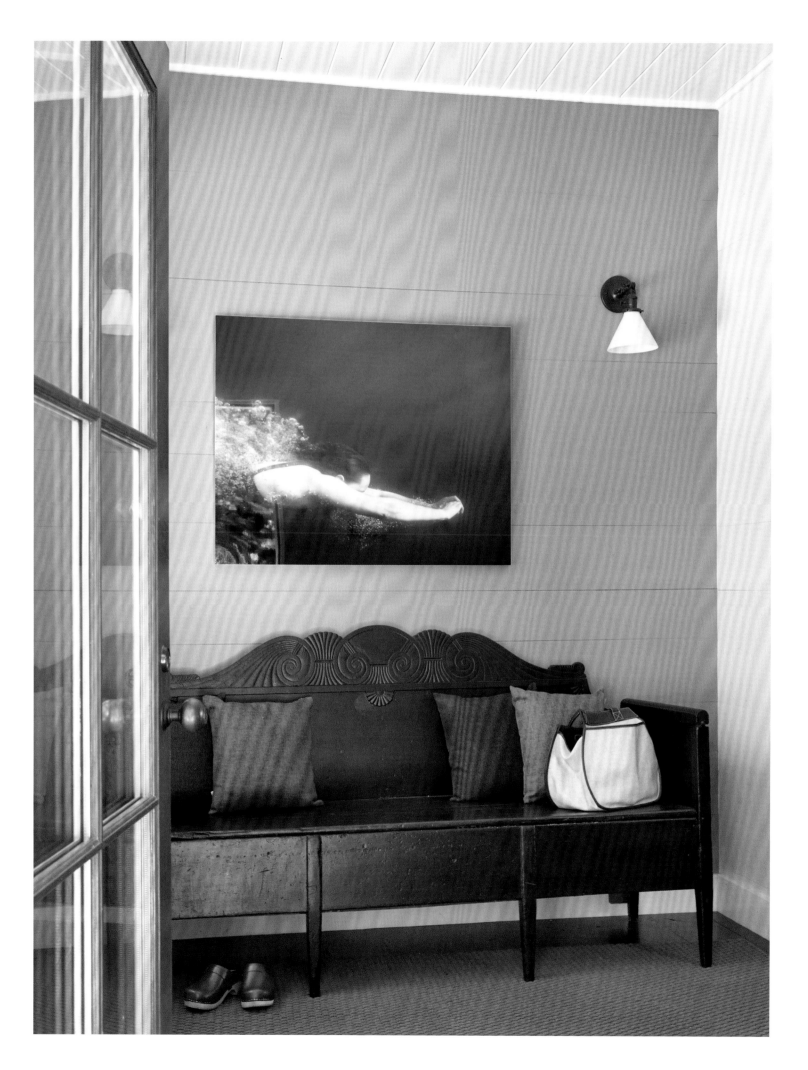

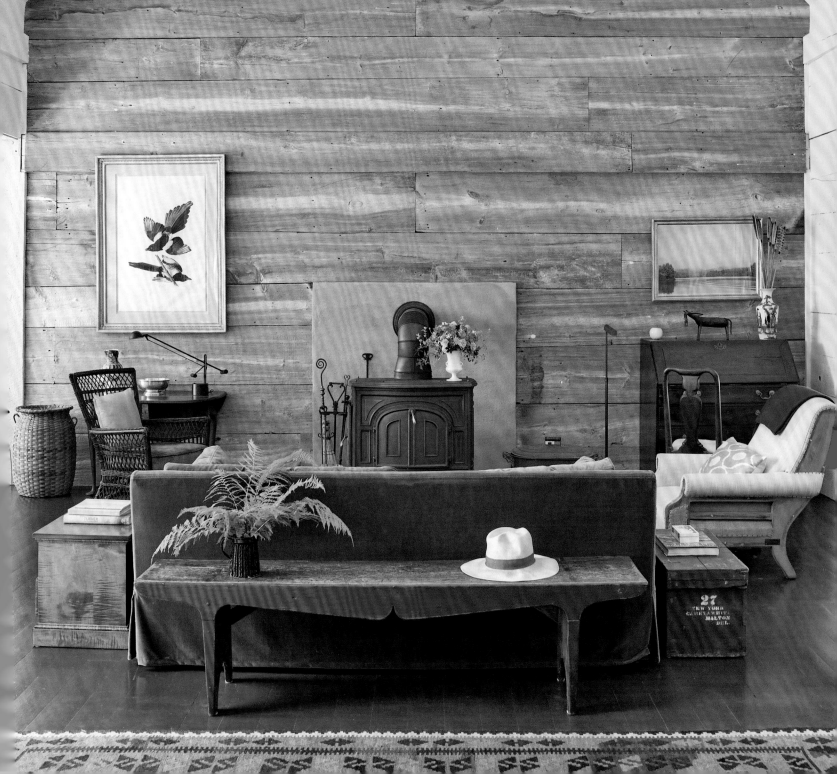

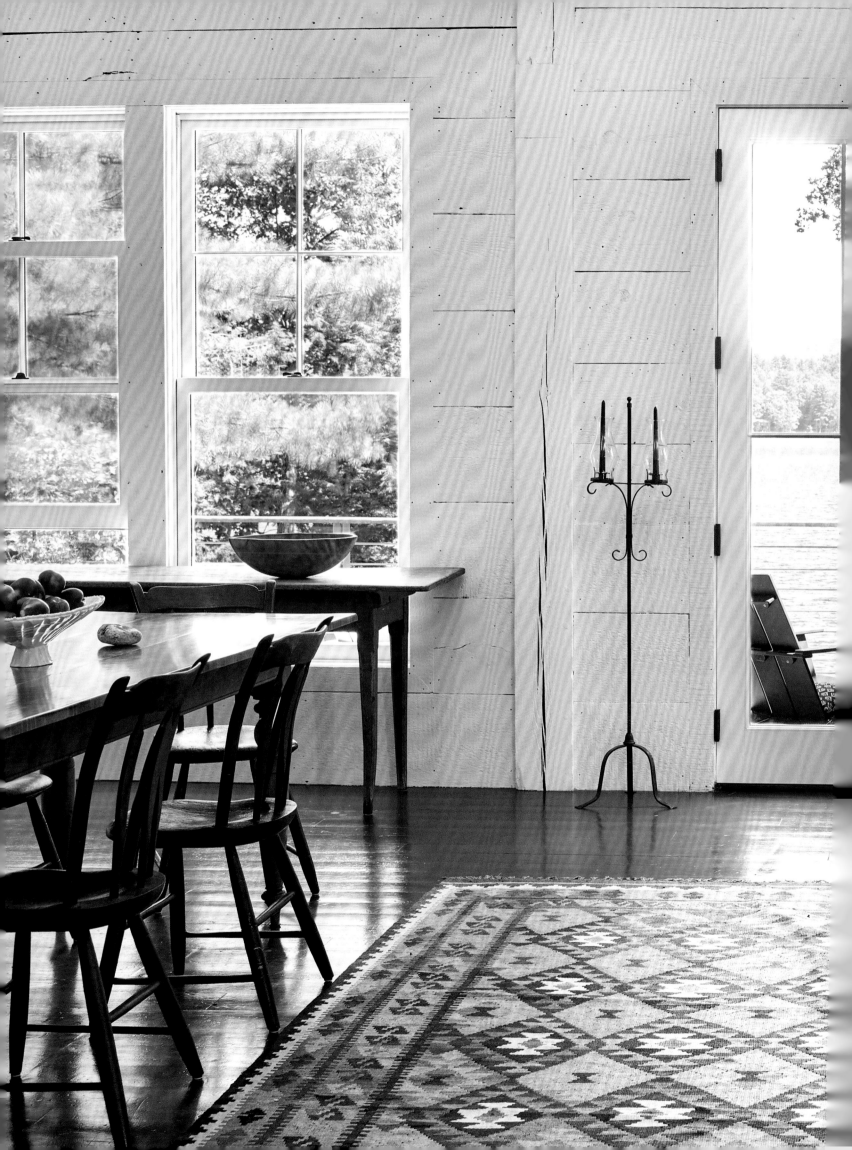

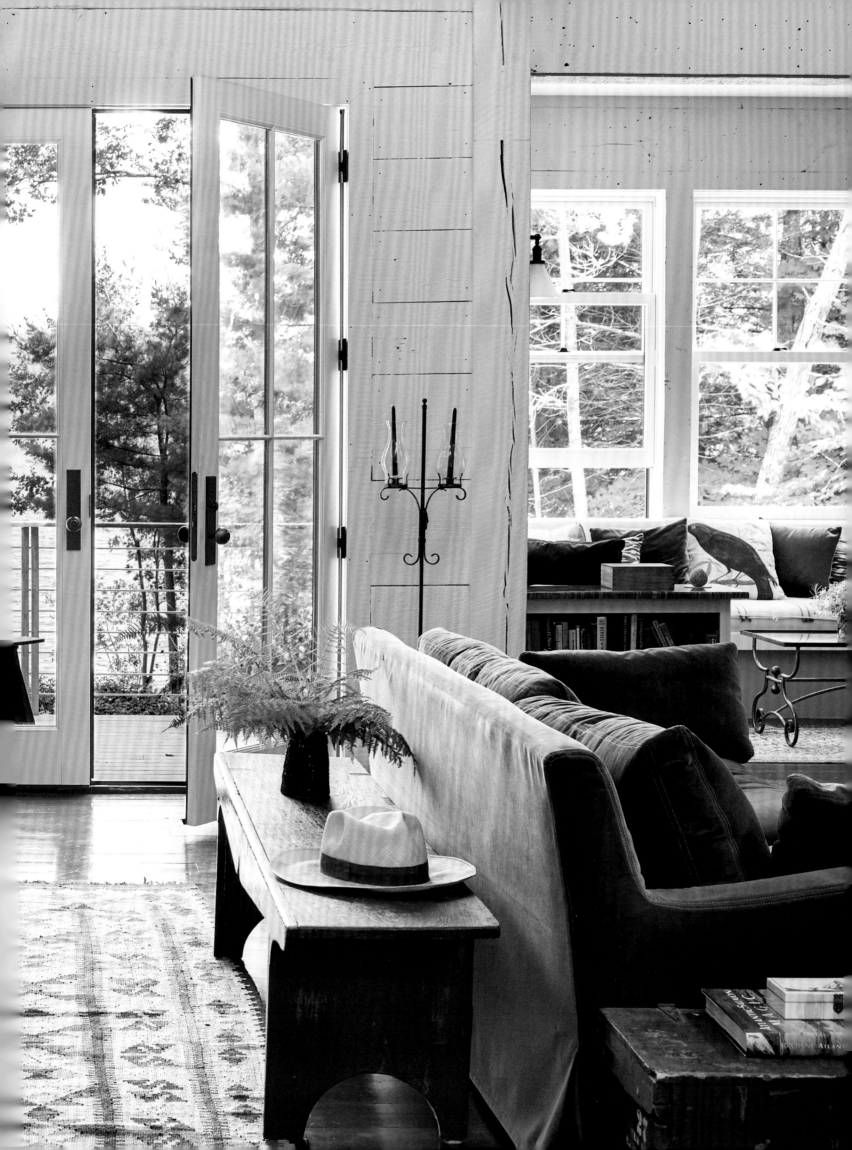

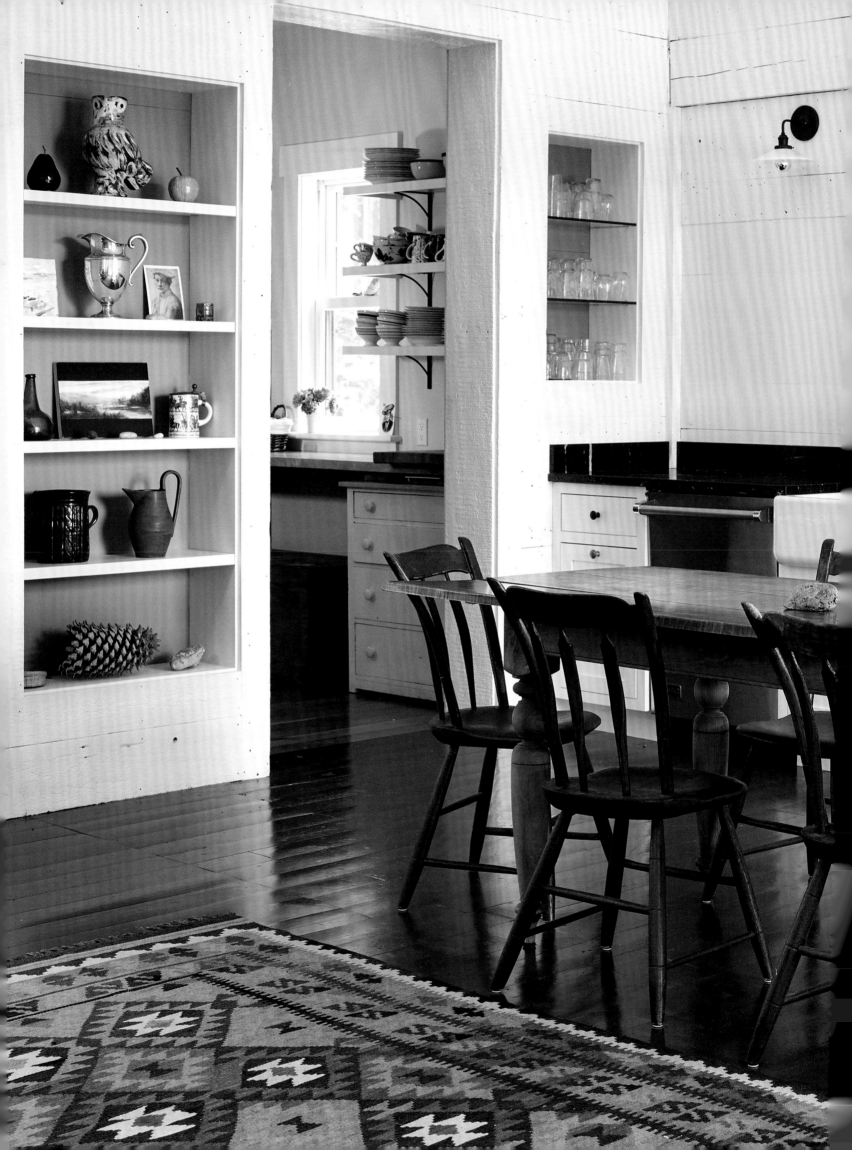

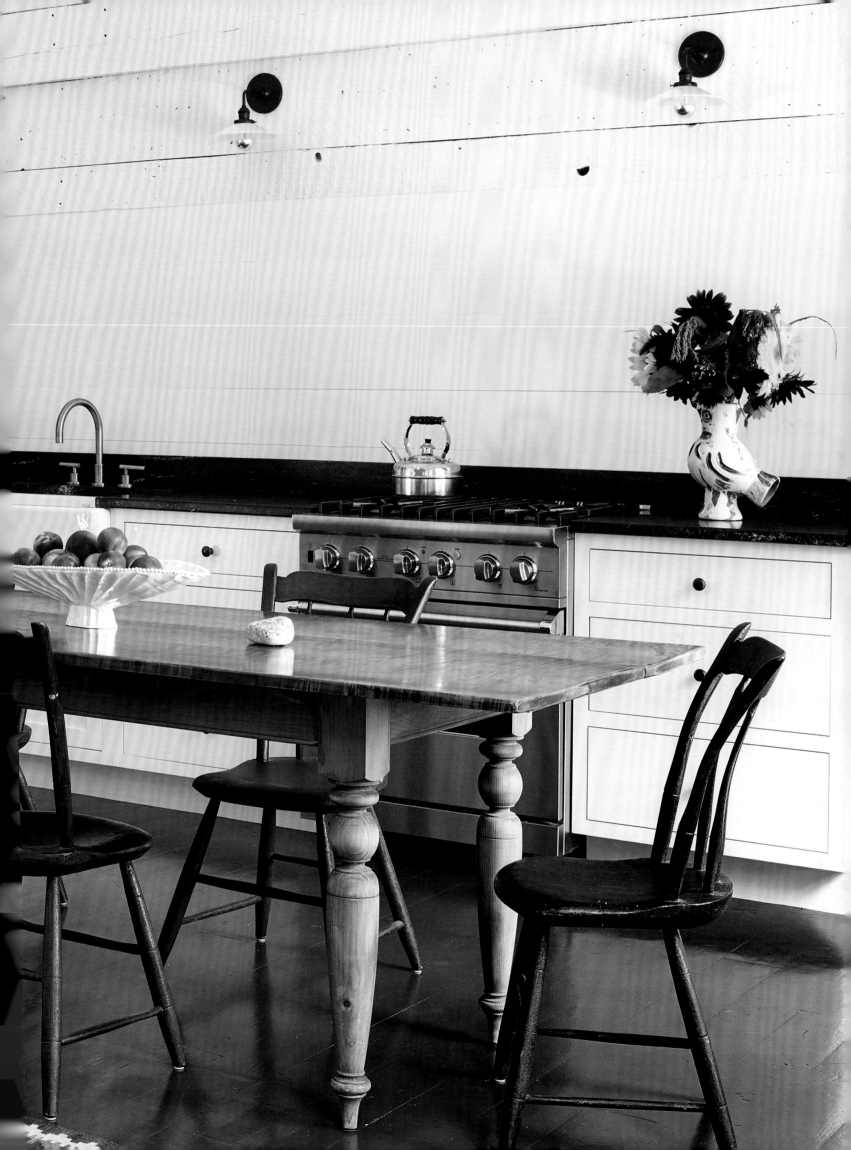

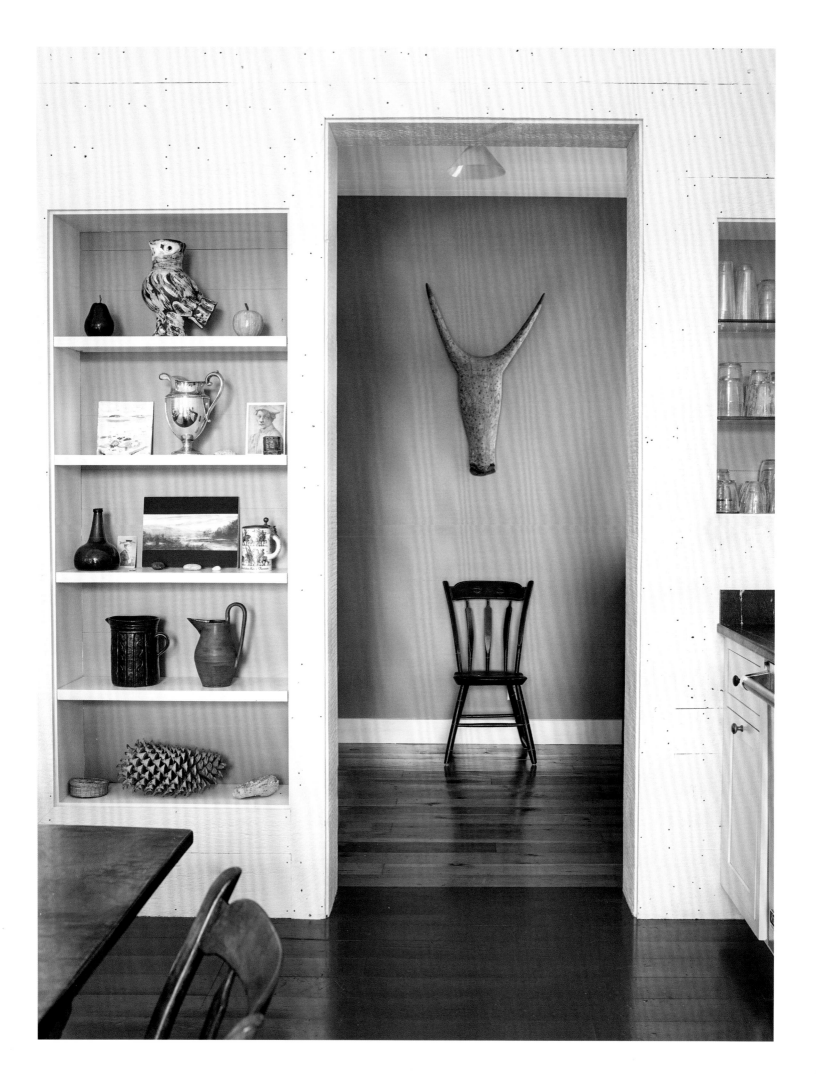

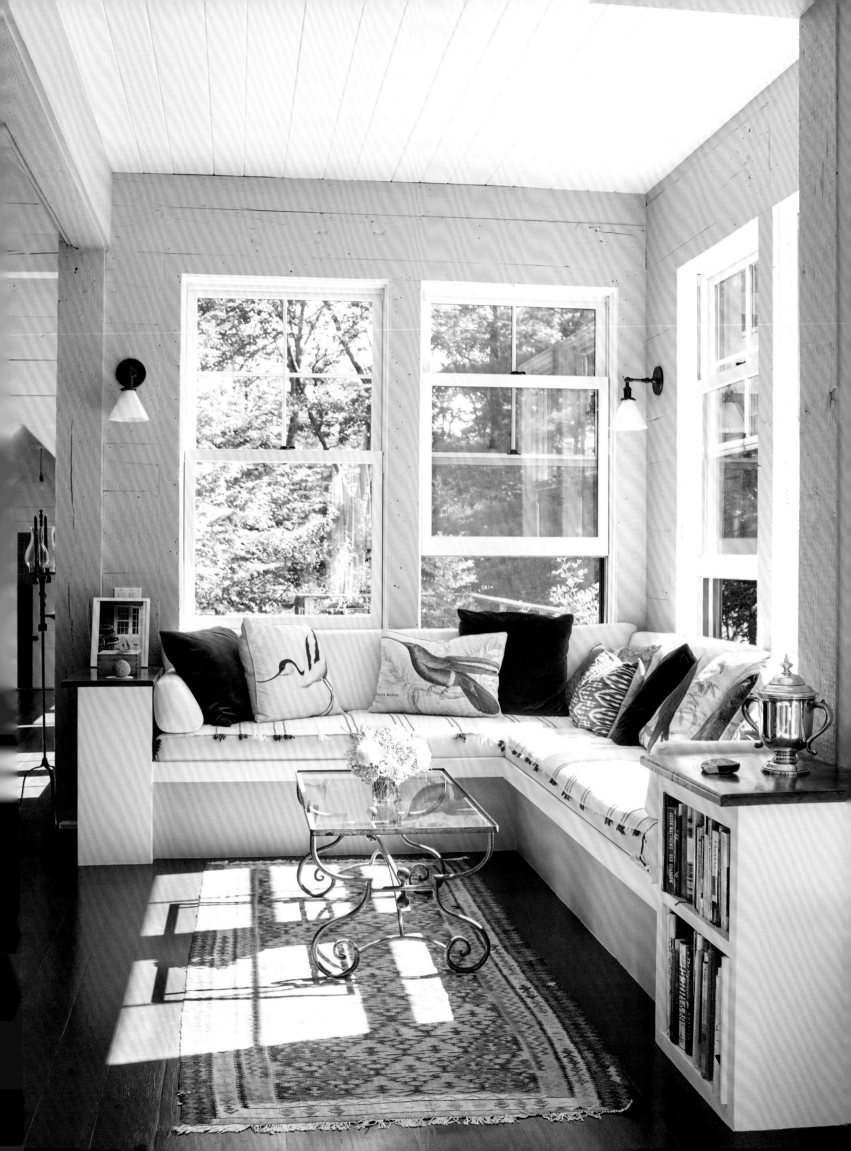

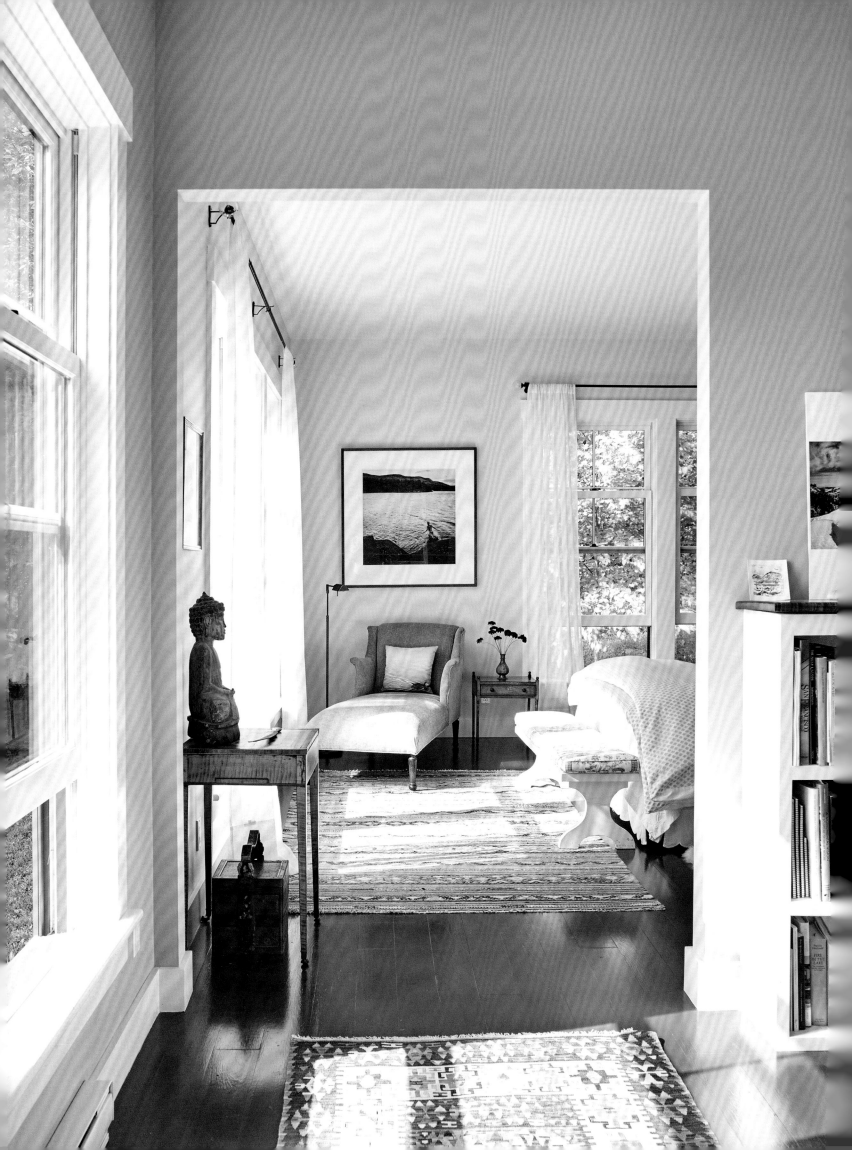

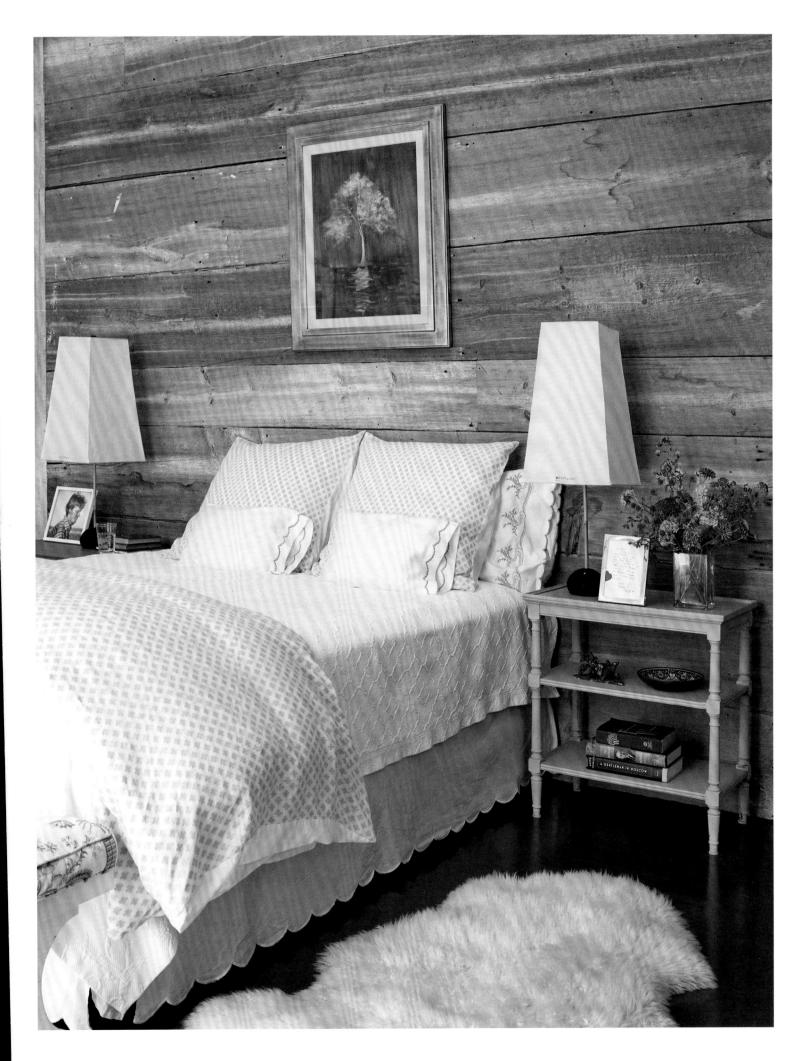

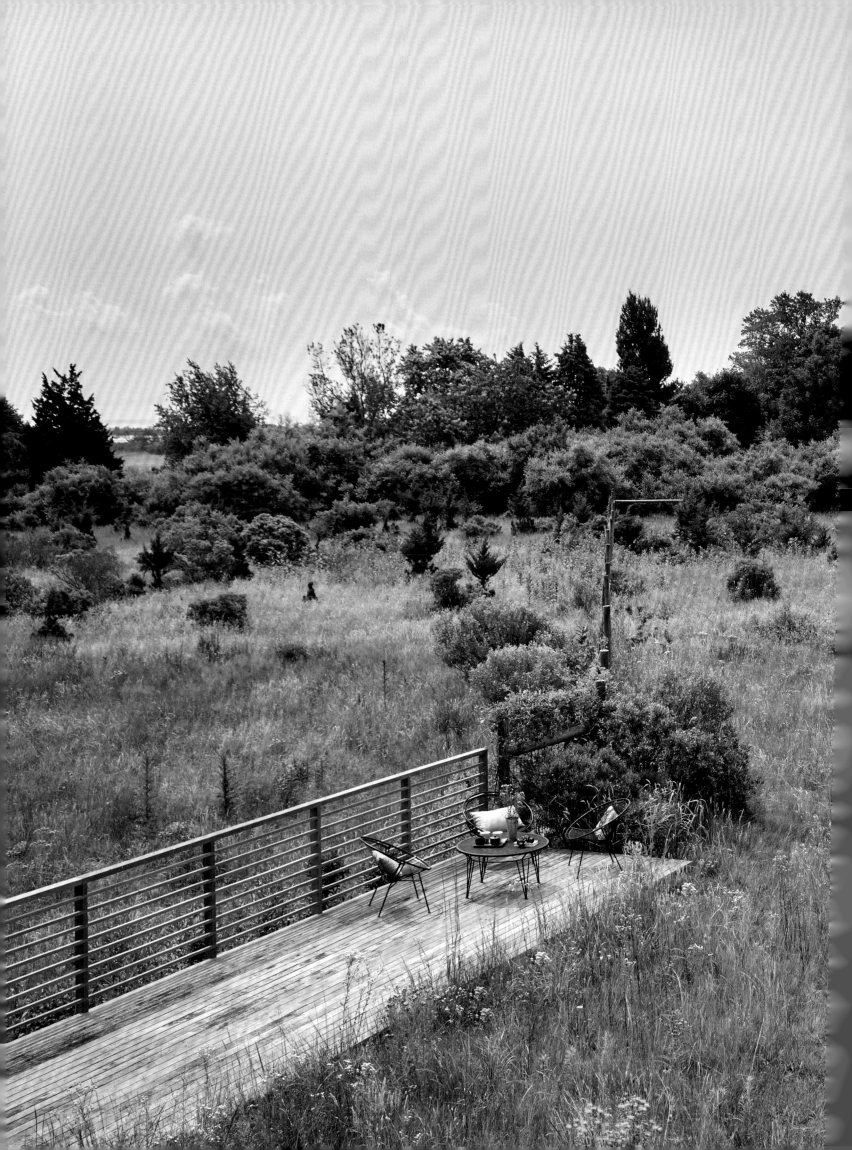

EVERGREEN
IN ORIENT

During their frequent bike rides along the Peconic River on the North Fork of Long Island, a couple had long admired a vacant waterfront lot—a rare commodity in Orient, New York. When they discovered that it was available, they submitted a bid that they quickly withdrew. "We had recently renovated a 1950s house nearby and we were trying to simplify our lives." But another ride past the property, with its views of the river and out to Gardiners Bay, proved that it still had a pull.

The couple turned to architect William Ryall of Ryall Sheridan Architects, who not only was well versed in local building codes and weather patterns but also specialized in building energy-efficient houses, a priority for the clients. They imagined a house that would maximize the property's potential by prioritizing the view without sacrificing privacy. "Bill's first suggestion was to build up. We were hesitant until he came to the property with a twelve-foot ladder; as soon as we climbed to the top, we immediately agreed." The panoramic views, Ryall explained, would connect the house to the landscape, while elevating the living quarters would protect it from storm surges.

Ryall clad the exterior in dark-stained cedar, which blends seamlessly into the landscape, and lined it with a high-tech membrane that shields it from wind and rain. The interiors are finished with light, natural-grain wood that accentuates the

natural light pouring in through floor-to-ceiling windows. Solar panels, triple-paned windows, and walls insulated with environmentally friendly cellulose reduce energy consumption.

The couple called upon environmental artist and land preservationist Lillian Ball to conceive a naturalist landscape. Ball has famously developed a water-remediation system that has rescued compromised wetlands and water sources from the Bronx to Nepal. "We didn't want anything manicured or fancy. We wanted the house to look like it was dropped into the field," says the owner. To that end, Ball removed invasive plants, replaced them with indigenous species, and created "rain gardens," which receive the house's runoff water through pipes, eliminating the need for additional irrigation.

"Seeing that the landscaping has brought in new butterflies, birds, and insects has been wonderful. People come from Cornell and say, 'I haven't seen this bug in thirty years.'" On an August day, the field is dotted with yellow and purple wildflowers, and countless swallows circle the sky, preparing to migrate south.

The deliberate simplicity of the house rising amid the naturalist landscape is a striking example of what can be conjured with nothing but light, air, and a reverence for the environment.

PAGES 226–27 AND OPPOSITE: A mahogany deck is the perfect perch to watch nature unfold while relaxing in the sun. Tall, indigenous grasses grow right up to the edge of the saltwater swimming pool.

PAGES 230–31: Architect William Ryall proposed building up, not only to protect the house from storm surges but also to provide panoramic views.

PAGES 232–33: The living room, with its pale Douglas fir floor, black walls, and floor-to-ceiling windows, is, like the rest of the 3,275-square-foot house, "full of contrasts—rough/smooth, dark/light, open/closed," says Ryall.

PAGE 234, CLOCKWISE FROM TOP LEFT: A bird's nest, Jill Moser's *Saffron and Sand* etching and woodcut, flowers in a vase by Paula Greif in front of Véronique Gambier's acrylic on paper, and river stones found in Nova Scotia's Bay of Fundy all tie the interiors to nature.

PAGE 235: In the kitchen, dark gray cabinets are paired with granite countertops and an island topped by white marble from Vermont. The dining area is separated from the living room by a poured-concrete fireplace.

PAGES 236–37: The master suite is located above the main living area. Works by Annie Wildey and Mats Gustafson rest on a shelf.

PAGE 238: The library doubles as a family room. The rug was found on a trip to Fez, Morocco.

PAGE 239: Half a flight below the main living area, a guest room opens onto the meadow.

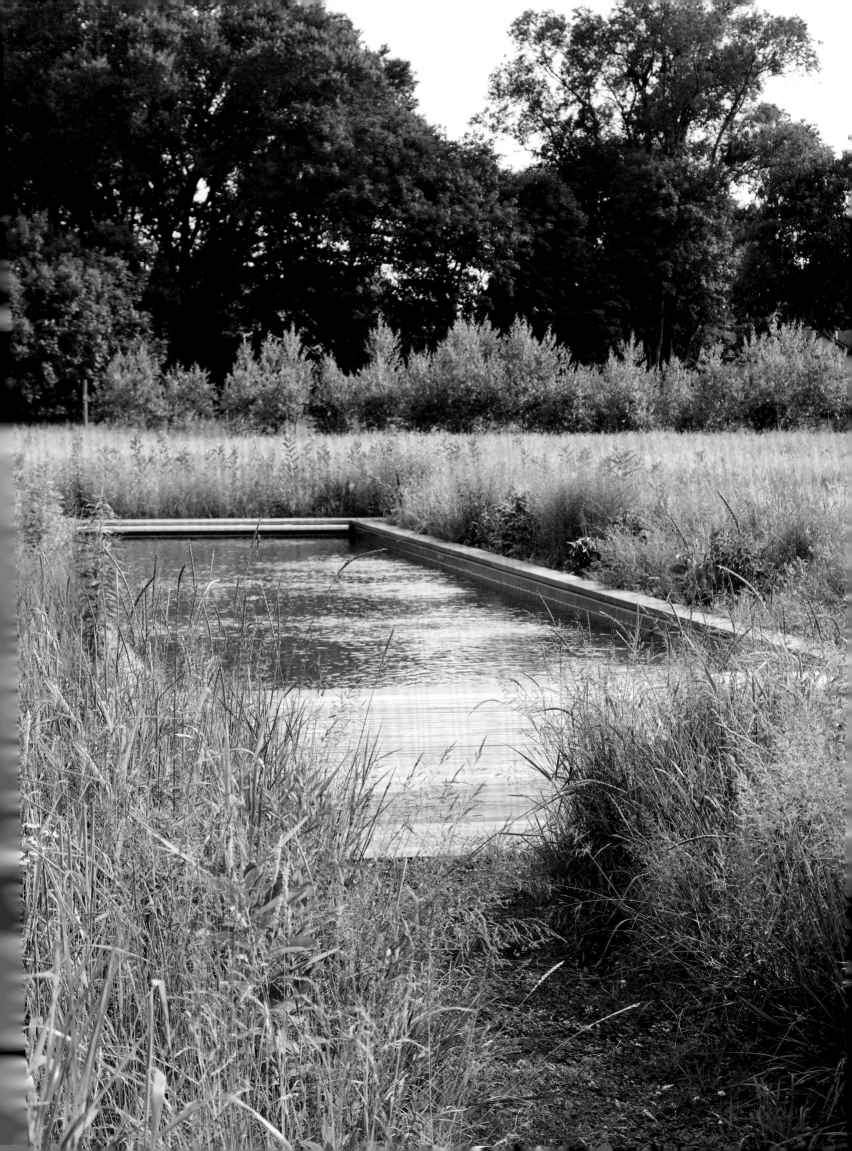

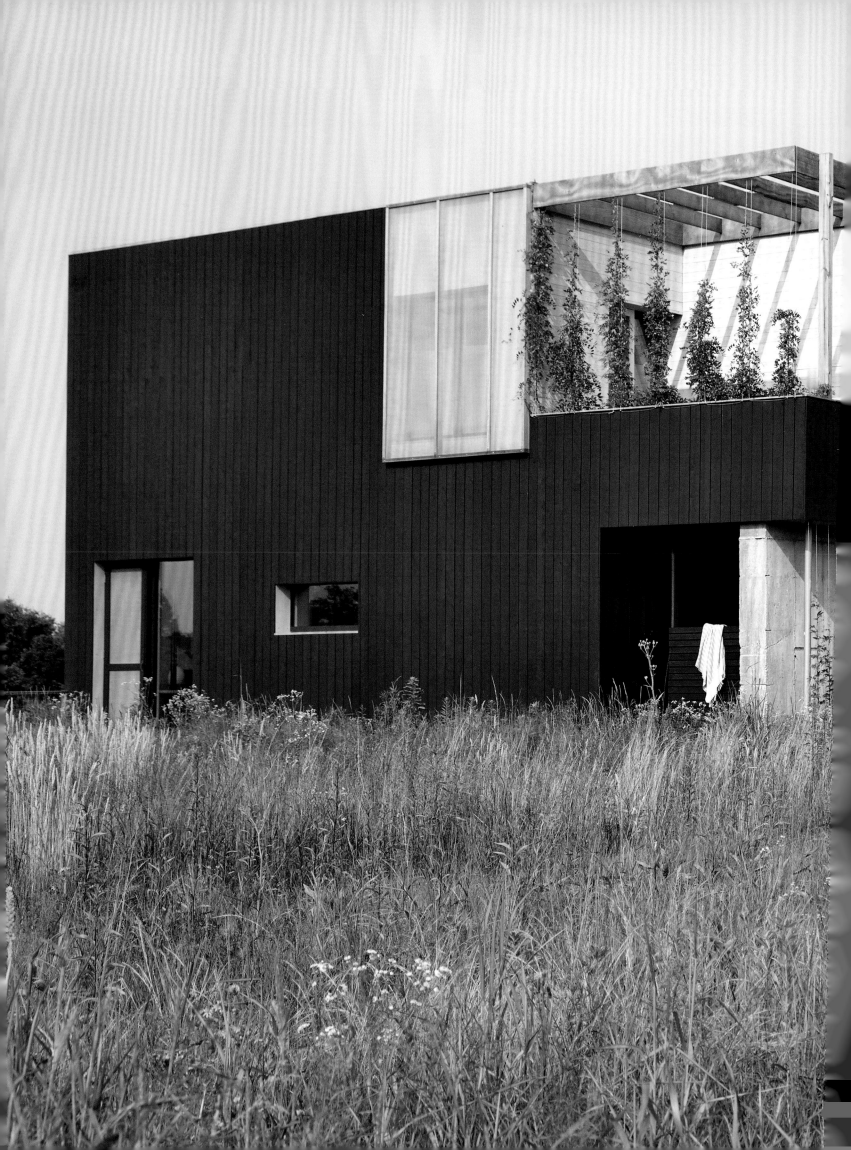

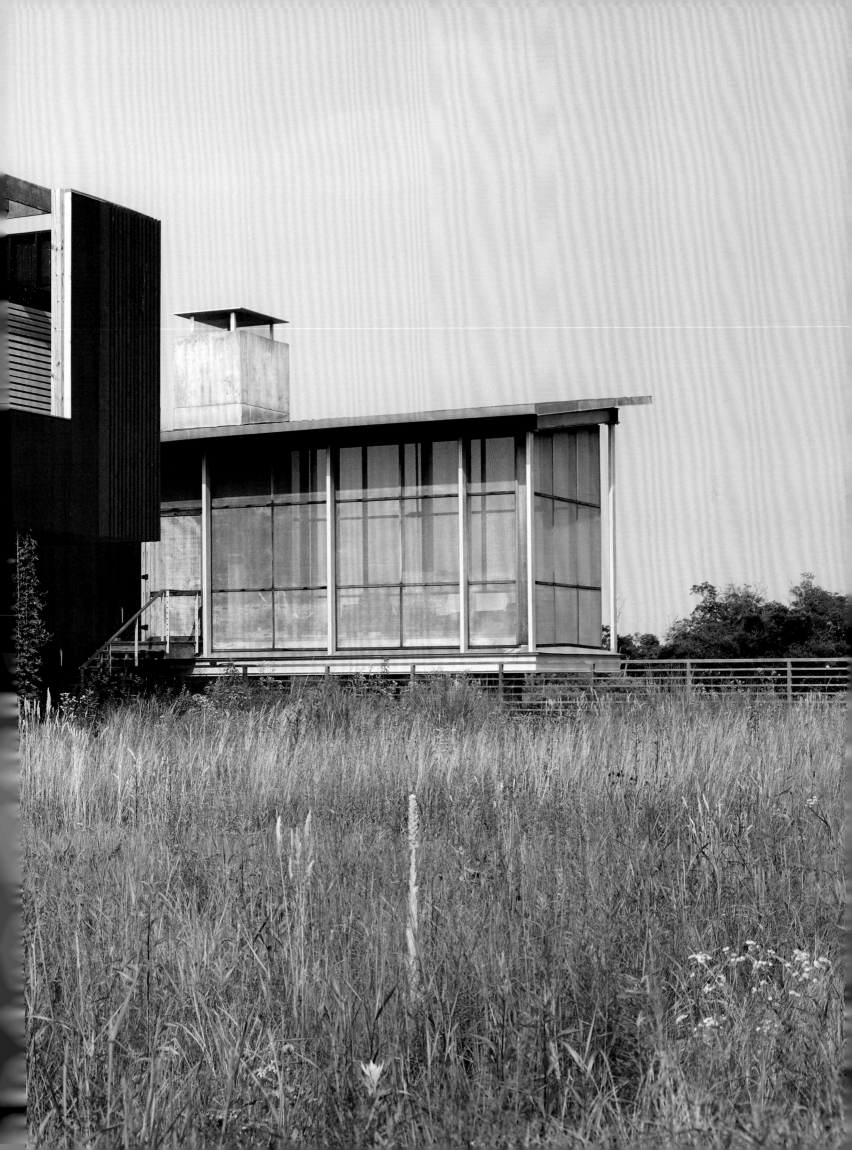

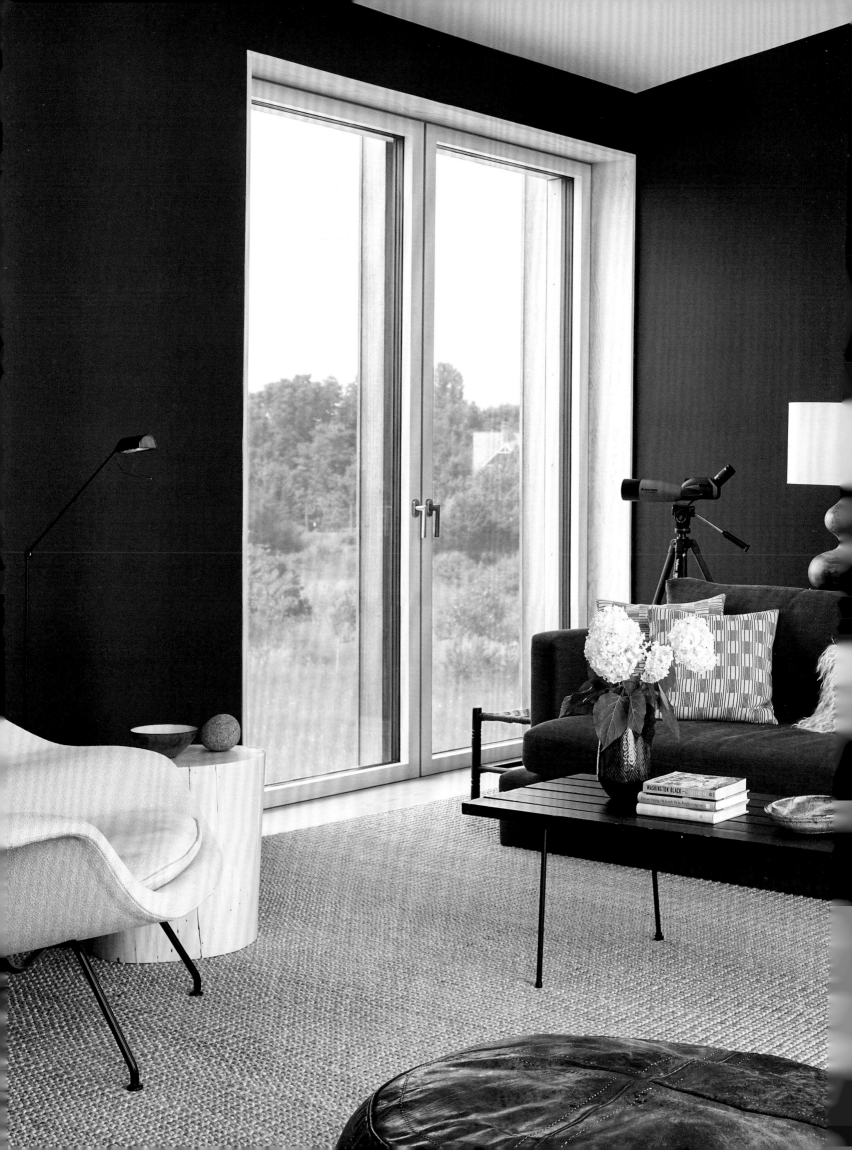

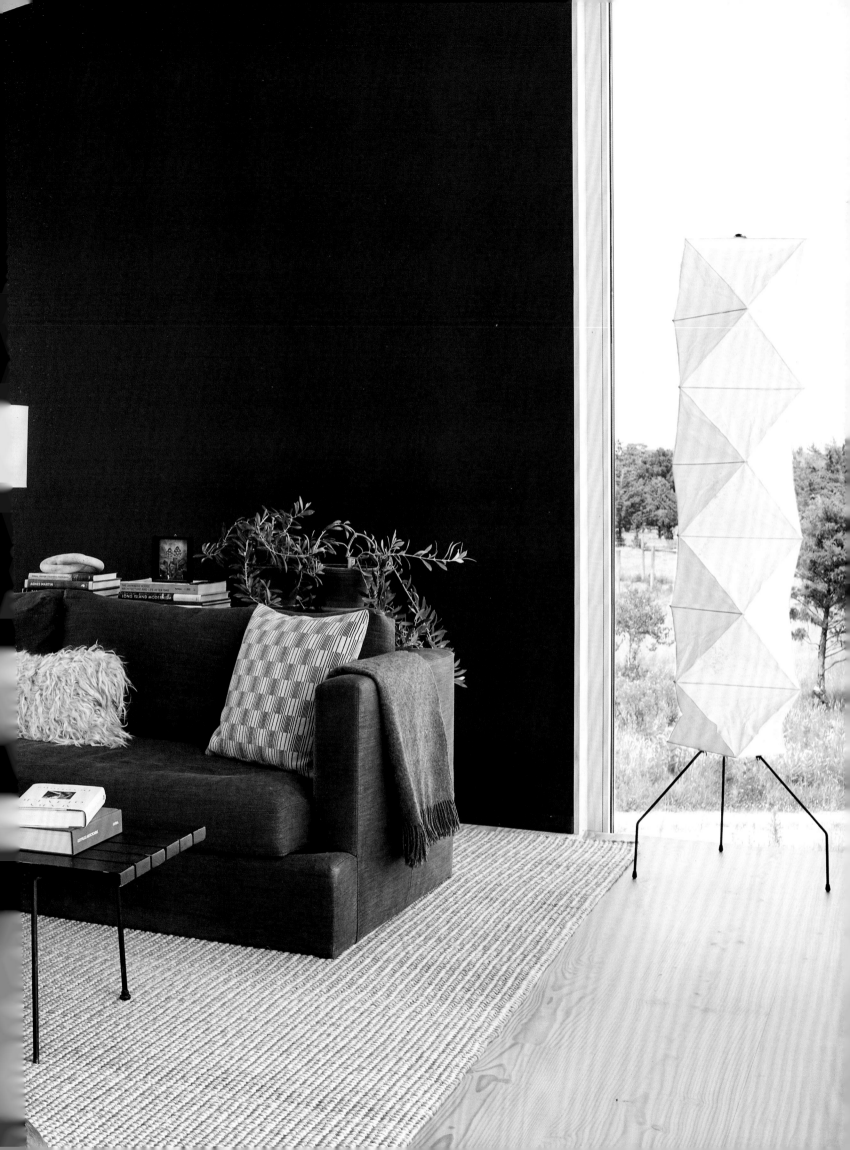

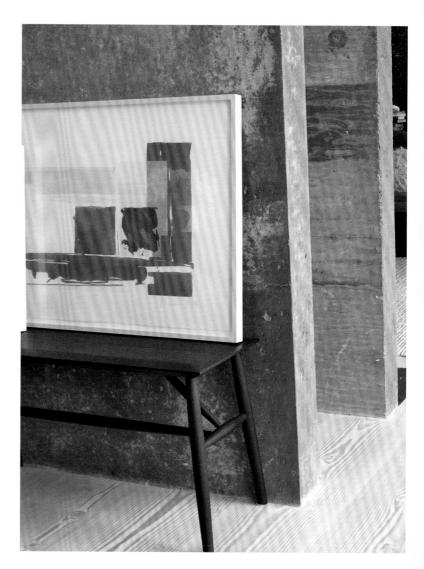
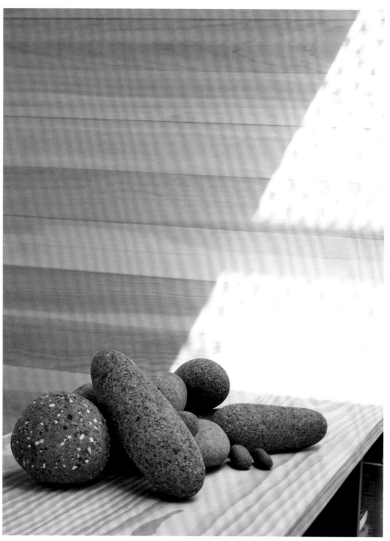
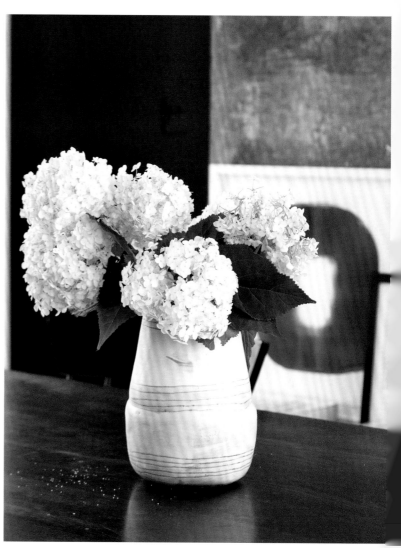

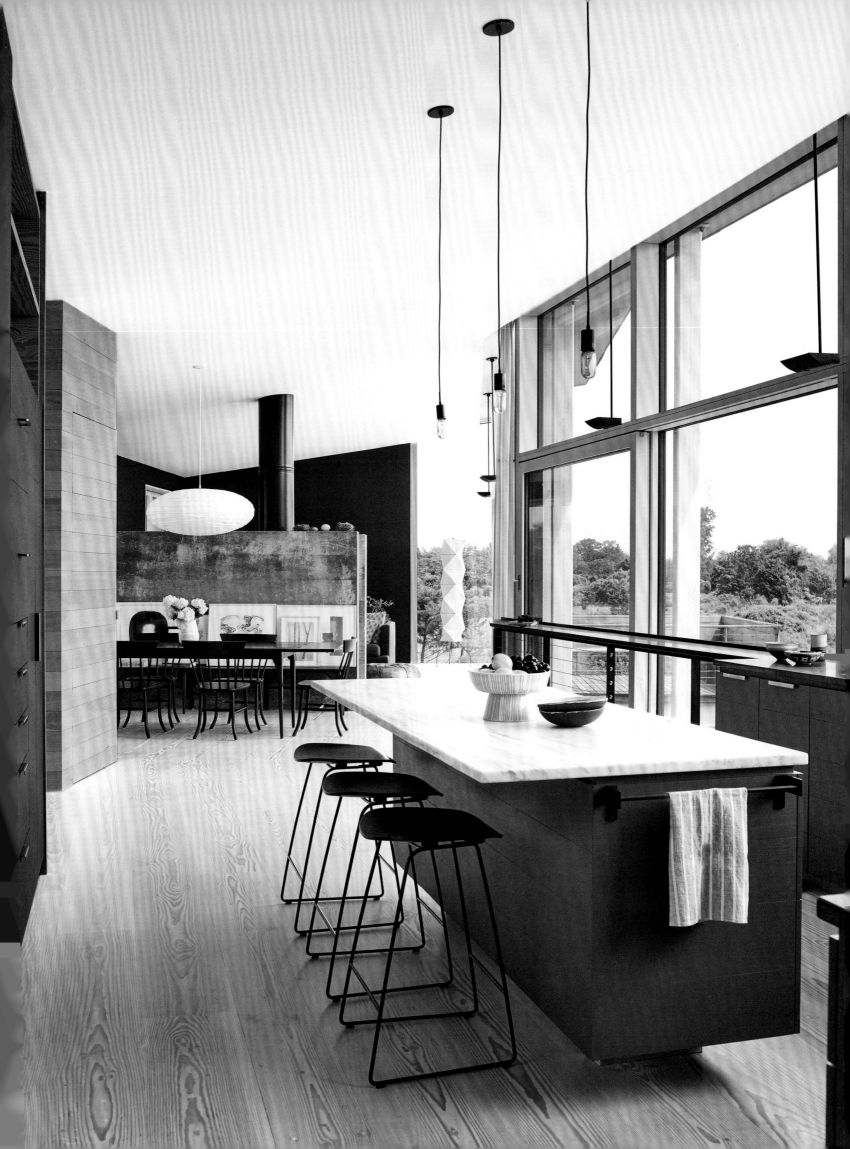

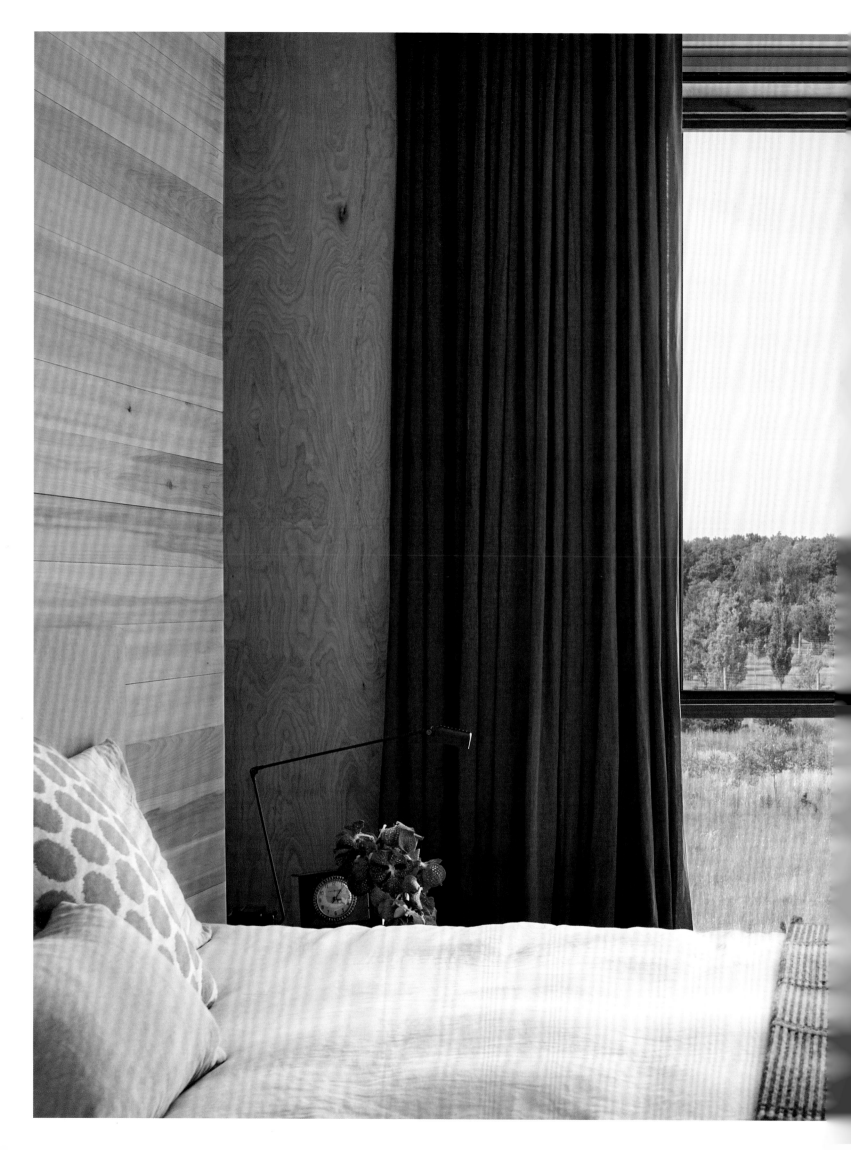

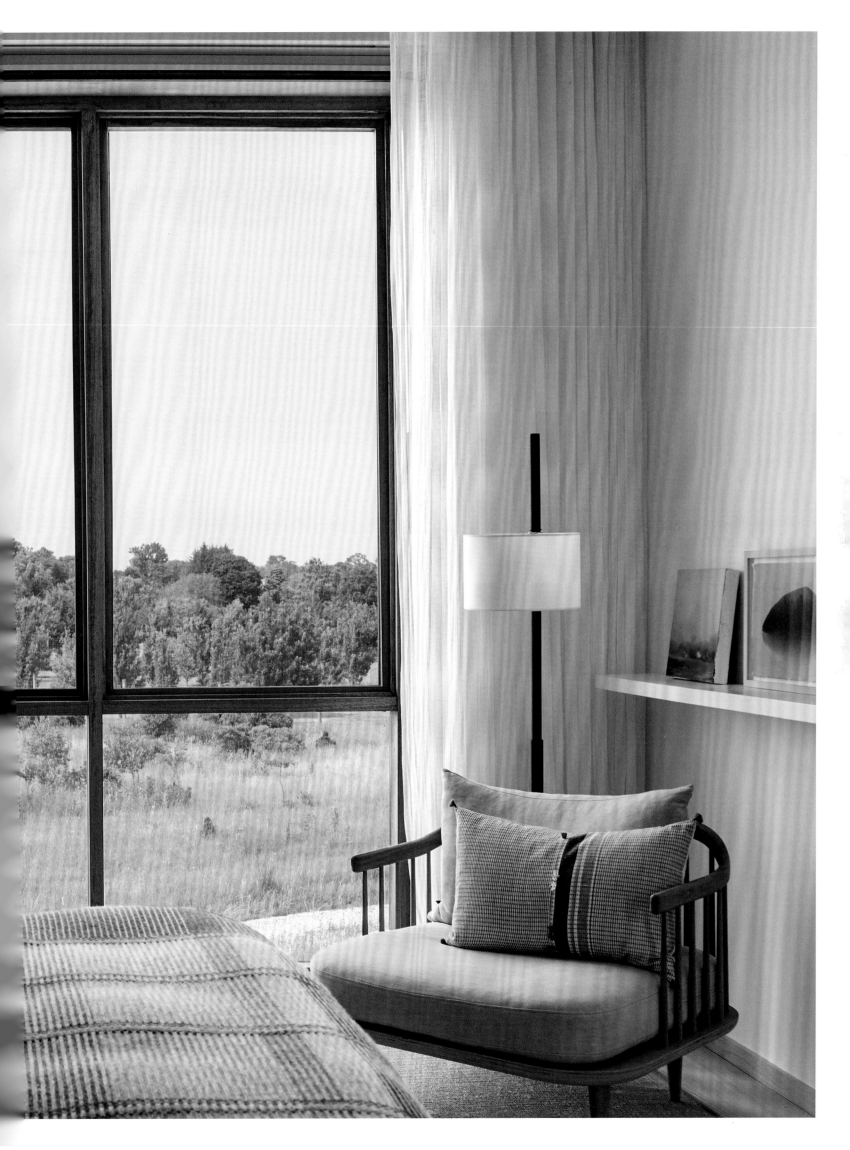

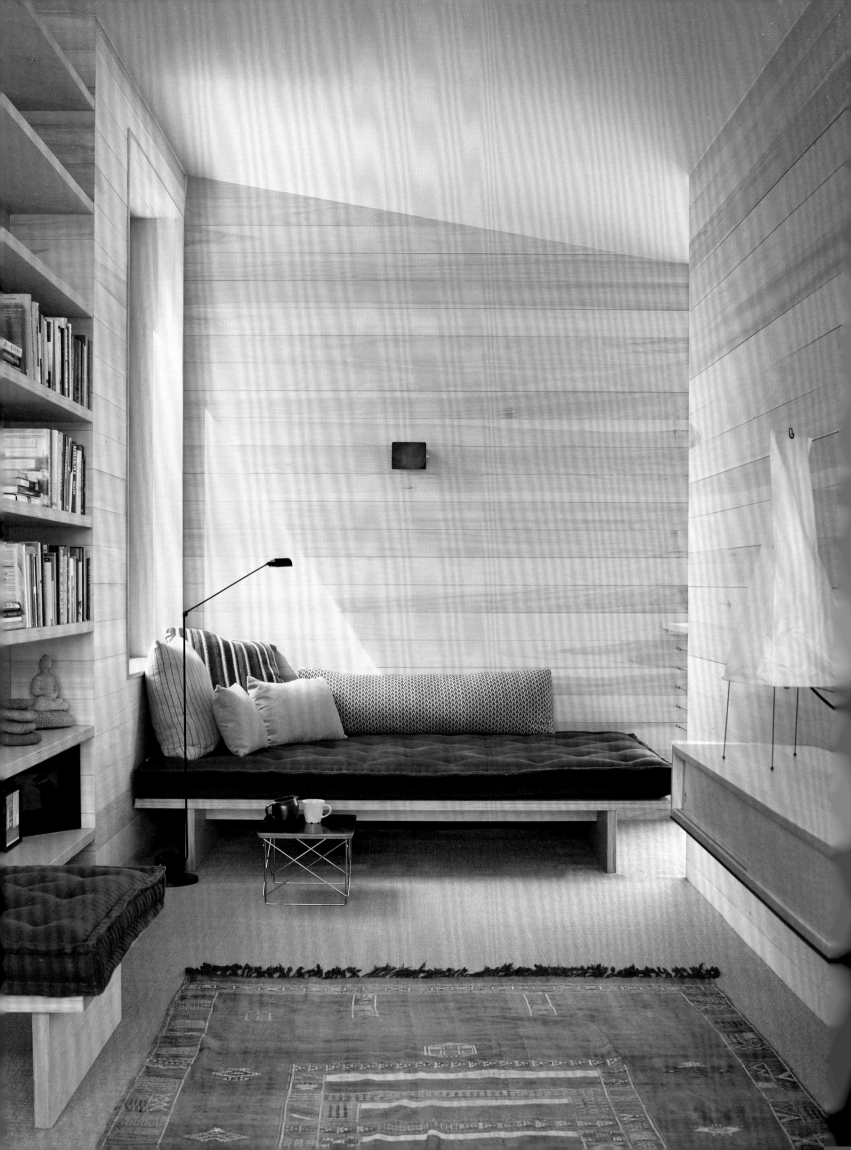

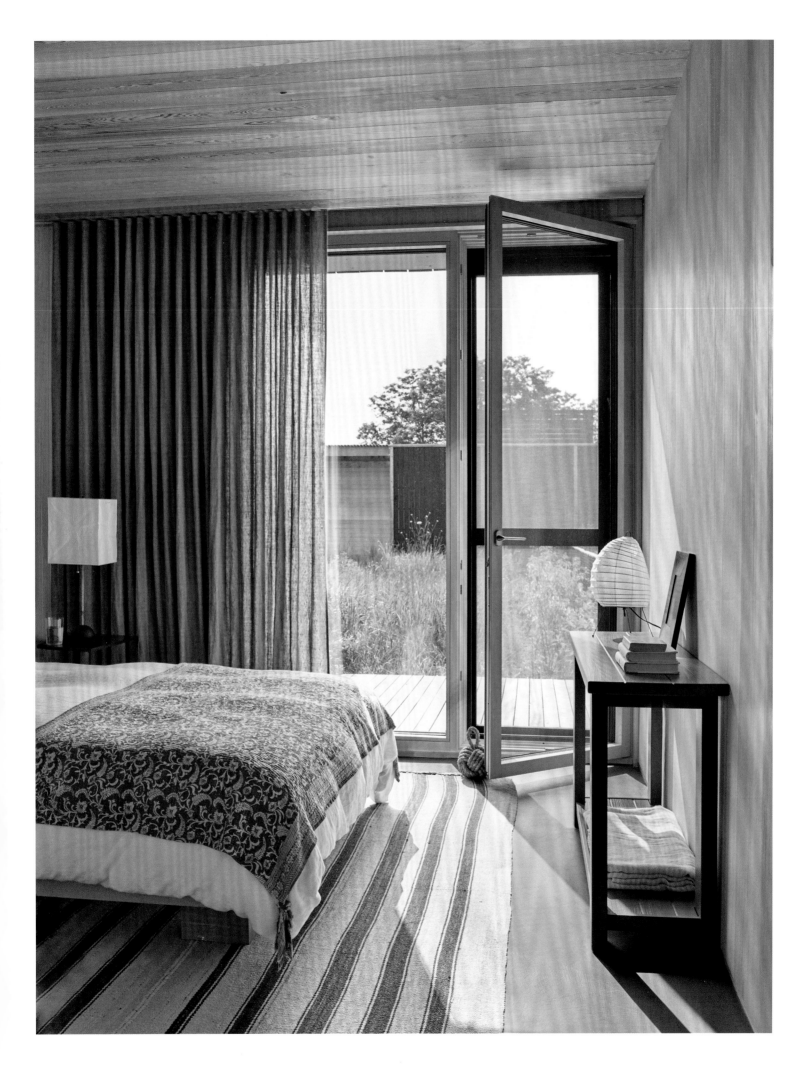

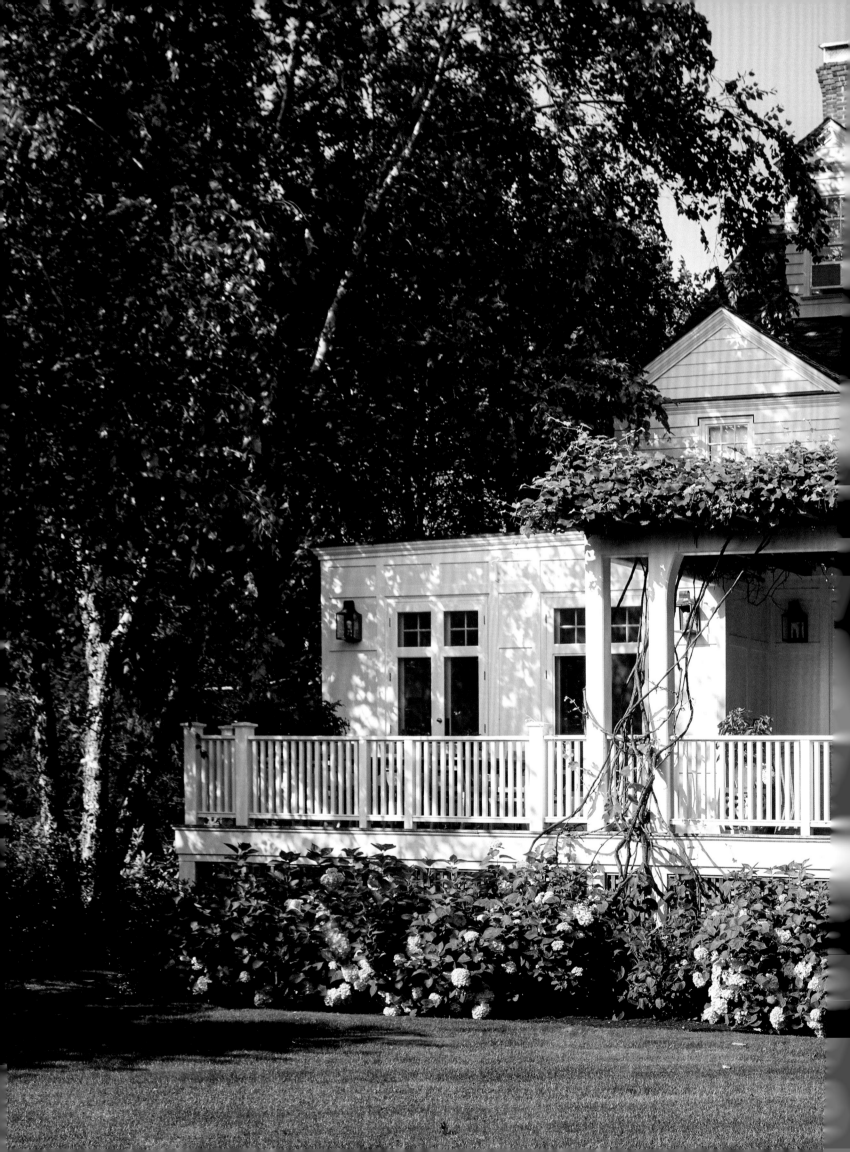

HISTORIC COLONIAL

For years, Meg and Doug Braff and their young sons happily spent summers at Horizons, the elegant limestone estate of Doug's mother, Alice Lynch, in Newport. But the day Meg returned home to find her sons dumping beach buckets of pea gravel from the driveway into the swimming pool, she began to worry that the antics of four boys under the age of six might prove too daunting for even the most patient of matriarchs. It was time to start a new chapter in a more child-friendly home.

They found a charming, historic Colonial not far from the center of town, on a quiet street where the boys could ride bikes. The fact that the house had been split into three units with a kitchen on each floor was only of mild concern to interior designer Braff, who is never known to shy away from a challenge. Even under ideal circumstances, renovations can be a monumental undertaking, but factor in Newport's strict building codes and time-consuming approval process, and the enormity of the task increases exponentially. With the dual goal of returning the house to its gracious nineteenth-century design and upgrading it for twenty-first-century living, her first order of business was to rework the floorplan, rewire the electricity, and add a more energy-efficient heating and cooling system. Braff, a Mississippi native whose style tends toward relaxed elegance, knew the house had to be practical and wanted lots of bedrooms and family rooms, but as the daughter and daughter-in-law of noted hostesses, it was impossible for

her to imagine a house without a proper dining room, a library, and a powder room. "Somehow we got it all in," she says.

For the interiors, Braff expanded her famous dexterity with color to include references to Newport history. "I like to thread a color throughout a house." In the Newport house, there is a bit of red in almost every room, often in the form of lacquered chinoiserie. Red begins with the front door and carries through a chest in the foyer, the trim in the dining room, and the Frances Elkins Loop chairs in the breakfast room. "The house is filled with Eastern-influenced furniture and decorative elements that, at least in my imagination, could have found their way to Newport via ancient trade routes," says Braff.

Braff has a natural ability to mix things up, making interiors feel layered and as if they have evolved over time. In this case, she found pieces at local auctions and from a generous mother-in-law. "I wanted this home to have a collected feel. I like to joke that I bought quite a bit of the furniture at auction and never bothered recovering it, which is very Newport indeed," she says, perhaps referring to a plethora of well-worn ancestral pieces in the gilded "cottages" that line Bellevue Avenue like regal ladies on a receiving line.

The house is a cozy hub for a lively family, and after fifteen years, with each son now pushing six feet, the driveway is lined with cars rather than tricycles. On a recent August afternoon, they trickled in from the beach and quickly changed into formal dinner jackets for the Preservation Ball, which was honoring Braff's mother-in-law and being co-chaired by Braff. But first they would convene at Horizons, which will always be the mother ship.

PAGES 240–41: Climbing wisteria drapes the pack porch of Meg and Doug Braff's Newport Colonial.

OPPOSITE: The front porch, outfitted with a cozy seating area, serves as an extension of the living room. A cheerful cherry-red door anticipates the dominant color inside.

PAGES 244–45: The house is filled with Eastern-influenced furniture and decorative elements that reference Newport's history as a trading port. Vintage chairs are upholstered in Brunschwig & Fils' Menars Border, and pillows are covered in Braquenié's La Rivière Enchantée Rouge. The blue-and-white lamps were a gift from Braff's mother-in-law, Alice Lynch, who lives nearby.

PAGES 246–47: Braff's favorite chinoiserie wallpaper is Scalamandré's Shanghai. It has remained in the dining room since it was hung fifteen years ago. The chairs, with cushions covered in Meg Braff Designs' fabric Marbled in yellow, are a new addition.

PAGES 248–49: In the library, a pair of carved vintage slipper chairs are from Meg Braff Designs in Locust Valley, New York. The vintage armchairs are upholstered in Pierre Frey's Papillons Exotiques. The burgundy lamp is by Christopher Spitzmiller.

PAGES 250–51: Meg Braff Designs' Swirls wallpaper in navy, combined with roman shades and seat cushions in China Seas'

Malay Stripe, lend buoyancy to the breakfast room "The Frances Elkins Loop chairs are longtime favorites. When I found this vintage set in a Chinese red, I knew I had to redo the breakfast room to accommodate them."

PAGE 252: The wallpaper in a guest bedroom is Meg Braff Designs' Imperial Garden in leaf and lichen on blue. The bedding is by Satori Fine Linens.

PAGE 253: Braff designed the master bedroom around her Castilia wallpaper, custom colored in Wedgwood on white. The headboard and bed skirt are a Bernard Thorp fabric, the throw pillows are covered in Quadrille and Madeaux fabrics, and the bedding is by Leontine Linens. "It's a happy room to wake up in," she says.

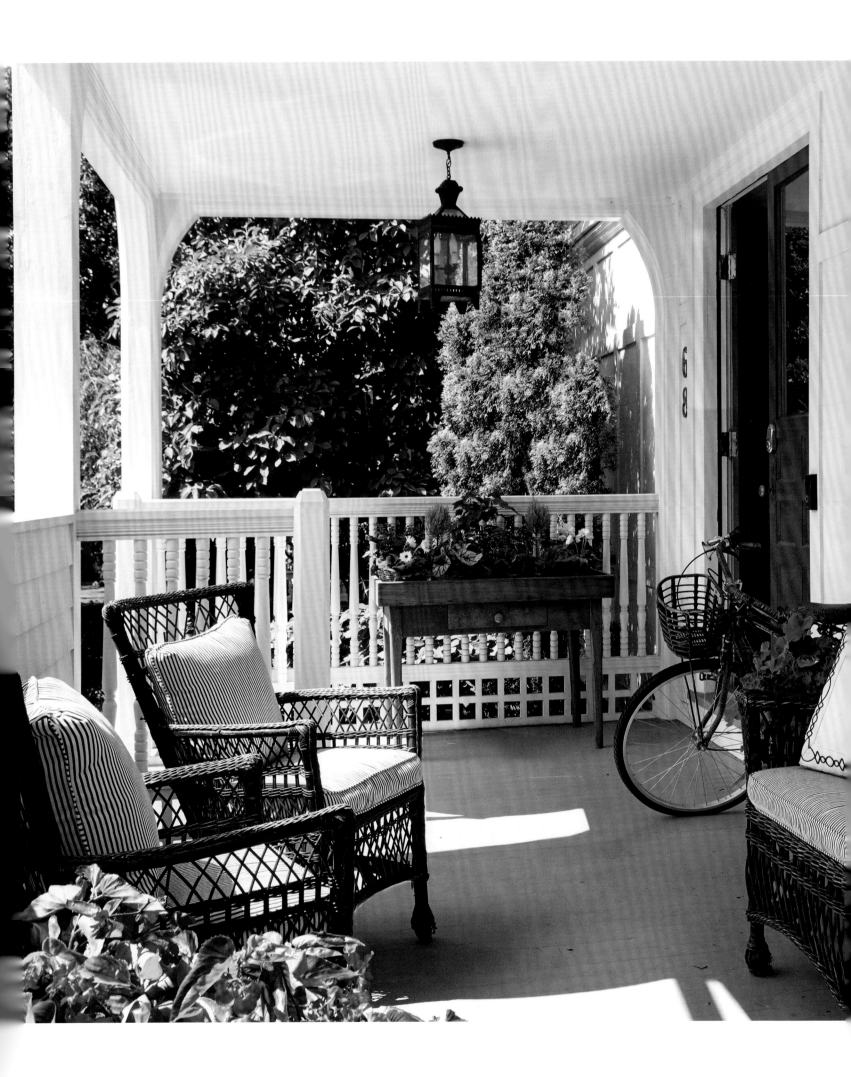

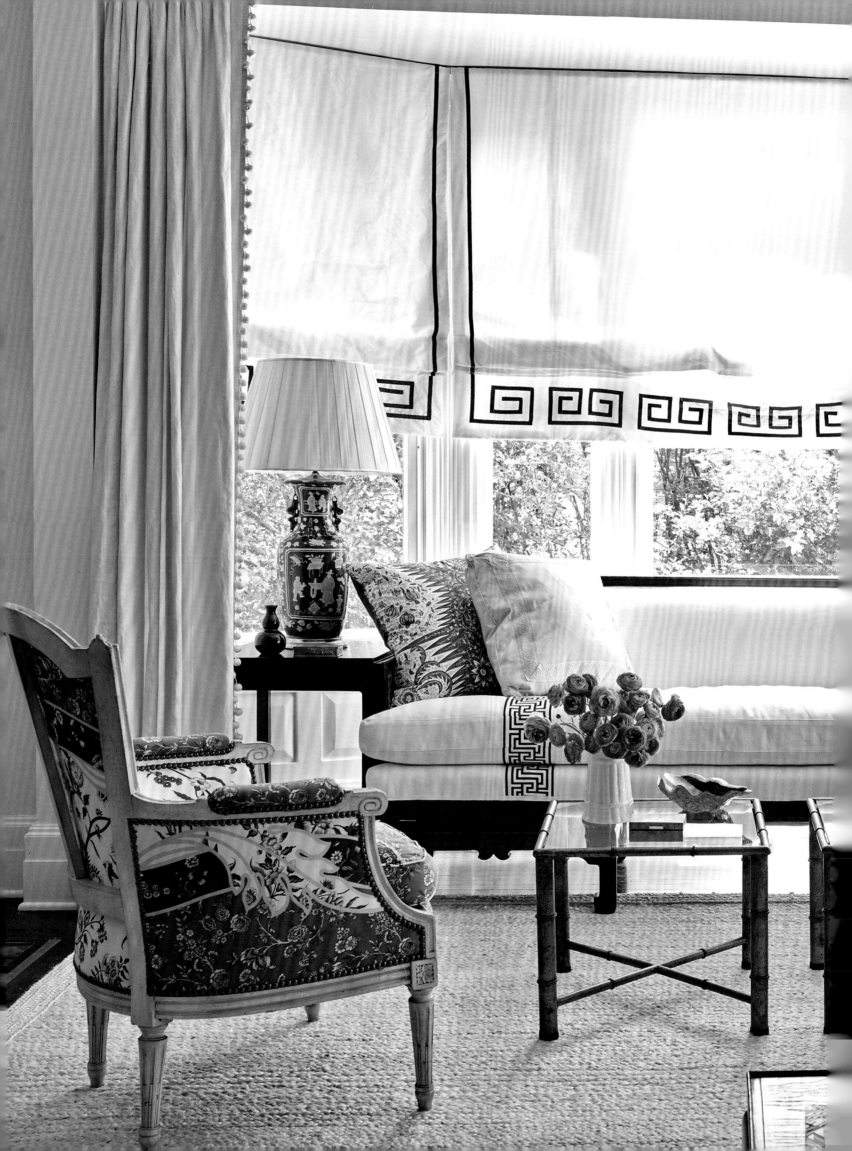

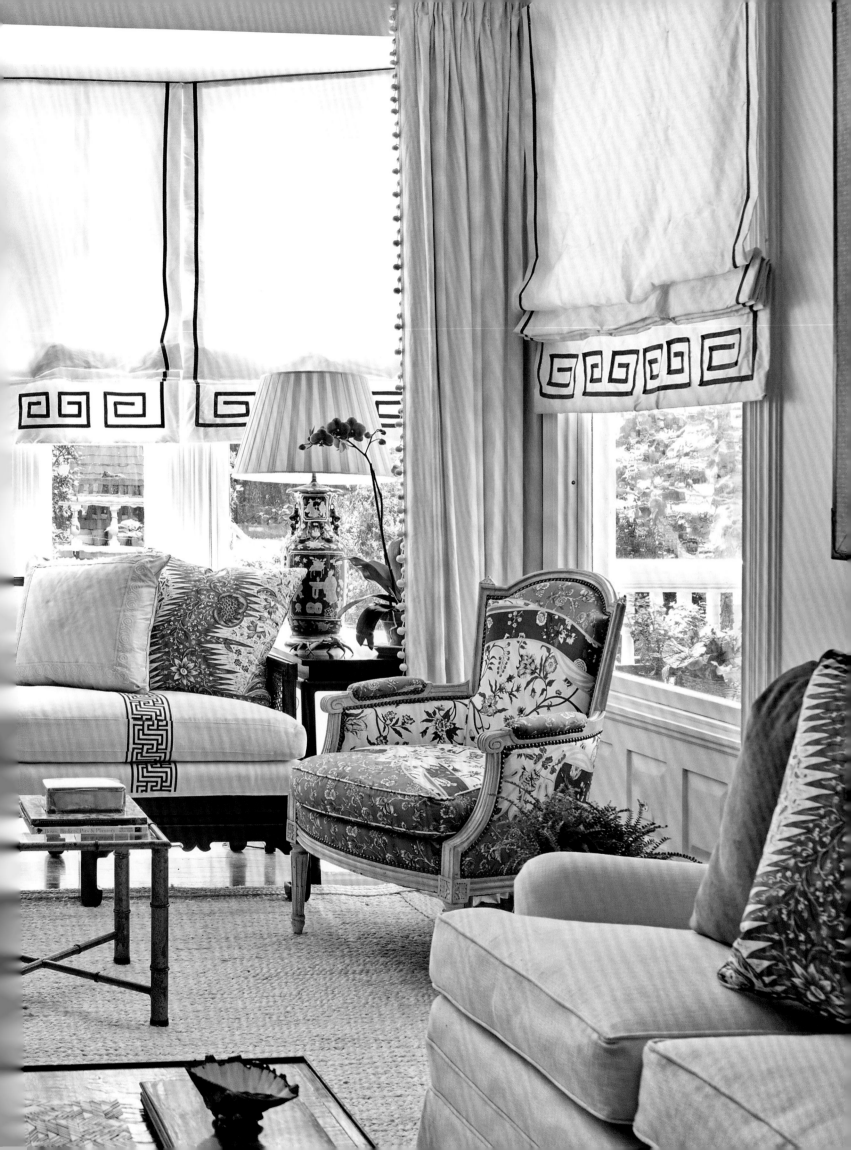

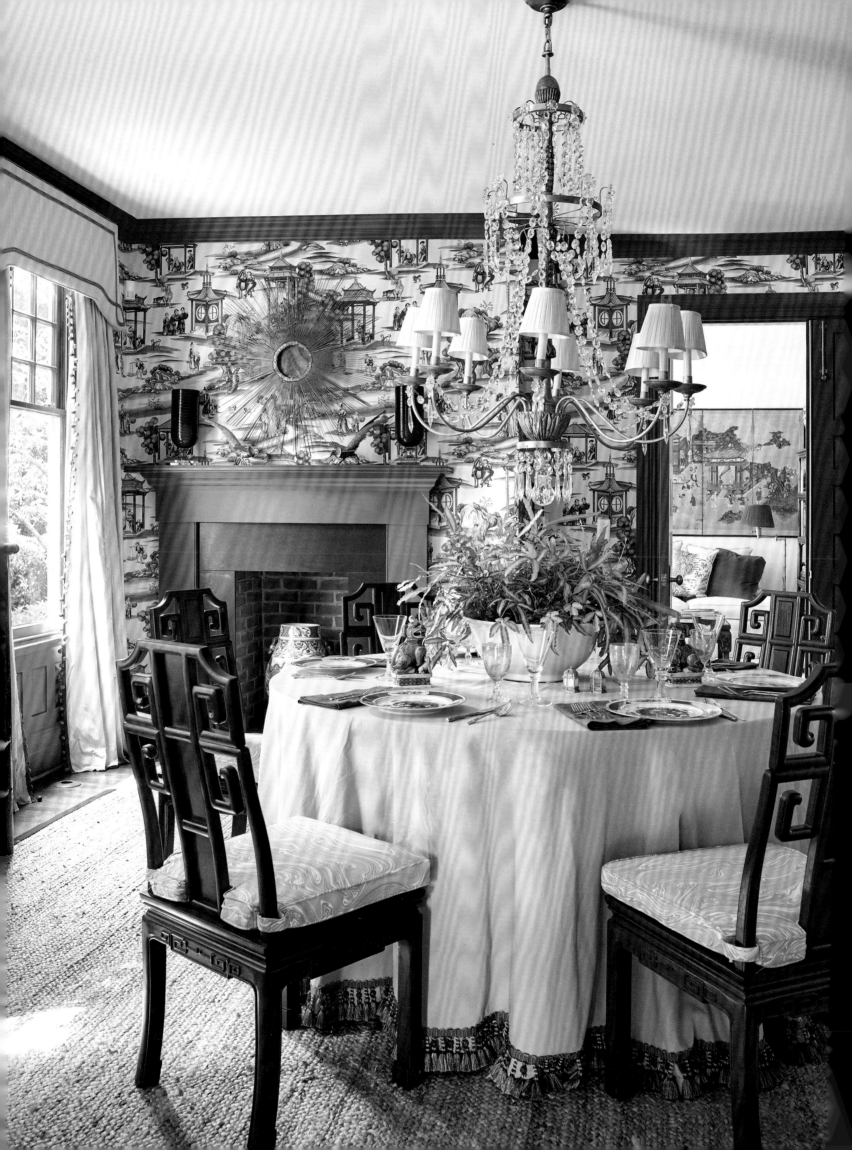

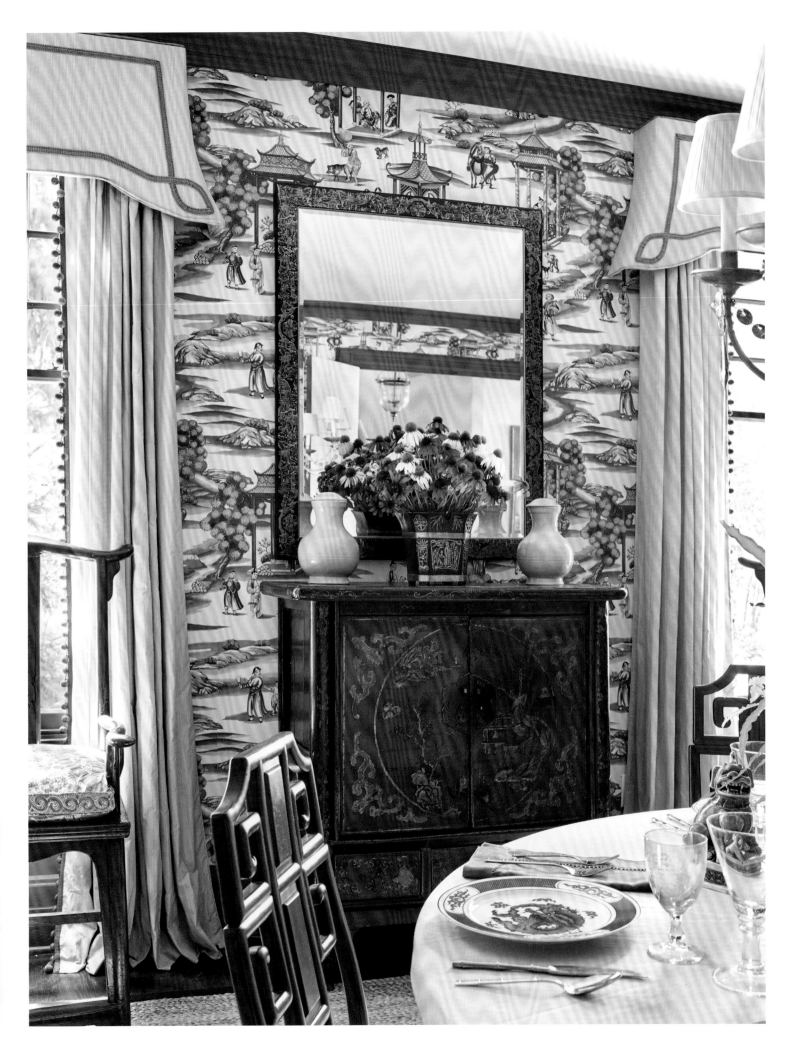

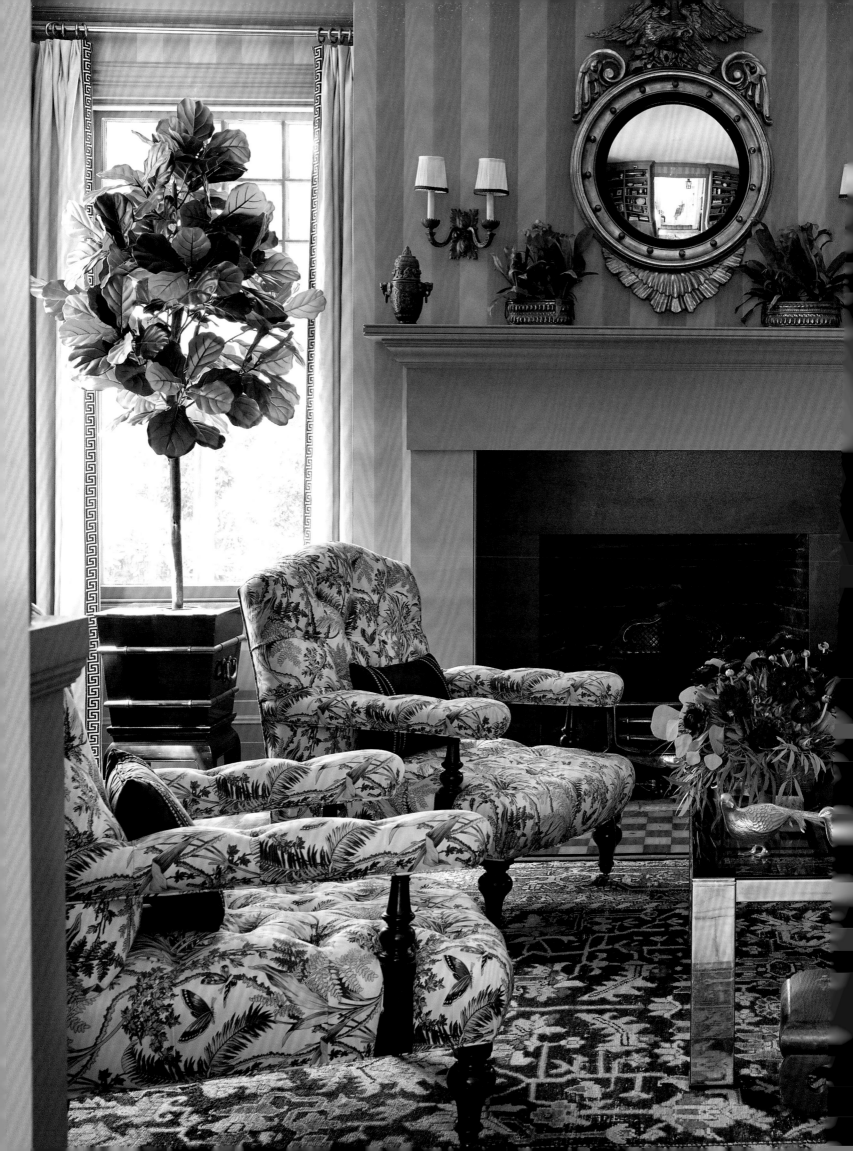

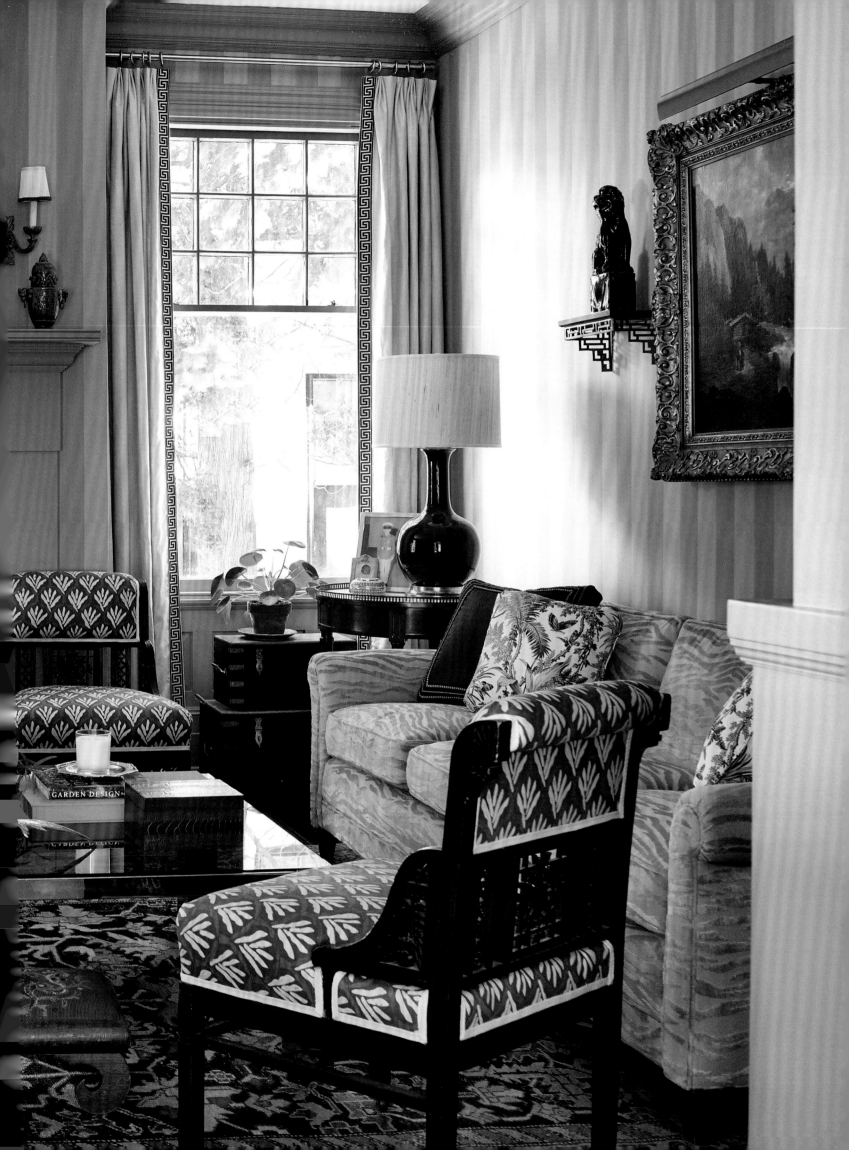

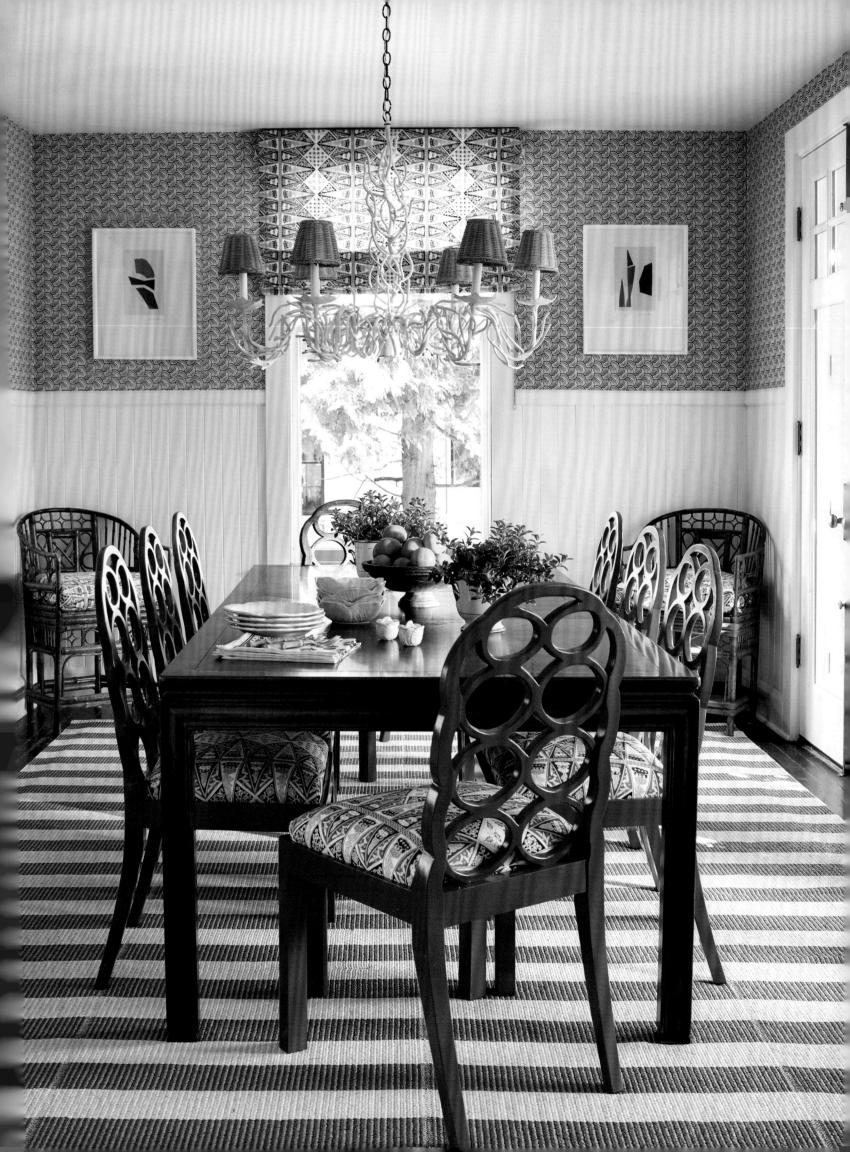

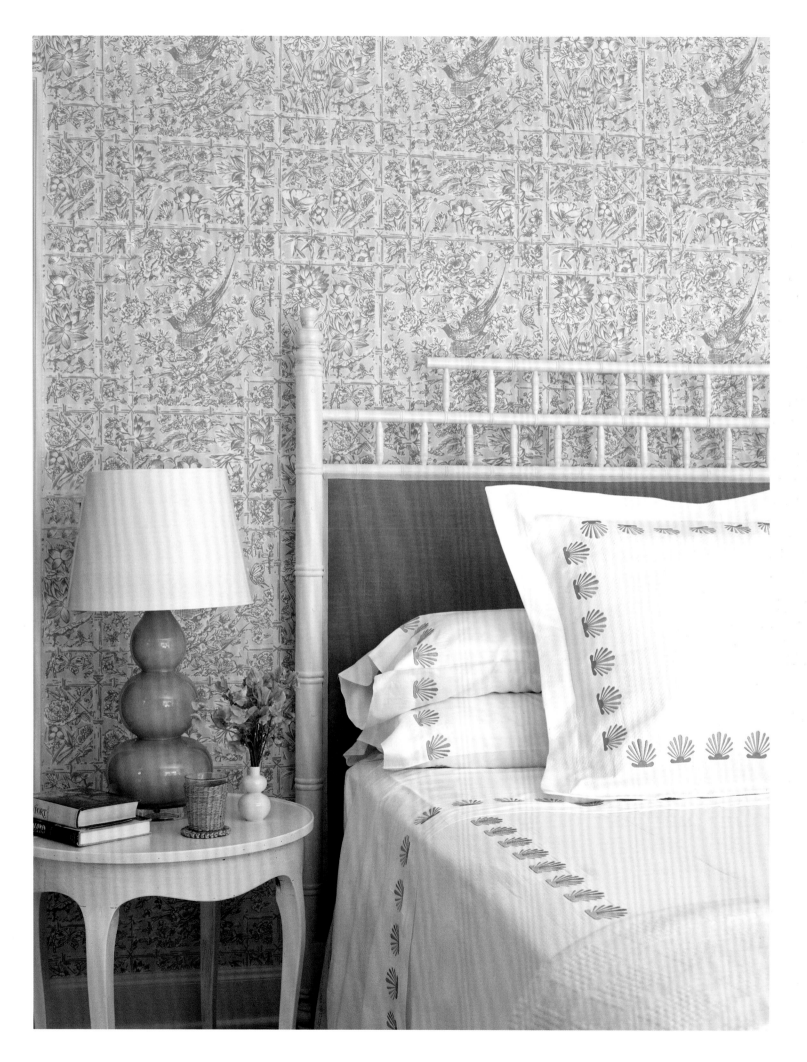

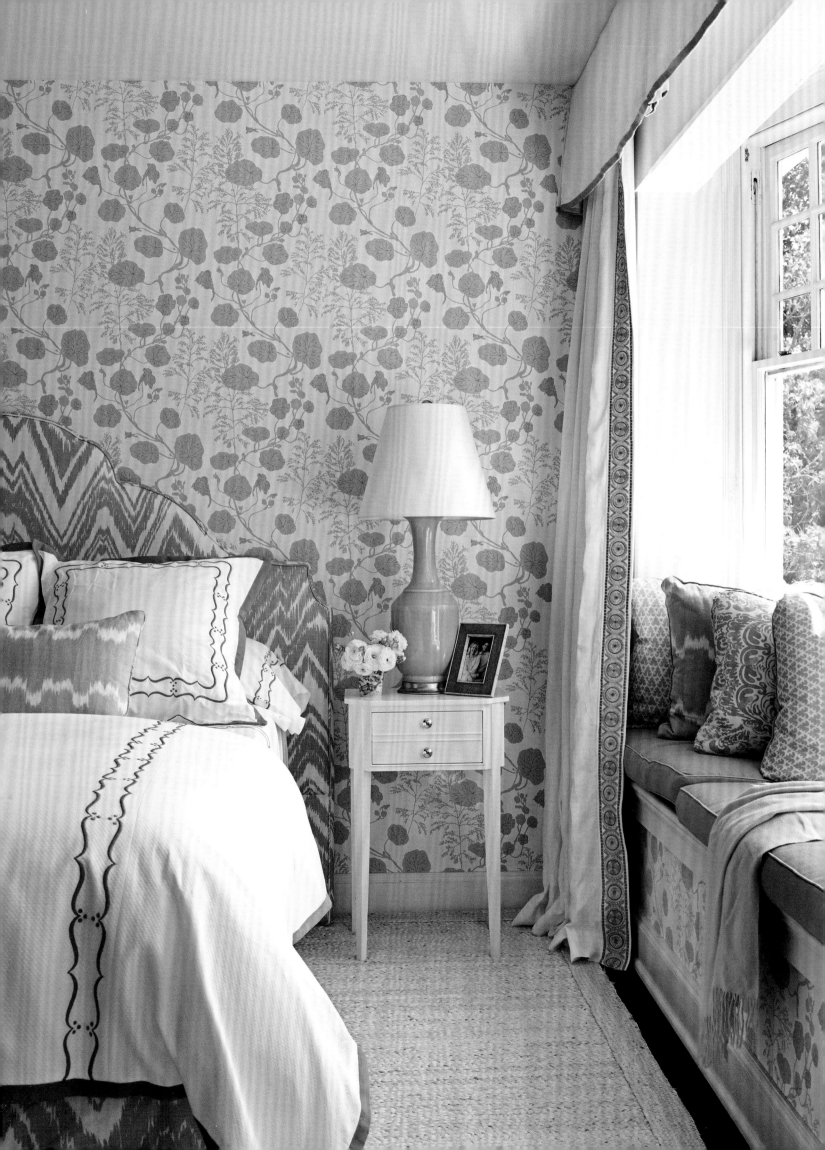

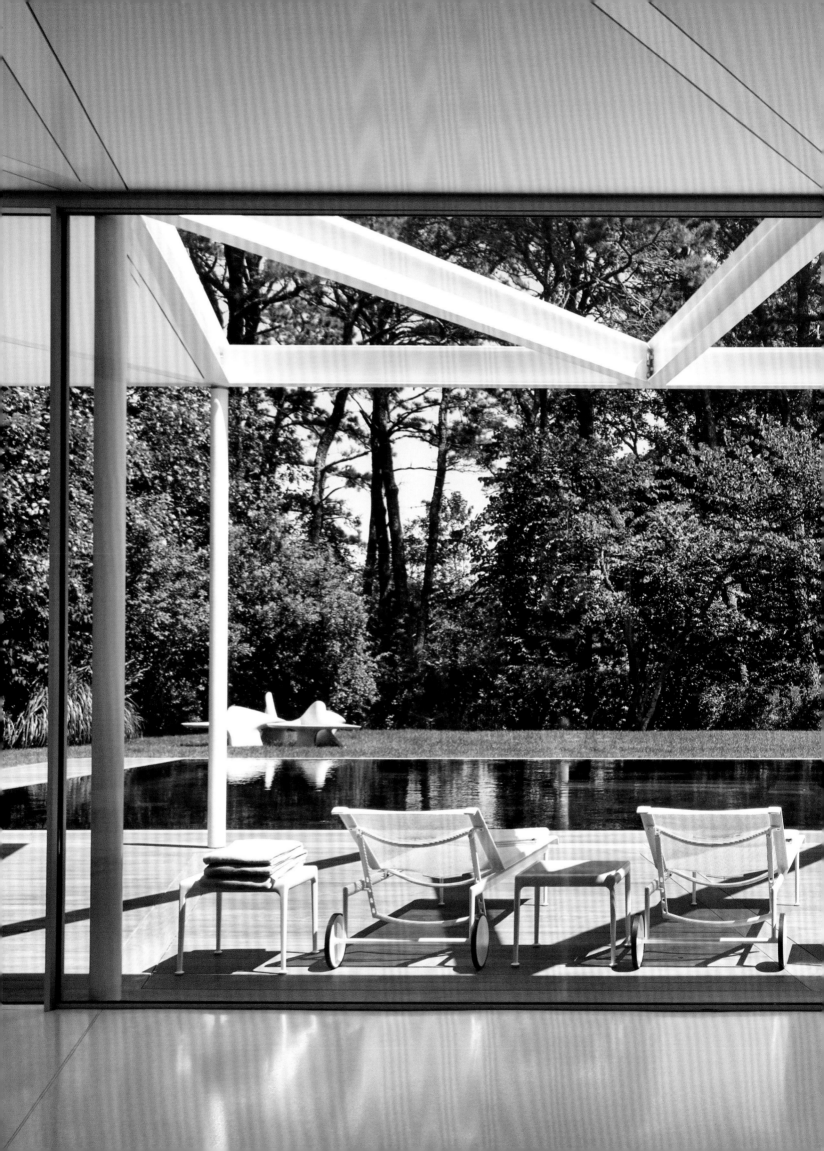

BLUE HERON FARM

A sleek glass pool pavilion at Blue Heron Farm on Martha's Vineyard serves as a pure distillation of Lord Norman Foster's ruminations on American architectural traditions. Its apparent minimalism entails more than meets the eye: doors open with ceremonial precision, luminous white walls reflect the island's watery light and scudding clouds, and the white terrazzo underfoot recalls the flooring of one of Foster's more famous collaborations—Steve Jobs's Apple Park in Silicon Valley and subsequent Apple stores.

For the past fifty years, Foster has designed hundreds of projects across five continents, including towers, airports, bridges, and museums, and has been awarded every major architecture prize: the Pritzker, the Praemium Imperiale, the Royal Gold Medal, the Stirling, the AIA Gold Medal, and the Aga Khan, among others. In Great Britain, where the distinctive form of his ecologically conscious Swiss Re Building, affectionately known as The Gherkin, reigns over the London skyline, he was raised to the peerage as Baron Foster of Thames Bank. In a review of New York's Hearst Tower, architectural historian Paul Goldberger called Foster the "Mozart of Modernism."

If Foster's childhood drawings of people traveling to the moon were an early predictor of his lifelong obsession with design and progress, his insatiable curiosity and irrepressible vitality have only increased with age. He enters the pool pavilion, at once courtly and bounding with energy, like a Thoroughbred at the starting gate and a perfect complement to his wife Elena's Spanish cool.

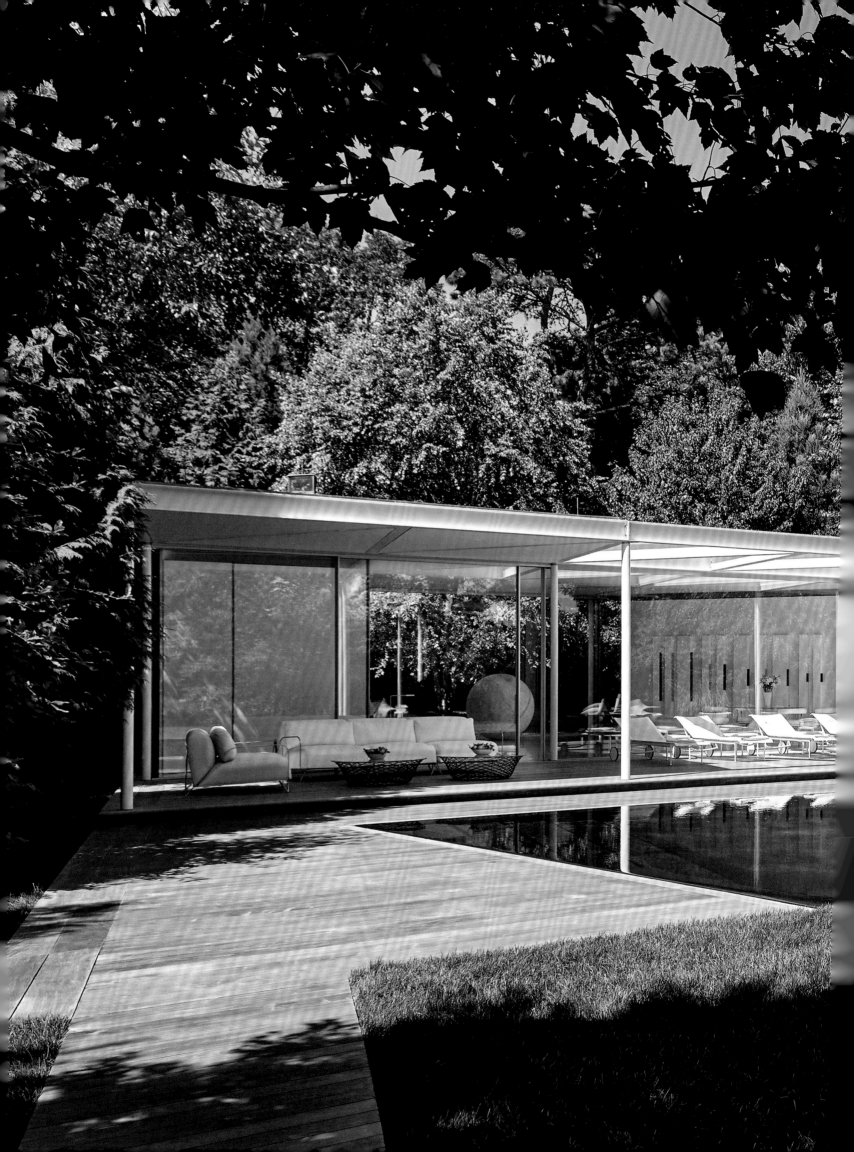

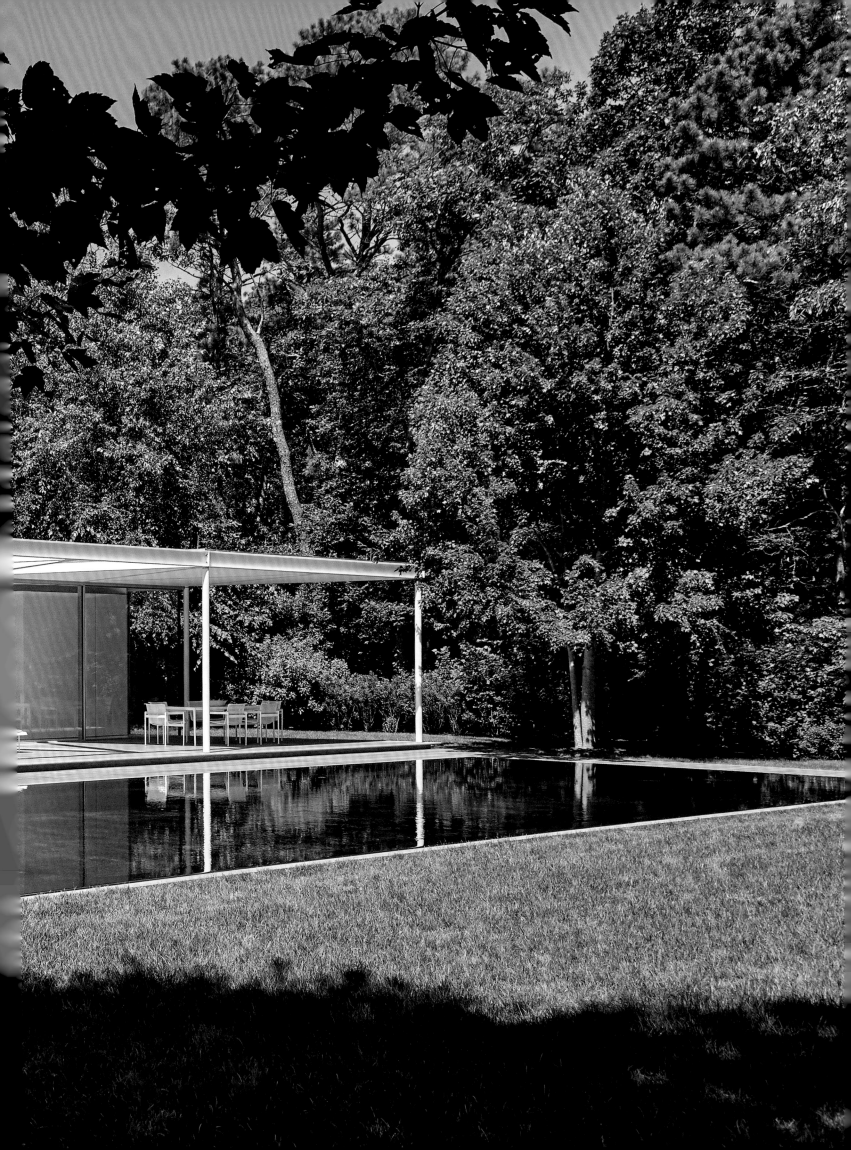

He describes the pavilion as a contemporary counterpart to the traditional structures on the property. "The main house is a typical New England lightweight wood-framed structure—modest, elegant, economic, and practical. Its roots are the balloon frame, dating from the early nineteenth century, when the industrialized mass production of nails enabled small sections of timber to be economically and swiftly joined together. The result is a timeless vernacular. The pool house is not a copy of that tradition but, two centuries later, it is in the same spirit, taking small steel sections instead of timber, joining them with bolts, replacing boarding with readily available glass panels, and adopting the ubiquitous New England language of white paint—even incorporating the traditional porch."

In addition to traditional American timber-framed houses, Foster cites California's historic Case Study houses of the mid-1940s–1960s, as well as Ludwig Mies van der Rohe's Farnsworth House and Philip Johnson's Glass House, as sources of inspiration. "However, these are based on a 90-degree rectangular geometry. The pool house, consciously, is wedge shaped to occupy the corner of the site, so its plan is based on a diamond rather than a square or rectangle."

The structure, which took six months to complete, is located on the site of an old pool in a field that Foster augmented with trees, so that as one approaches the shimmering pool and glass pavilion, one has the sense of coming upon a welcome clearing in the woods.

Its intention as a venue for intimate family gatherings and larger parties seems to have been fulfilled. "As an architect, one learns never to take anything for granted—only use will determine the degree of success or otherwise."

Elena Foster smiles at this. "Come over any evening and there are lots of teenagers here," she says. Clearly, the structure is an unqualified success, and it's apparent that the family feels completely at home on the island. Before leaving, we turn around to observe the structure from a distance. Nestled amid the trees, it seems at one with nature.

PAGES 254–57: Lord Norman Foster designed a pool pavilion on the family's Blue Heron Farm. Wedge-shaped, it occupies the corner of a clearing, its plan based on a diamond, rather than a square or rectangle. The boundary between exterior and interior is eliminated by the transparency of glass, and a generous porch overhang provides shade and shelter. A Carrara marble moon sculpture by Swiss artist Not Vital can be seen in the interior. The chaises longues are by Mies van der Rohe. Foster designed the sofas and tables.

OPPOSITE: The planting of numerous trees around the new pool and pool house created both a sense of enclosure and the feeling of a clearing in the woods. The sculptural benches are by the late architect and Foster family friend Dame Zaha Hadid, the first woman to receive the Pritzker Architecture Prize. They were featured in a Hadid retrospective at Elena Foster's Ivorypress art gallery in Madrid.

PAGES 260–61: An abstract geometric work by Argentinean artist César Paternosto brings a touch of color to the white interior. Le Corbusier chairs surround a table designed by Foster.

PAGES 262–63: The white terrazzo floor throughout the interior is reminiscent of the flooring in one of Foster's major projects, the Apple headquarters in Silicon Valley. A fireplace, stacked wood, and book-filled shelves add warmth.

PAGES 264–65: A collection of sun hats hangs at the ready in a changing room (left), which can be seen from the outdoor shower (right).

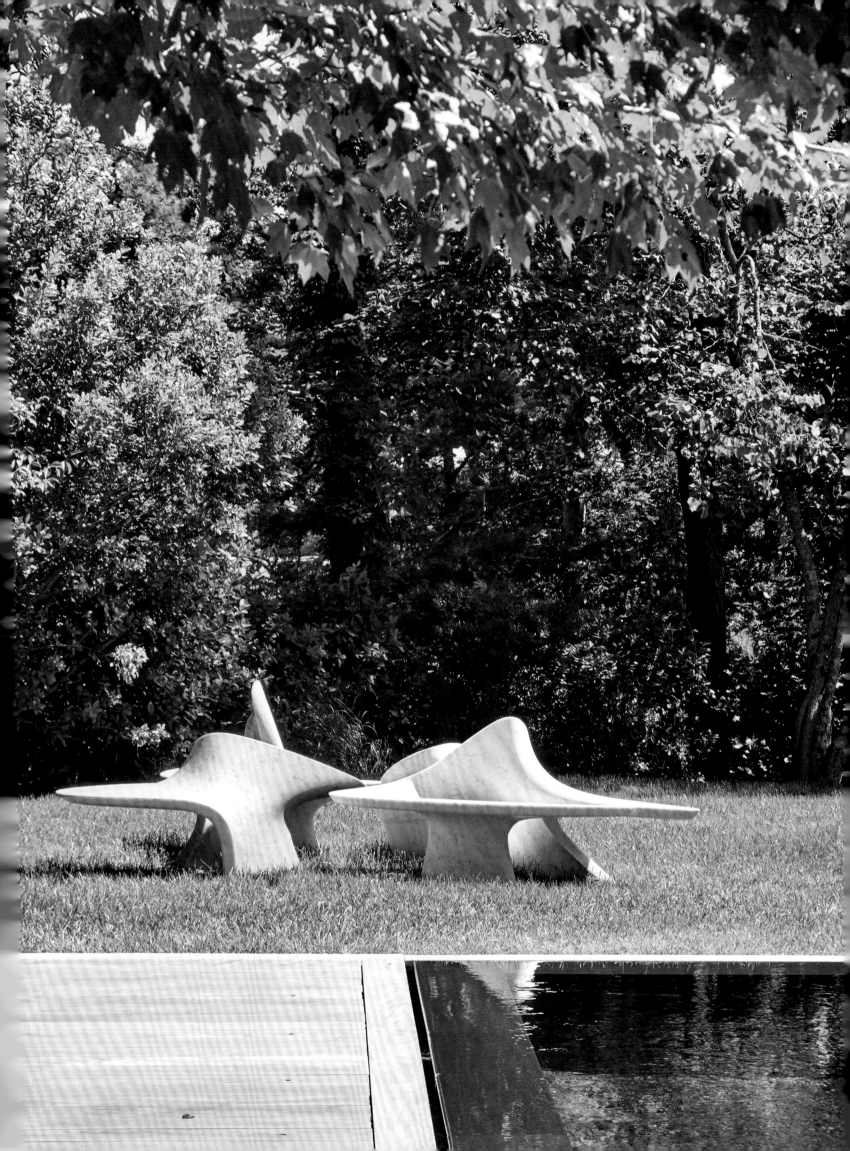

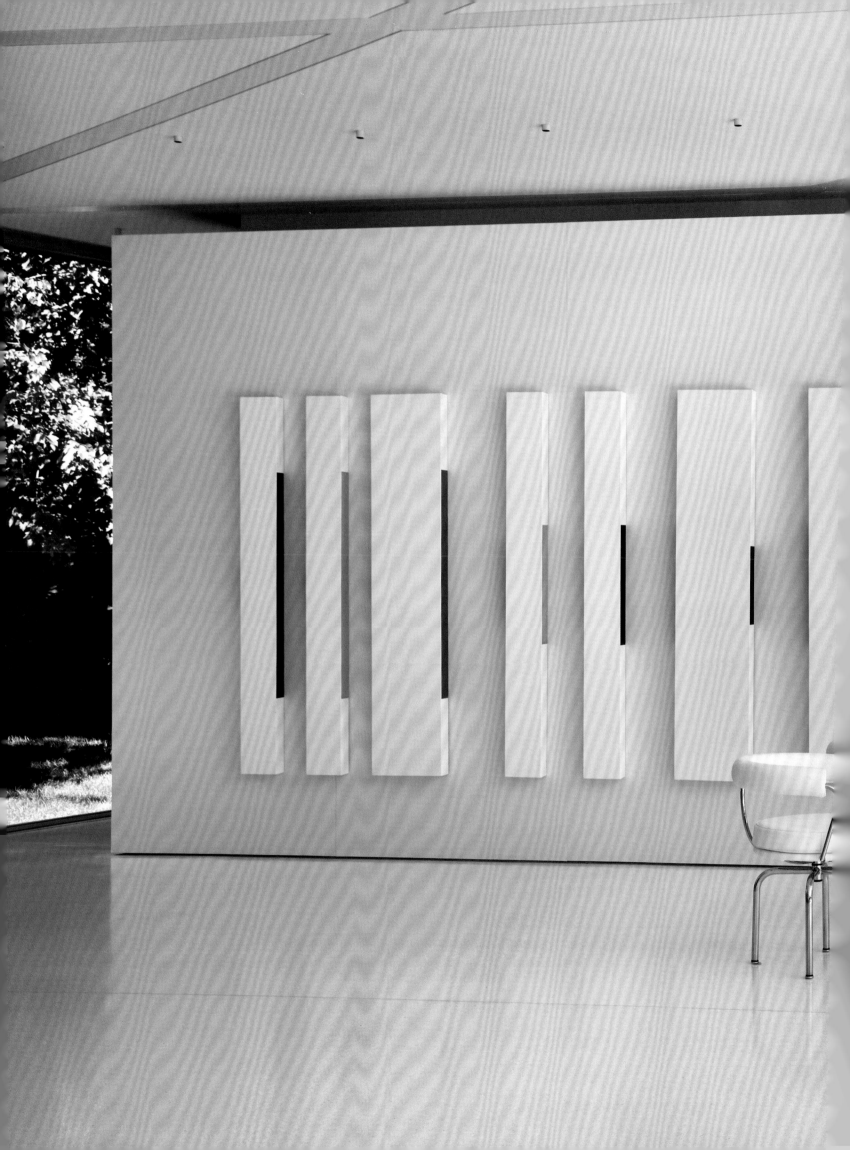

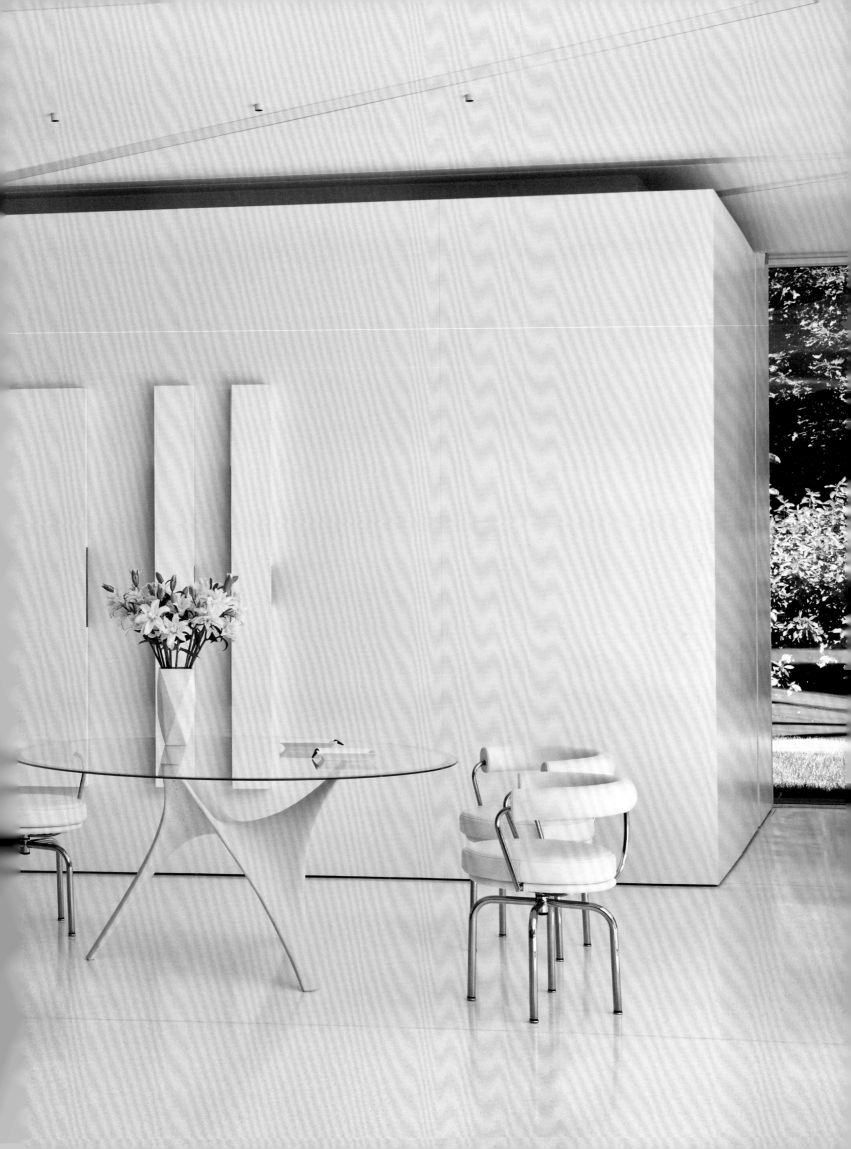

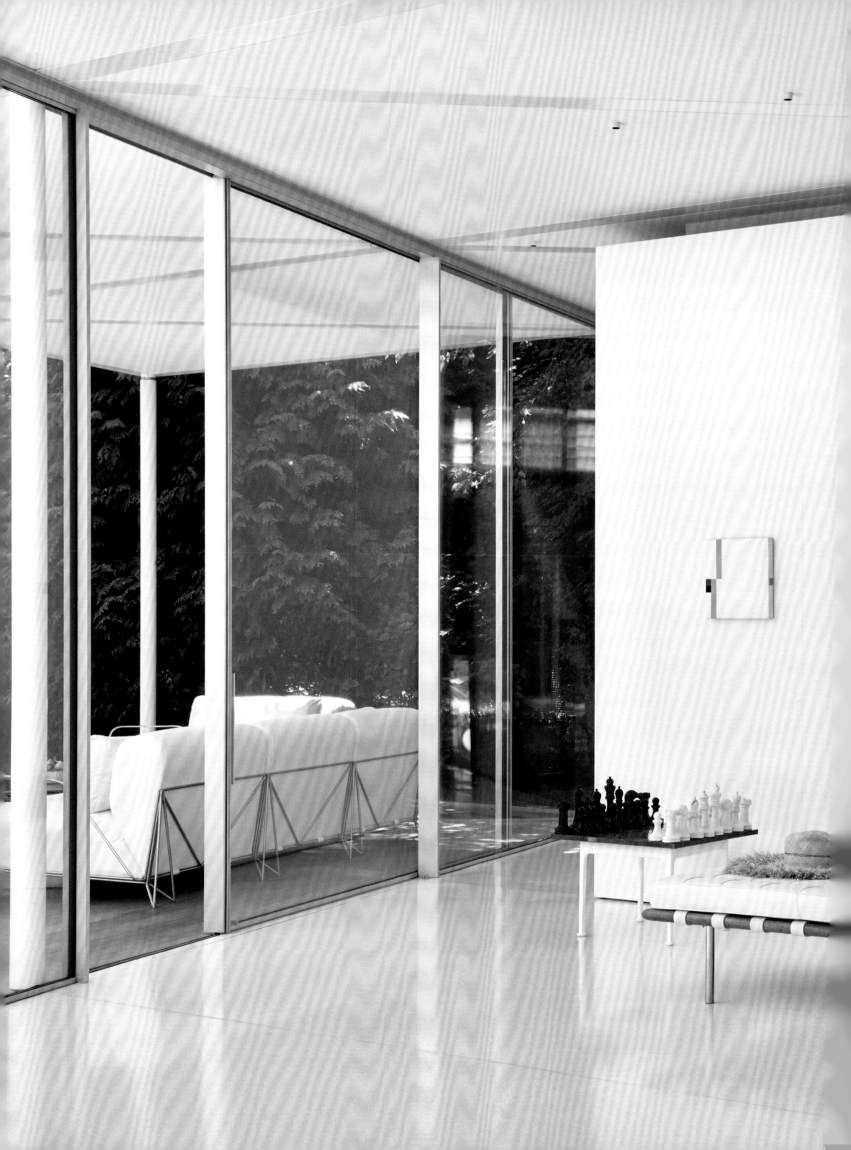

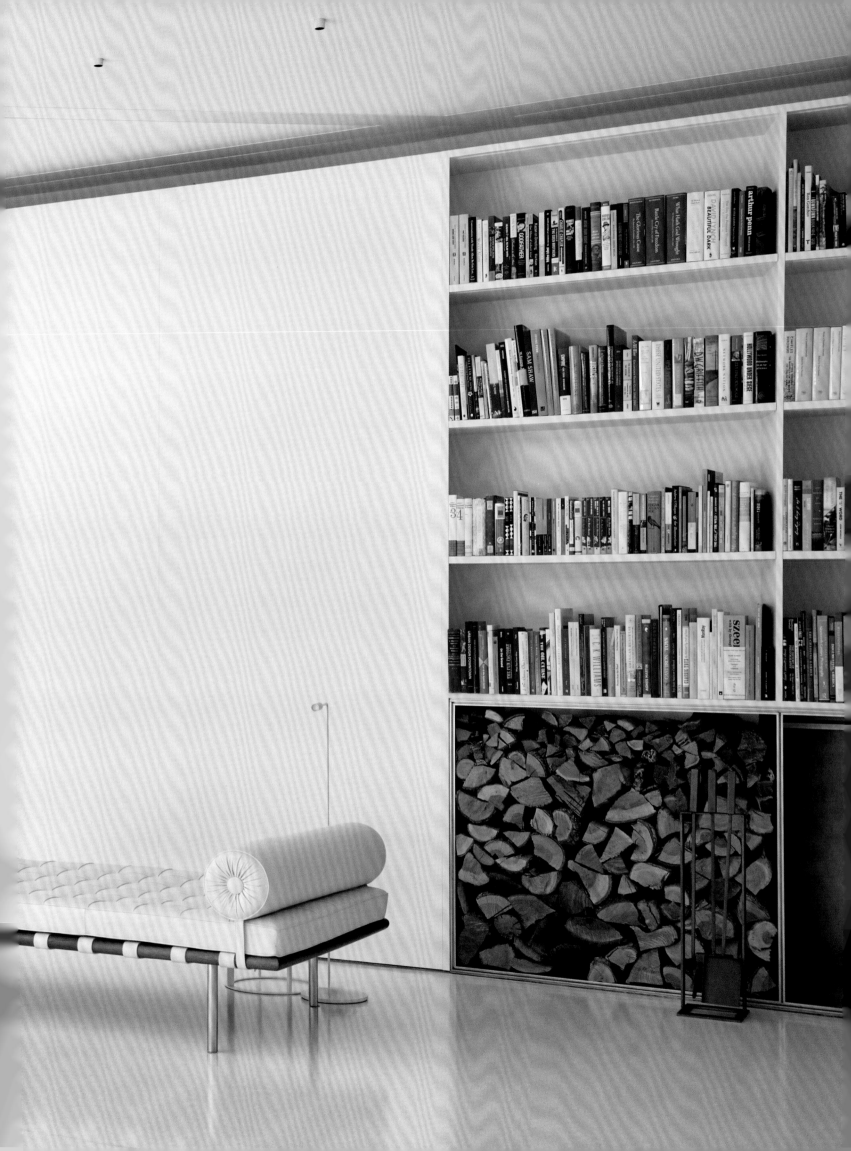

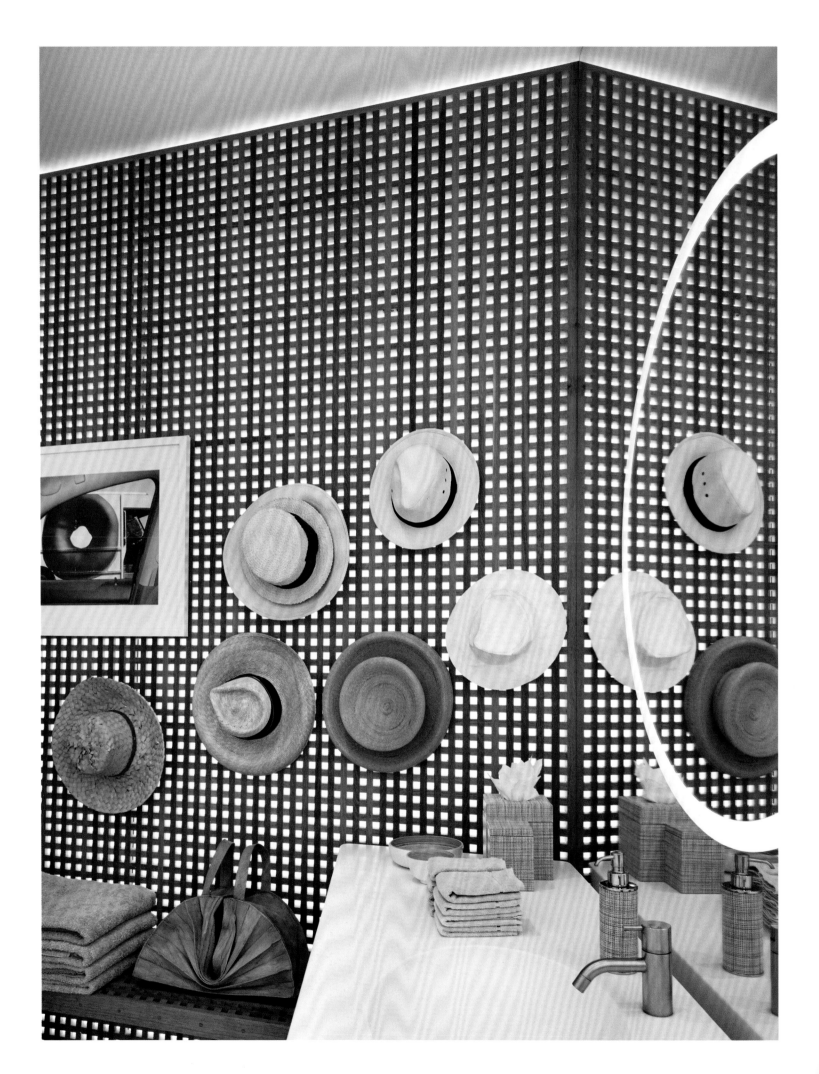

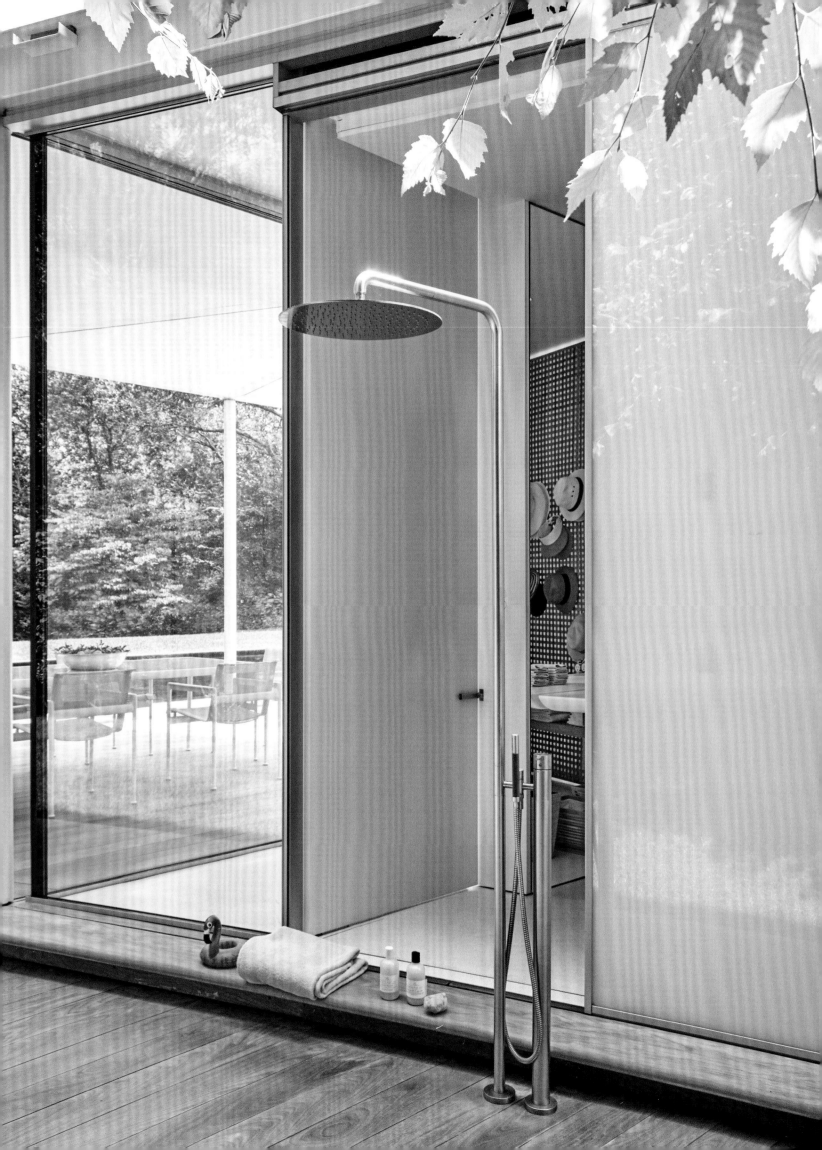

DOWN EAST CONVERSION

It's hard to imagine how interior designer John Fondas and John Knott, owner of the venerable fabric and wallpaper firm Quadrille, whose busy professional and social lives demand equal parts precision and accountability, manage in a summer house with no dishwasher or cell service on an island that has spotty internet and is accessible only by boat. Little Cranberry's ferry service permits only small freight such as bicycles—in other words, no four-poster beds, Georgian armoires, taxidermy collections, ceramic garden stools, rolling bar carts, Syrian inlaid chairs, or oversized sofas, all of which somehow made their way to the couple's summer home to glorious effect.

As it turns out, Fondas was bred for the task, having been raised in Nassau, where improvising is not so much a novelty as a way of life. With limited resources, island dwellers are always thinking about where to find this or how to rework that. "The first rule of island life is making due," Fondas says. "You can't run out to the store for everything. Power cuts are a reality in the Bahamas—and on Little Cranberry Island. Weather is real and present and affects access and supplies. Boats are canceled and, first and foremost, ice cream often melts on the dock."

So it should come as no surprise that Fondas lost not even a single night's sleep improvising a moving plan. "Someone at our warehouse in upstate New York drove a moving van full of furniture onto the local oil barge, which had

[267]

been a World War II troop carrier—and it was a lot of furniture, gathered from other houses we'd had. It was the flotsam and jetsam of our lives coming together—the grand recycling that makes old vacation houses so homey and quirky, which suits this house," says Fondas.

Built in 1905 as a hotel for "rusticators" from places like Boston and Philadelphia, the house had nineteen tiny bedrooms, which Fondas and Knott combined to make more sumptuous spaces. They also upgraded the electricity somewhat and swathed the interiors in Quadrille fabrics. The design took root with a blue ikat on an oversized living room sofa. "We kept adding various blues and white, and we finally said, 'With all this pattern, the only logical thing is to keep adding one more,'" remembers Fondas. The lively collection of fabrics and furnishings alludes to the kind of Old China Trade exotica that a New England sea captain might have amassed and is perfectly in sync with the house.

The dining room, hung with paisley wallpaper and an extraordinary coconut-shell chandelier, seats eight people and is the heart of the house. "It's grilled chicken, vegetables, a salad, and ice cream. That's it," claims Fondas. On a cool August afternoon, six guests arrived en masse, moaning about plane and ferry delays, but their griping evaporated as the sun set over Cadillac Mountain and their gin and tonics were drained. The party moved to the kitchen, where every-one pitched in, preparing chicken Milanese for eight, which they devoured around the dining room table, aglow in candlelight.

PAGES 266-67: John Knott and John Fondas's house on Little Cranberry Island, Maine, has views of Cadillac Mountain and Acadia National Park.

OPPOSITE: Knott and Fondas transformed a 1905 hotel into a welcoming summer retreat. They designed a new entrance portico using salvaged columns from upstate New York.

PAGES 270-71: Antique wicker adorns a hall papered in Quadrille's Vanderpoel Stripe.

PAGES 272-73: The living room's vibrant fabrics, all by Knott's firm, Quadrille, blend perfectly with an exotic mix of furniture, including Syrian inlaid chairs and Chinese ceramic stools, evoking the far-flung travels of New England seafarers.

PAGES 274-75: The bold geometry of curtains in Quadrille's Tashkent pattern and an Adirondack folding screen complement furniture covered in China Seas fabrics such as Nitik II on the armchair at the right and New Batik on an Albert Hadley armchair in the foreground, both with pimento trim. The dining room's coconut-shell chandelier and Home Couture's Taj paisley wallpaper contribute to the exotic vibe.

PAGES 276-77: Tableware and linens, stored in a glass-fronted antique armoire, are not only easily accessible but also decorative.

PAGE 278 AND PAGE 279 BOTTOM LEFT: This guest room is referred to as the Princess Room, as every little girl, and some not so little, who sees the eighteenth-century Portuguese bed flips for it and wants to climb right in.

PAGE 279, TOP LEFT: The Green Room is furnished with original pieces from the house's earlier incarnation as the Woodlawn Hotel. TOP RIGHT: The aptly named George Washington Room features antique American flags, engravings of the first president, and Quadrille's Independence Engraving wallpaper. BOTTOM RIGHT: Collections of butterflies, insects, and taxidermy birds enliven a room with China Seas' Fez wallpaper.

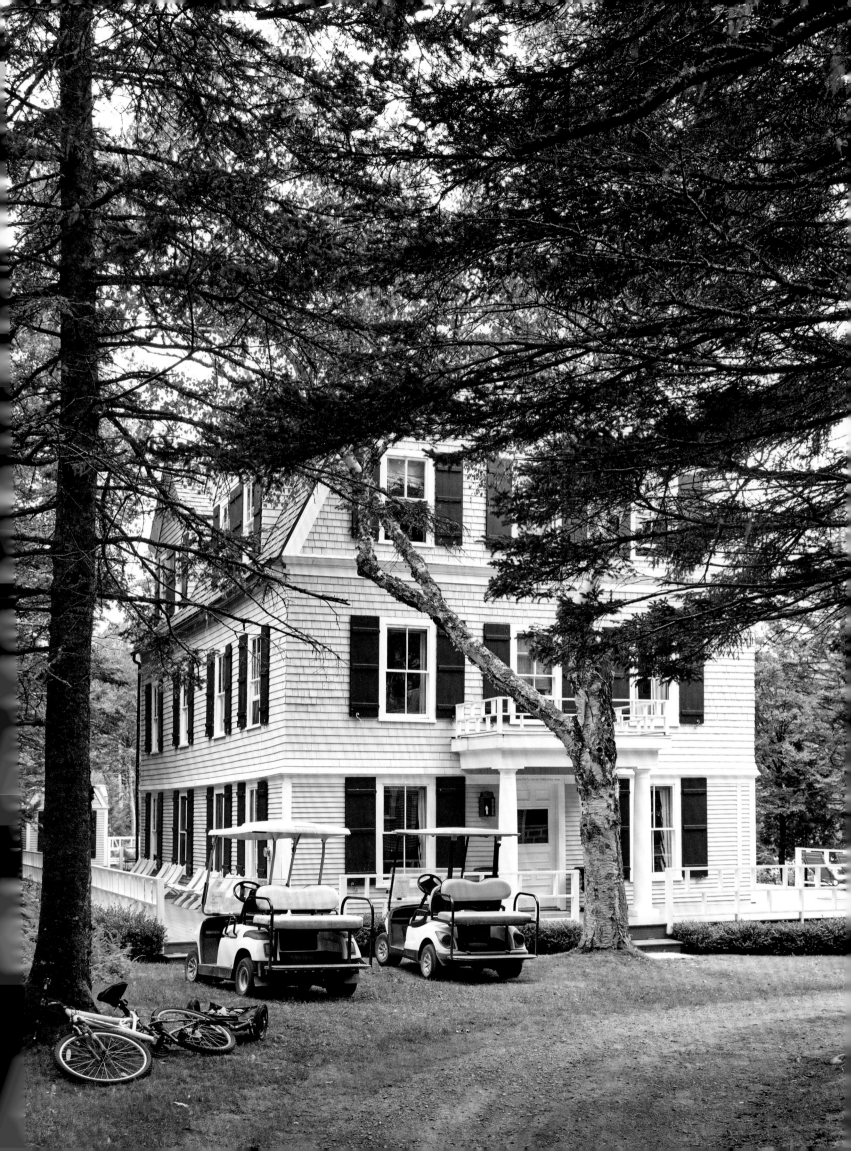

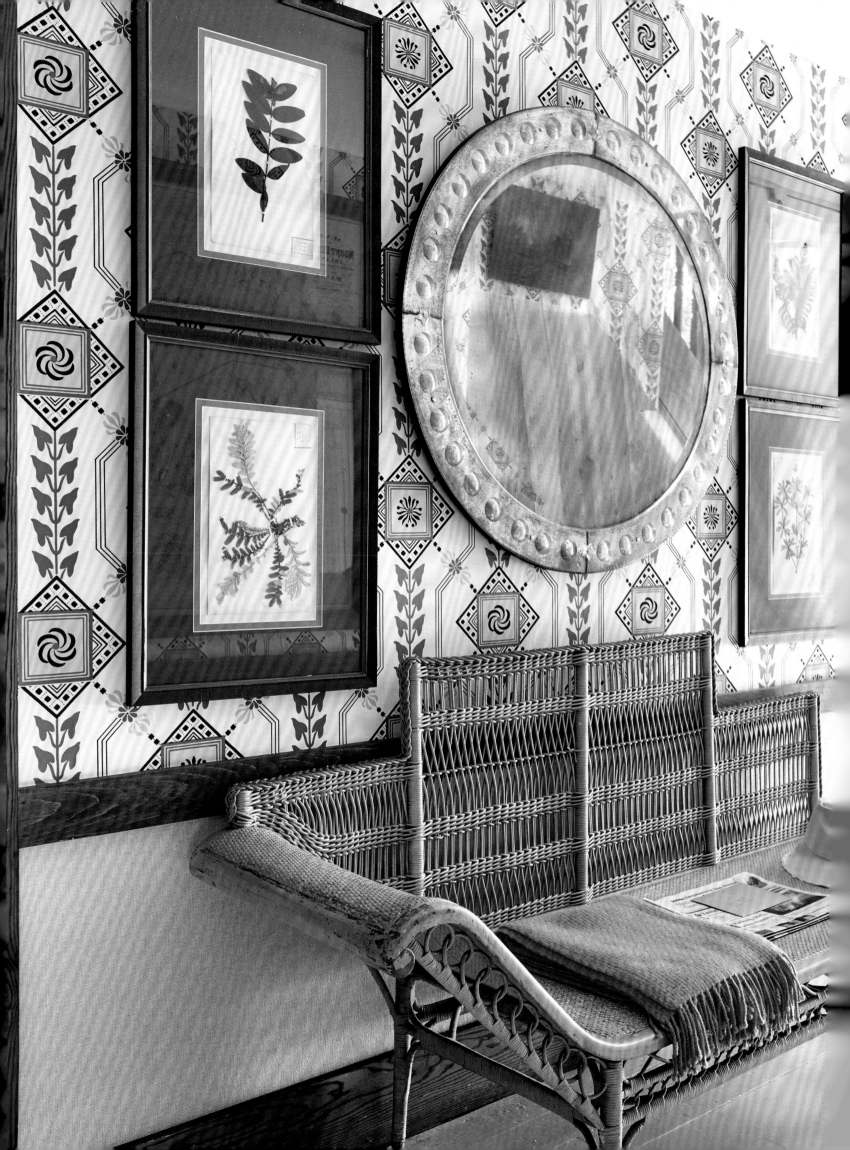

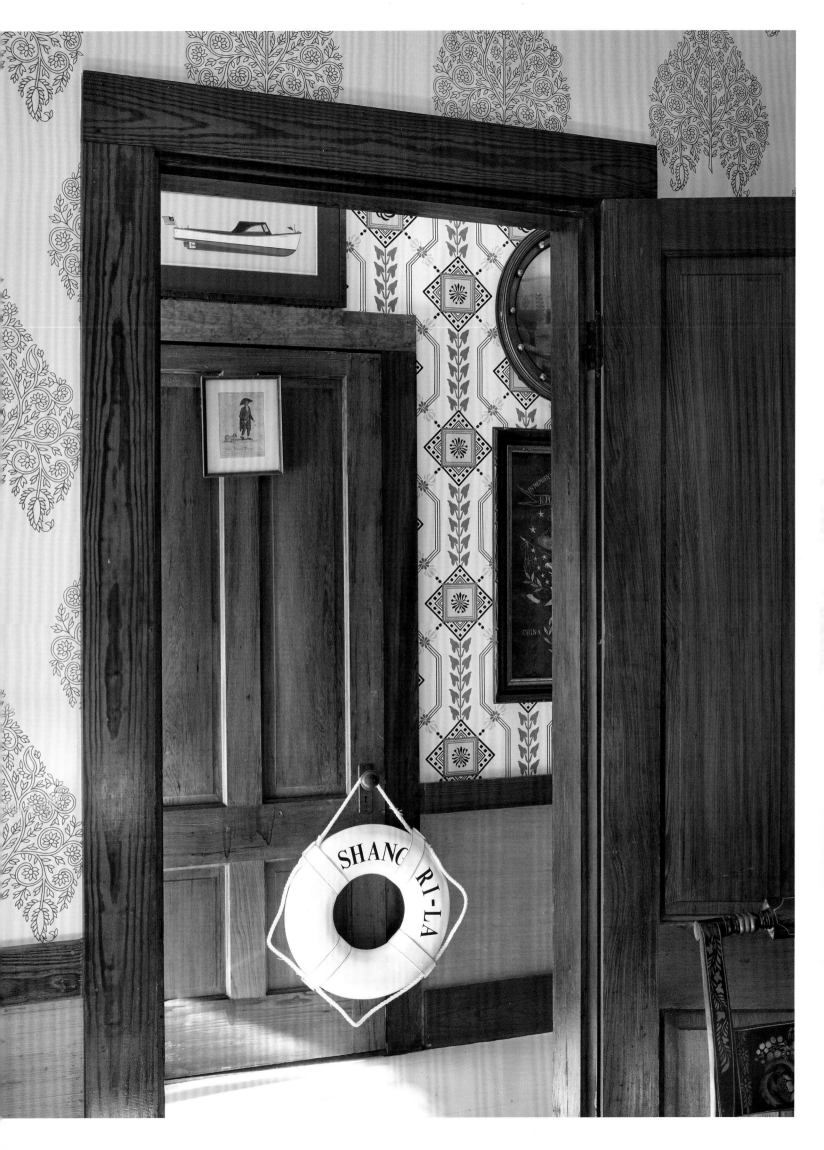

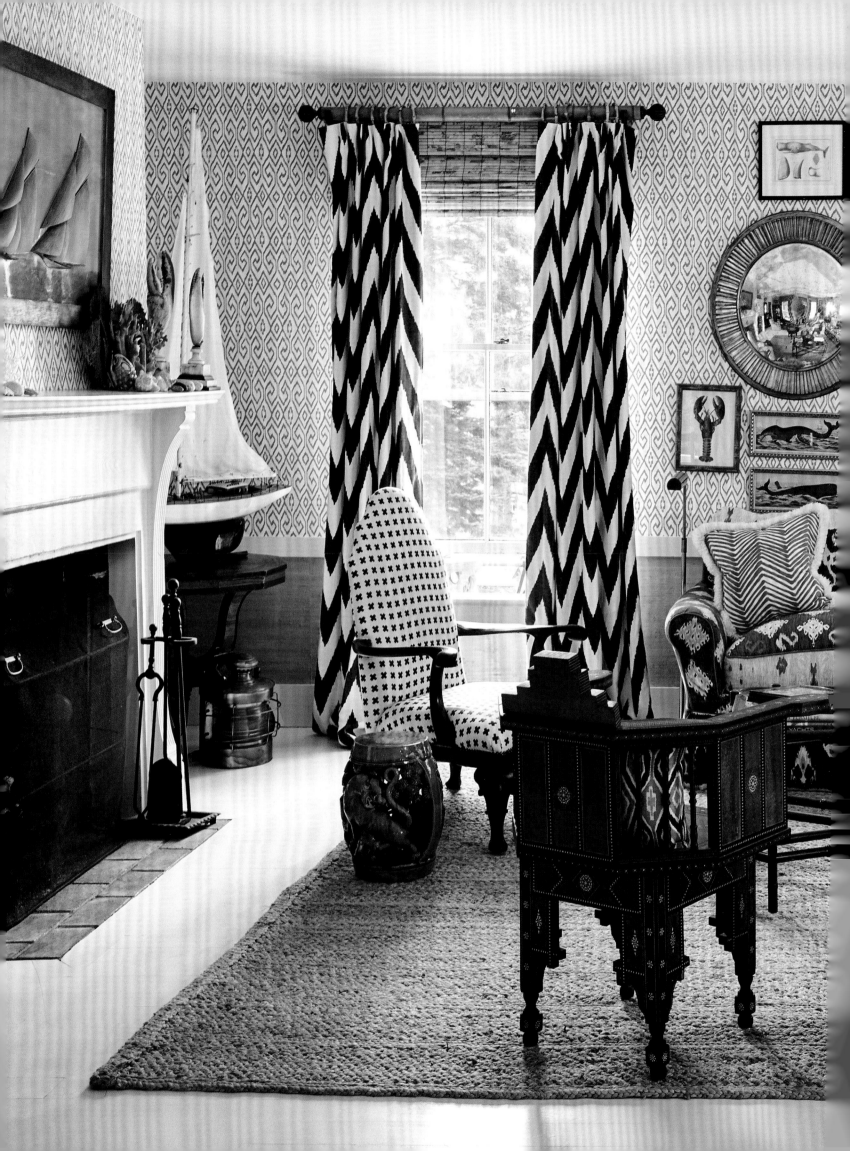

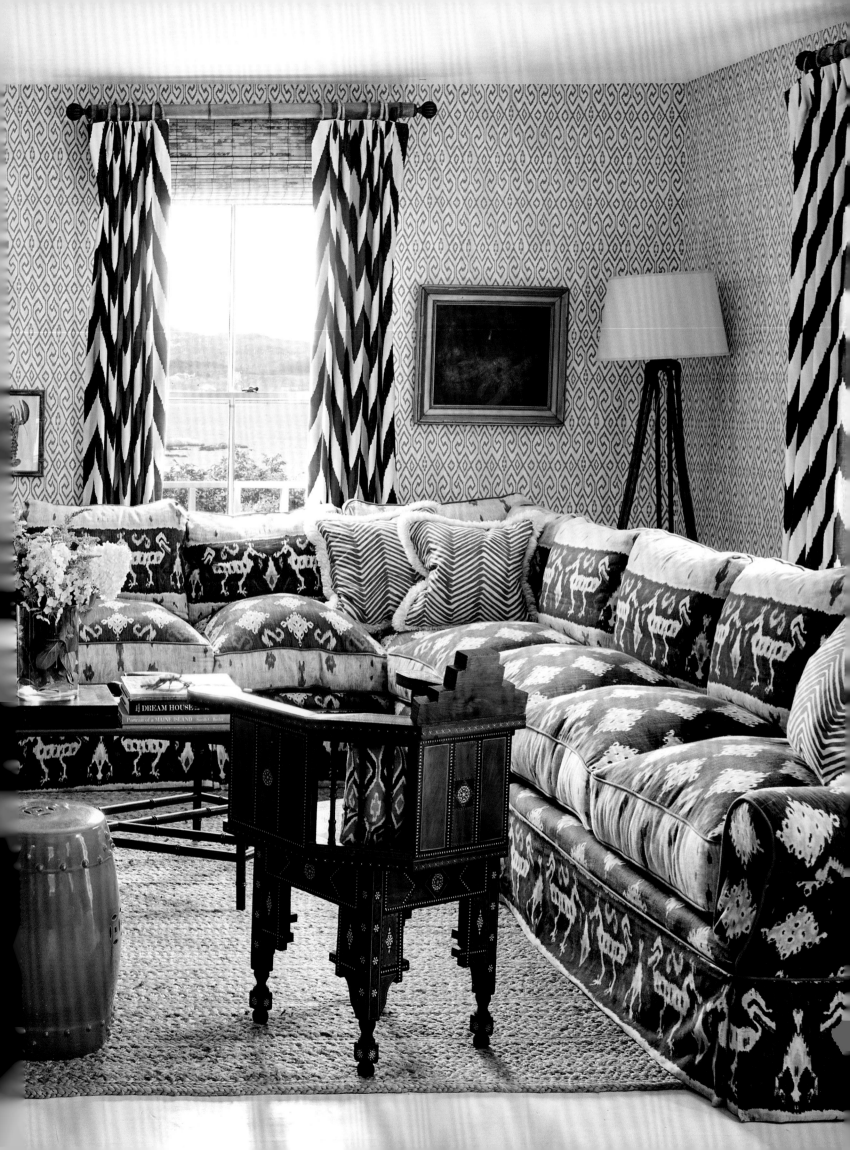

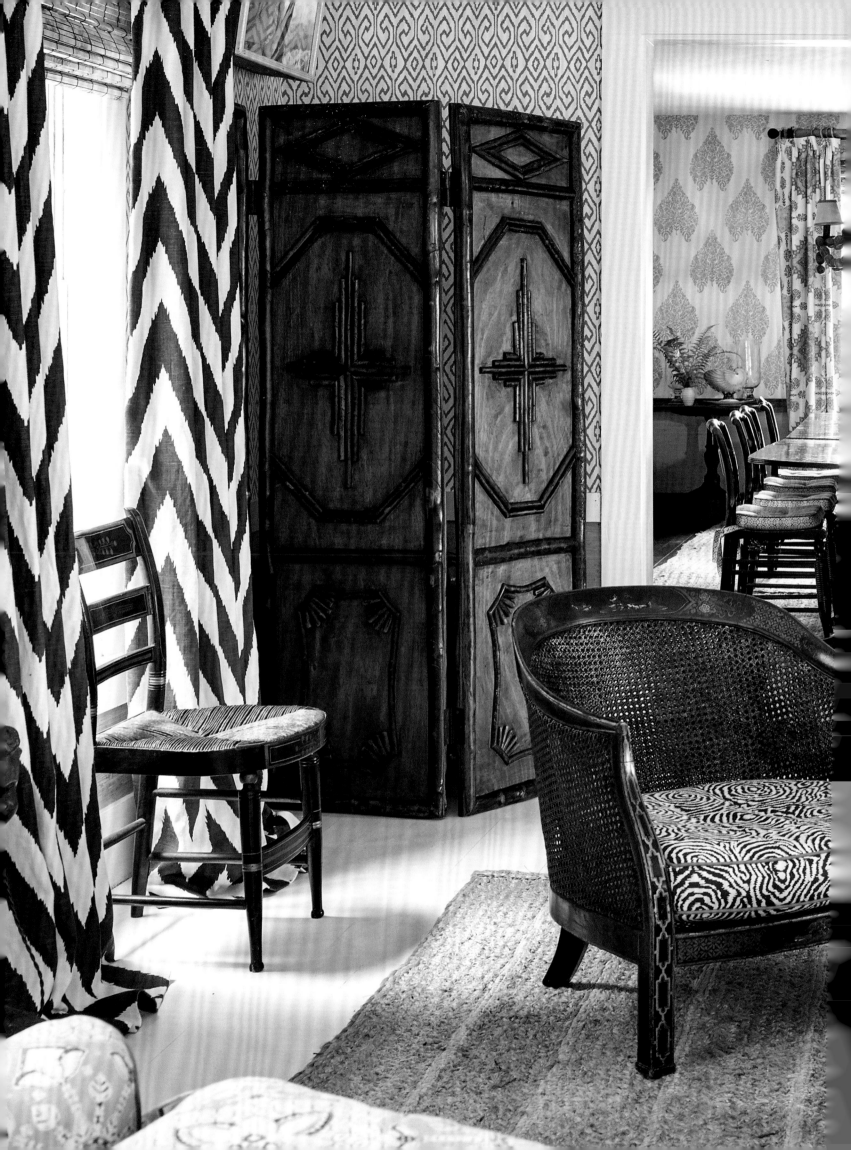

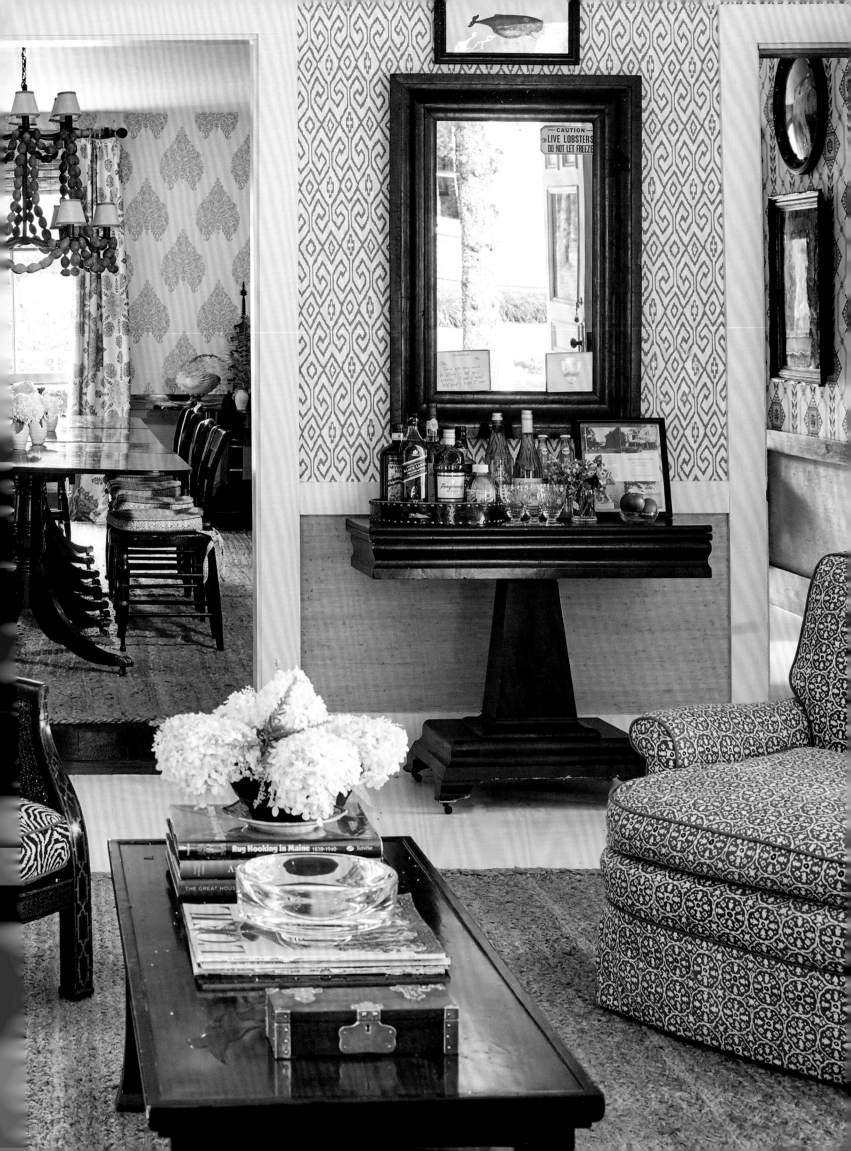

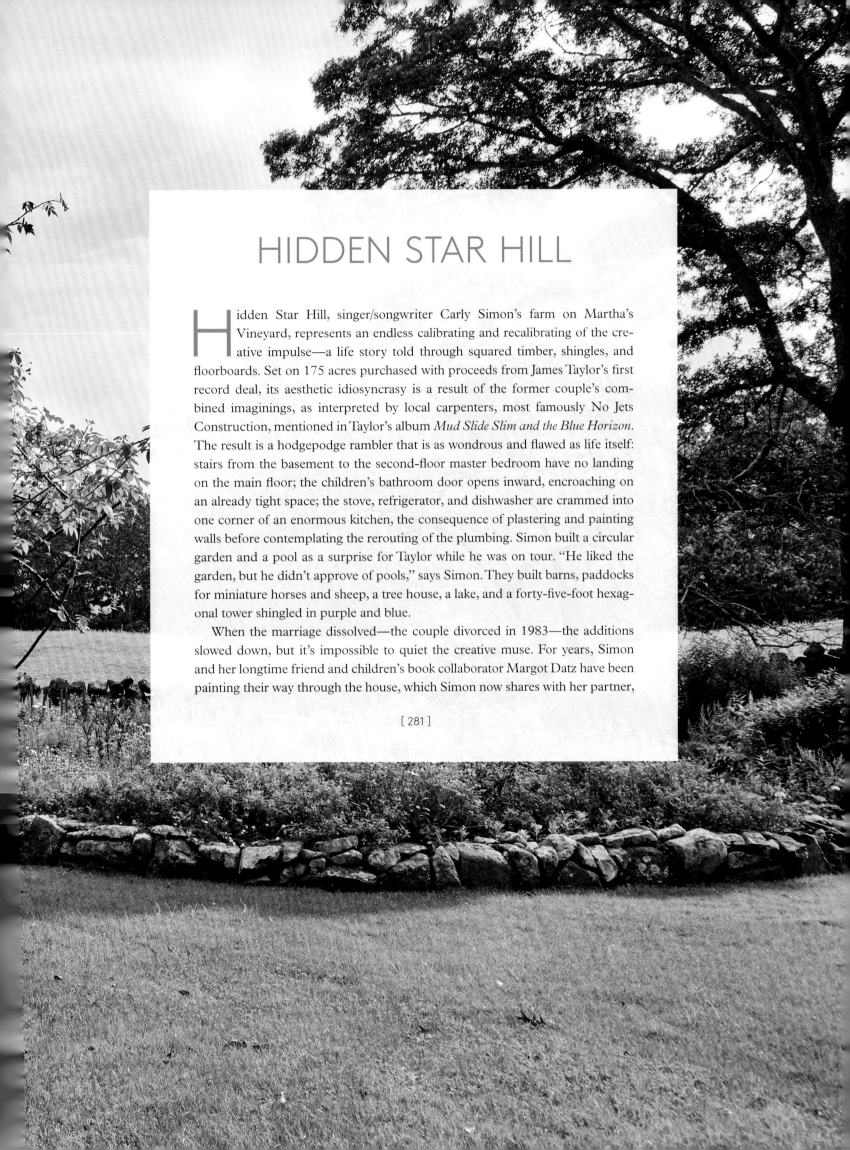

HIDDEN STAR HILL

Hidden Star Hill, singer/songwriter Carly Simon's farm on Martha's Vineyard, represents an endless calibrating and recalibrating of the creative impulse—a life story told through squared timber, shingles, and floorboards. Set on 175 acres purchased with proceeds from James Taylor's first record deal, its aesthetic idiosyncrasy is a result of the former couple's combined imaginings, as interpreted by local carpenters, most famously No Jets Construction, mentioned in Taylor's album *Mud Slide Slim and the Blue Horizon*. The result is a hodgepodge rambler that is as wondrous and flawed as life itself: stairs from the basement to the second-floor master bedroom have no landing on the main floor; the children's bathroom door opens inward, encroaching on an already tight space; the stove, refrigerator, and dishwasher are crammed into one corner of an enormous kitchen, the consequence of plastering and painting walls before contemplating the rerouting of the plumbing. Simon built a circular garden and a pool as a surprise for Taylor while he was on tour. "He liked the garden, but he didn't approve of pools," says Simon. They built barns, paddocks for miniature horses and sheep, a tree house, a lake, and a forty-five-foot hexagonal tower shingled in purple and blue.

When the marriage dissolved—the couple divorced in 1983—the additions slowed down, but it's impossible to quiet the creative muse. For years, Simon and her longtime friend and children's book collaborator Margot Datz have been painting their way through the house, which Simon now shares with her partner,

surgeon Richard Koehler. They reimagined the entrance hall as a potting shed, added fanciful peacocks, falcons, and faux peeling wallpaper to Simon's recording studio, and ornamented the doorframe of a newly installed master bath, so tiny that Simon dubbed it "the dot."

On a late August morning, workmen are putting the final touches on an outdoor staircase that will connect the master bedroom terrace to the entry courtyard, where Simon's son, Ben Taylor, a gifted musician and stonemason who lives on the property with his partner, musician Sophie Hiller, is positioning lookalike two-ton pieces of granite to form a dramatic rock garden. His work, most notably a sprawling fire pit he calls "Stoned Henge," can be seen around the property. Simon's daughter, Sally Taylor, a musician who founded Consenses, an educational arts program that focuses on empathy and perception, lives in Cambridge, Massachusetts, with her husband, Dean Bragonier, and their son, Bodhi, and has an apartment above one of the barns. "I'm so lucky to have them close," says Simon, adding, "At this phase, I think of home as a place to be with my family and to feel a real appreciation for the life I've gathered and amassed."

The basement is stacked with reels of films and pictures from ages past that Simon wants to organize someday. "I also want to make another album. Just a kind of stream of consciousness." For now, she's off on a book tour, but while she's away, she's asked Datz to paint another mural. "I gave her the budget and asked her to surprise me."

PAGES 280-81: Hidden Star Hill, Carly Simon's 175-acre farm on Martha's Vineyard, where she has lived since 1971, features rolling hills, woods, gardens, barns, paddocks, and a lake. "My grandson, Bodhi, swings on the swings. But we all do, all of us!" says Simon.

OPPOSITE: Simon commissioned local craftsmen to make a table topped by her mother Andrea's needlepoint tableau of Simon & Schuster titles; the company was co-founded by Simon's father, Richard, in 1924.

PAGES 284-85: Simon's daughter, Sally, designed a tile mosaic of guitars belonging to her, her brother, Ben, and her mother. Nearly everyone in the family's orbit is musical.

PAGES 286-87: Carly Simon and James Taylor referred to the original part of the house as the "everything room." In addition to the Baldwin piano, it had a kitchen area and a foldout couch. Now the piano room, with a book- and album-filled nook, it's where Taylor recorded his *One Man Dog* album, which included the song "Don't Let Me Be Lonely Tonight." Simon estimates that she wrote some fifty to sixty songs in the room, among them "Let the River Run" and 'Coming Around Again."

PAGES 288-89: Simon's dear friend the artist Margot Datz painted some of the walls and curtains of her Moroccan-flavored bedroom. Her Best Original Song Oscar for "Let the River Run" stands on the windowsill. The song earned a Golden Globe and a Grammy as well.

PAGES 290-91: Simon designed the circular garden in the 1980s. "I thought a circular shape would be more romantic than a rectangular one." The beds include dahlias, poppies, and Simon's favorite flower, peonies. She's transferred digitized versions of her peony photographs onto wallpaper and scarves.

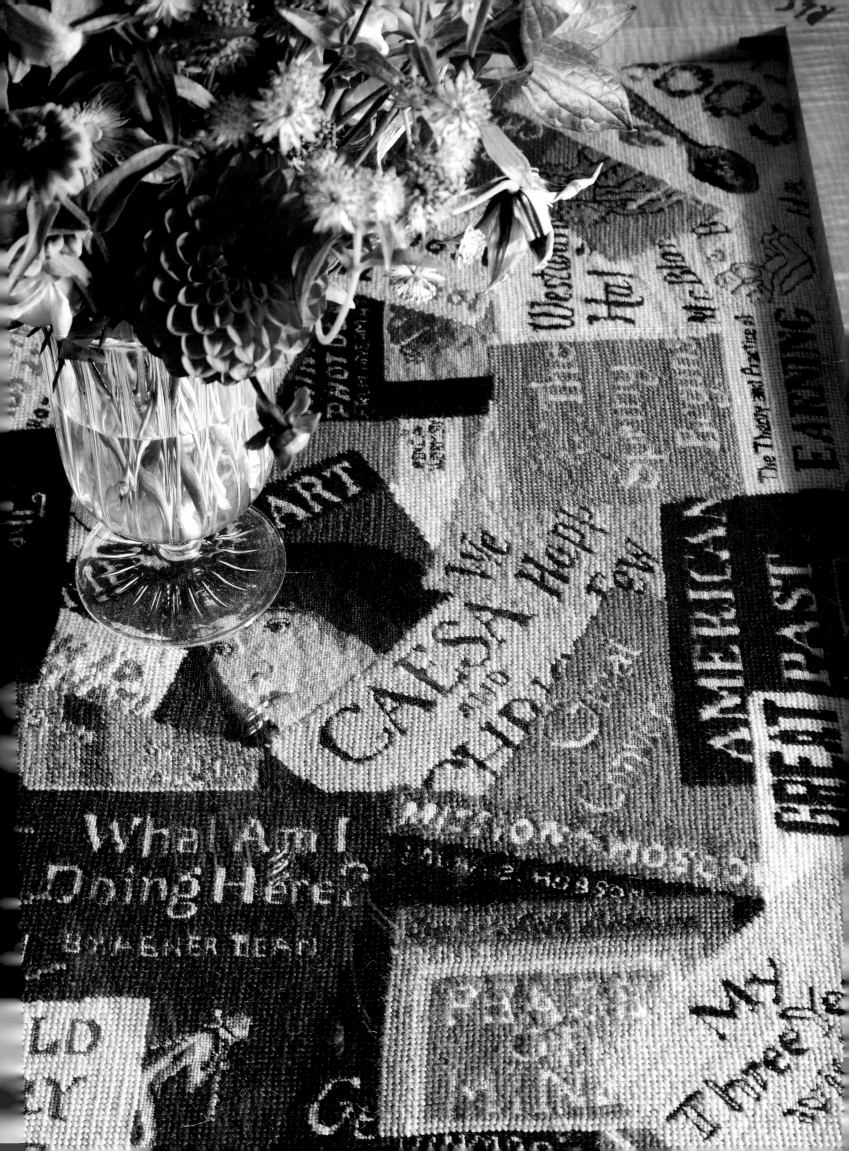

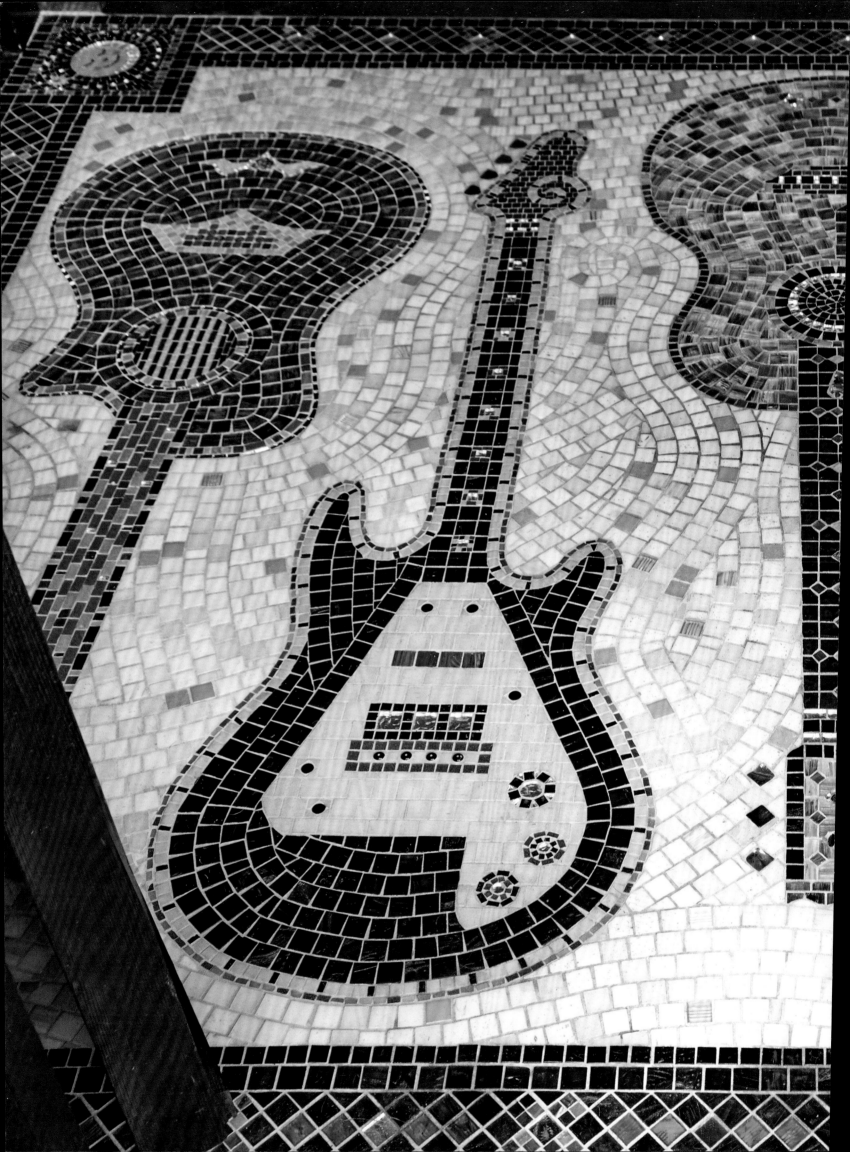

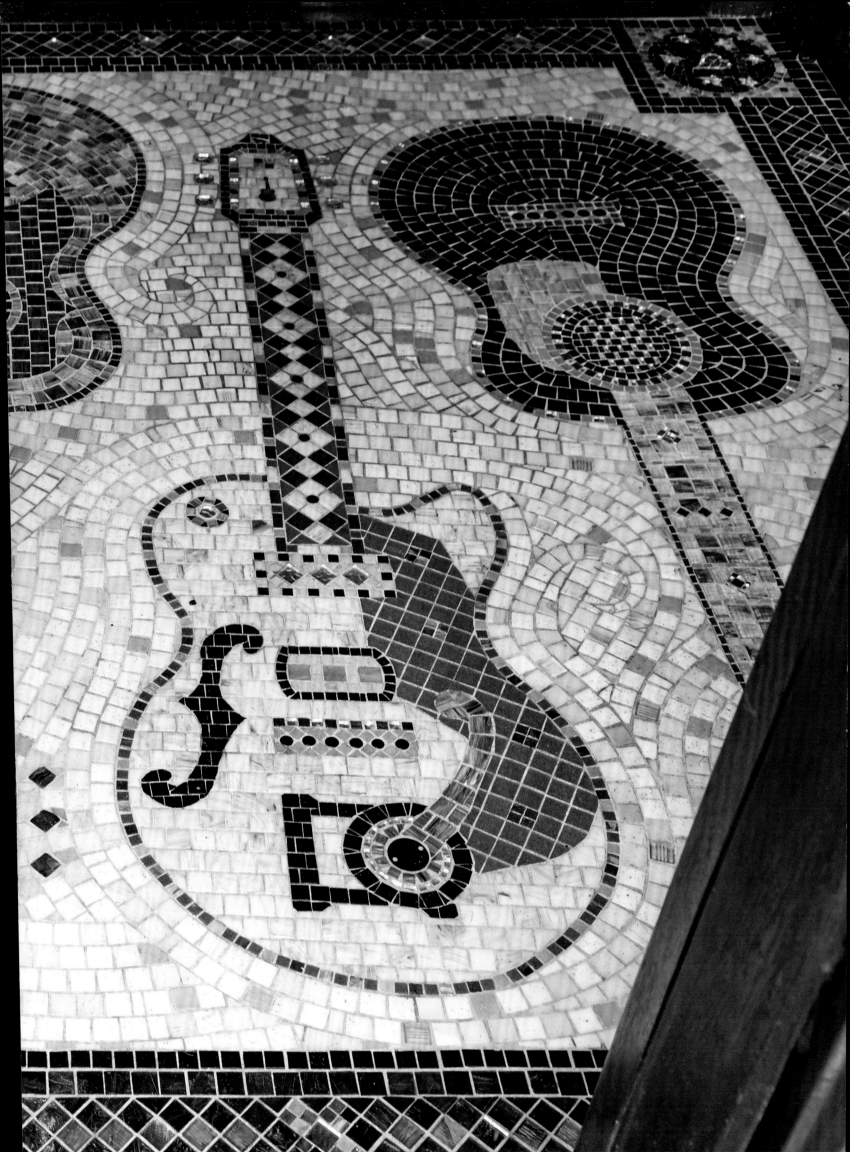

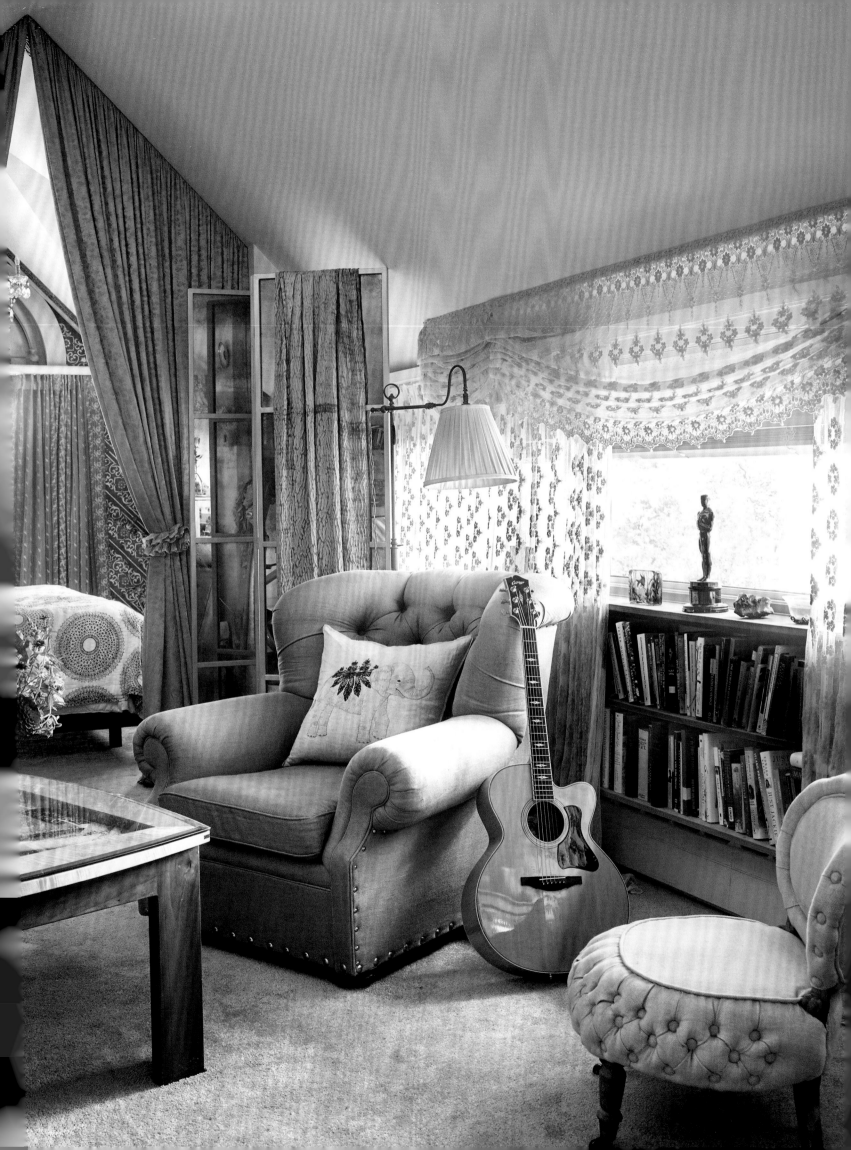

TUNA WALK

Architect Horace Gifford's modernist beach houses, designed between 1960 and the early 1980s, have become glass-and-cedar personifications of Fire Island's coming of age as a mecca for the gay community. Their sublime integration into the island's grassy dunes and pine forests impressed the likes of Truman Capote, Halston, Calvin Klein, Geoffrey Beene, Andy Warhol, and Jed Johnson, who spent summers on this narrow barrier island south of Long Island.

Medical researcher Dr. Michael Giordano, who developed the protease inhibitor drugs that changed the prognosis of HIV, was inundated with praise and questions on his few visits to Fire Island in the 1990s. "Thankfully, life has moved beyond that," he says. It wasn't until a more recent visit that he took time to explore the island's architecture, becoming so enamored with Horace Gifford's work that he purchased the iconic Tuna Walk sight unseen. "The real estate agent called me in New York in October and said, 'If you don't bid on it, you'll lose it.'"

Giordano, a natural collaborator, immediately sought the advice of his wide range of creative friends, whose diverse expertise and continuous exchange of ideas became essential to his mission to update the house without compromising the enduring appeal of Gifford's original design. On the roster were interior designer Peter Dunham and architect Andrew Franz, who had collaborated on Giordano's Central Park West apartment; Los Angeles–based architect and designer Jamie Bush, whose parents owned houses on Fire Island and who was

[293]

therefore well versed in Fire Island's strict zoning restrictions; and London-based garden designer and traveling companion Tania Compton. "We all knew that for Michael, restoring an heirloom was an act of love. It was always about protecting this iconographic modernist building, not our egos," says Franz.

Giordano invited Peter Dunham along for the first walk-through on a day when the island was snow swept and deserted. "We wore insulated clothing," Dunham recalls. "It looked very different from my visits to the island in the summer in the '80s. Then it felt otherworldly, like a gay Jurassic Park with its narrow boardwalks overgrown with vegetation and strung with lights." Dunham immediately determined there was little to do but restore and furnish the house. "It was locked, loaded, and ready to fire." Franz concurred. "A modernist house, it is ultimately about restraint and trying to do less. We edited and advised Michael to keep the palette and gestures simple and consistent."

For the addition of a gate, pool, and guesthouse, Franz and his associate North Keeragool were determined to respect the language of the main house, rather than distract from it or merely copy it, implementing a simpler geometry on a different scale with modern twists such as copper fascia.

Dunham approached the interiors much the same way, always deferring to the simplicity of the architecture. He created a relationship between the two ter-races on opposite sides of the house, designating one as a seating area, the other for dining. The main room is divided into living and dining areas. Dunham replaced the living area's black potbelly stove with a modernist fireplace—the only change to Gifford's original design that he made. Giordano and Dunham found a vintage dining table and chairs, Charlotte Perriand stools, and an Alexander Calder wall hanging at markets and auctions. "We both belong in an auction recovery program," says Dunham.

Compton strove to preserve the wild look of the smallish parcel, cleaning out scrub and augmenting the native grasses and pines. She turned to New York garden designer Christopher Freimuth to collaborate with her and oversee the installation.

"There were a lot of voices, maybe too many, but they seemed to enter at different phases—a symphony in the end," says Franz.

PAGES 292–93: Motor vehicles are not permitted in the hamlet of Fire Island Pines. The only mode of transportation is via foot on a network of boardwalks that cut through grasses and skirt scrub pines.

OPPOSITE: Tuna Walk is an iconic example of Horace Gifford's modernist, cedar-and-glass beach houses, designed between 1960 and the early 1980s.

PAGES 296–97: In the living area of the main room, Dunham installed a vintage 1960s fireplace in place of the original potbelly stove. A 1970s Pace coffee table was found at Rago Arts and Auctions,

and Charlotte Perriand stools were found in France. The white sofas were custom designed, and pillows in Peter Dunham fabrics provide pops of color. The wool-and-jute rug is from Dash & Albert.

PAGES 298–99: In the dining area of the main room, an Alexander Calder maguey tapestry presides over a vintage dining table and chairs found in France. The white vases are by Los Angeles ceramicist Miguel Torres.

PAGE 300: A guest bedroom is furnished with a 1960s Danish dresser and a Chandigarh chair from Hollywood at Home.

PAGE 301: A Dash & Albert rug grounds a guest bedroom. Erica Thorpe's trio of inkjet prints *What Money Can Buy*, found at Christie's annual staff art show, hangs above the bed. The side chair is by Gio Ponti.

PAGES 302–3: Architect Andrew Franz designed the pool and a small guesthouse. "Our greatest goal was to make sure that the additions to the original house did not distract from it and that there was a clear distinction between what was old and what was new," says Franz.

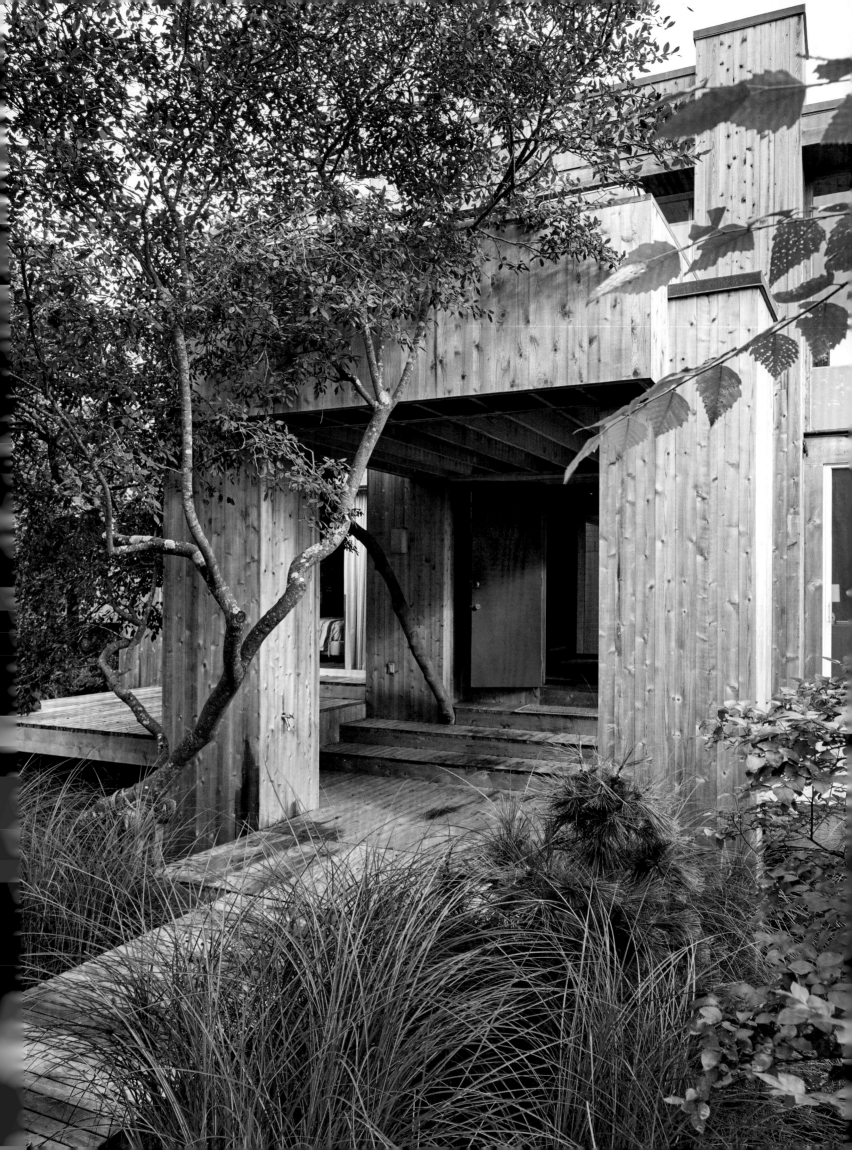

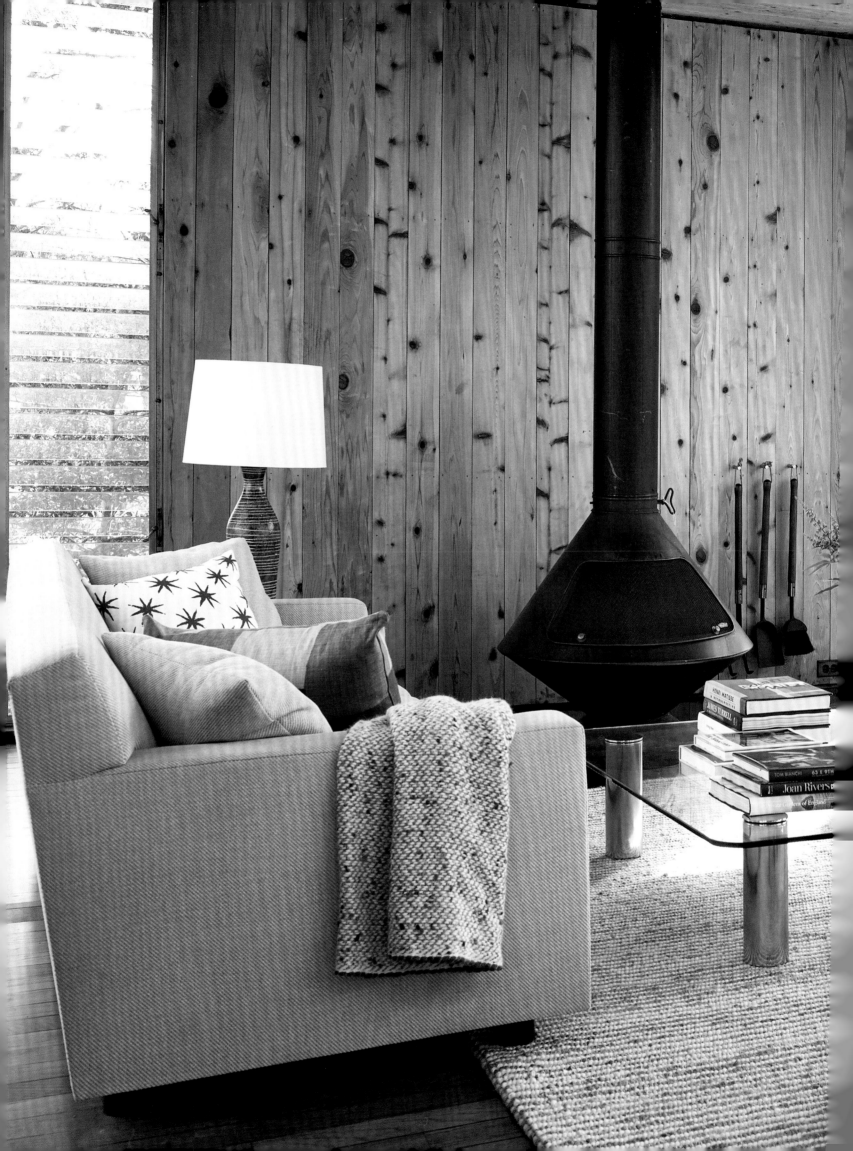

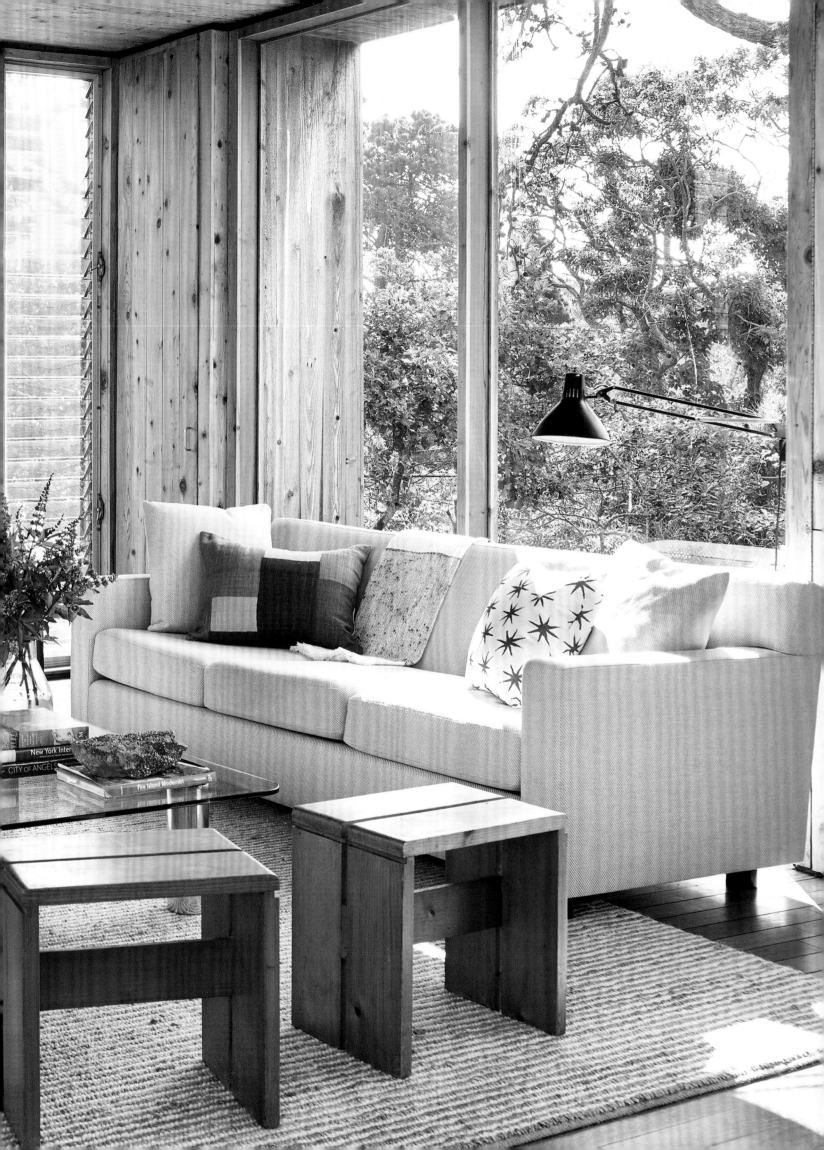

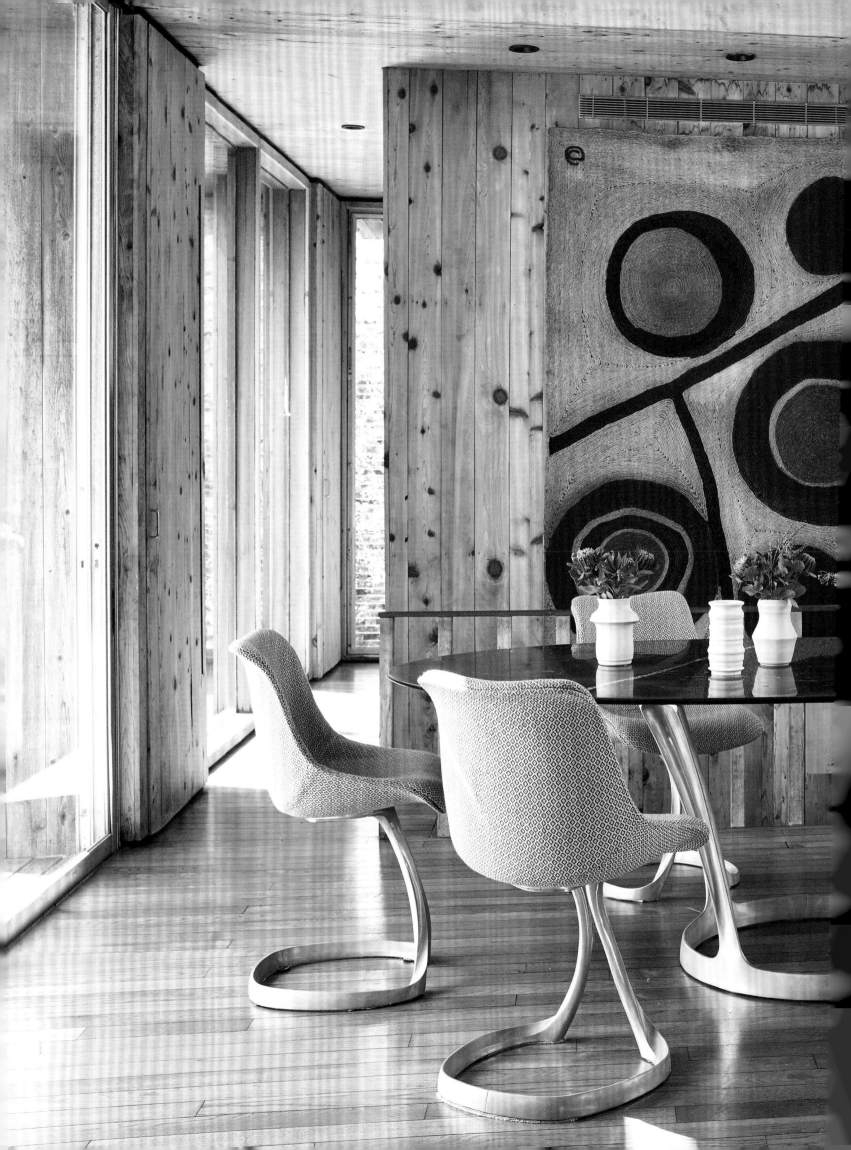

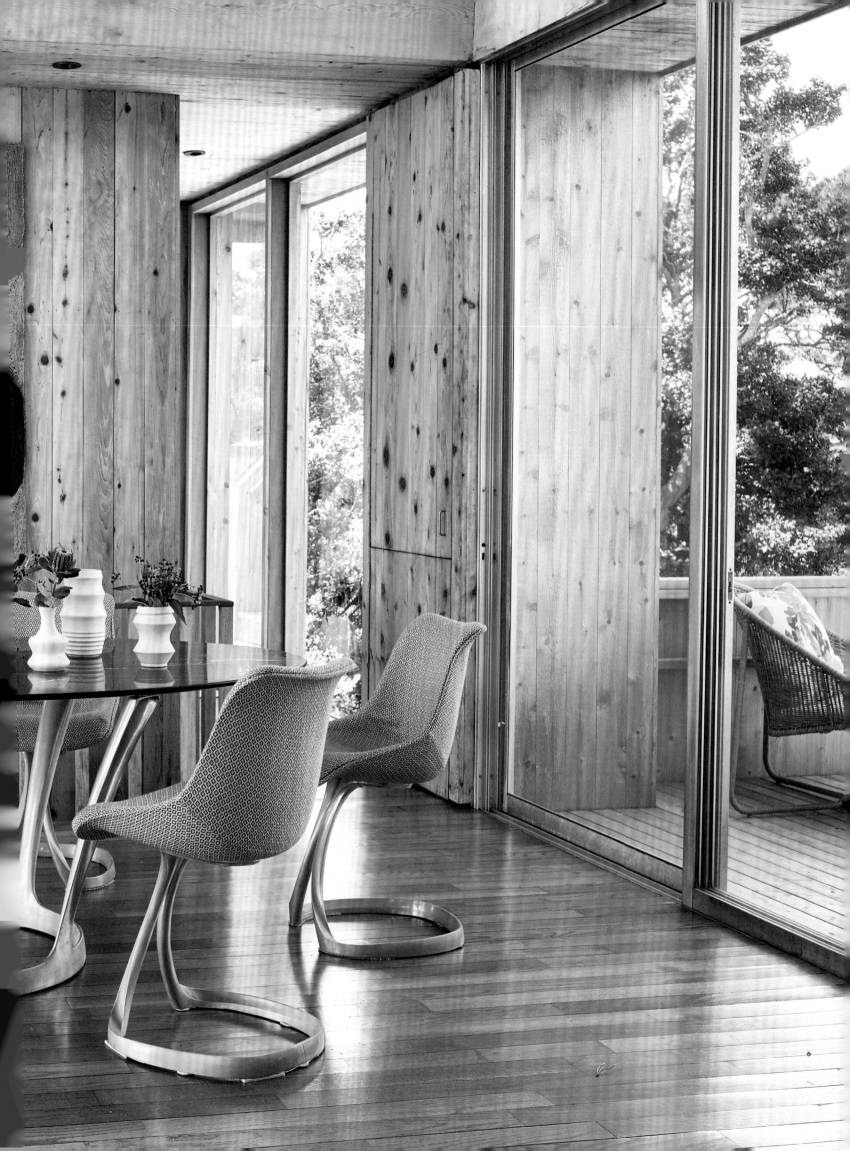

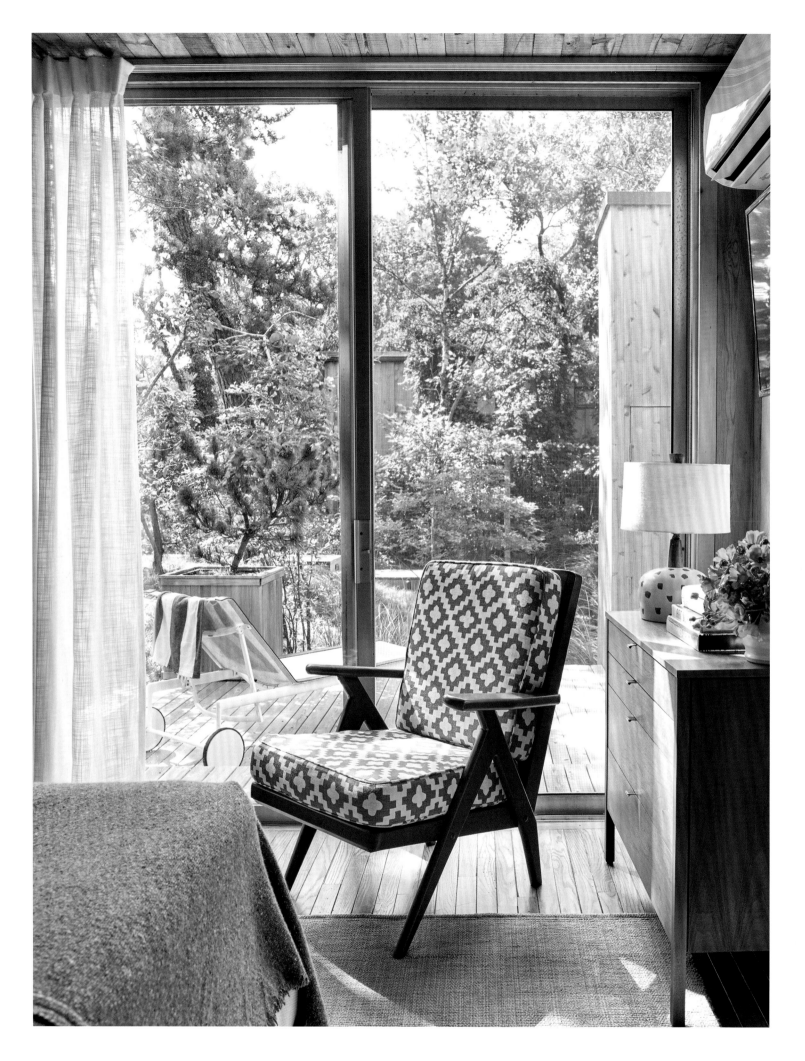

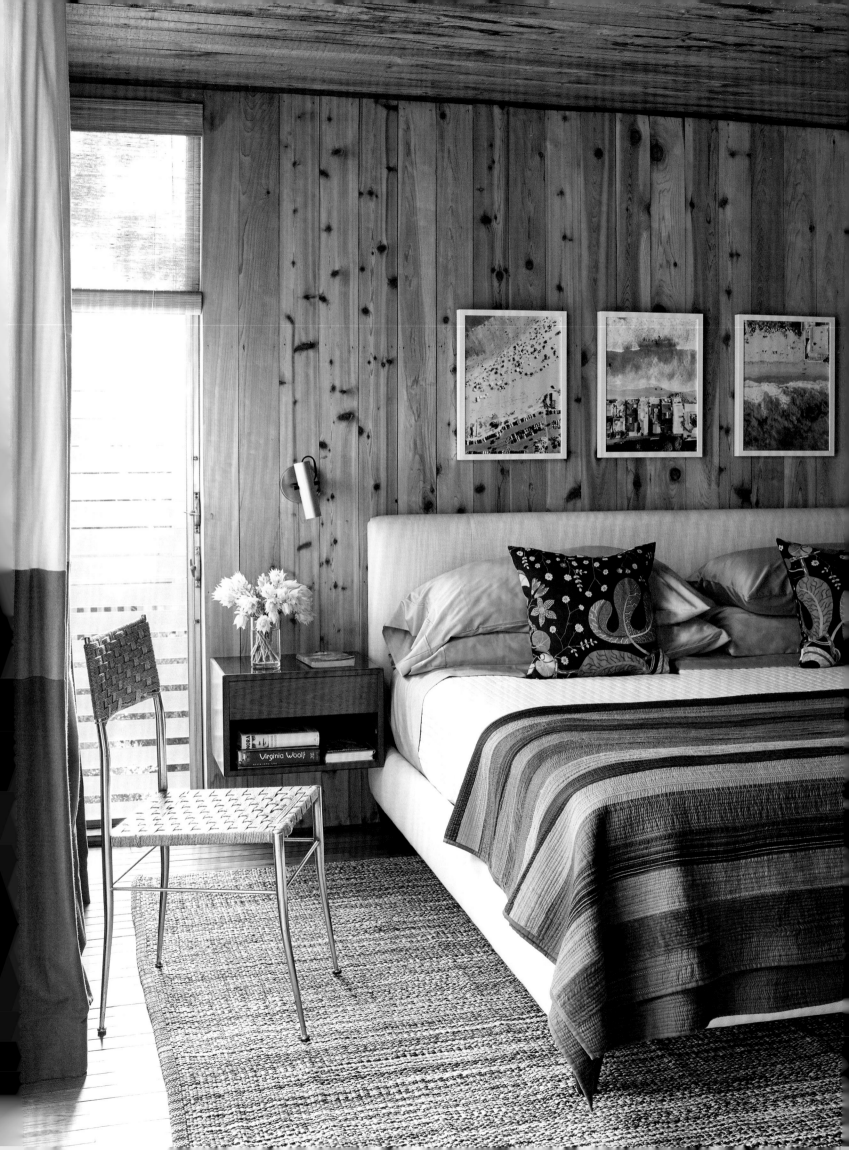

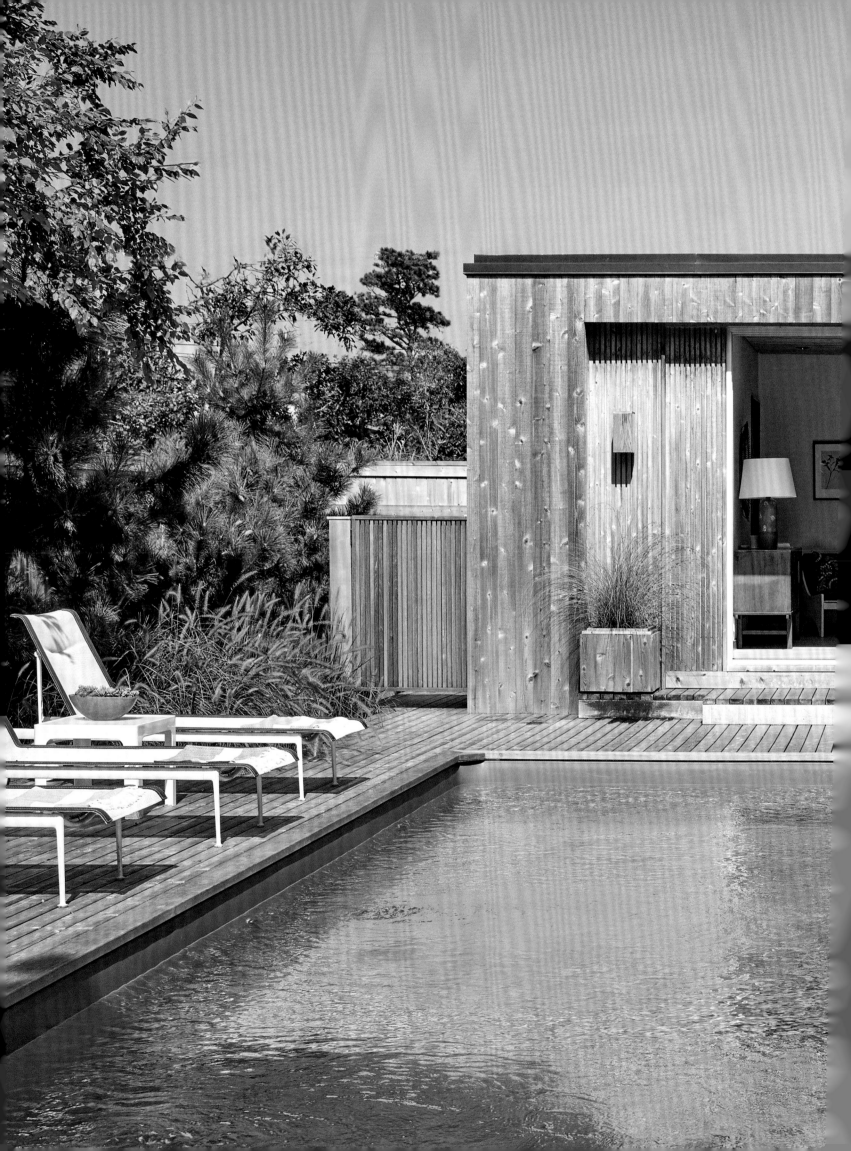

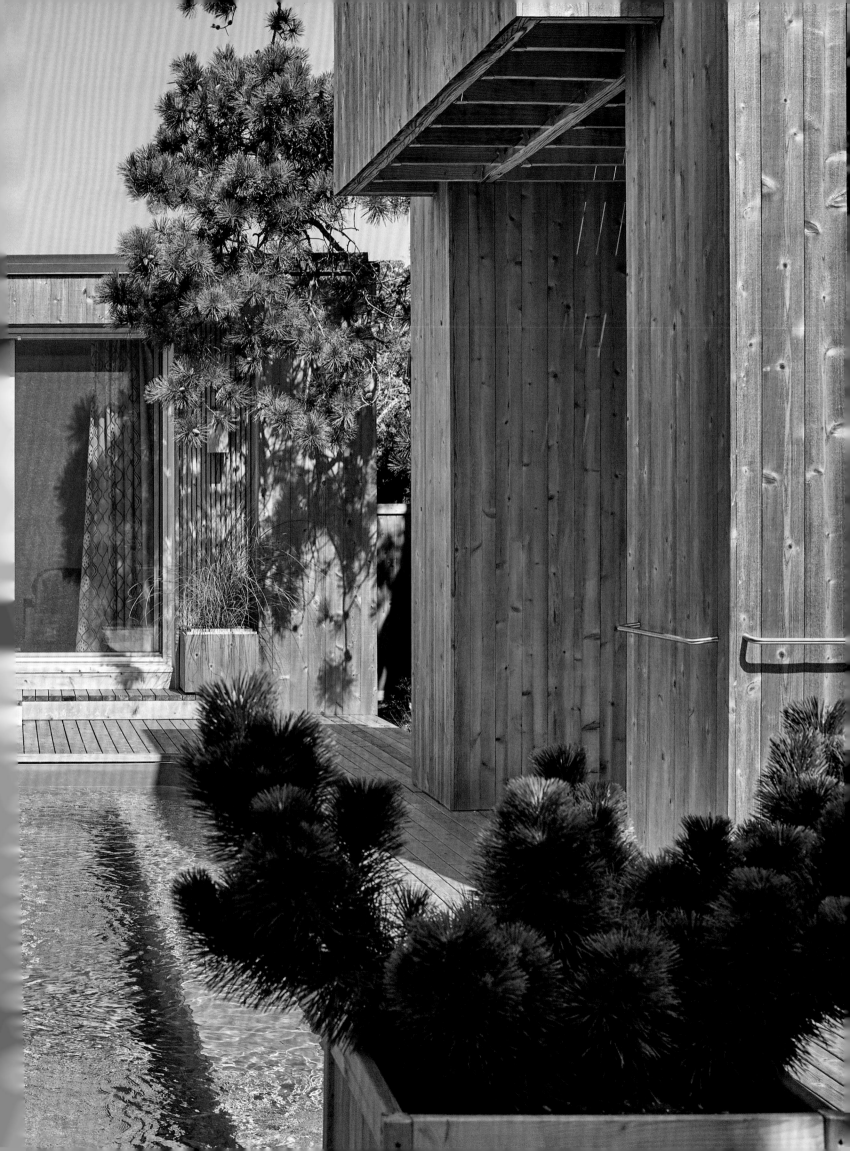

BLUFF-SIDE BEAUTY

Forty percent of Block Island's undulating landscape, demarcated by winding walls of indigenous stone, is protected by the Block Island Conservancy and other environmental organizations, creating the impression of an island far more expansive than its ten square miles. A commitment to environmental causes is embedded in the souls of photographer Susan Paulson and gallery owner Peter MacGill. Susan's father, a Wisconsin native, discovered the island in the early 1960s while traveling with friends from Harvard Business School and returned with his family, spending long days at the beach and playing flashlight tag and board games in the evening. Years later, when Susan brought her then fiancé, Peter, to the island, he was immediately mesmerized by its picturesque knolls, ravines, and clay cliffs, but what most beguiled him was Susan's profound connection to the place. Before leaving the island, the couple inquired about possible summer rentals, and someone pressed Alice and Captain Rob Lewis's number in Susan's hand.

The following winter, Alice Lewis picked up the MacGills from the ferry with her two Weimaraners in tow, to look at a rental on the Lewis family farm. Captain Rob Lewis is considered the island's "father of conservation," having pushed for the creation of the Block Island Conservancy to protect Rodman's Hollow, a 230-acre glacial basin, from development. By the time the group arrived at the southwest corner of the island, a snowstorm had moved in, rendering the road to the farm impassable by car. Undeterred, Alice led a mile-long

[305]

hike down the road, until they reached a converted chicken coop, which she offered to Peter and Susan for the following summer, and the couple knew they were home. For the next twenty years, they rented various cottages on the Lewis farm, imparting to their own children the distinct summer pleasures Susan had enjoyed in her youth.

Years later, when a Lewis family house was offered for sale, the MacGills jumped at the chance to have a permanent home on what they had come to consider sacred ground. Despite vines growing through broken windows, the MacGills only saw promise in the 1950s Cape. It had slate floors, efficient fireplaces, a few outbuildings, and a protected 180-degree ocean view, thanks to Keith Lewis, Alice and Captain Rob's son, who had donated almost a hundred priceless acres to the conservancy. Determined to maintain the house's elegant simplicity, the couple did nothing more than repair windows, fix roofs, update the mechanicals, and consolidate the planting beds for easier maintenance.

"The varieties of perennials that the former owner, Bill Lewis, and his partner, Norman, planted here are rare and spectacular. The peonies and daylilies are in colors I've never seen anywhere, and the butterfly bushes are a deep purple. The sandy soil, combined with the salt air, is fabulous for the Russian sage. My daughter Mary makes bouquets for the house, for her shop, and for friends," says Susan MacGill.

Mary MacGill, a jewelry designer who owns an eponymous shop in town, has converted one of the property's cottages into a studio. More recently, as grandchildren have come into the picture, the family has been turning outbuildings into guesthouses, just as Alice and Rob Lewis used to do. With renovations complete, Susan continues to examine the meaning of home and family through her photography. There could be no better subject than the singular world of Block Island.

PAGES 304–5: Over the years, Susan MacGill has consolidated rare varieties of perennials, originally planted by the property's former owner, Bill Lewis, and his partner, Norman.

OPPOSITE: The house, which enjoys 180-degree views of farm fields and the ocean beyond, was furnished with finds from Brimfield and Block Island yard sales. Textiles and lamps come from local shops such as the Glass Onion and the Lazy Fish. In the living room, the family Lab, Piper, occupies the sofa. The coffee table is by Isamu Noguchi. The chrome-and-leather chair was found at Brimfield.

PAGES 308–9: The dining room table, from Brimfield, is surrounded by Eames chairs. The rubber plants in the dining room are probably thirty years old. They were in the rundown house when the MacGills moved in.

PAGES 310–11: A Block Island ¾ bed in the "sun porch bedroom" belonged to Captain Rob Lewis, often called the island's father of conservation. The quilt is from the Lazy Fish on Block Island. The chair is from Luddite, an antiques store in Germantown, New York. The wood shade is original to the house.

PAGES 312–13: Susan and Peter MacGill's summer house on Block Island abuts the Lewis farm, much of which was donated to the Block Island Conservancy. The property is typical of Block Island, with its rolling hills, ravines, and clay cliffs leading to the sea. The island boasts some 350 miles of stone walls.

PAGES 314–15: Mary MacGill, a jewelry designer, created a studio out of a cottage that originally had six beds and a Ping-Pong table, perfect when she and her siblings were teenagers. Now it is furnished with beer-hall tables, a leather bench picked up at Brimfield, and a plant stand from Luddite. The pillows, by D. Bryant Archie, are from Mary MacGill's shop in town. Twin beds accommodate the occasional guest overflow.

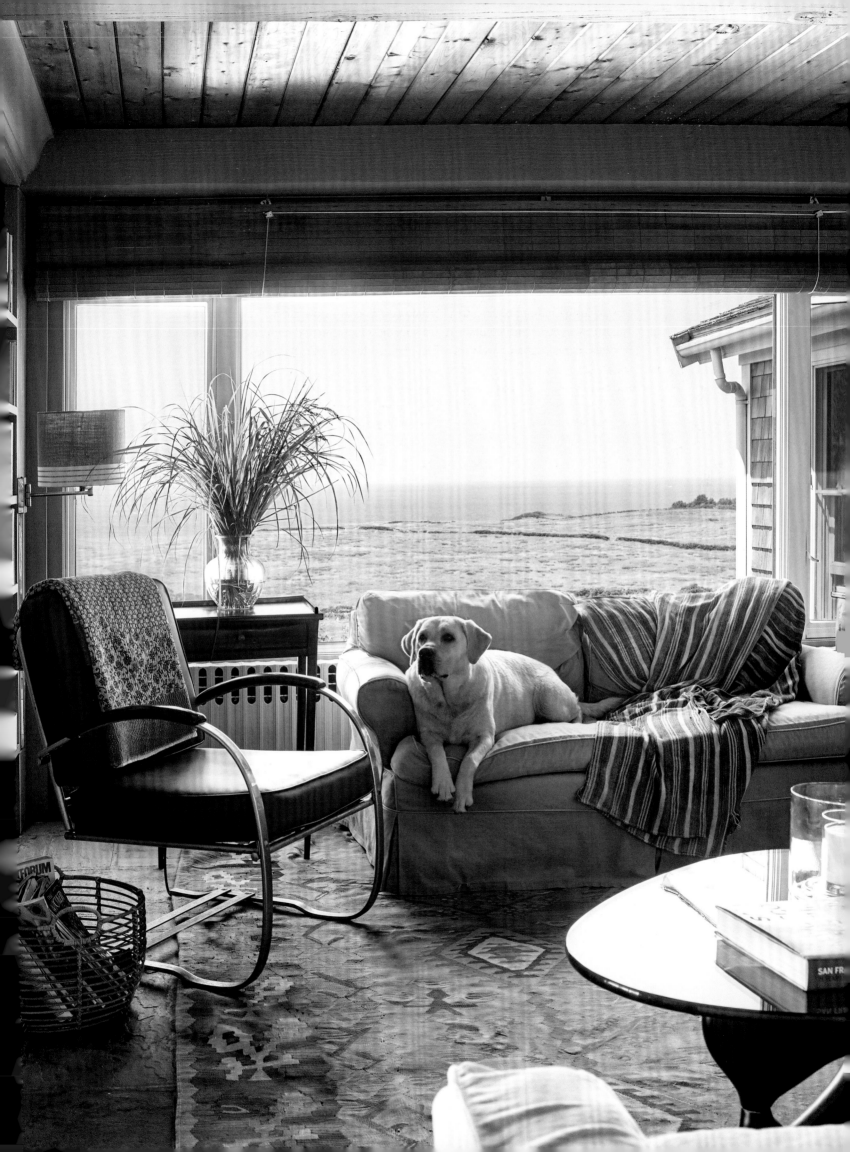

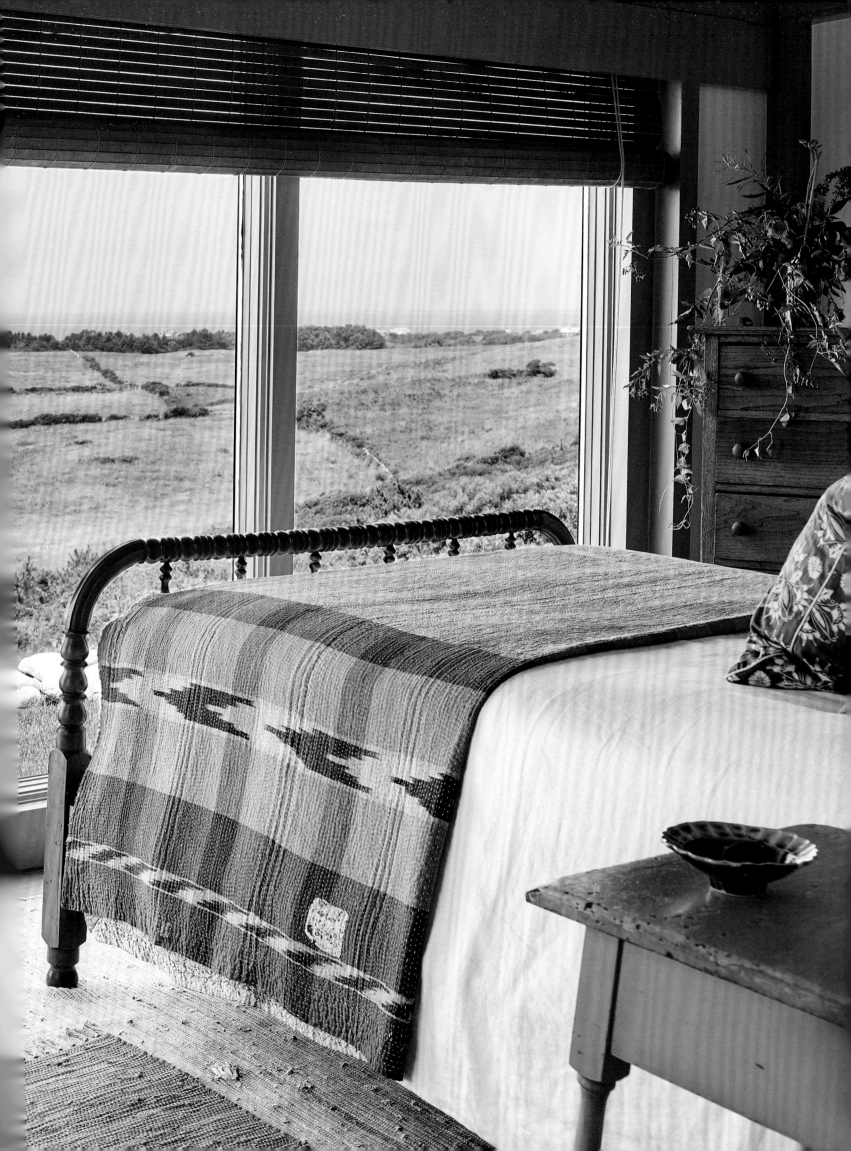

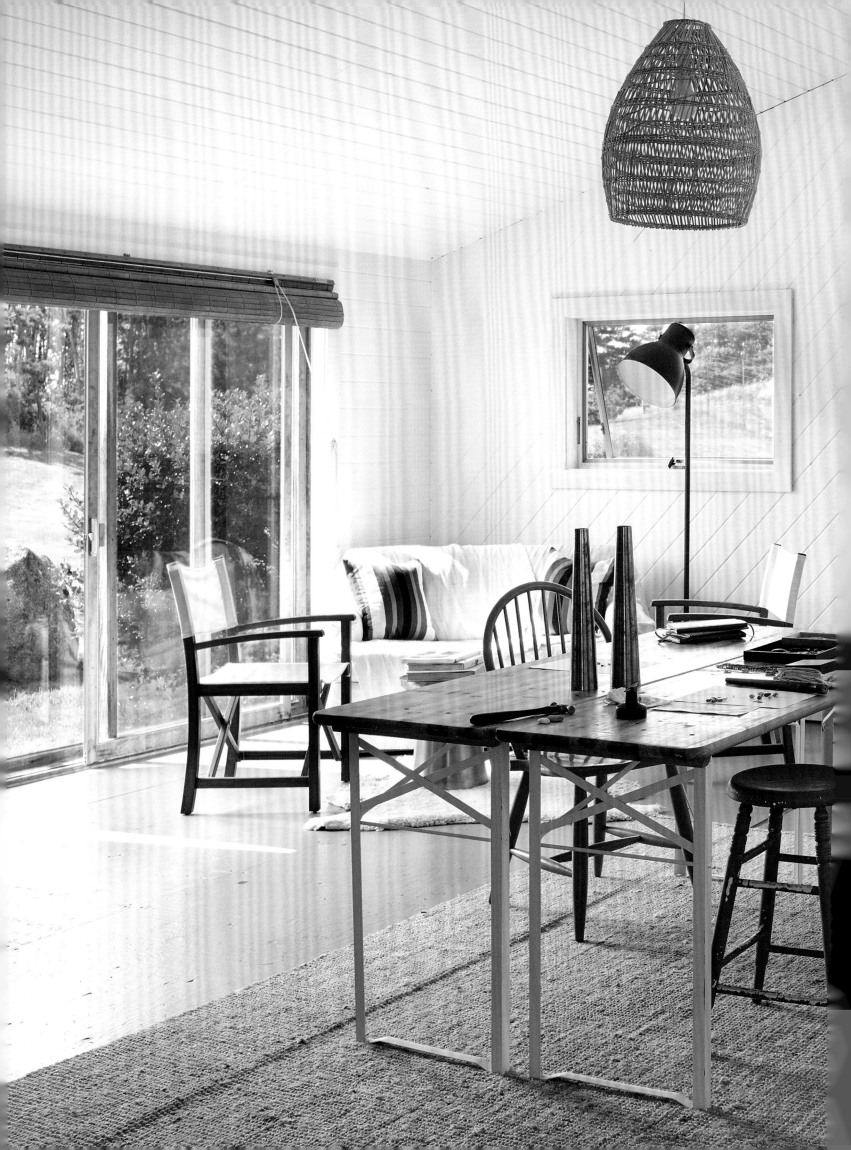

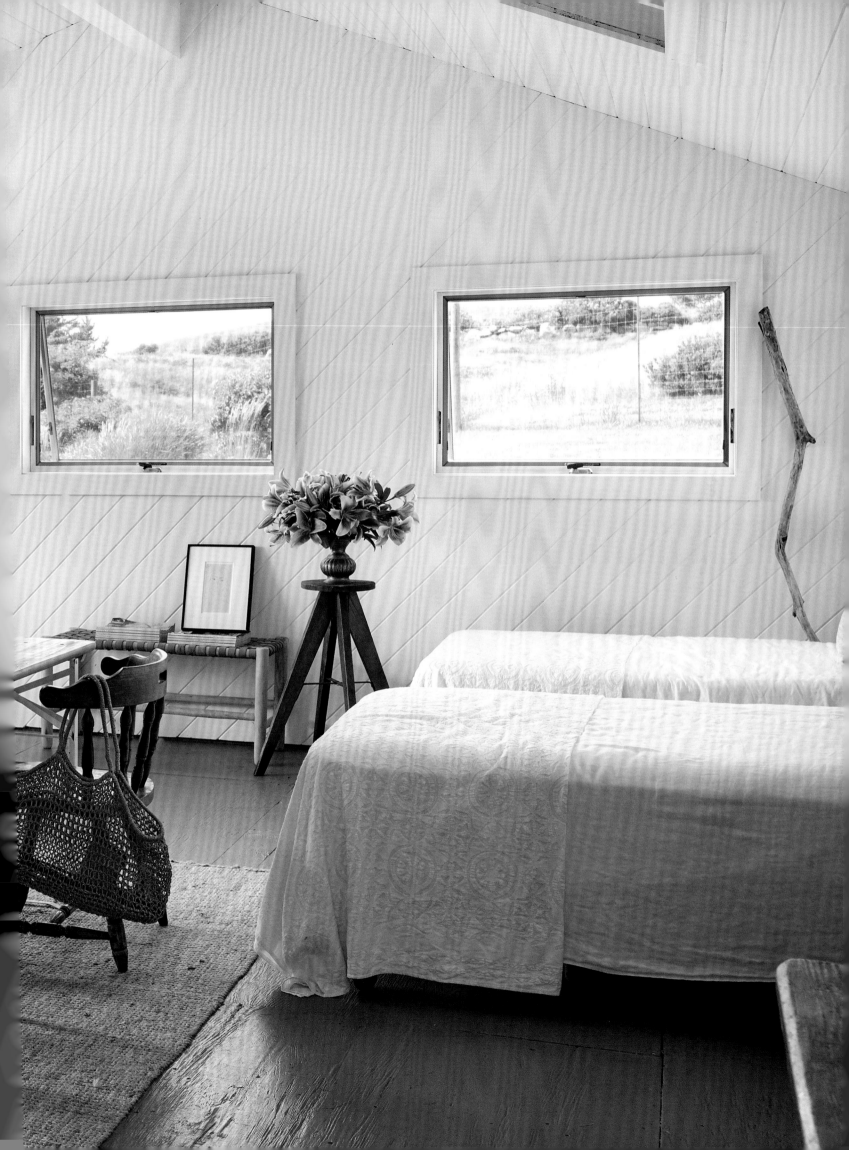

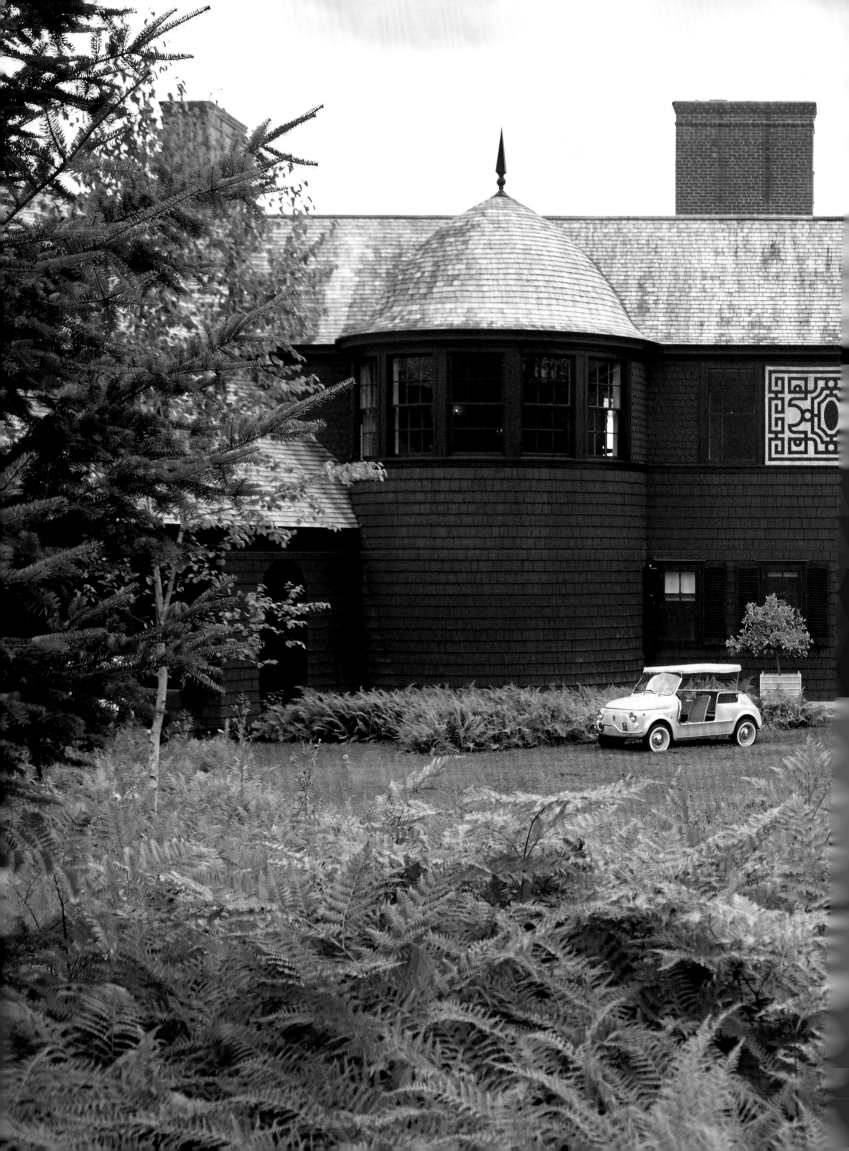

ISOLA BELLA

The remoteness of a twenty-five-acre island off the coast of Maine, dense with fragrant pine, fir, beech, and birch trees, might have daunted most people, but the owners of Isola Bella imagined nothing but time and space to hunker down with family and friends. They embraced the challenge of creating a home from scratch, a place that would withstand the vicissitudes of fashion.

In the early 1900s, the island's original owners, the Folwell family, named it Isola Bella after having gone on a Grand Tour, a custom of seventeenth- and eighteenth-century young British nobles to broaden their minds by immersing themselves in classical cultures far from home, especially Italy. Coincidentally, the current owners loved a tiny island in Sicily called Isola Bella and began referring to their island by that name. They discovered only later that they had come up with the same name as the family who had spent summers there a hundred years earlier.

They imagined a house that someone might build in Maine as a summer cottage after going on a Grand Tour. To fulfill their dream, they called upon the architect Peter Pennoyer, who proposed a shingled house that would be in keeping with Maine's traditional coastal architecture, enhanced by details suggesting the influence of buildings that might have been seen on the Grand Tour, including an elaborate bracketed entrance with a diamante-patterned transom and sgraffito panels above the front door. Interior flourishes also reference the classical world, including a "peppermill" element that houses the entrance hall

with its sweeping staircase and pink terrazzo floors inlaid with marble shards cut on the island. In color and construction, the floors were made to resemble mortadella. The terra-cotta pavers in the dining room are set without grout, so the open joints lend a rustic texture to the floor. And modern conveniences such as air conditioning, built-in lighting, and an audio/visual system were eschewed.

For the grounds, Madrid-based minimalist landscape architect Fernando Caruncho was called upon for his ability to enhance, rather than impose on, the land. Caruncho suggested a subtle reordering of trees. He eliminated pines and firs to create vistas and paths in some areas and augmented others with deciduous trees, including birch, *Pyrus*, ash, and *Prunus*, which change color with the seasons, contrasting with the dark firs and pines. Caruncho likened the constant battle between the deciduous and coniferous trees for space on the rocky island to the feud between the Montagues and the Capulets. Through his careful stewardship, this ecosystem has been brought back into balance.

Inside, the family lives among treasures that those young milords might have acquired on their Grand Tours, including majolica dishes and cast-iron urns combined with wicker and chintz. And what about those bamboo-lined walls painted chartreuse? The owners loved the way light filtered through the bamboo tops of pergolas in Italy and thought, why not an entire wall of shades? So they asked for the plaster on the wall to be covered with bamboo panels, which they painted a greenish citrine yellow. Such details achieve the elusive: an inimitable look.

PAGES 316–17: Isola Bella sits atop a bluff on a twenty-five-acre private island in Maine's Penobscot Bay. Architect Peter Pennoyer designed a shingled house with classical embellishments, including two sgraffito panels above the front door. Madrid-based landscape architect Fernando Caruncho created a grassy clearing in front of the entrance.

OPPOSITE: Afternoon iced tea and drinks are offered on the sun porch.

PAGES 320–21: A saltwater pool overlooks Penobscot Bay.

PAGE 322: The curved, paneled stair provides a dramatic entrance. The entrance hall floor is terrazzo inlaid with shards of marble cut on the island.

PAGE 323: The house faces the Camden Hills, about which poet Edna St. Vincent Millay penned "Renascence." A relatively narrow plan allows light and breezes to traverse the rooms from seaside to land side. Topped by a classically inspired transom with curved mullions, the terrace doors open to a steel-framed pergola with bamboo screening.

PAGES 324–25: In the living room, a gooseberry-patterned Jean Monro fabric covers the sofa and pillows and is used for the curtains. Bamboo panels were applied to the plaster walls and painted a greenish citrine yellow.

PAGES 326–327: In the dining room, the terra-cotta pavers are set without grout, giving the floor a rustic texture. An elaborate, geometrically patterned coffered ceiling, shallow pilasters framing the window bays, and paneled wainscoting contrast with the otherwise simple room. The wooden ceiling was prefabricated in four large panels on the mainland, then shipped to the island and assembled in one day. The owners were responsible for the interior design, including all of the finishes, colors, and furnishings.

PAGE 328: The breakfast room, overlooking the bay like all of the principal rooms in the house, was designed to have the atmosphere of a garden gazebo embedded in the house. The lattice ceiling and distressed antique marble floor are classical touches, while the fireplace and the rough-plaster walls ground the room.

PAGE 329: The screened porch was conceived as a classical folly appended to the end of the Shingle Style house. The Tuscan-red piers contrast with the whitewashed shingled wall. Because the ceiling is fourteen feet high, the porch is flooded with light and provides panoramic views of the conifer stand and the bay beyond. The floor is covered in hand-painted cement tiles from Villa Lagoon.

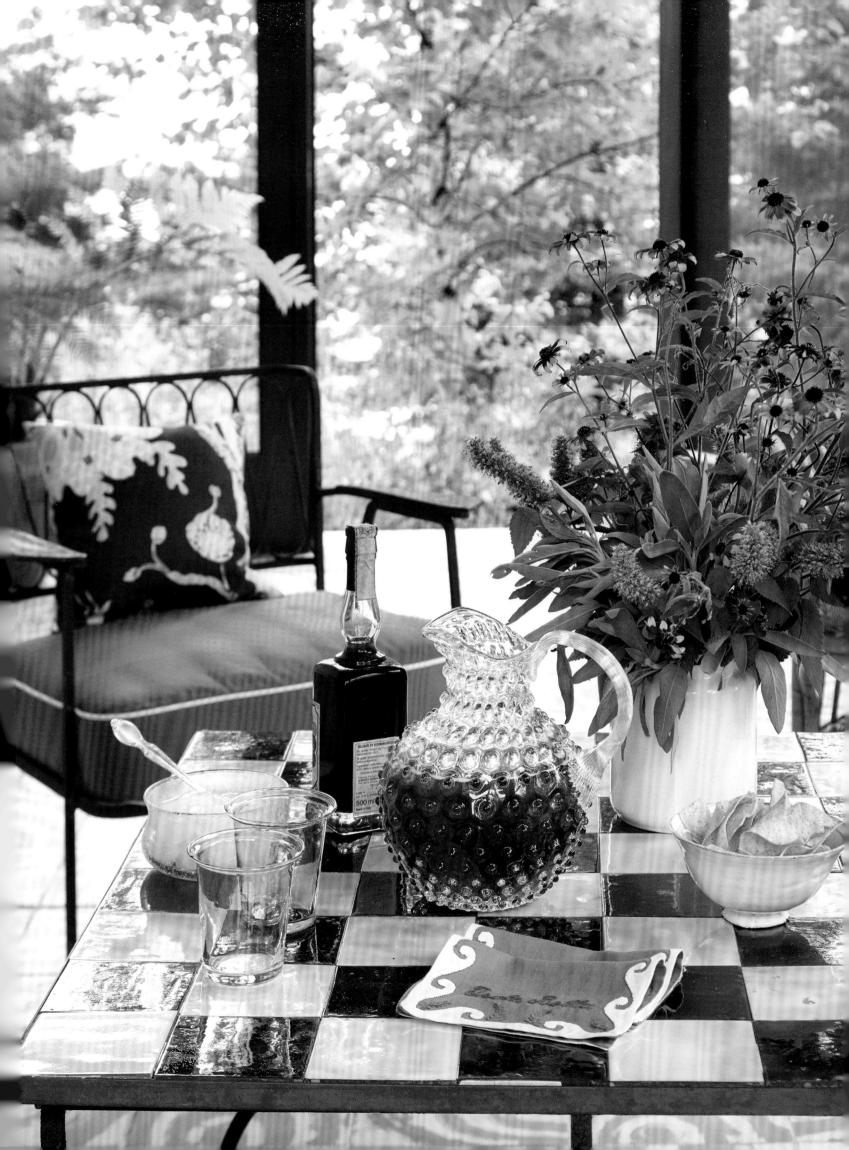

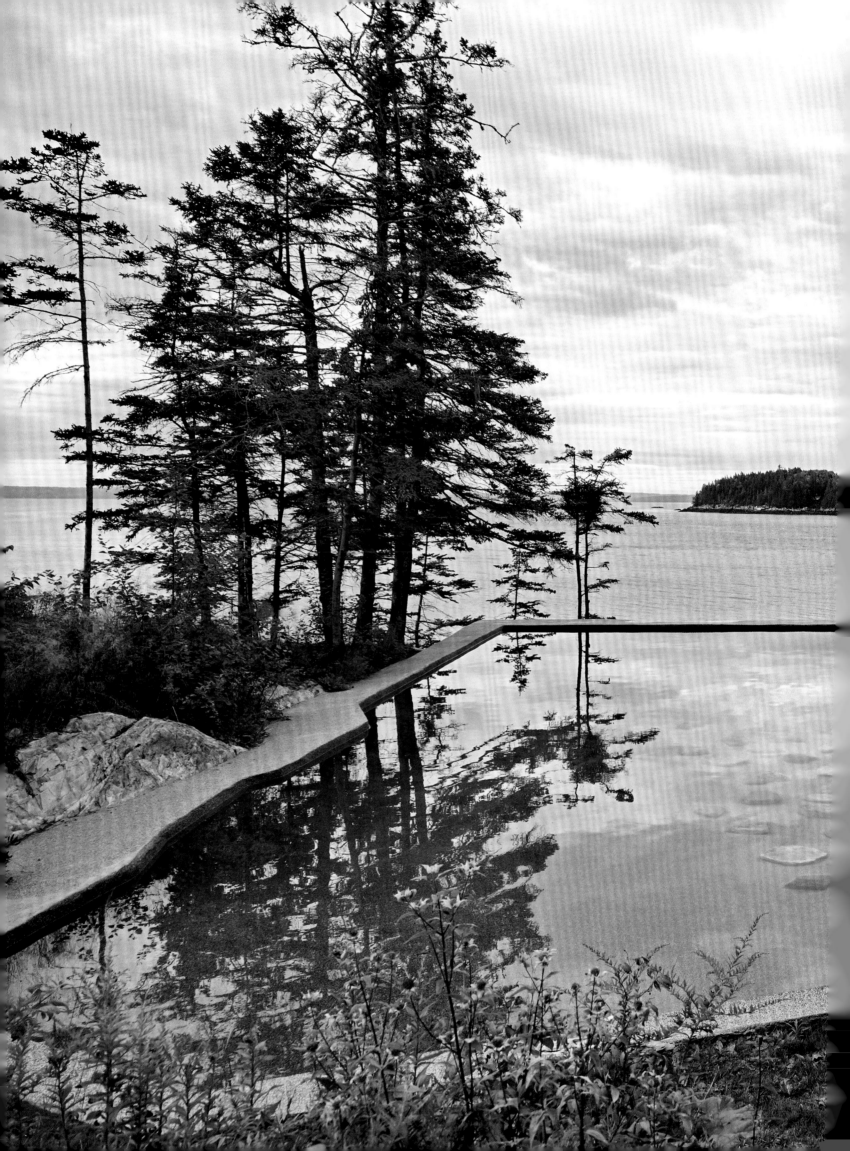

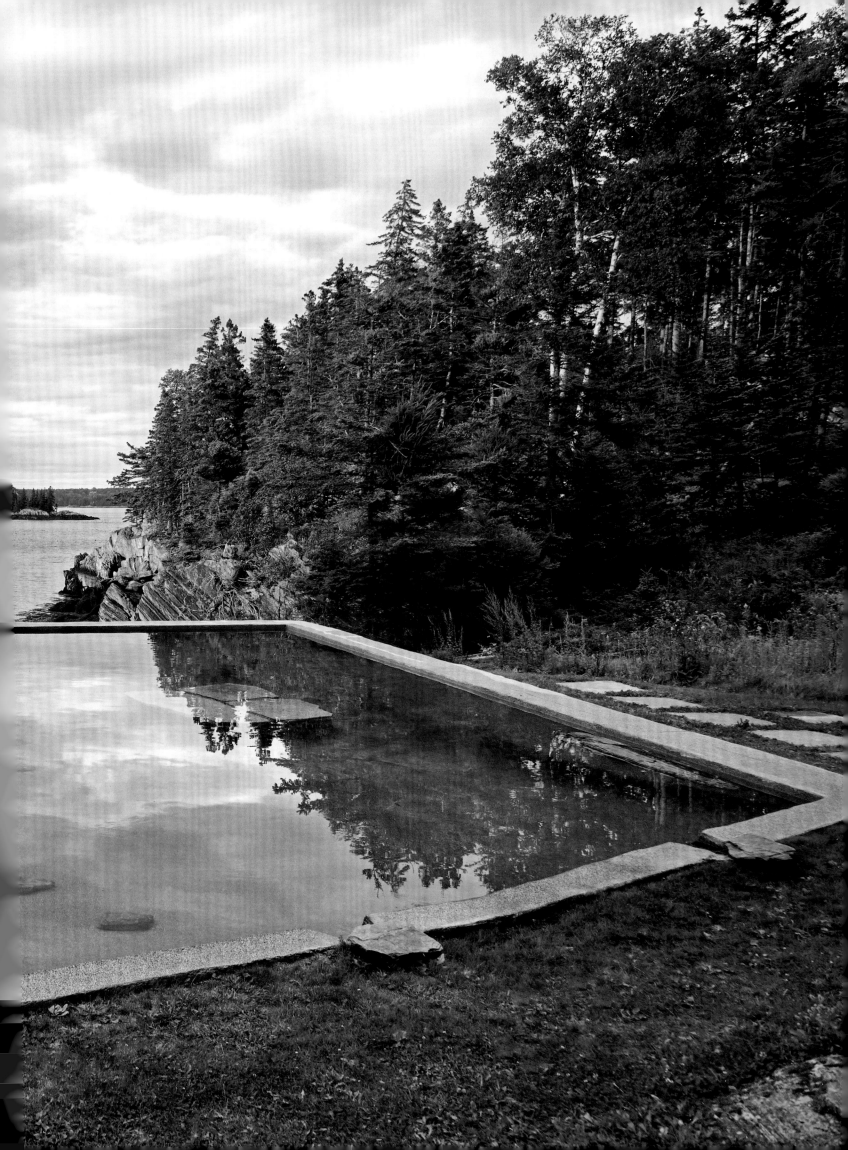

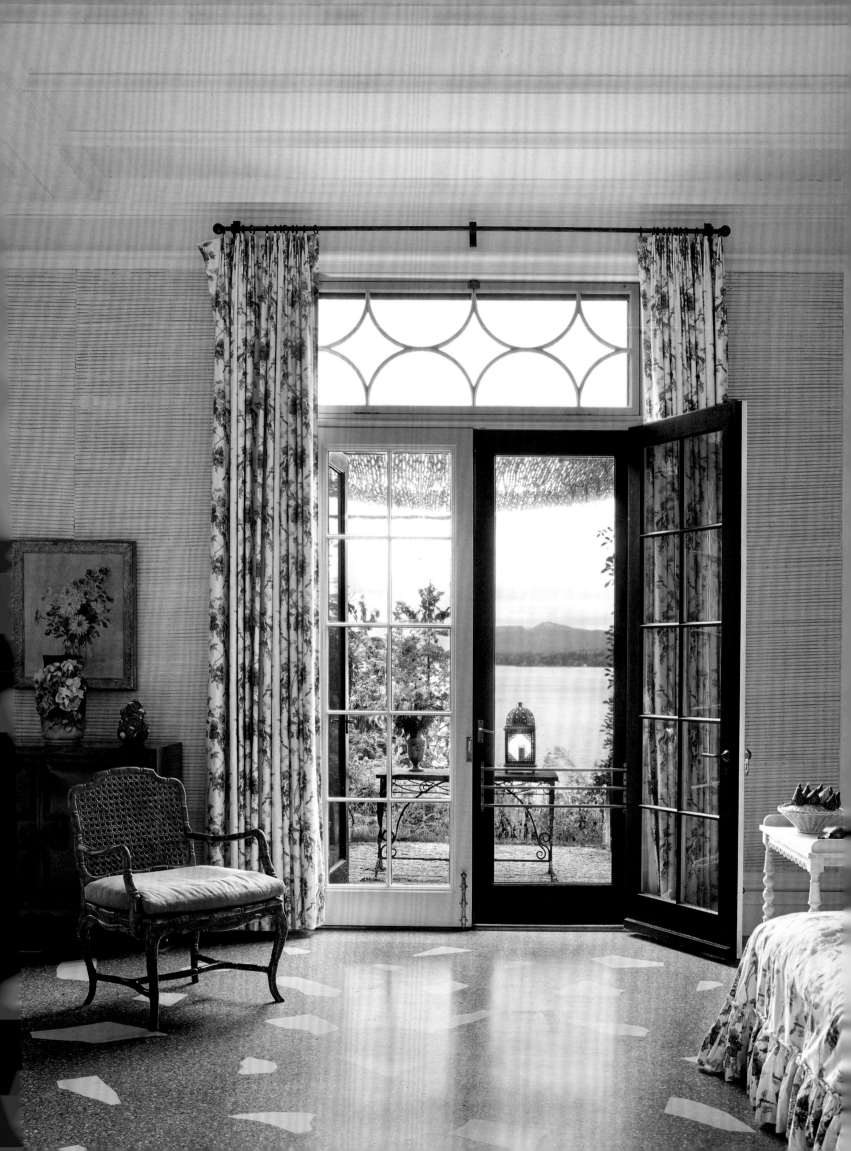

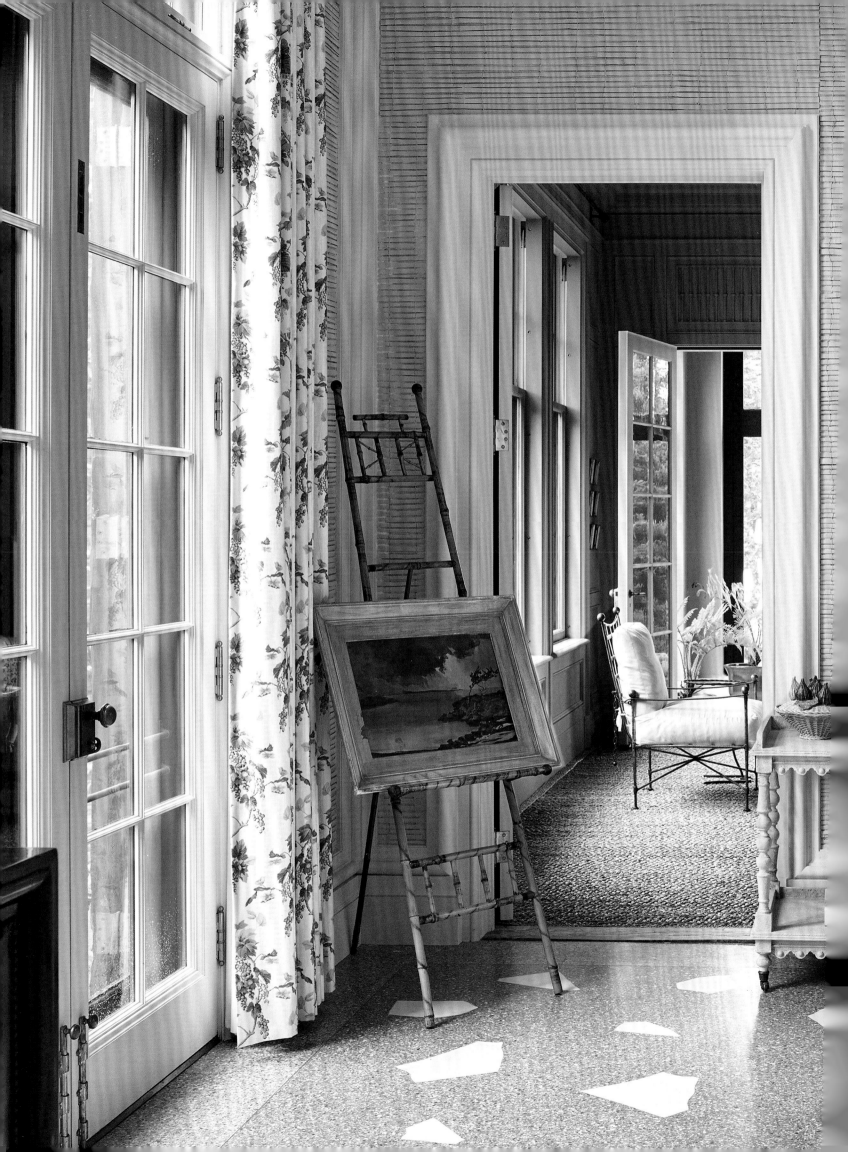

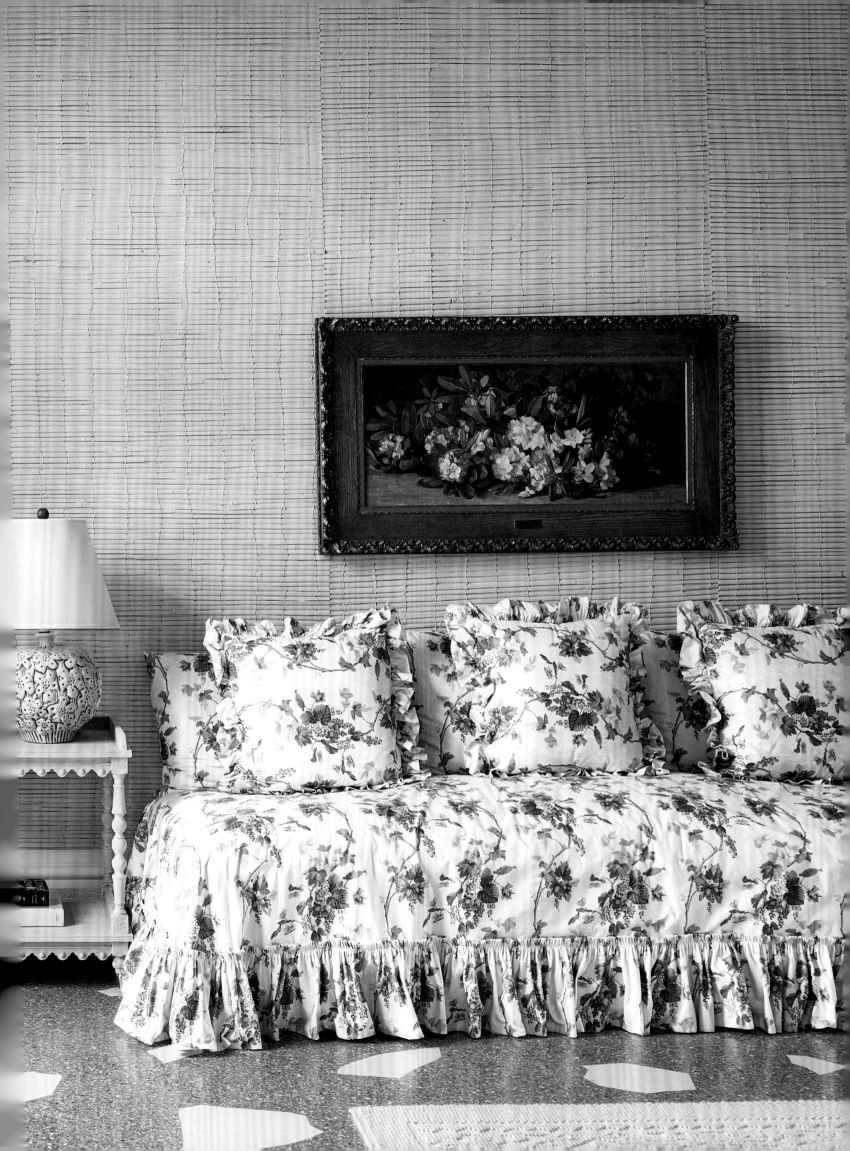

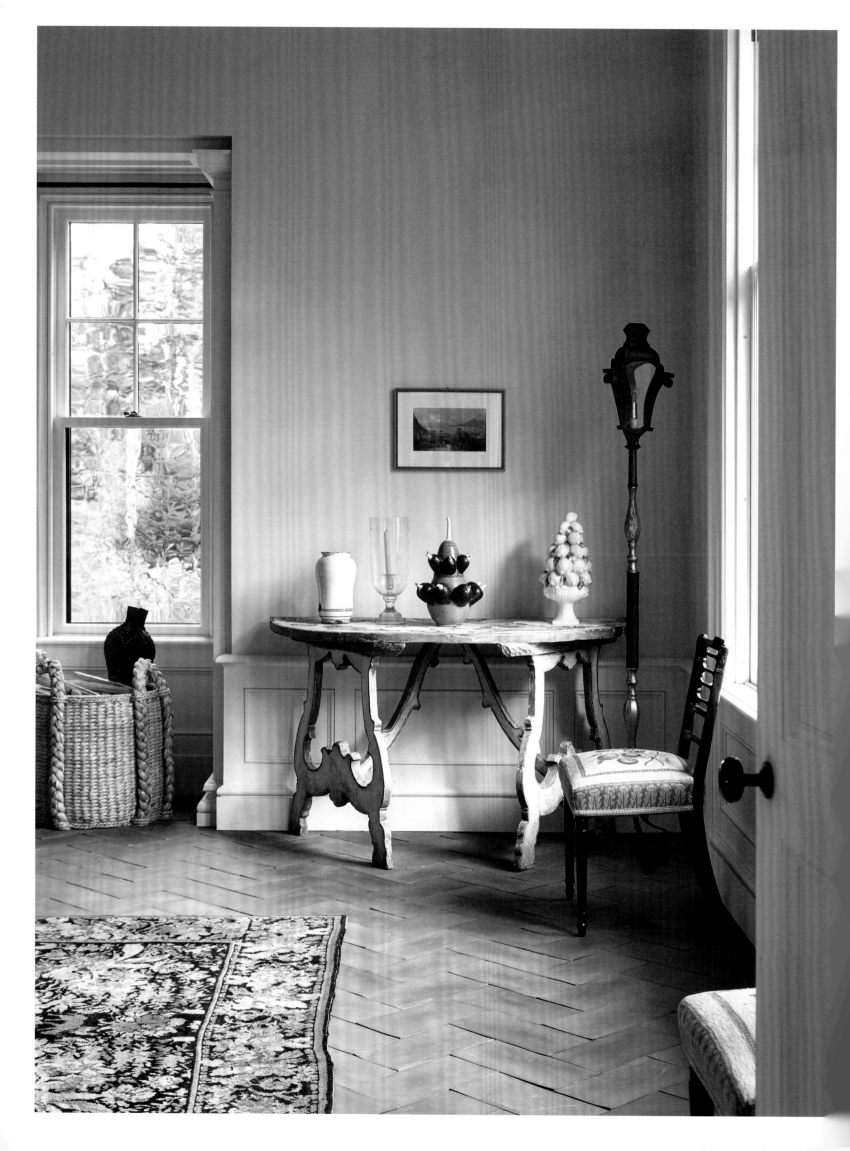

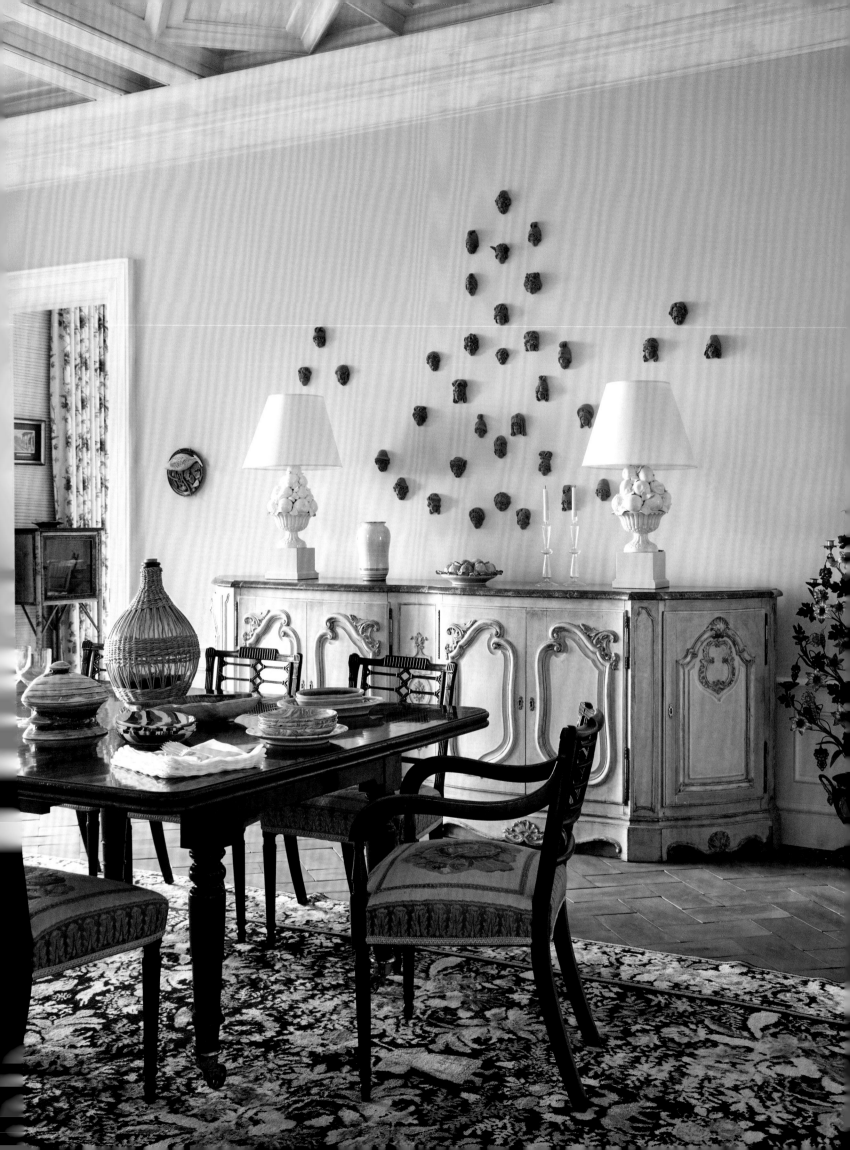

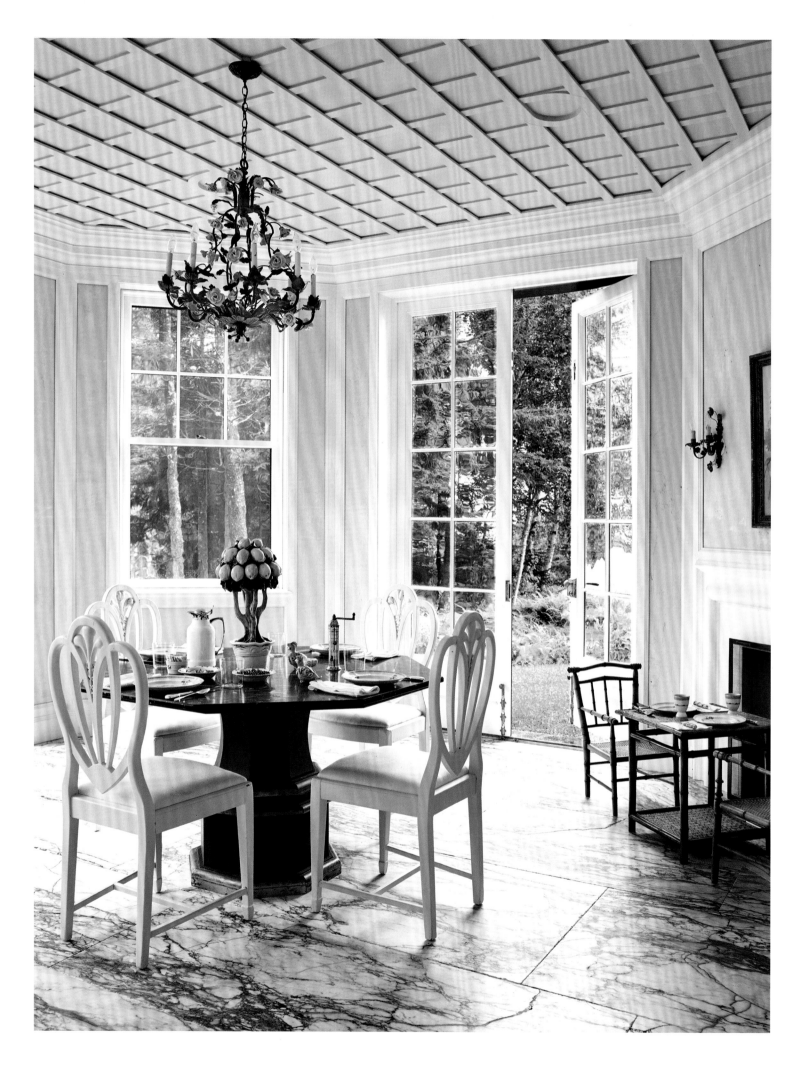

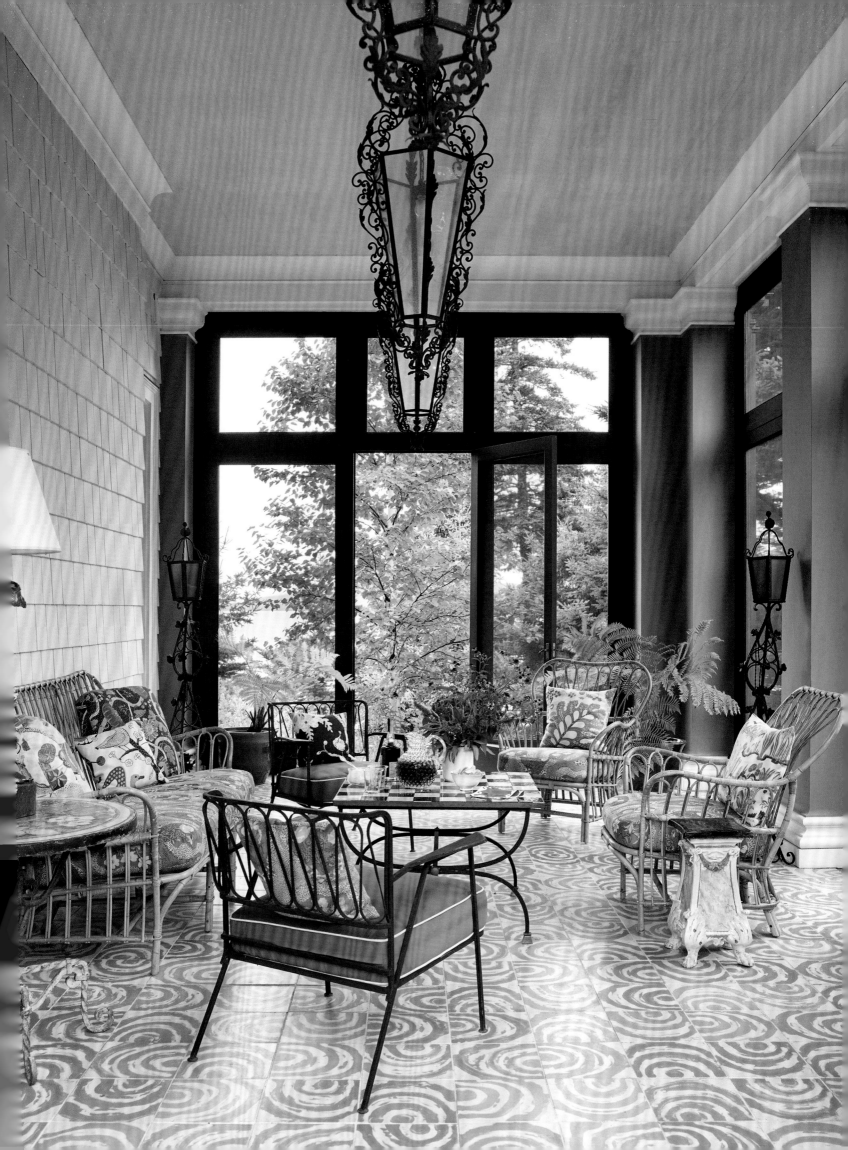

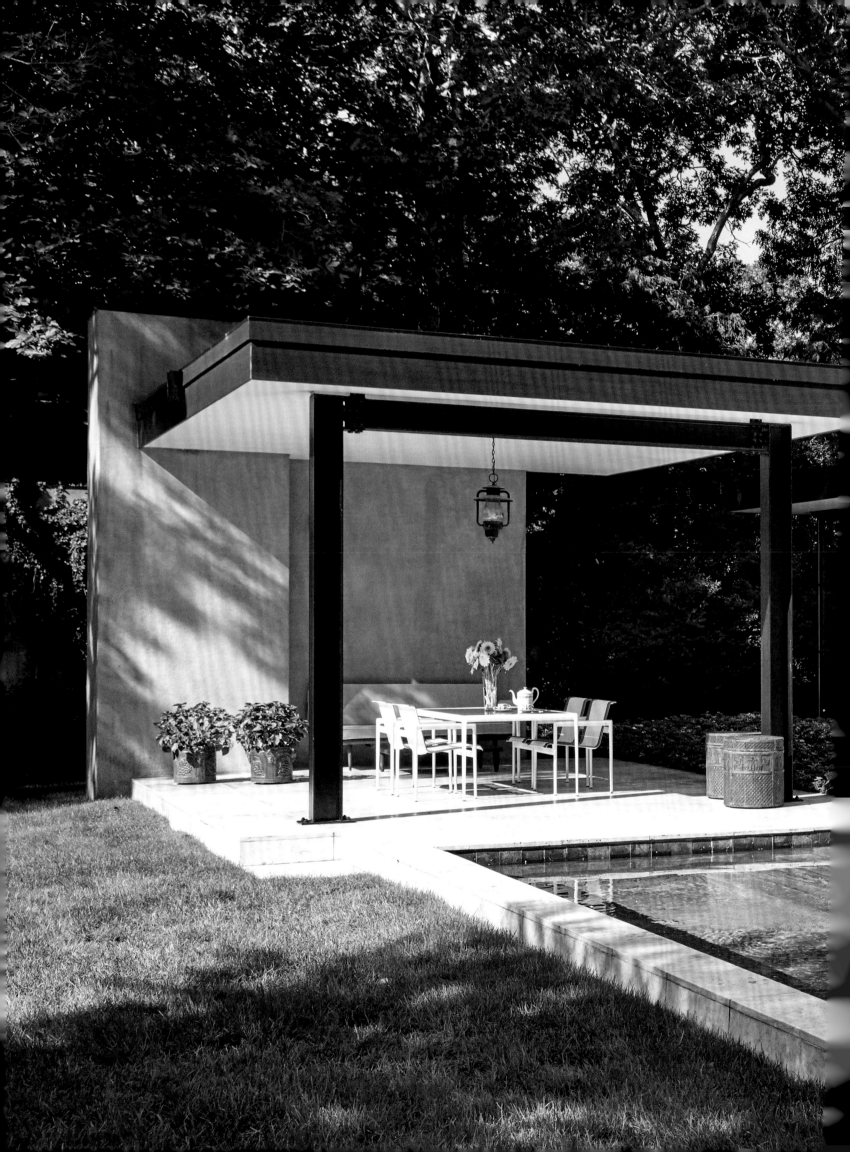

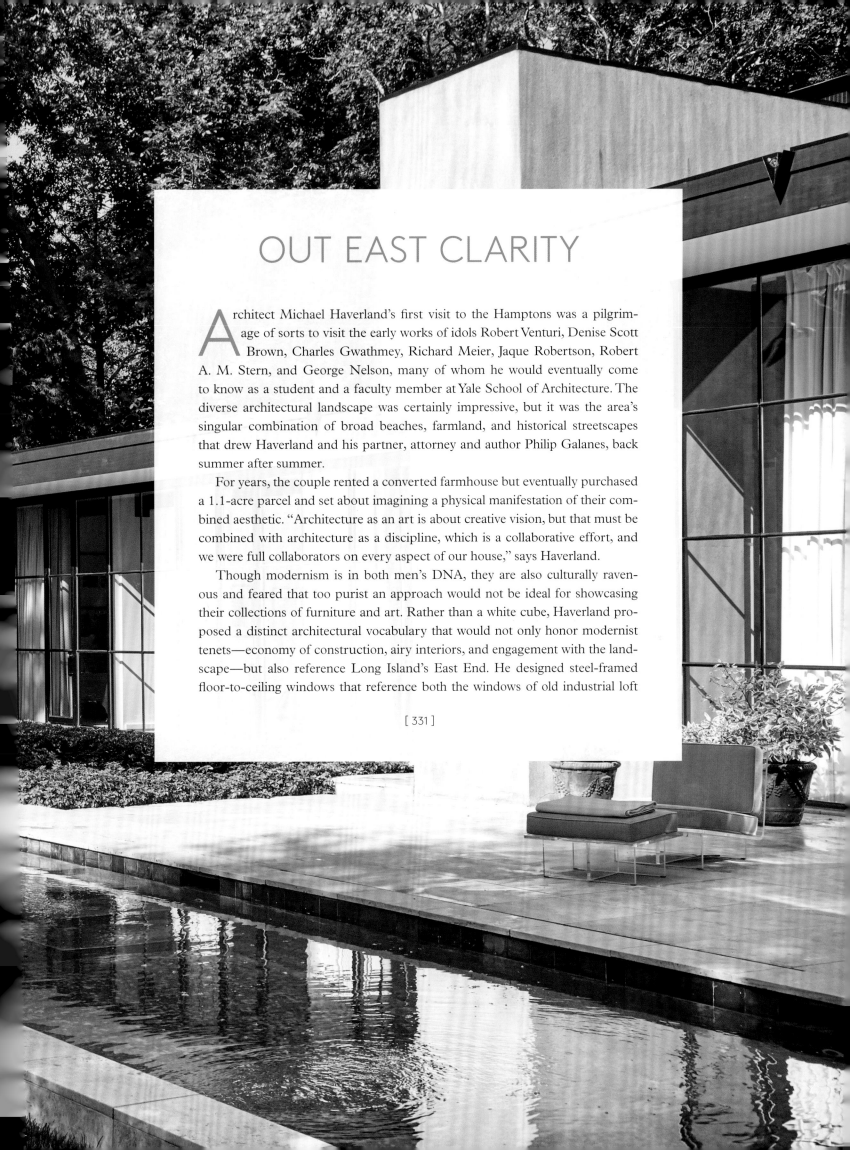

OUT EAST CLARITY

Architect Michael Haverland's first visit to the Hamptons was a pilgrimage of sorts to visit the early works of idols Robert Venturi, Denise Scott Brown, Charles Gwathmey, Richard Meier, Jaque Robertson, Robert A. M. Stern, and George Nelson, many of whom he would eventually come to know as a student and a faculty member at Yale School of Architecture. The diverse architectural landscape was certainly impressive, but it was the area's singular combination of broad beaches, farmland, and historical streetscapes that drew Haverland and his partner, attorney and author Philip Galanes, back summer after summer.

For years, the couple rented a converted farmhouse but eventually purchased a 1.1-acre parcel and set about imagining a physical manifestation of their combined aesthetic. "Architecture as an art is about creative vision, but that must be combined with architecture as a discipline, which is a collaborative effort, and we were full collaborators on every aspect of our house," says Haverland.

Though modernism is in both men's DNA, they are also culturally ravenous and feared that too purist an approach would not be ideal for showcasing their collections of furniture and art. Rather than a white cube, Haverland proposed a distinct architectural vocabulary that would not only honor modernist tenets—economy of construction, airy interiors, and engagement with the landscape—but also reference Long Island's East End. He designed steel-framed floor-to-ceiling windows that reference both the windows of old industrial loft

[331]

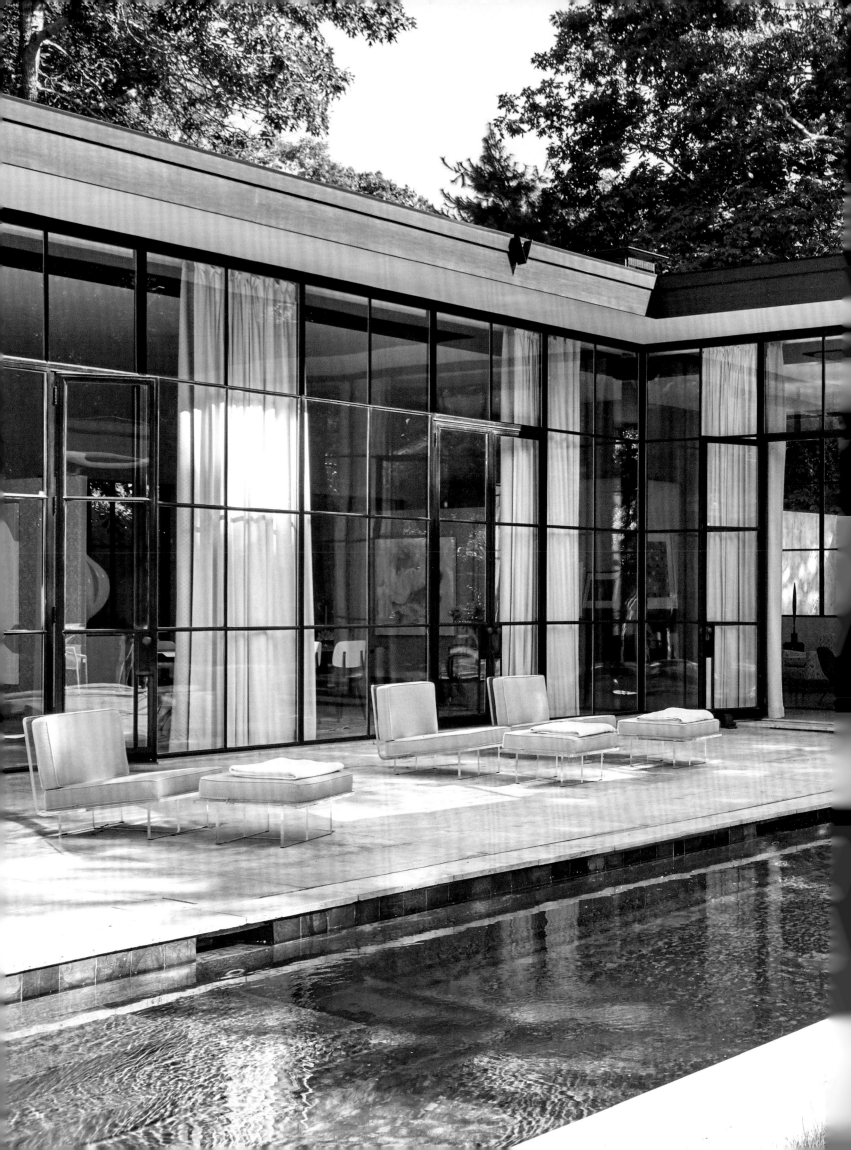

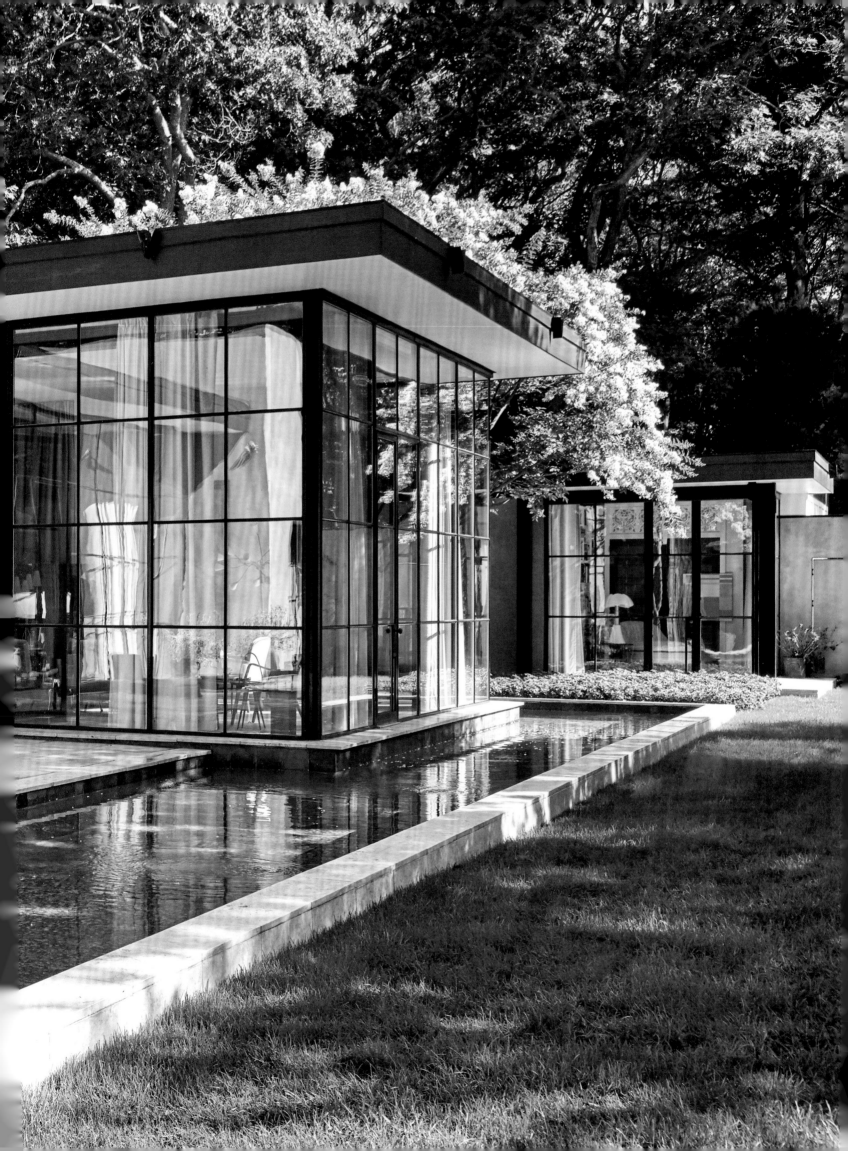

buildings and the smaller wood-framed windows typical of the Shingle Style houses in the Hamptons, thus merging industrial cool and homey warmth. "The windows created a different, modern feel, but are rooted in history and local context." He painted the interior beams black to underscore the industrial look.

The result is an enduringly chic house of understated elegance, the perfect receptacle for the couple's collections. One of Galanes's earliest purchases was a George Nakashima dining table for which he saved for a year. His home office has not one, but two, classic mid-century desks: one by Jean Prouvé, the other by Jacques Adnet.

Surprises are everywhere. A Jenny Holzer marble bench was a law school graduation gift from Galanes's mother. Six brass trivets that the couple found in Palm Springs were converted into sconces. Despite the overall modern look of the house, there are 1930s French country sinks, claw-foot tubs, glass and porcelain fixtures, and vintage push-button light switches.

Beware an invitation for drinks. Anyone who spends time here begins to see things their way. Parties have led to commissions from style.com executive fashion director Candy Pratts Price, photographer Arthur Elgort, and artist David Salle. When Calvin Klein attended a book party for Galanes's second novel, *Emma's Table*, he declared, "Your house is genius," and he subsequently hired Haverland to collaborate on his latest beachfront house. Perhaps most rewarding, two of the modern masters Haverland looked up to, Charles Gwathmey and Richard Meier, have both lavished the house with praise.

PAGES 330-33: Michael Haverland designed steel-framed floor-to-ceiling windows that are rooted in local history but impart a modern feel to the house. The long lap pool and patio are situated to get the best southern light all day long.

OPPOSITE: Mimmo guards the pool house, where a painting by Karen Dow (ca. 1995) hangs. The pendant light is Venini glass and the table lamp is a mid-1960s Pipistrello by Gae Aulenti. The laser-cut heating and cooling vent is in the William Morris style.

PAGES 336-37: The living room's twelve-and-a-half-foot-high ceiling offsets the house's forty-foot width. Three hundred fifty yards of chenille curtains soften the clean modern lines, providing warm color and texture, as well as thermal insulation. A pair of early 1950s Marco Zanuso Lady chairs, found in Rome, are upholstered in a royal-blue fabric. The painting is by

friend and client Peter Nadin. It is made of all natural materials from Old Field Farm. The open-frame sofa is by Edward Wormley, ca. 1953. An Aubusson tapestry covers a 1933 chair by Jules Leleu.

PAGES 338-39: The dining room is furnished with a 1970s table by George Nakashima and a mid-1960s sideboard by Raymond Loewy. The painting is by Robert Harms, and the photographs are Cindy Sherman's *Untitled (Doctor and Nurse)*.

PAGES 340-41: In the kitchen, images of birds, inspired by those that are often seen on the property, which is adjacent to a large reserve, were scanned and printed to the dimensions of the cabinets, creating an artful composition.

PAGES 342-43: Galanes's office includes an Eero Saarinen Womb chair, a mid-century Jean Prouvé desk, and an Arne Jacobsen High Back chair.

PAGES 344-45: In the master bedroom, Richard Prince's photographic triptych *Joke, Girlfriend, Cowboy* (2001) hangs over the bed. The ceiling fixture is a 1950s Medusa chandelier by Gino Sarfatti. The sconces are vintage Anglepoise.

PAGE 346: In the guest bathroom, the crystal sconces are by Palwa, ca. 1965. The mid-century wastebasket and the tray and stand are by Piero Fornasetti. The walls are finished in painted masonite.

PAGE 347: In this bedroom, the bas-relief-like wall covering, first used in the couple's New York City apartment, features leaves, branches, small flowers, and buds laser cut from masonite and hand-placed to form an organic plant that appears to emerge from behind a suite of Dorothy Draper cabinets. A cool gray lacquer was chosen to contrast subtly with the wall color.

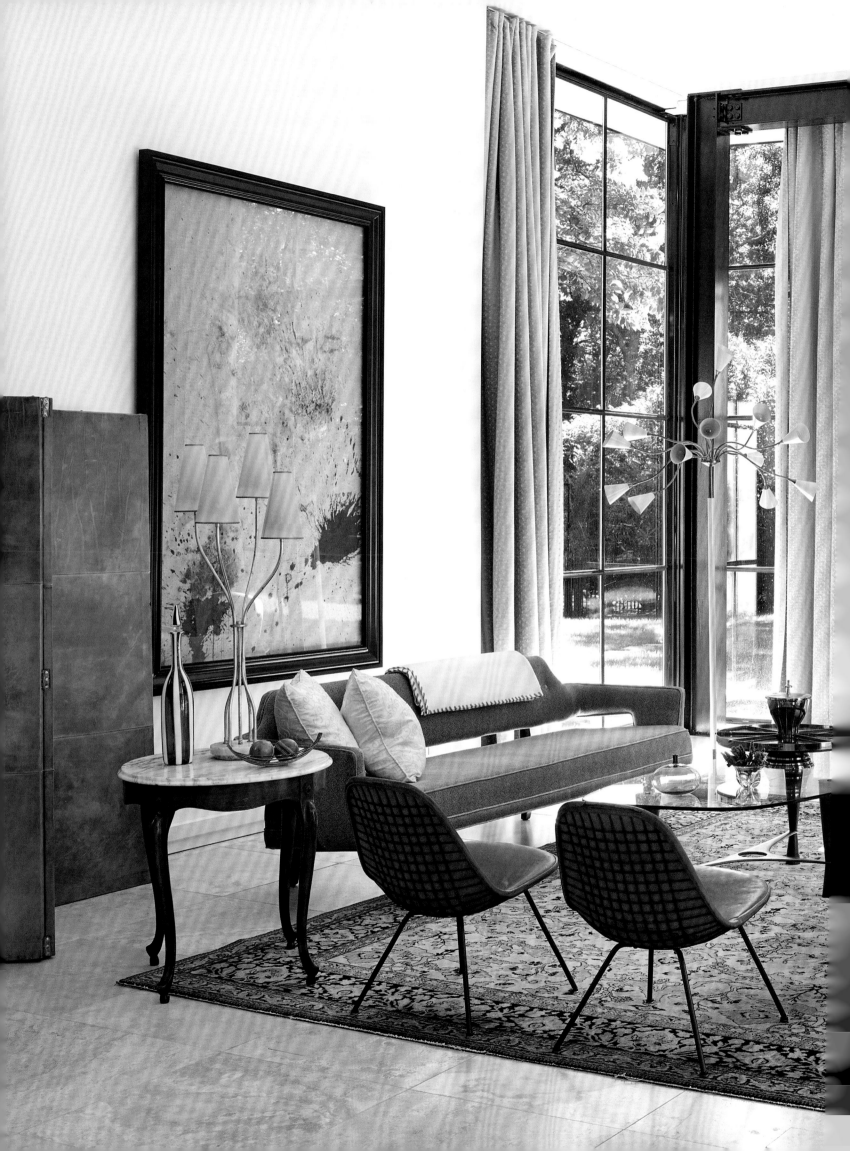

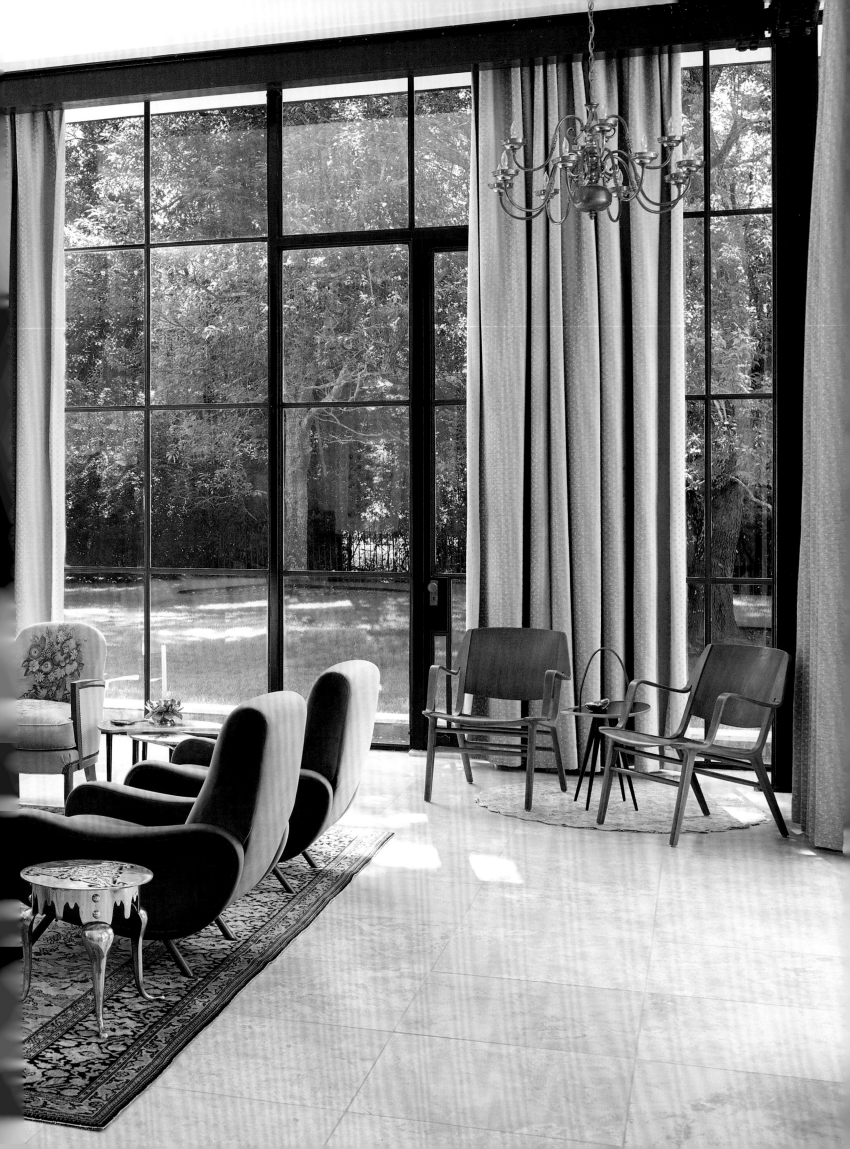

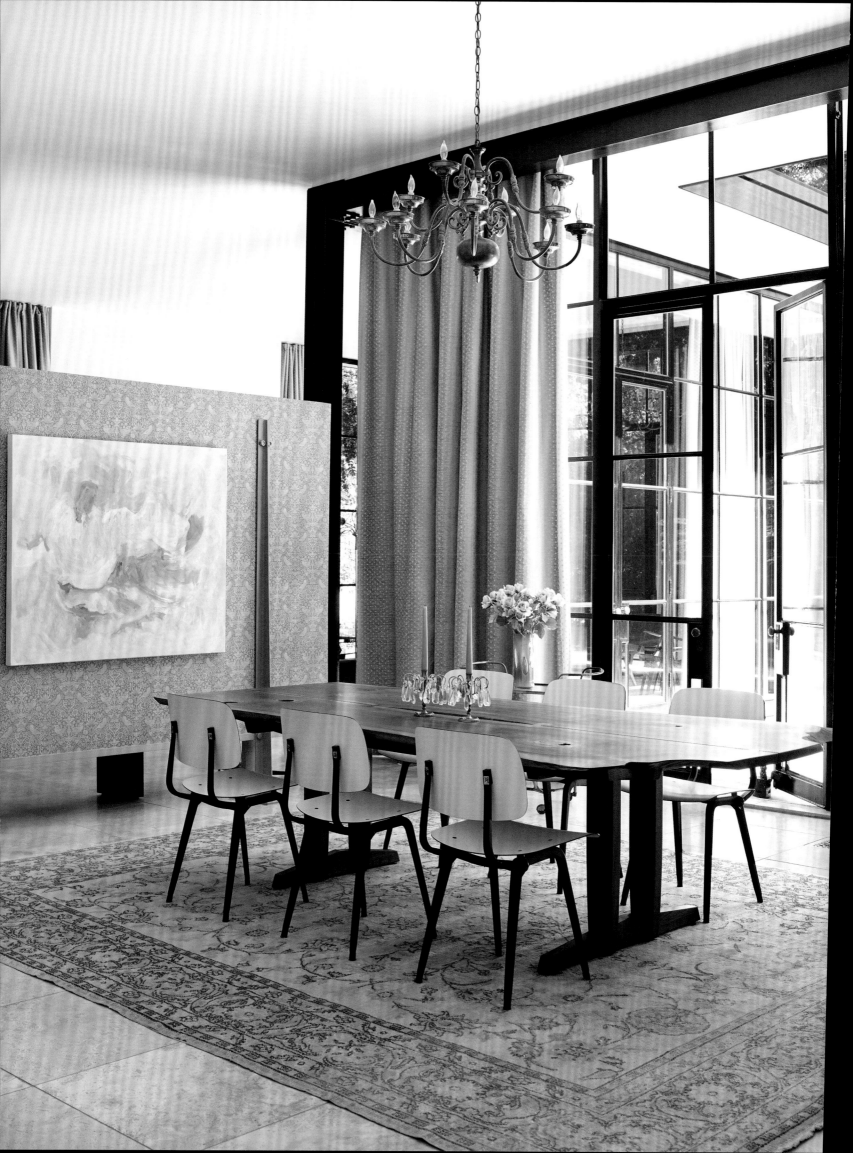

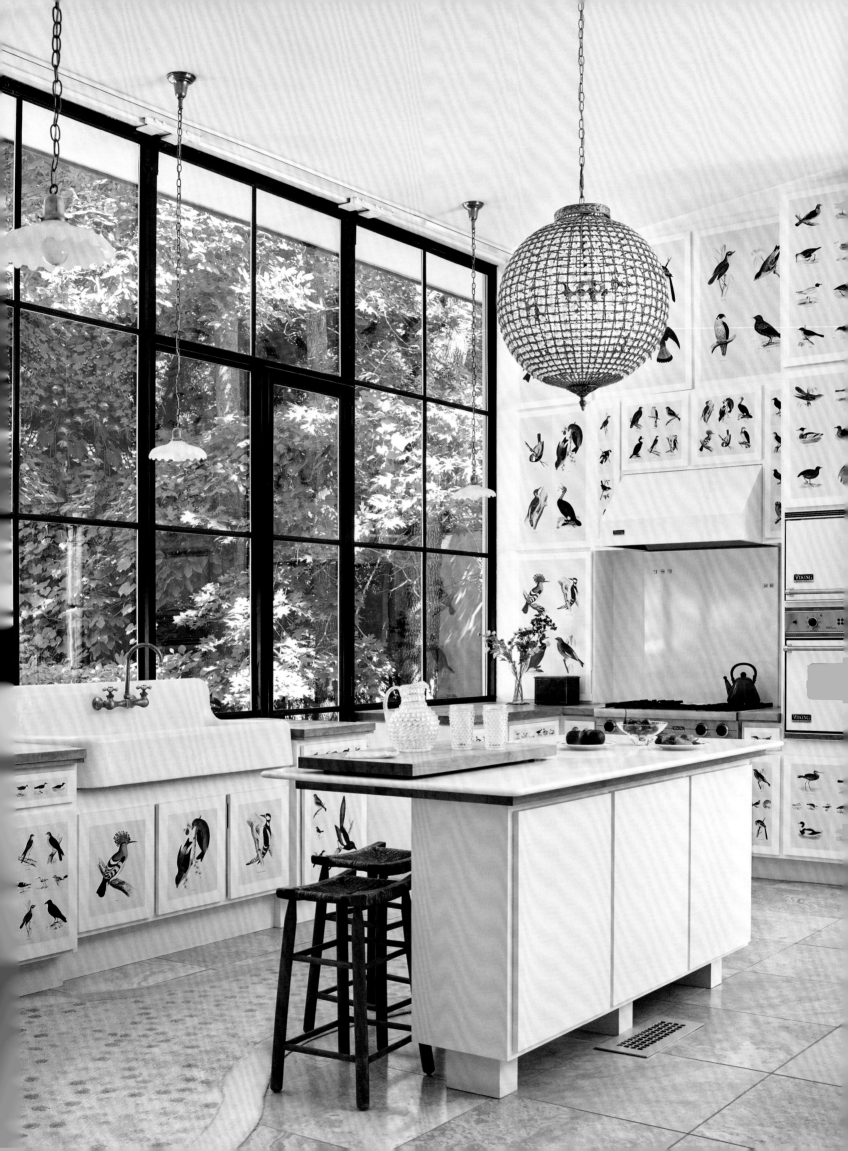

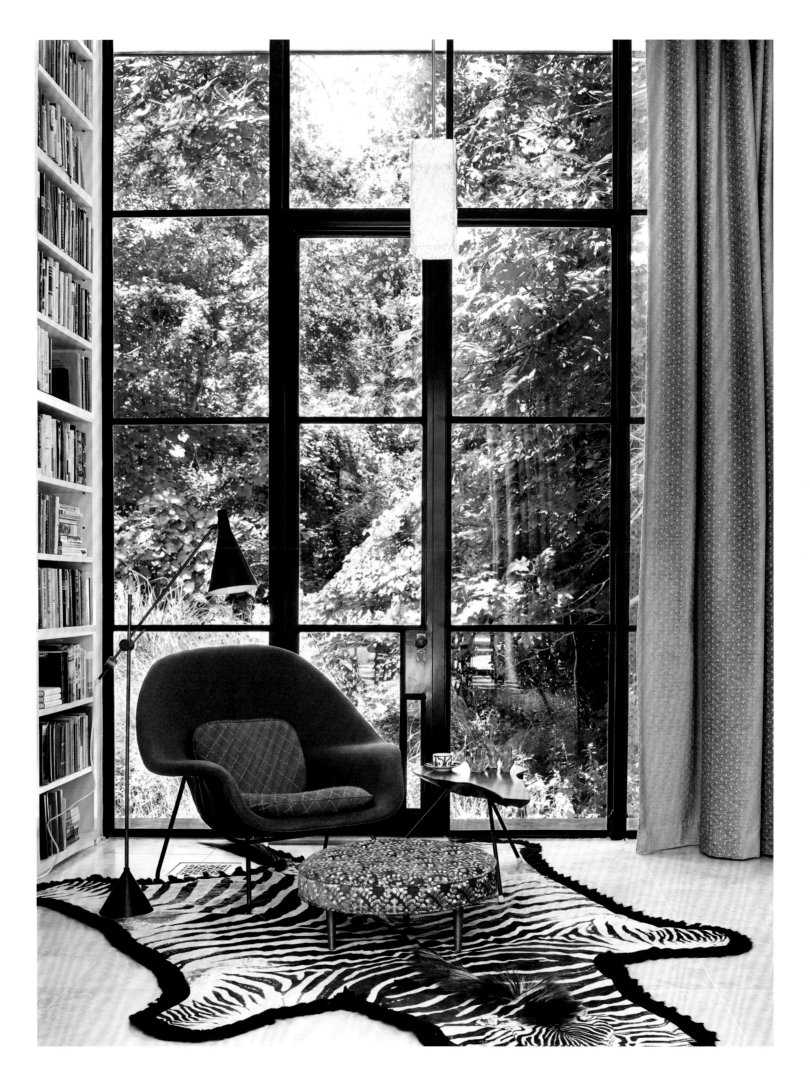

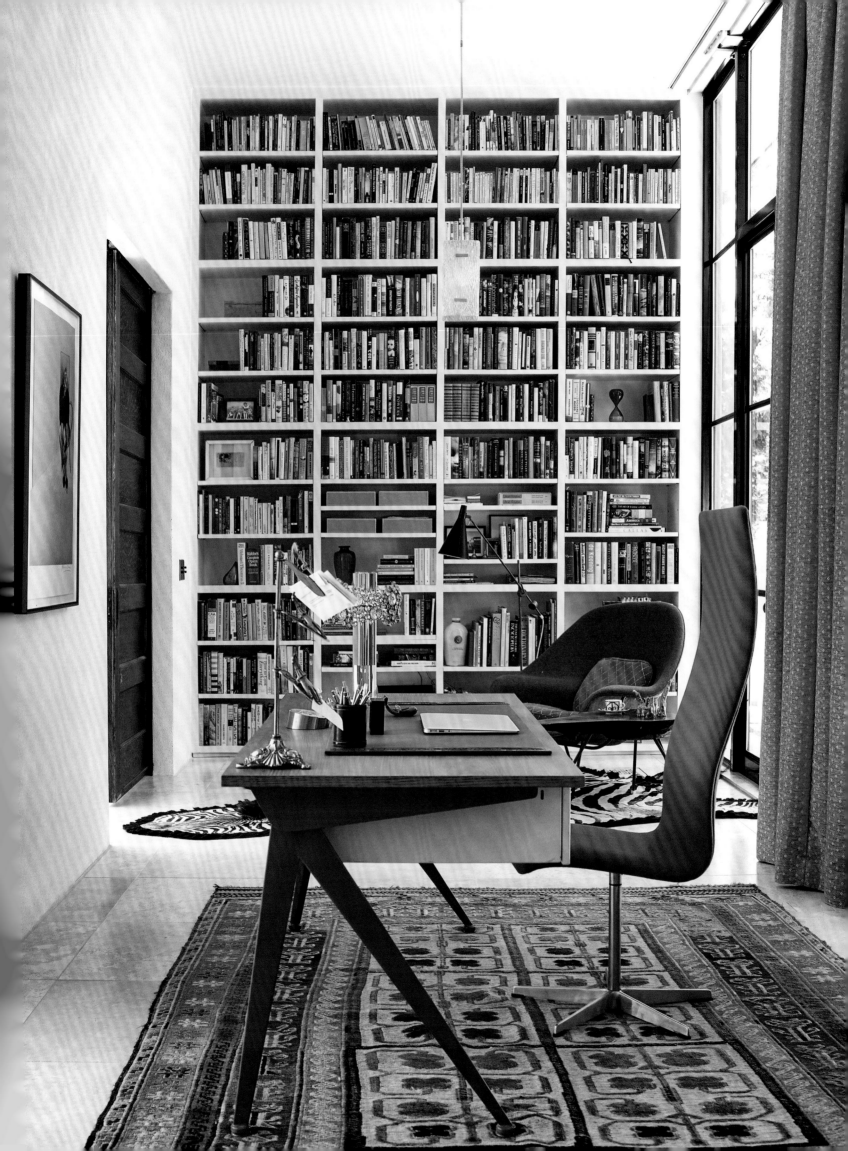

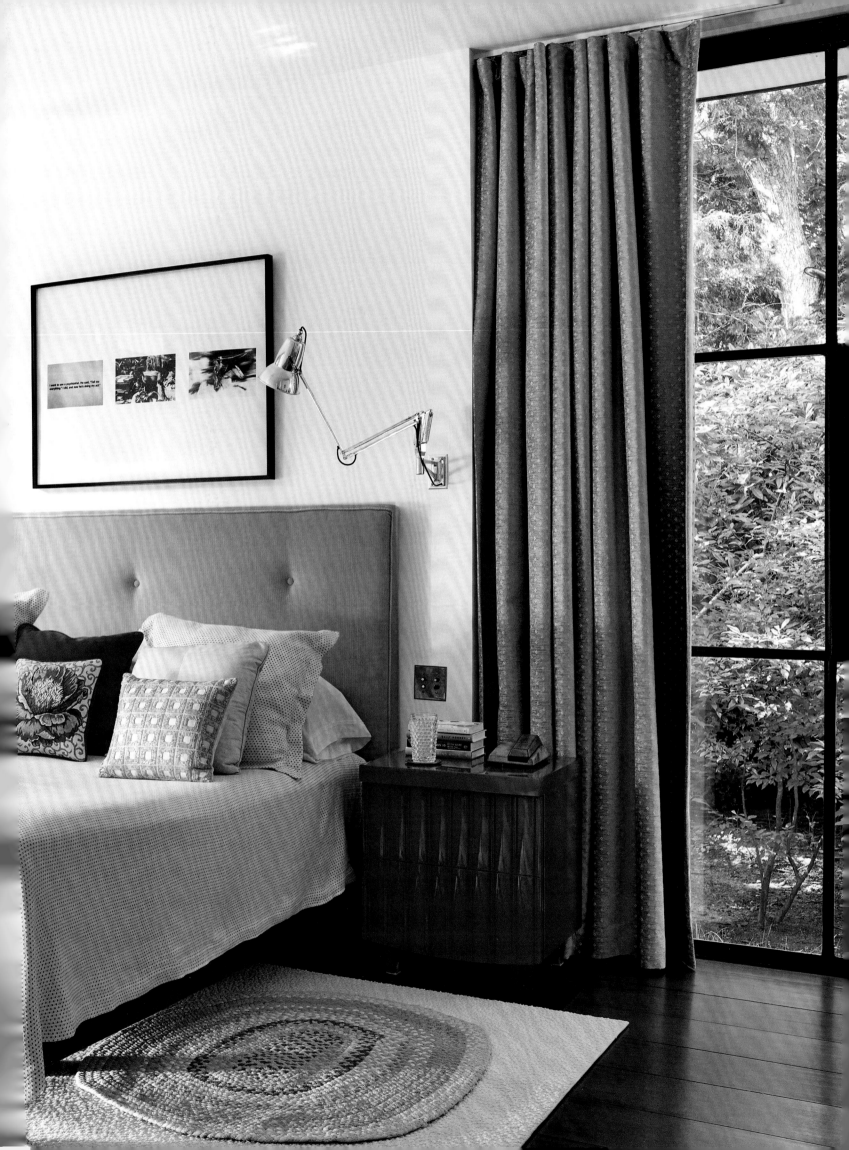

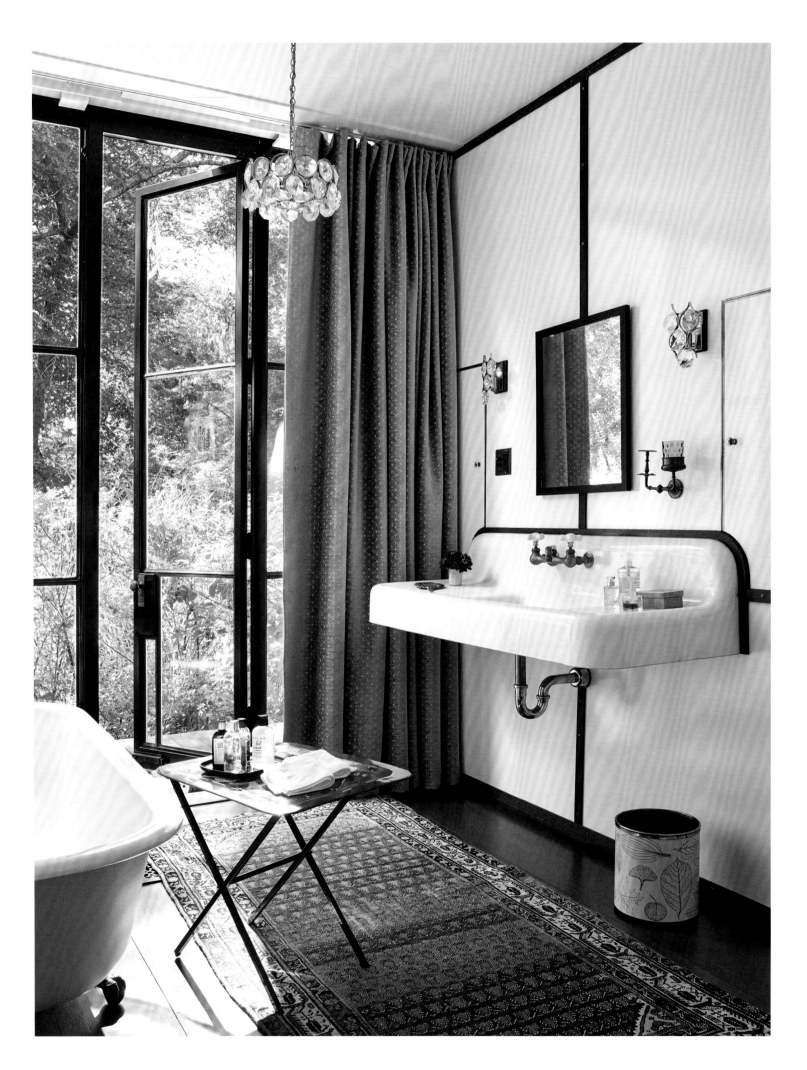

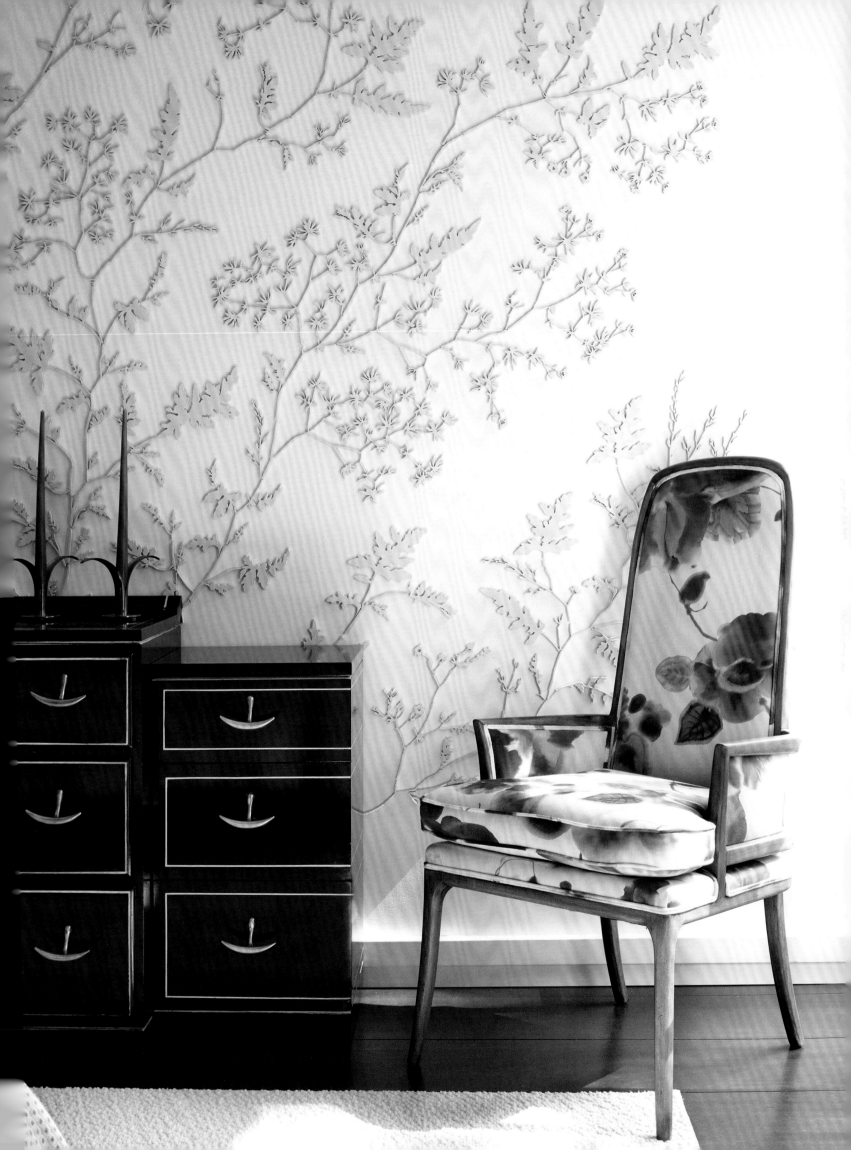

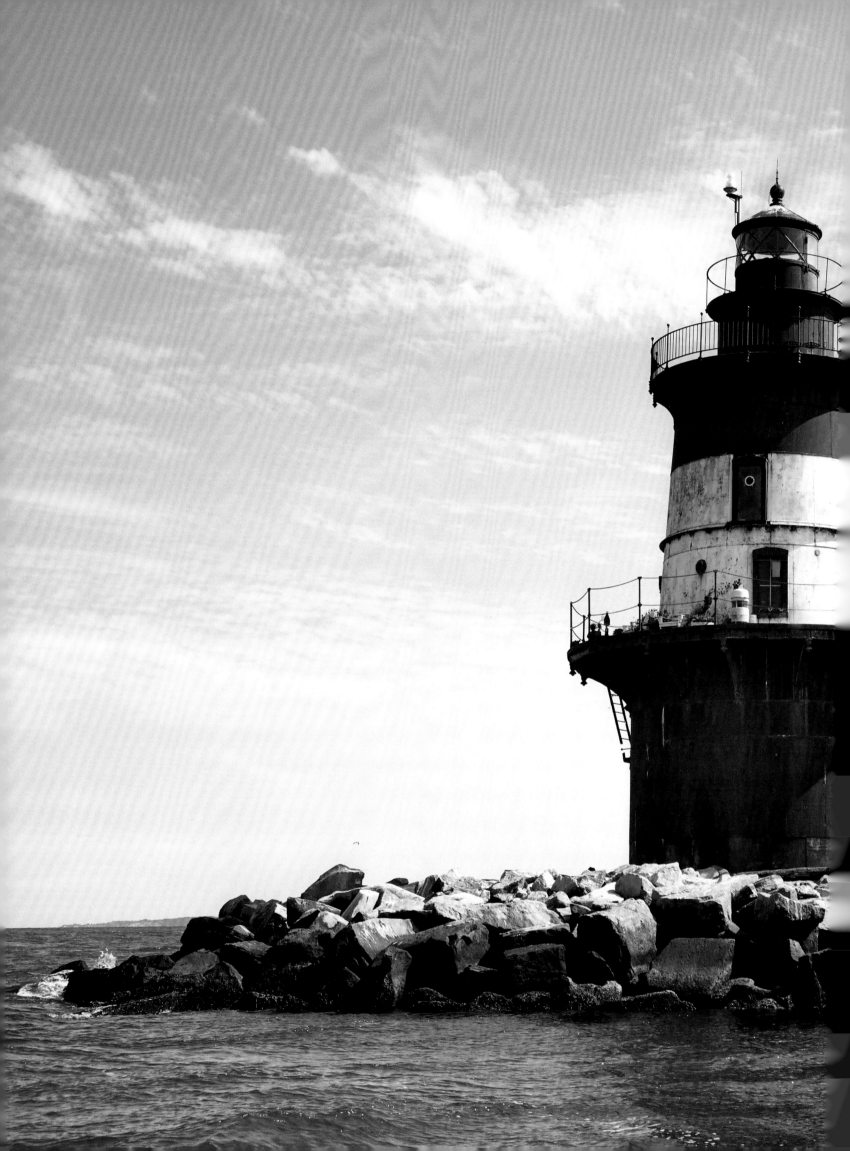

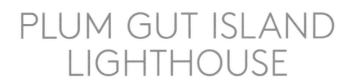

PLUM GUT ISLAND
LIGHTHOUSE

Artist Randy Polumbo is no stranger to extravagant gestures. His large-scale installations, partly imagined and partly an interpretation of the world around him, scramble your neurons before stilling your mind; the more you surrender, the more profound the experience. There's a rambling house in the Mojave Desert built and furnished with recycled finds from junk shops, dumpsters, eBay, and swap meets—paint and sheetrock need not apply—and an underground "grotto," fashioned from hundreds of hand-blown glass phalluses ablaze with LEDs at Tasmania's Museum of Old and New Art (MONA), alongside works by Jean Tinguely, Charles Ross, Richard Wilson, and James Turrell.

It was while searching government auction sites for castoff parts for his *Lodestar* project—a gutted fuselage topped by a spherical cage that thrusts upward like a whale leaping out of the sea—that Polumbo came across a nineteenth-century lighthouse for sale off the eastern end of Long Island, and he couldn't help himself. Almost immediately, he entered a three-month bidding war, urged on by his longtime friend the writer Rick Moody, who predicted, "This is the next logical step in your progression creatively. You are going to make something important of this." The five-year renovation was a heroic effort, even for Polumbo, whose day job is as founder of the eco-construction company Plant, which executes artful interiors for the likes of Santiago Calatrava, Rafael Viñoly,

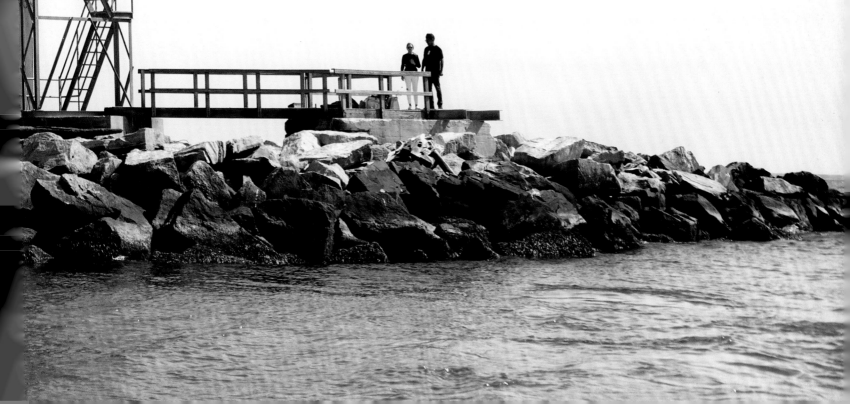

Richard Gluckman, Jacques Grange, Deborah Berke, Robert Couturier, Lee Mindel, and Maya Lin. He outfitted the two-hundred-year-old lighthouse with USB ports, outlets, appliances, a composting toilet, and, of course, one of his otherworldly grottos. The entire operation runs on a newly installed windmill and solar panels.

Polumbo suggests that visitors engage Captain Bob to take them to the lighthouse, as "he's the only one who doesn't get caught up on the rocks." As Bob maneuvers his center-console boat toward Plum Gut Island, he instructs us to "jump fast" (and apparently far) onto what looks like a jury-rigged pool ladder. Two more flights of ladders bring us to the first floor of the lighthouse, where we navigate a narrow walkway, the edge marked by a thin chain-link railing. Polumbo identifies a box the size of a microwave as the foghorn. "It's really loud and I never know when it's going to blow, hopefully not when someone's nearby or we'll lose them over the rocks." We step into the relative safety of the everything room, which is outfitted with a portable kitchen, teak dining table, six chairs, and two army cots equipped with cozy blankets and hand-crocheted pillows. On the next floor, the atelier holds a teak writing desk, and one more flight up is the grotto, where throbbing, color-changing lights create the sensation that one has stepped into a turning kaleidoscope. "You experience a different kind of claustrophobia here, trapped in the open," says Polumbo, as he produces a cheese plate complete with fruits and floral garnishes. He offers cappuccino, the production of which necessitates the revving up of a miniature generator, usually saved for emergencies.

When inevitably asked about the significance of the grotto, Polumbo answers, "The vintage grottos had water features and nymphs and mysterious symbols and sculpture as well; this is just my version of that tradition. I feel like there is a symmetry between humans and their unconscious and the lighthouse and this grotto, a dreaming space where energy and connections are amplified and catalyzed, sometimes in a person, or even between them and the elements. It's like a nondenominational chapel coupled with a particle accelerator, coupled with Wilhelm Reich's Orgone box, coupled with a 360-degree ocean view."

It's an explanation that makes the lighthouse a logical place for an artist's residence, which Polumbo calls his micro-philanthropy. "I am picturing writers, visual artists, and composers coming here for two- or three-week periods and maybe presenting their work in the grotto to robust members of the public wishing to make the voyage." As the sun sets, we back down the narrow rungs, our faces dappled with light cast from an illuminated crystal-clad ball spinning outside, beckoning boaters and dreamers alike.

PAGES 348–49 AND OPPOSITE: A ball of marine epoxy, four feet in diameter and covered in three types of crystals, tiny glass beads, and color-changing LEDs, spins in front of the Plum Gut Island Lighthouse, which has been transformed by artist Randy Polumbo into a work of art and an artist's residence.

PAGES 352–53: The everything room includes a newly built teak dining table that seats six, two army cots that serve as beds, and a portable kitchen. The entire lighthouse is powered by energy generated from a newly installed windmill and solar panels.

PAGES 354–57: On the third floor, Polumbo installed a grotto featuring an undulating, twenty-foot-long banquette and a ceiling of hand-hammered, highly polished aircraft aluminum and hundreds of hand-blown glass orbs aglow with color-changing LEDs.

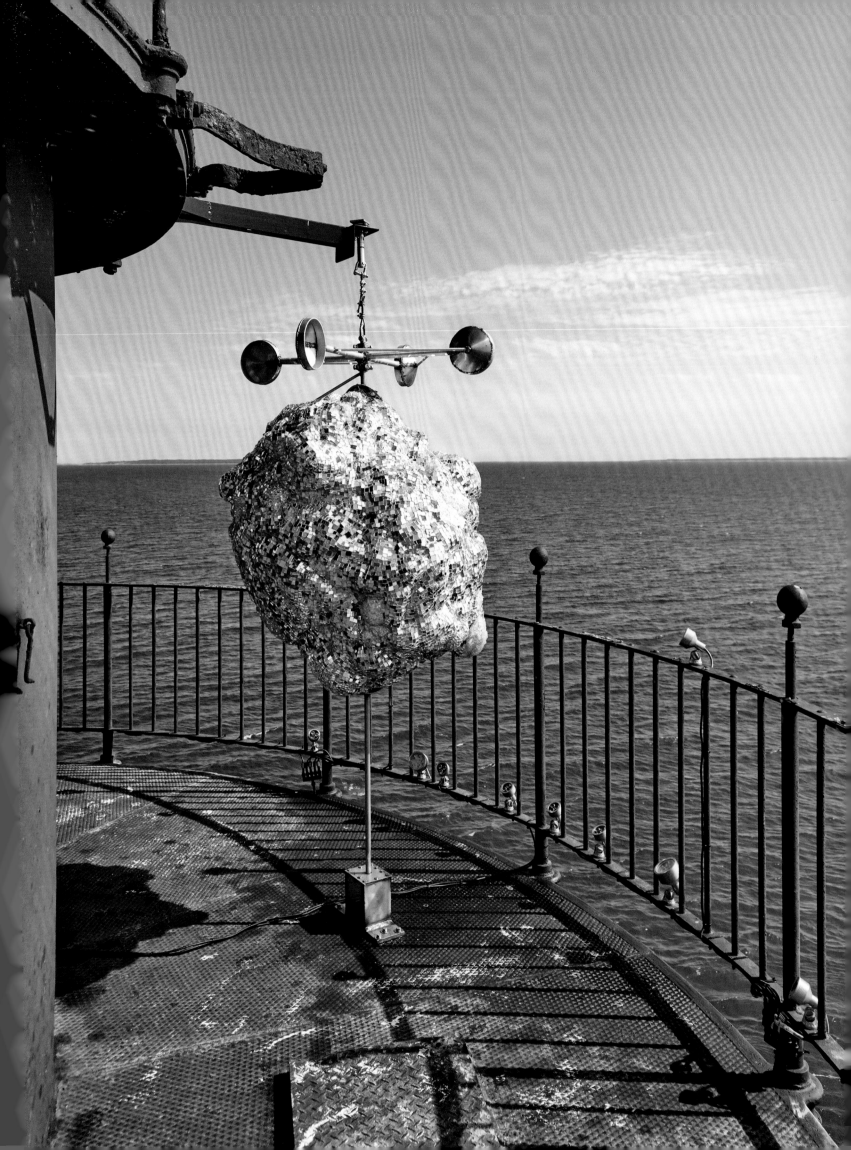

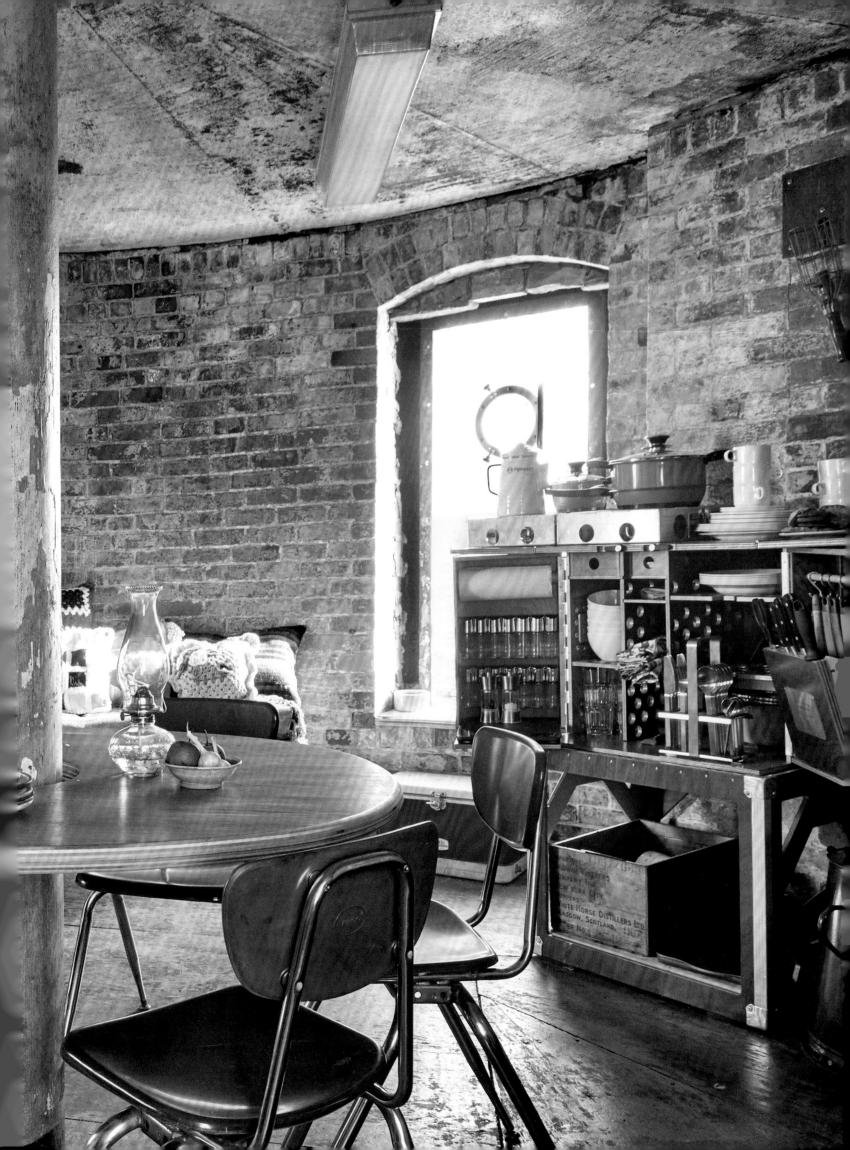

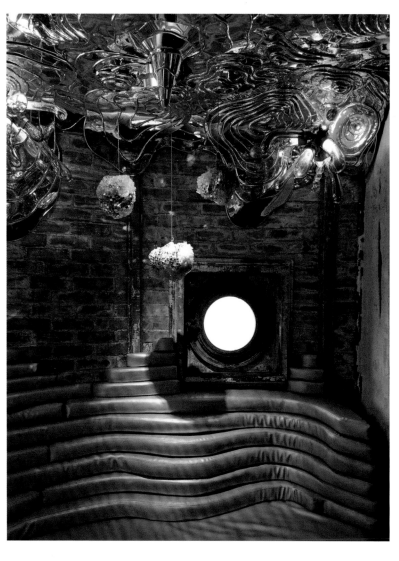
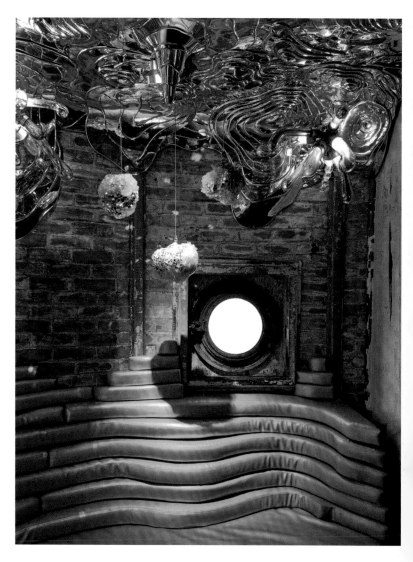
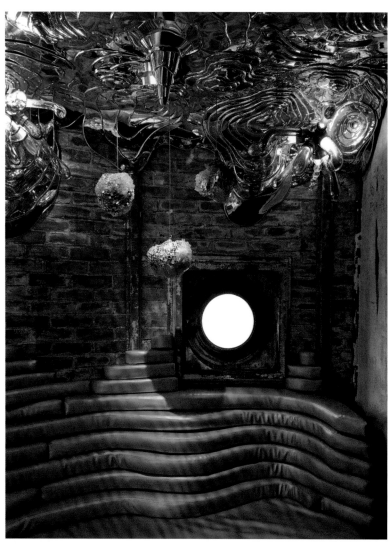
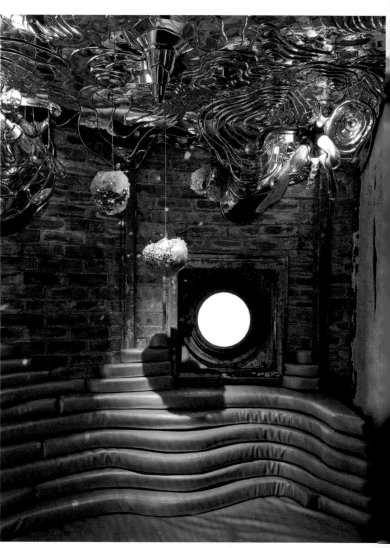

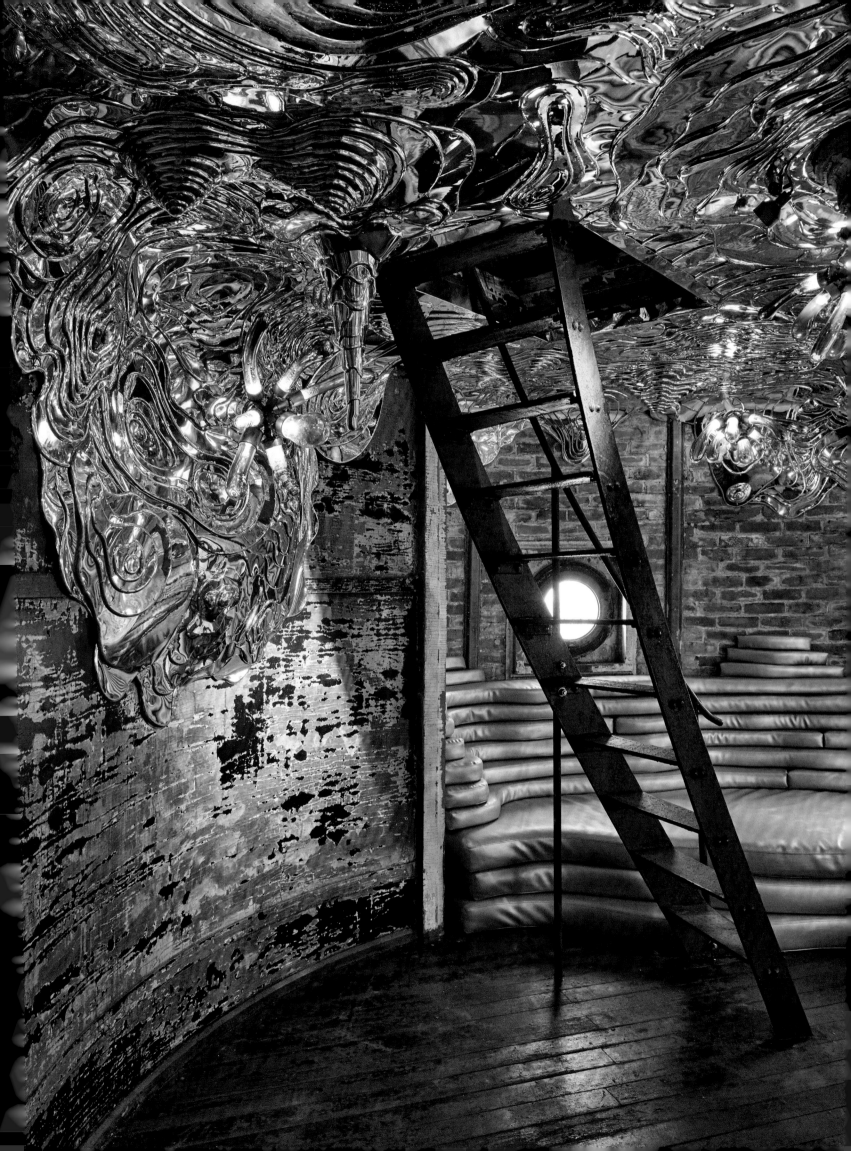

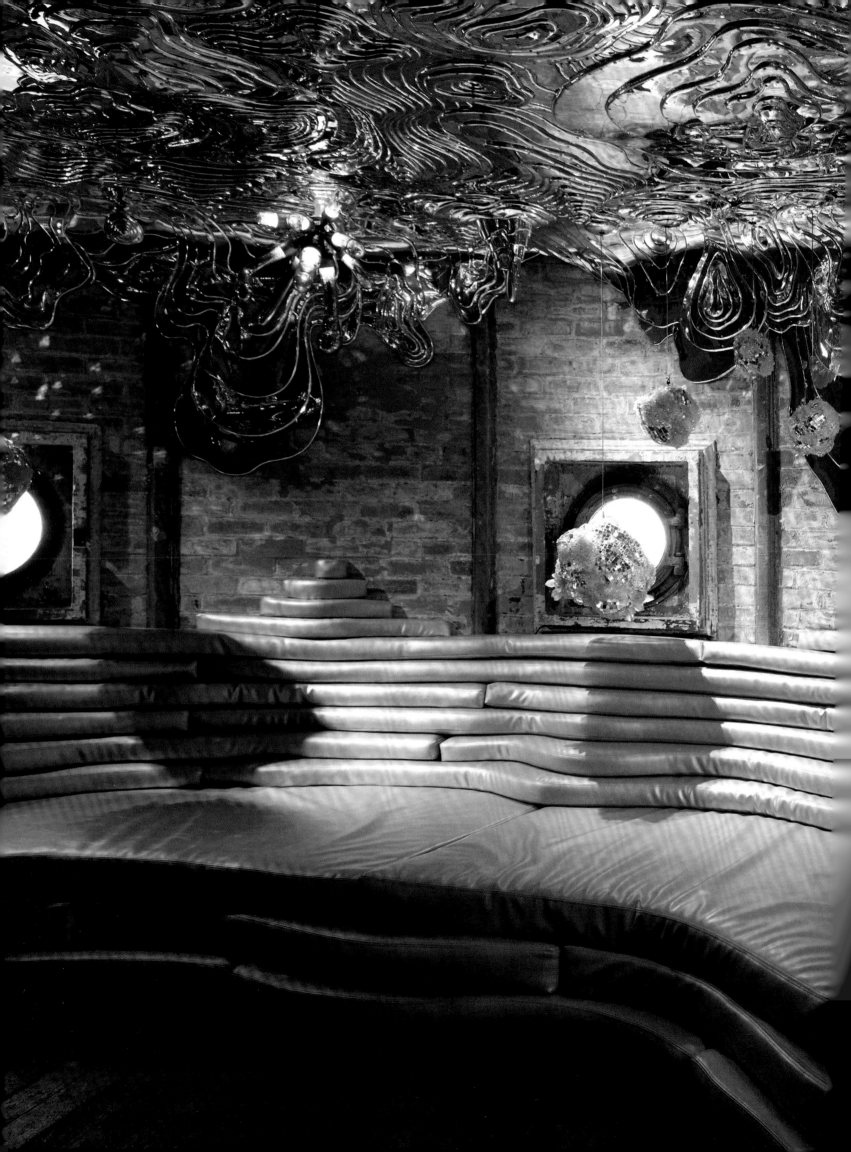

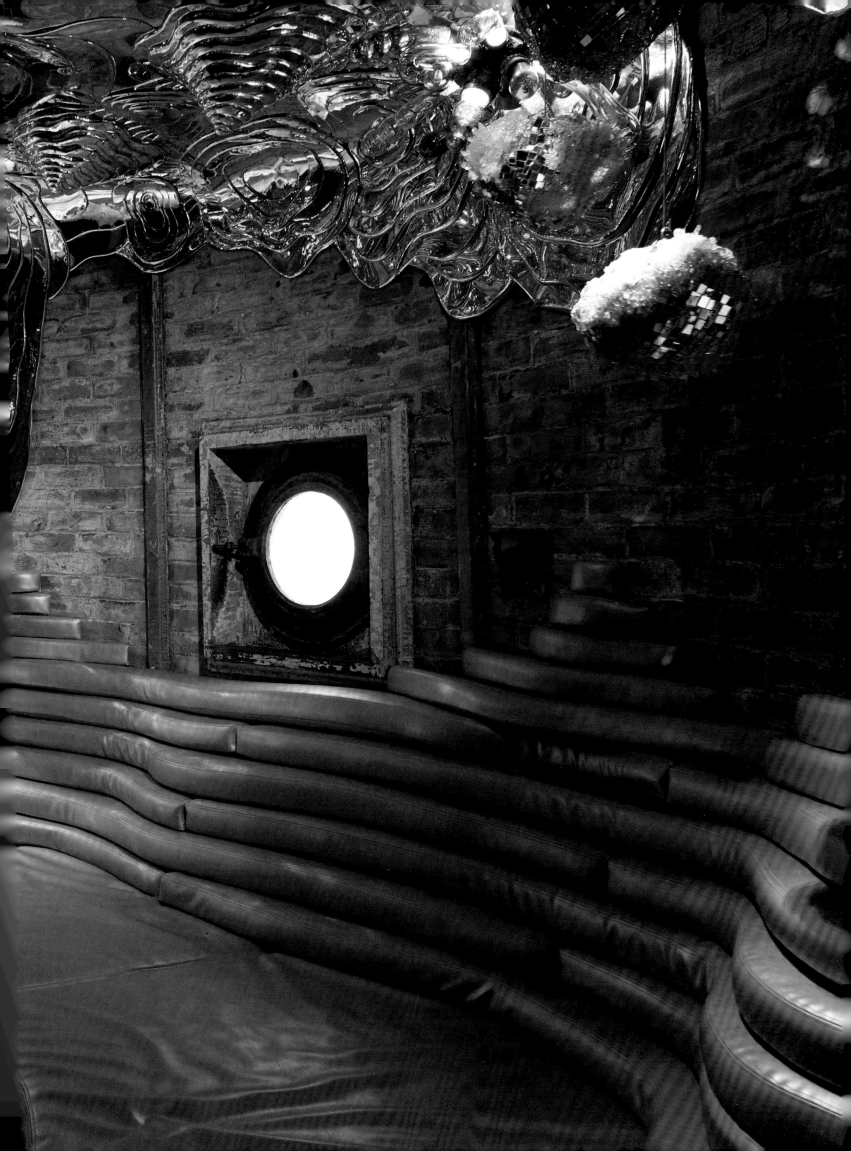

ACKNOWLEDGMENTS

I owe a debt of gratitude to everyone at Vendome Press. It has been a rare pleasure to work with publishers Mark and Nina Magowan, editor Jackie Decter, and designer Celia Fuller on six books over the course of twenty-five years. Their enthusiasm, discerning eye, meticulousness, and unflappability have carried each project from start to finish, and their friendship has provided endless joy. Publisher Beatrice Vincenzini is a welcome force of nature; her passion for design and life in general is an inspiration.

For the exceptional quality of the book's production, I thank Jim Spivey and Dana Cole, and a heartfelt thank you to Meghan Phillips for ensuring that advance copies make it into the right hands.

This book's splendor is indebted to the extraordinary talent of photographer Tria Giovan. The clarity and precision of her work brought each house to life, and her companionship kept us going on long days of shoots and travel by plane, train, and ferry, usually all on the same day.

I owe my career to my parents, journalists Agnes and Clarke Ash, who set a brilliant example that there is pleasure in hard work and collaboration. They taught me the power of observation and encouraged me to find the heart in every story. I am forever grateful to my older brothers, David, Eric, and James, whose humor and gentle ribbing reminds me to take the work, not myself, seriously. My children, Clarke and Amelia Rudick, are constant champions and, as young adults, have become invaluable advisors. The greatest gratitude goes to my husband, Joe Rudick, whose optimism and support make every project pleasurable and possible.

It would be impossible to overstate how grateful I am to each homeowner, architect, interior designer, garden designer, and friend who pointed me in the right directions, providing introductions or opening their own houses, gave freely of their time, and trusted me with the stories about how their residences came to life. There would be no book without the generosity of: Bunty Armstrong, Lillian Ball, Suzy Bancroft, Apple Bartlett, Ann Bartram, Amanda Benchley, Orli Ben-Dor, Barbara Bestor, Mark Brady, Meg and Doug Braff, Tamara Buchwald, Susan and Ordway Burden, Jamie Bush, Shirin Christoffersen, Leslie Cohen, David Collins, Tania Compton, Liz Cook, Dan Costa, Heidi Cox, Susan Crater, Vanessa and Matt Diserio, John Dowd, Peter Dunham, Martha Ferrell, John Fondas, Elena and Norman Foster, Leta and Ridgley Foster, Molly Frank, Andrew Franz, Christopher Freimuth, Ken Fulk, Philip Galanes, Michael Giordano, Penelope Green, Melinda Hackett, Michael Haverland, Rachel Horovitz, Stephen Jay, North Keeragool, John Knott, William Laird, Jenny Landy, Aerin Lauder, Alexia Leuschen, Barbara and Bobby Liberman, Susan and Peter MacGill, Lucinda Ballard May, Gillian, Rebekah, Sara, and Philip Maysles, Ashley and Jeff McDermott, Liz and David Netto, Peter Pennoyer, Randy Polumbo, Michael Rock, Tom Scheerer, Jason Schwarz, Susan Sellers, Ted Sheridan, Carly Simon, Joseph Singer, Rose Styron, Patricia Sullivan, Sharon Johnson Tennant, Mish Tworkowski, Susan and Rufus Williams, Tamara Weiss, and Kurt Wootton.

JENNIFER ASH RUDICK

Summer to Summer: Houses by the Sea
First published in 2020 by The Vendome Press
Vendome is a registered trademark of The Vendome Press, LLC

NEW YORK LONDON
Suite 2043 63 Edith Grove
244 Fifth Avenue London,
New York, NY 10001 SW10 0LB, UK
 www.vendomepress.com

Distributed in North America by Abrams Books
Distributed in the United Kingdom, and the rest of the world, by Thames & Hudson

ISBN 978-0-86565-381-8

PUBLISHERS: Beatrice Vincenzini, Mark Magowan, and Francesco Venturi
EDITOR: Jacqueline Decter
PRODUCTION DIRECTOR: Jim Spivey
PRODUCTION COLOR MANAGER: Dana Cole
DESIGNER: Celia Fuller

Library of Congress Cataloging-in-Publication Data available upon request

PRINTED IN ITALY

FIRST PRINTING

CASE: Detail of Meg Braff Designs' Swirls wallpaper and roman shades in China Seas Malay Stripe in a Newport, Rhode Island, breakfast room.

ENDPAPERS: Rose-covered cottages and fences are quintessentially Nantucket.

PAGE 359: Heart-shaped stones, found on the beaches of Nantucket, serve as backgammon pieces on a board designed and stitched by needlepoint guru Erica Wilson.

THIS PAGE: Peter MacGill drives his beloved truck, Jerry, along the scenic dirt roads of Block Island.